WAYNE
ART CENTER
413 Maplewood Avenue, Wayne, PA 19087
www.wayneart.org

Memories and Images

MEMORIES

AND IMAGES

The World of Donald Vogel
and Valley House Gallery

DONALD STANLEY VOGEL

THE UNIVERSITY OF NORTH TEXAS PRESS ✳ DENTON, TEXAS

10 9 8 7 6 5 4 3 2 1

Permissions:
University of North Texas Press
P.O. Box 311336
Denton, TX 76203–1336

The paper used in this book meets the minimum requirements
of the American National Standard for Permanence of Paper for Printed Library
Materials, z39.48.1984. Binding materials have been chosen for durability.

Book design and composition by Mark McGarry,
Texas Type & Book Works
Set in Fournier

Library of Congress Cataloging-in-Publication Data
Vogel, Donald S., 1917–
Memories and images : the world of Donald Vogel
and Valley House Gallery / by Donald Stanley Vogel.
p.cm.
Includes index.
ISBN 1-57441-117-9 (alk. paper)
1. Vogel, Donald S., 1917– 2. Painters—Texas—Dallas—Biography.
3. Art dealers—Texas—Dallas—Biography. 4. Valley House Gallery.
I. Title.

ND237.V62 A2 2000
759.13 —dc21 00-062934

Cover art, Untitled (Abstraction) by Hugh H. Breckenridge: a study for
students in his school in Gloucester, Massachusetts, 1920. 7 ½ x 9 inches.
From the collection of the author.

Contents

Foreword by Decherd Turner *vii*

Introduction: The Beginning: *The journey of a lonely boy* *1*

1 Chicago: *Impressionist painters bring joy and direction* *13*

2 Dallas: *A home at last* *44*

3 Marriage: *The highs, the lows, and the delights between* *71*

4 Art Dealer: *Creating the first art gallery* *87*

5 Valley House Gallery: *An ideal gallery / home comes to life* *102*

6 Spring Sculpture and the Growing of Collectors *119*

7 Rouault's *Passion*: *The anatomy of an exhibition* *132*

8 Of Painters, Children, and Henry Moore *160*

9 The Flood: *Rain, taxes, and a new book descend on Valley House* *167*

10 The Meadows Caper: *The art fraud that made international news* *175*

11 Gallery Follies: *Valley House adds a new gallery and new artists* *191*

12 Angels and Other Gifts *200*

13 *Nana*: *A beautiful lady finds a home* *212*

14 Loss: *We bid farewell to Peggy* *216*

15 Conflicts: *The IRS and other personal losses* *220*

16 Companionship: *New beginnings at Valley House* *229*

17 Travels: *Discovering the source of great artists* *241*

18 A Painter and Art Dealer: *Creator and Matchmaker* *253*

19 The Value of Reputation: *New York and Dallas* *261*

20 I Am a Painter: *My gift of thanks* *278*

Index *285*

Foreword

There are two Donalds in this autobiography: Donald the painter, and an extended Donald—Donald the institution. Without stretching the point in any way, one can say that indeed, this book is the profile of a trinity of principals, for many sections reflect the presence and strength of Donald's late wife, Peggy. Shared goals united Donald and Peggy into one voice.

I am convinced that Donald Vogel knows himself far better than most of us know ourselves. Could it be that his capacity to examine a painting—its qualities, strengths, imperfections—gave an added strength to the lens of self-knowledge? Not narcissistically, but clinically, he charts the growth of his own soul. As he deals with the acceptances and rejections from childhood to the present, there emerges the profile of a man who could always cope because inside he had an immense package of good will, happiness, confidence, and a necessary stubbornness. He could take it. And he could dish it out, but his public reserve checked many an appropriate counterthrust.

Absent from this autobiography are the tales of excess—wine, women, and song—which have become standard fare in contemporary lives of artists.

Donald honored art by giving it all his energy. Even his storybook marriage to his beloved Peggy became a partnership for the cause of art. Having nothing to hide, nothing to shock, his account restores to public sight the figure of a gentleman—a class in rare supply these days. He handles with superb taste those inevitable moments of poignancy which come to us all: births, deaths, children's decisions, etc.

The complexities that derive from his being the product of a broken home are handled without self-pity. The intensity of the struggle for food and shelter during his student days in Chicago and his early years in Dallas was tempered by the joy of discovery, both of art and of people. In retrospect it is clear that the difficulties of adolescence and early manhood provided the training that enabled him to fight through and survive the later decades of stress invested in making Valley House Gallery a success.

The private Donald Vogel closes his book with the celebrative declaration of having reached his goal started a little less than sixty years ago: "I am a painter." That accolade had long ago been conferred upon him by many people. But only the individual artist can claim for himself the approval and judgment of his own soul.

The institutional Donald Vogel was both supportive of and in conflict with the private Donald Vogel. But had he taken just one path exclusively, his artistic legacy would be seriously reduced. Although the Gallery took hours and days and years from his painting, it also added much to his painting when he got to it. Through Herculean efforts, Valley House wrought a miracle: the taste and feeling for art in Dallas were released from the bonds of a self-satisfied naiveté. The Gallery opened the doors to the highest levels of sophistication in art. Not all entered, but the triumph of the Vogel story is that many did!

It was inevitable that the institutional Donald would have to deal with many individuals and institutions in Dallas and the Southwest. He gives specifics. He names names. He tells us what was said. Many happy events transpired and are reported. Many other events did not turn out well. On several occasions Donald and Peggy, often after tremendous labor and

incredible personal expense, saw the Dallas art leadership allow great opportunities to pass. At those times it would have been natural to cast doubts on the characters of the sainted mothers of the group. Not Donald. By simply reporting such events as they happened, he makes a far more important case with the reader. Time heals all of us in the loss of loved ones. Time never heals the loss of great art, and the wounds of Dallas's loss of Rouault's *Passion* will cause fresh tears forever. Perhaps this was the greatest artistic loss to the city of all those brought about by limited taste and vision. Other readers might choose other occasions as the darkest, however. There are plenty to choose from.

For years, the true art academy and museum in Dallas was neither on the campuses of local universities nor in the museums. Valley House Gallery was it. And the Gallery still carries on its programs of educating the eye and the mind by its exhibitions. As Donald turns more and more to his painting, the administration of the Gallery is in the capable hands of Kevin and Cheryl Vogel.

I have noted previously that Donald handled poignant situations with characteristic restraint. However, one particular moment sticks in this reader's mind. When the trucks pulled out of the Valley House campus carrying a portion of the world's greatest art because no one in Dallas could be persuaded to make the effort to keep it, Donald and Peggy watched with breaking hearts. "O.K.," this reader yells: "Now, Donald and Peggy, please cry and wail!" But, that was not their way. Adversity renewed their resolution. "We vowed to continue bringing the finest work to Valley House in hope that one day Dallas would respond." Other men would have been crushed. Not Donald. And, not Kevin. I'm sorry I won't be here to read *Kevin's Way* some decades down the line.

Donald's autobiography is a modern-day *Pilgrim's Progress*. Both Donald Vogel and John Bunyan had full measure of enemies, difficulties, and disappointments, but both made it to their goals. For just as John Bunyan entered into his journey "from this world to that which is to come delivered under the similitude of a dream," Donald Vogel had a dream of becoming a

painter, and in the process of its realization, transformed his world, and the world of many other people.

Bunyan wrote:

> Some said, 'John, print it': others said 'Not so':
> Some said, 'It might do good': others said, 'No.'

And Bunyan did have it printed, and the concept of pilgrimage has never been the same since.

· Donald was urged by many to write this book. His commitment to truth will elicit the dual responses that John Bunyan's did.

DECHERD TURNER

Acknowledgments

The purpose of this book is mainly for your pleasure. In part it is to establish that period when life still retained some innocence, charm, and ease. It was a time when a rapid growth began. Expansion became uncontained and land values soared. We gave up our friends who operated the neighborhood grocery stores, the milkman, paper boy, and postman whom we knew by name. Replacing them, shopping centers and supermarkets sprang up like mushrooms in every direction and transportation began to crawl at a snail's pace as our super highways continued to become obsolete before they open as the population explodes.

As this was happening, our cities slowly awakened to a consciousness of art. This is to record part of this growth as seen through my eyes.

Making this book possible, I offer my grateful thanks and gratitude to the following:

My thanks to Dona Rhein whose idea it was to produce a history of art with me as a centerpiece. Her interest in what I represented and had done between the years of 1942 and 1988 were fully researched. Her material was turned over to me when circumstances stopped her pursuit. Without her efforts I doubt this project would ever have been thought of.

To Decherd Henry Turner for his most generous Foreword. His support and belief in my effort cannot be measured.

Others to be thanked include The Amon Carter Museum, Dallas Museum of Art, Cleveland Museum of Fine Art, The Art Institute of Chicago, Beaumont Museum of Art, The Old Jailhouse Museum, The Meadows Museum, Art Department of Southern Methodist University, Wildenstein Gallery, Dallas Public Library, Bridwell Library at Southern Methodist University, The Texas Hall of State, Ellen Buie at Jerry Bywaters Special Collections, Billie Sparks, Margaret and Trammell Crow, John Douglas, Peggy Goad, Joy and Marvin Krieger, Margaret McDermott, John Morrie, Teddi Newman, Arthur and Earnestine Osver, Byron Sachs, Drew Saunders, Pauline Sullivan, Janie Sylvan, Frances B. Vick, my wife Erika, sons Eric and Kevin, and daughter Katherine Barley Vogel. With special thanks to Jane Albritton whose skilful editing brought my efforts into focus and Defae Weaver for bringing the text into a comfortable form to read.

My sincerest thanks for the generous support of the Eugene and Margaret McDermott Foundation.

Introduction

The Beginning:

The journey of a lonely boy

MY ORIGINS in this country began with my Grandfather Vogel, born Jake Vogels in Holland, who had taken to the seas as a young man. His ship brought him into the Great Lakes and, for reasons unknown, he disembarked at Milwaukee and stayed to become a citizen. The *s* disappeared from his name, which was shortened to *Vogel* during this time. He found employment as an engineer, maintaining the power plant at the Hilty Lumber Company, which manufactured wooden boxes.

Grandmother Vogel, a woman of German stock, died from a dreadful accident before I was born. She was starting to prepare breakfast one morning. As she poured coal oil onto a few sticks of kindling she had added to the fire box in the kitchen stove, some hot coals she had not noticed ignited the oil. It exploded and covered her with flames. Panicked, she ran down the cellar stairs, her movement creating a draft which intensified the fire. She died before help arrived. This story from my childhood gave me such a terror of fires that I designed Valley House so that it would not burn if a fire were lit in the middle of any room.

My childhood memories of my father, Walter Fred Vogel, are of a loving

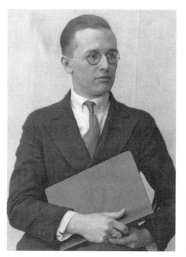

LEFT *Walter Vogel at eighteen years of age.* RIGHT *My father with his father Jake Vogel. Milwaukee, Wisconsin, circa 1940.*

and concerned parent who enjoyed picnic outings, motor trips in the country, and celebrations of holidays and birthdays. He was a quick and eager learner, mostly self-educated. He had left school after the eighth grade to work, but spent much of his time reading in the public library and taking correspondence courses in electrical engineering. At seventeen, he went to work for the Cutler Hammer Company, designing switch boxes and related components. However, he found his niche in life when he later joined Milwaukee Pump Company—a firm that produced some of the first gasoline pumps for service stations—and became a salesman.

My mother, Frances Osborne Talmadge, came from a well-established family on the wealthy side of Milwaukee. Mother had enjoyed a privileged childhood. She lived in a large house with gardens and had her own pony, and there was a nursemaid to look after the children's needs.

Her business- and politically-oriented family descended from a governor of Wisconsin and a mayor of Milwaukee. Archives record Mayor Talmadge as a most respected and generous public official who, often with his own personal funds, helped men returning from the Civil War to reestablish themselves.

In response to my boyhood curiosity when I asked, "How did you and Dad get together?" she related a most delightful story. It all started with two families living on opposite sides of the tracks in Milwaukee. One day, the maid called Mother to the door, saying that a young man was asking for her. When she went to the door, there stood my father, quite handsome and self-assured, with a bouquet of flowers in his hand and a box of candy under his arm.

"I am Walter Vogel, and I want very much to know you," he began.

Walter had come calling at her door because he had seen a picture of her in the window of a photographer's shop. He had fallen in love with the por-

trait of the young girl and had gone into the shop to ask about it. He left with her name and address. She felt overwhelmed by his presence and, totally charmed, invited him in.

She and my father promptly fell in love. Walter was all of seventeen and Frances, eighteen—just one year, less a day, apart. Mother's family, horrified that their young daughter should entertain the idea of keeping company with a boy of a lesser background and from the other side of town, would not give her permission to see him again.

One warm and pleasant afternoon, they ran off and married in Waukeegan, then continued south to the suburbs of Chicago. They knew little about Chicago or its ways, and as darkness arrived, they counted themselves fortunate to find a room in a small hotel where they felt they would be secure for the night. The woman behind the desk, and a number of others sitting around the small lobby, smiled at them and exchanged amused whispers with one another. The next morning, when Walter paid for the room, the woman at the desk smiled and said, "It was our pleasure to have you as our guests. We wish you much happiness." Only then did he realize they had spent their wedding night in a whorehouse.

Ruby Vogel, my father's sister, 1919.

My brother, Robert Fred, was born about a year later on August 25, 1915. October 20, 1917, I landed on a stage already full of international players positioning themselves to change the course of the world. The Germans had been sinking neutral merchant ships; the U.S.had declared war on Germany in April. Puerto Rico became an U.S. territory, and the Russian revolution broke out. How's that for timing? At a safe distance from such cataclysmic events, I arrived unnoticed by the world at large.

I have only vague impressions of my childhood in Milwaukee, mostly from photo albums. Not until we moved to Pittsburgh did I become aware of my surroundings. Since Lily, the maid, lived with us, we sometimes took her to visit her mother some distance away. Accompanying Dad on those trips, I saw the steel mills belching tongues of fire and smoke, lighting the low-hanging clouds. It was a frightening

My mother's father Samuel Talmadge, circa 1885.

sight to me, a haunting and mysterious world where menacing, unknown things must live. Farther on, small houses nestled tightly together, clinging to the sides of the hills, while dim, yellow light from kerosene lamps shone from their windows and lampposts. The contrast between our home and that of our lovely Lily came as a revelation for me.

Our balanced life in Milwaukee and Pittsburgh was warm, secure, and loving. That changed, however, when one day in 1925 Dad came home and announced that we were moving to New York City and that Lily could come with us. Dad soon left for New York to find a house for us and an office for his business. We followed a week later and moved into our new home in Queens.

We were big city children now, and our fun and games took us into the basements, onto the roofs, up and down in dumbwaiters, into new buildings under construction, and everywhere else boys were forbidden to play. Any parent would have been horrified to know our secret turf. Sometimes, in the midst of play, I would hear a heavy throbbing from above as a great silver airship floated easily overhead, glittering in the blue sky. Many dirigibles flew over the city: the *Akron*, the *Macon*, and the *Los Angeles*, as well as the *Graf Zeppelin*. Little did I know then that in those great ships rode Lieutenant-Commander Roland G. Mayer, the man who would one day be my father-in-law. At one time or another he flew in all the great U.S. dirigibles.

One Christmas, to my delight, my parents gave me a box of charcoal, a large pad of newsprint, and an easel, and I set off to become a great artist. What could be more rewarding than making a mark or a line and watching it respond to my wish: to will it to climb, fall, curve, wiggle; to become light, heavy, thin, thick; to be anything I wanted it to be—an animal, a bird, a fish, a flower, a house, a man, or a woman. This visual adventure surpassed all others, and it was mine alone. No one could tell me what to do, and no one else could do it quite the same way I did.

Then things began to change at home. First, our lovely Lily, on her day off, discovered Harlem. One day she just packed her bags and disappeared from our lives. We never saw her again. But by that time we were moving up into a new and larger apartment, just a few blocks away. We now lived on the fourth floor and had access to a large garden between the buildings. Dad and

Mother joined a group known as "The 400" and social priorities became more important to my parents. They seemed to be drinking, wearing formal clothes, and going out more often. They began to say mean things to each other, and their voices grew louder and louder, until finally they began shouting a lot. It was a very uncomfortable and frightening time for us. Their conduct seemed so unlike them, I wondered what our new city was doing to them.

The shouting became louder and the bickering more frequent, until one day all fell silent. In 1929, when I was eleven, Father disappeared, gone without a trace, leaving no word. Mother became desperate, for there was little money, an expensive apartment to maintain, and two boys to feed and look after. A community aid grant brought us food and a few dollars. A friend took me for a week or two while Mother sold the furniture and settled the bills.

With father gone, we moved into a small theatrical hotel off Broadway, just behind the Palace Theater. My new life behind the Palace more than made up for the playtime lost from my school friends. This proved especially true when our neighbors, Stella and Sam Harrison (Sam was the stage manager for the Florenz Ziegfeld Theater), gave me a box of oil paints for my twelfth birthday. Oh, the happy hours I spent painting! I painted on a piece of glass, so that after I finished each picture, I could remove it and paint another. I had no interest in keeping any of them; I just liked to see them appear.

When the school term ended, Mother sent me to stay with my Grandfather Jake Vogel in Milwaukee, the first stop on a six-year odyssey that brought me at age eighteen to the doors of the Chicago Art Institute. Grandfather owned and operated a large white boarding house, where he lived with his wife, Virginia, and stepdaughter, June. I quickly learned to love and respect Virginia for a good woman who gave patient comfort to her husband, who was not always an easy person to deal with. I remember him as a stern, tough old coot. He seldom smiled, and he wasted no words when he gave orders. Perhaps he never felt comfortable with the English language.

I remember almost nothing of this time, other than that Grandfather's family treated me with kindness and my life was relatively uneventful. Soon the family passed me on to my mother's brother, who lived in a wonderful little village in Illinois. There I would experience a turning point in my life.

I arrived in Cary, Illinois, by train from Chicago. As we pulled into the station, a small, white-haired lady stood waiting for me on the platform. Her oval face was full of wrinkles that disappeared when she smiled. Her hands were small with thick fingers that produced delicate as well as heavy work.

"Donald?" she asked.

"Yes, yes that's me," I answered.

"I am your Aunt Eleanor. Your Uncle Bud and I are very pleased you have come to live with us for a spell."

We got my bag and walked to their house, about a block and a half from the station. My new home was a dull white stucco house with two bedrooms. Though it was a small house, it felt warm and comfortable, full of good will. In Cary I spent some of my happiest times, times that I look back on with great pleasure and love, for once again I discovered the simple marvels of nature and grew to love my aunt and uncle even more than my parents. There I learned to think of others, not just of myself.

Uncle Bud had worked for the Chicago Northwestern railroad as a freight conductor for many years and enjoyed seniority, which meant he could work when it pleased him because he could bump other men who had not served as long. On my first day in Cary, he arrived in time for dinner. I had settled into my new room, clothes neatly placed in the bureau drawers and closet, my treasured paint box put carefully away.

Uncle Bud exploded through the door. "Hi, Fritz," he called. "Has Frances' boy arrived? Aha! There you are young man! Did you enjoy your trip?"

Before me stood a mountain, a giant—about six-feet-six, over five feet around the waist, weight well over three hundred pounds, with huge hands extended toward me in welcome. He smiled with both his mouth and his eyes. I felt secure immediately.

Uncle Bud took me fishing and rabbit hunting, and we had fish fries by the river at Fox River Grove, occasions in which the adults enjoyed much dancing and beer drinking. In the winter we enjoyed the ski jump, in summer the motorcycle hill climb in the gravel pit.

To a young boy, happiness meant living with loving people and staying

busy doing exciting things. Of course, it had to end. After two years of happiness, a letter to Bud and Eleanor arrived from Mother. She had moved to Chicago and now shared rooms with her mother, so she thought it was time to relieve them of the burden of caring for me. She thanked them so much for putting me up. No one consulted my feelings. I had to obey. After a tearful parting from Uncle Bud and Eleanor, I left Cary. I stared out the window as the train moved slowly away, toward the dirty, mean city that later would establish the foundation for the rest of my life.

Mother and brother Bob met me at the railroad station. We took a streetcar out to the south side, where Grandma Talmadge lived on the second floor of a rather depressing looking apartment house. As we approached the door, a wonderful, spicy, baking odor filled the air. Mother unlocked the door, and we entered to meet Grandma holding a plate of hot buttered cinnamon rolls to welcome me. She knew how to win a boy's heart. It had been many years since I had seen her. She was a good, kind woman whose family's wealth had been diminished by their generosity in supporting veterans returning from both the Civil War and World War I. Business losses and bad loans failed to replenish their gifts, but she had accepted her loss of position and wealth without complaint. Her spirit and memories served her well.

Nothing felt right to me in Chicago. Never before had I felt such a sense of uselessness. I tried to run away once by following the railroad tracks into town, knowing they would take me to a station where I could board a train for either New York or Cary, whichever train I would find waiting. Midway to town, a group of five black boys, bigger and older than I, yelled "Hey, white boy, hol' up, we want you." Much as I loved to fight, I knew when to run, and run I did. But it didn't take them long to catch up and stop me.

"Ya got any money? No? Well let's see, empty yo' pockets, boy." I had less than a dollar.

Another one said, "Gimme yo' jacket," as he wrested it from me. "Now, run boy, run," they yelled. They picked up heavy gravel from the rail bed and pelted my back as I sped away from their taunting shouts. I continued, my bruised back smarting where the gravel had landed. With my new leather jacket gone, I had only my shirt for warmth, and no money. I trotted toward

the station with thoughts of bright skies and the warmth of friends. I did get to the station and on board a train for New York, only to be caught by the conductor and unceremoniously returned home by a policeman.

Within two weeks I left by train again. This time Mother took me to the station and we said our goodbyes. No one was waiting at the station in Cary when I arrived, so I hurried to Uncle Bud's house, almost running, shouting, "Hello, hello!" to familiar faces as I passed. I opened the door and shouted, "Aunt Eleanor!"

She was in the kitchen. The odor of fresh gingerbread filled the air. "What took you so long?" she said. Her arms closed around me.

Everyone seemed glad to see me, even my teacher, though I had never been a very good student. I felt as if I had awakened from a bad dream. All was right with the world, and what a wonderful place Cary seemed.

A few months later my father made contact and requested that my brother Bob and I come to Texas and live with him and his wife, Helen, in San Antonio. What was I to think? Texas? A stepmother? I didn't want to give up so much for the sake of a new world, but then at age fourteen I had no choice.

Bob and I boarded a Greyhound bus in Chicago and headed south. It was a dull, uncomfortable trip, with long waits between two bus changes and bad-tasting food at shabby rest stops. In Oklahoma a man got on and sat across from us. We knew we were near the border. He wore boots and a Stetson hat and carried a side arm. We nudged each other—a real cowboy, like in the movies. Many miles later Bob pointed out the window: cactus. This had to be the Wild West. I confess I felt a sense of excitement.

Dad and Helen met us at the bus station. "Welcome to San Antonio, boys." They seemed genuinely happy to see us. On the way to their house Dad talked a great deal about the city, its people and how nice they were, the climate and such things, ending with how happy he was with Helen and that he knew we would respect her. Helen was a lean, handsome woman carefully made up and smartly dressed. Her dyed black hair was well groomed. Eye-shadow was meticulously applied as was the lipstick that colored full, wide lips that tried to balance a long, oval head.

They lived in a one-story duplex with a private drive and attached garage on each side. Deciding it would be better that we not all live in such quarters, Dad built, with our help, a small cabin in the backyard. It had bunk beds, and I got the lower one. The cabin proved a good solution and we all were happier because of it.

The next year, in 1934, Mother remarried, this time to a lawyer named John E. Marshall, who was a prosecuting attorney for the Internal Revenue Service in Washington, D.C. He had met her in Chicago while working on the John Dillinger case. They bought a house in a place called Vich Summit Falls in Virginia, just past Arlington, across the Potomac River from Washington.

Mother decided she wanted her boys again. For some reason, I returned to her alone on another long and unpleasant bus ride, bouncing about on unyielding seats and hoping for another rest stop soon, if only to be still for a moment or two.

When at last I reached Washington, D.C., how beautiful it looked to me: so big, with such wide streets and clean buildings. I started yet another new school, Washington Lee Junior High School, but I also entered night classes three times a week at the Corcoran Art Gallery. In my drawing class, we had to work in charcoal from plaster casts, those dead white casts of heads and figures. Our task was to choose one and reproduce it as best we could. The instructor gave me a great deal of his time, showing me tricks about how to measure the proportions by

Thomas Jefferson High School, San Antonio, Texas.

using a plumb line, and holding my arm at full length and using my thumb and the tip of the charcoal stick to measure.

I did that for two weeks and came to hate it. I enjoyed drawing class when I could sneak into the life class to watch students draw from live models. That was what I wanted, not the unyielding white plaster. But not until I completed the term and the instructor said I was ready could I enroll in life class.

Within a year, my parents apparently changed their minds about where I should live, and soon, after another long bus ride, I was again in San Antonio. I arrived there in time to graduate from Hawthorne Junior High School and enter Thomas Jefferson High. Architects considered Thomas Jefferson one of the most beautiful schools in the country, and I believe it still is. It sprawled in the midst of vast, open fields at the edge of town, about a ten-minute bus ride from the new house my father had bought during my absence. The school, of impressive Spanish design, matched my father's new house. Of all the eleven schools I ended up attending, none could match the rewarding experiences I enjoyed as a part of Thomas Jefferson High School.

Before long, the students looked upon me as the school's artist. I took all the art classes possible, as well as a class in mechanical drawing. I submitted two renderings at different times to the *Pencil Point,* the national architectural magazine, and the magazine published both. I entered a life drawing class held at the Witte Museum, taught by Eleanor Onderdonk, the sister of Julian Onderdonk, the noted Impressionist painter best known for his blue-bonnet paintings. This class offered me my first opportunity to draw from the nude, though none of these drawings remain today. All about my room I pinned up photos of nudes to use as references for drawings and paintings. Eleanor and I became friends and saw much of each other.

In addition to my role as artist, I also became "stage manager" of the high school's marvelous theater, with a small office all my own. Many visiting artists used the fully equipped stage for their performances, and my office served as a place where they could relax before a performance and during intermissions. I met Sergei Rachmaninoff and Joseph Hoffman there. Both permitted me to do charcoal portraits of them while they rested. I learned little about them while I sketched, because they were more interested in asking me how I felt about school and how I lived. I found them wonderful talents and true gentlemen. Rachmaninoff's music has always been among my favorites. I often listen to tapes and disks of his work while I paint.

In 1936 school ended for me. I graduated in the upper five percent of my class. I could not be classified as a good student, for I did not do homework because it took time from my painting and from discovering my world.

Home life seemed pleasant enough until one Sunday my brother told me what he had discovered about our stepmother. He had seen her, on several occasions when Dad was out of town, with a strange man in bars and in his parked car.

Bob had just returned from an errand for Dad and had seen this fellow sitting in his parked car at the end of our block. He felt that Dad should be told, and I agreed. Helen had left the house for a few minutes, and we agreed that this should be the time to tell him. We went into the kitchen where Dad was cooking, and my dear older brother suddenly nudged me and said, "You tell him."

I stammered and stuttered and finally related what I had just been told. Dad didn't want to believe it, but with anger and suspicion, he confronted Helen when she returned. After a long and heated exchange, she finally screamed, "Yes, it's true," and banged the door behind her as she ran from the house. After several hours, she returned. It was obvious that Father loved her very much, for it was I, not Helen, who got thrown out. On parting, my father gave me a hundred dollars. While shaking hands he said, "You are now of age, the world is open to you, take it and make the most of it."

I headed north on a bus to Chicago, where I would get the train to Cary for the summer. Nothing that I wanted remained in San Antonio.

In Cary, no one was waiting for me at the station, for no time of arrival had been sent, only the information that I was on my way. I yelled, "Hello!" as I entered my uncle's house, and Aunt Eleanor came downstairs, leaving her sewing machine, to welcome me with a big hug. "Your room is ready, and there's gingerbread in the oven." I was home.

That summer I got a job on the Hertz estate, which was called the "Leona Farm" after the owner's daughter. Leona had married a New York advertising man named Etlinger. The estate had two mansions. One, the home of John D. Hertz, the father, was built of stone and brick. A long sweep of grassy terrace sloped down to an Olympic-sized swimming pool. A tall, dense hedge of lilacs, quite spectacular when they were in full bloom, bordered the driveway. Their fragrance lingers in my memory. Beyond the pool flowed a stream that was stocked with trout for John D.'s fishing pleasure only.

I worked out of the greenhouse as part of the grounds maintenance crew, working each day at a different job, directed by a foreman. The grounds had been divided into sections: there were barns for the polo ponies and equipment; breeding stables for the thoroughbreds, connected with the trainer's house; barns for hay and feed; a full-scale glass-covered polo field; and two more polo fields, one on the high ground, the other close to the Fox River.

A country road split the estate. On the other side from the barns and polo fields was an exercise track for the thoroughbreds and a full working farm. There were orchards of apple, cherry, and pear trees, as well as an abundance of hazel, walnut, and chestnut trees. A variety of fowl were housed on the farm, including chickens, turkeys, ducks, pheasants, and quail.

It was a time when desperate men would work for any wage, and it felt strange to learn that I made the same wage as married men who had children to support. I received eighteen dollars for a nine-hour day, six days a week. That came out to thirty-three and a third cents per hour. I paid my aunt five dollars a week for my room and board, put ten dollars in the bank, and used the remainder for clothes and for materials to draw and paint. I could even afford a dish of ice cream now and then at Meyer's drugstore.

The summer had nearly ended when I received a letter from my father. In essence, it said, "Dear Son, You wanted to become an artist. I suggest you stay up there and go to school in Chicago. Good luck, Dad. P.S. You are now eighteen and should be on your own."

I learned many things that summer as I mowed vast areas of grass, scythed acres of poison ivy, tamped miles and miles of polo fields, exercised race horses, painted fences, shoveled horse apples from paths, and so on.

With summer over and the job promised me again for next year, I said my goodbyes to my loving aunt and uncle, boarded the train for Chicago, and headed into my future.

1

Chicago

Impressionist painters bring joy and direction

IT WAS QUITE A WALK from Union Station to the Art Institute. I climbed the twelve stone steps, flanked by two magnificent bronze lions, passed through one of the four arched doors of the Institute, and began my life in what was to be my second home for the next six years. I checked my worldly possessions, which were contained in two small bags, and was directed to the lower floor where I found two lines of students waiting their turn to enroll. At each registration desk two administrators were enrolling prospective students. Soon I stood before a young lady who filled in my name and other information on a card and collected eighty-five dollars from me for tuition.

"Has your portfolio been approved?" she asked.

"No, I didn't know one was required. I'm a painter, and I should need no other's approval."

She smiled at my response. "O.K., you're in."

I told her I had no place to live and knew no one in the city. She wrote down a name and address with instructions on how to find the place. I thanked her, and with the help of the directions, arrived at a corner house at

39th Street and Lakeside, an area I soon learned was one of the toughest in the city. The house faced Lake Michigan, a block away. It was three stories high, made of red stone and brick. It had bay windows and a basement half above the sidewalk level. When I rang the bell, a tall, bony man with a large moustache and a smile opened the door.

He was impressive with a silver shock of gray hair, a full mustache, bushy eyebrows, and a strong, handsome face with deep-set eyes. He was heavy-framed and well proportioned, suggesting a man of strength who had seen hard labor. A loose, blue, open-necked, light linen pullover shirt hung free over baggy, tan cotton pants. Open leather sandals gave comfort to his feet. He looked like a painter, reminding me of photographs of Paul Gauguin. My first response was joy, for at last I was to be in the company of artists. I introduced myself and explained my needs and condition.

He gave me a warm smile and said, "Come in."

We walked through a hall, past a staircase, and into a good-sized room, once a dining room, but now called the community room. The next room was a large kitchen that held a long table with benches; a grand, restaurant-sized gas stove; a good, roomy sink and cutting board; and, at one end, a walk-in pantry with lockers. This place had been designed and built to be used as a boarding house.

"Sit down. Coffee?" he offered.

He poured the coffee and, as we sat, he inquired about my background and plans.

Then he said, "I'm Malcolm Hackett, and I'm in charge here. We call this the Artist Community House. It's a co-op. You pay an equal share of the total expenses, such as the bills for gas, electricity, water, coal, and whatever else comes up. The room rent is determined by the size of the room. You can share a room, or be alone. No one makes a profit off the rentals."

I explained that I had very little money and no prospects.

"Well," he responded, "you come to me, and I'll see what can be done when the time comes."

We went up to the second floor, and he introduced me to another student who wanted to share his room. Then Malcolm left me with my new room-

mate, a second-year student at the school who gave me an idea about prospects for work and introduced me to the customs of the house. A kitchen locker was assigned to me to store whatever food I should need. We could use the kitchen anytime we wanted, as long as we kept it clean. The same applied to the two bathrooms, one on the first and one on the second floor.

That evening I met ten or eleven of the fourteen fellows who lived there. It was an exciting time, getting acquainted with others who felt as I did. I was the only first-year student. The rest of the group were second- or third-year students. All of us were full of the spirit of art, knowing we stood on the threshold of producing great works for future generations.

In the morning we all left to begin the new term at the Art Institute. I immediately inquired about the possibility of a job on the janitorial force, but was told that such jobs went only to second-year students, never to beginners. I pressed my case and finally was told to see Max, the man in charge. Luckily, he hired me. Max explained my duties and gave me a pass that granted me early entrance to the museum. I punched the time clock early the next morning and started my new job. I was paid thirty-seven cents an hour.

I had drawing and life classes in the morning and, in the afternoon, classes in design, still-life painting, and composition. A timely bit of advice sent me to obtain the job of monitor for both of the morning classes. The pay wasn't much, but it helped. Three jobs the first day—whoowee! Two mornings each week I attended an art history class taught by Helen Gardner, who had written the much-used *Art Through the Ages* favored in most university art courses, and a woman named Blackshear, who gave most of the lectures. The Institute held these classes in the dimly lit Goodman Theater, which was furnished with soft, comfortable chairs. All this comfort, right after an hour and a half of mopping, dusting, and setting up easels and drawing benches, was too much. Thus, after each slide lecture, Mrs. Blackshear, a woman of generous proportions with a monotonous, sing-song voice, would say, "Wake up your neighbors. Time for assignments." And someone always had to awaken me. I have since read a good deal of art history and studied untold numbers of master works, but I certainly flunked art history at the Institute. My spirit was willing, but my flesh was exhausted.

A young man, George Anderson, headed the drawing class. He taught us perspective and cast-shadows, starting with wooden forms in the shapes of spheres, squares, and cones. I had no trouble with this; my mechanical drawing from high school provided a good background. The instructor made the course interesting and challenging.

About two weeks into the term, I remarked to him that the painting of Gauguin's *The Day of the God* looked like a stupid picture. I sensed a bit of angry resentment in his response: "Vogel, I want you to promise to spend time with this painting every day for the next two weeks—and not less than five minutes each time. Then we'll talk about it."

When I first visited the Gauguin my attitude was that if it didn't fill my requirements, it was no damn good. I was defiant. It took two or three visits before I recognized that the painting was not going to change. I began to sense something haunting about it. It felt primitive, yet in no way naive. It was totally professional, painted by a master's hand, produced in a studio far from the islands he knew so well. Gauguin expressed his feelings about a world and a people he knew well and shared its mysteries in this canvas. The more questions I asked myself about the painting, the more awed I became as I realized how beautifully it had been composed. Nothing could be changed or added to it without lessening its tensions. Its interlocking forms and unreal colors created a new reality. Slowly, it became apparent to me why it had been titled, *The Day of the God*.

In drawing, what could be more beautiful, or more challenging and demanding, than the human figure? The instructor assigned us to draw very quick sketches, a minute each to start, then two minutes, then five to fifteen, and finally an hour's study, sometimes in action as the model moved about. The amount of paper I used, to say nothing of the charcoal and Conté (a French crayon), was enormous. I ate little during that time, first of all because I had almost no money, but also because I wanted to spend as much of my time as possible exploring all the galleries the museum had to offer. What unbelievable works of art the people of our world created. The wonder of it all! To look and look was feast enough.

I understood so little, but told myself, "I will know. They only require time, and they shall have my time, for I must know their secrets."

Most of all, I remember the first time I entered the gallery hung with Impressionist works. I found myself smiling as I gazed about at them. They made me feel so very good. How could any paintings fill me with such joyous excitement, such enormous pleasure? I realized I had discovered the reason for becoming a painter. I had found a direction. I knew I wanted to create paintings that would make everyone who looked upon them feel pleasure and satisfaction. If my paintings could make someone smile, I would have succeeded and, in some small measure, repaid a debt for pleasures received. This I vowed to do. It became my religion. I had no doubt that God could only agree and help me along the way as long as I remained sincere. My first thoughts, naive as they were, were that I had only to pick up my brush and continue where the master Impressionists had stopped. How easy. No problems. Did other young artists feel this way? Now and then I would inquire, but my questions brought only strange smiles and looks, no answers, from my contemporaries.

In 1936 the Depression was at its height, and times were truly hard. In some areas of the city I felt the cries for help. Need hung like a dark cloud over the land. Everything seemed covered by a dark patina, everything but those joyous paintings I visited daily. In them I found my own world. I felt sheltered and, in many ways, I was able to escape from the real world, though not entirely. To eat, I found meal jobs, which meant getting up earlier to mop the floor and polish the serving table in a cafe in exchange for a bowl of oatmeal, toast, and coffee. Then I hurried to school to work on the janitorial force. At the Arcadia Cafeteria I worked as a bus boy at lunch for an hour and was glad for the opportunity. One day, after I'd loaded the dirty dishes from a table onto my tray and was about to head for the kitchen, a man, putting on his heavy coat, flipped his sleeve up and out, sending my tray flying.

"You stupid idiot," he yelled and stormed away. As I retrieved the broken dishes, I looked up to see the manager glowering at me.

"Half rations until you've paid for this loss," he said, as he itemized the cost, marking it down on a small card.

A week after that, I got a job at a very elegant restaurant called de Mets. The tables were set with fine silver, linen napkins, gold-rimmed china, and crystal glasses. Vases of fresh-cut flowers were centered on the heavily

starched white tablecloths. On the job I wore a white jacket, also starched, and was not permitted at any time to rest my tray on a table. Very attractive young ladies in black dresses with lace-trimmed white aprons and caps waited on the patrons. All went well until one day, when I was removing a soup plate containing the remains of a cream soup and a spoon, things got out of balance.

As if in slow motion, the spoon floated from the bowl, bounced about a bit, landed on its victim's blouse, and slid down to rest on her lap. I remember how kind and considerate the lady was, and how graciously she forgave me. The woman in charge was not so forgiving, however, and I found myself in the basement, without a white jacket, unloading dishes from the dumbwaiter and putting them into steaming hot water. I had been demoted to dishwasher. Actually, it wasn't so bad, but God, that water was hot!

These jobs all had one drawback: time lost from my classes, for I arrived late for almost every class and had to leave early. I solved the problem later, though, when I proposed a plan to the fellows at the house as we were sitting around the kitchen table. I offered to cook two meals a day for them if they would pay for the food and help wash the dishes. First, of course, they asked if I could cook. "I'm the best," I boasted. We agreed to try it out. We planned menus for a week, inquired about costs from the neighborhood grocer and divided them equally, then added a little more money just in case. In that way I gained more class time plus two good meals, but, most importantly, I escaped that awful, steaming hot water.

We talked art at breakfast and dinner, on the way to the Institute and back, all day, and long after dinner as we sat about the table. Often I made a big batch of doughnuts or jam pies, and always a large pot of coffee. The coffee pot was mottled blue and white enamel with a heavy wire handle at the top and a metal one near the bottom. It held a half gallon. It might have been one that served the soldiers during the Civil War. It defied anyone to discard it.

The stove, a wonderful restaurant gas range, had six burners and two large ovens. On holidays I delighted in preparing an appropriate feast: the traditional turkey with sage dressing, candied yams and mashed potatoes with gravy, fresh vegetables, biscuits, celery sticks and olives, tea and coffee, rounded off with a couple of pumpkin pies. The kitchen became to us what

the Paris cafés had been to the French artists. Visitors dropped in, mostly painters or instructors from the school, and we found the conversation always stimulating. Before long, all of us looked forward to these times.

We talked of upcoming exhibitions, the jurors, what we thought or knew of their work, who was doing what, shows at the galleries, museums, what was good or bad, and anything else related to our world. We ate, slept, dreamed, and lived art; it seemed as if nothing else existed. The atmosphere was so stimulating, so filled with hope that no student could imagine anything but a future in which he would produce exciting paintings to give the world. Work, work, and more work, an artist can only learn through work. But something seemed wrong. This wasn't work. It felt like pleasure, a privilege to spend our lives painting. We must have been blessed.

With fervor and intensity we worked alone and together. If one of us exhibited a painting or had an exhibition, we all offered to help frame, cut mats, or whatever. We took turns modeling now and then for watercolor studies and drawings. With no set patterns, we put up exhibitions of our cho-

sen work in the community room, inviting the faculty from the school, as well as other painters and friends. We made no sales, and never expected any. It was reward enough to share our efforts.

Our rooms served as studios as well as sleeping quarters. At times a few of us gathered, when invited, in one of the studios to start with a clean canvas on the easel and take turns painting on it. The one to start selected a color and destroyed the purity of

On a bitter cold morning, workers leave the I.C.R.R. to enter the bleak canyons of Chicago. Oil on canvas. Painted 1942.

the surface, having then to defend what he did. As each had a turn, arguments grew from defending and opposing the results. These sessions proved challenging and fun.

The day came all too soon when I had no money to pay my share of the house expenses. I went to Malcolm Hackett and explained my plight. He offered me the job as janitor for the house, and I moved into the basement

room, which was fairly generous in size and had a half-window close to the ceiling, facing the street. The basement was divided into three areas. Steps from the kitchen led into a large room that served as a laundry and storage area. A door opened from there into the furnace and coal bin area in the center portion of the basement. The wall that made up part of the coal bin served as the dividing wall for my new quarters. I promised to be an excellent janitor. A burden had been lifted, and I no longer worried about money, at least for awhile.

In return for my rent I cleaned the bathrooms, swept the floors, mopped the kitchen, and fired the furnaces to keep the water hot and the house warm. During the next few months, I also earned about four dollars doing laundry for some of the fellows. Monies earned at school I applied against tuition. To quote a common saying of those days, "I was never broke, but was often badly bent."

Somehow there always seemed to be material to work with, mostly secondhand. I acquired many brushes, partially filled tubes of paint, charcoal pieces, newsprint, and such left behind in the rooms I was assigned to clean.

I did take courage once and write to my father for a little help, but his reply was that I should ask my mother, who, he said, could afford it better than he. Mother replied, "Ask your father." I was caught in the middle. Later, I learned that each thought the other had sent me money and that I was trying to take advantage of them. At least I knew where I stood, so I gave up, knowing that whatever I did had to be up to me alone. I found out that I liked the idea, though, for it convinced me that nothing could stop me from fulfilling my aims.

Malcolm Hackett had a large studio above the carriage house in the back. He seemed to appear and disappear at odd times and paid little attention to us in the house except to see that the bills were paid and everything was in good order. He always seemed pleasant, and when he joined in our evening sessions now and then he spoke with authority. We listened to him as to a master. No one seemed to know about his work, but because anytime the subject came up, he would just pass it off, it aroused our interest. I became bold enough to ask his opinion of one of my paintings, and he obliged me with

comments both kind and helpful. I felt flattered that he spent time on it, and our friendship began to grow.

One day he asked me to wash his studio windows on the outside. They were so extremely dirty, I wondered how he could have let them go so long. I had to climb a long ladder to reach them. With a scrub brush and a bar of lye soap I went to work and polished them until they sparkled. As the grime vanished, I peered into his so closely guarded private world and saw an awe-inspiring number of canvases, stacked in racks and leaning against the walls, and piles of watercolors and gouaches lying on a low table. The easel held a large canvas of a white, reclining nude. I almost fell trying to press myself closer to the glass. Malcolm was not there at the time, so I decided to say nothing, but hoped one day he would invite me to visit.

※

The time came to write Aunt Eleanor and think again of the pleasures of the country and Cary. The Artist Community House all but shut down during the summer, when most of the students returned home. I left my belongings behind, for the house seemed well protected and safe. To my memory no one had ever had anything stolen. Perhaps this came from the respect we shared and our willingness to help each other. The house had no locked doors.

Departure day came at last, and before long I was hopping from the train onto the station platform in Cary. Everything looked the same, as if time had stood still. The deserted old red brick factory with its towering smokestack assured me that I had arrived at the right place. I smiled, saluted it, and headed for home. At the sound of the door closing behind me, Aunt Eleanor came out of the kitchen with open arms. I had looked forward to her hug.

After a cup of tea, a slice of fresh lemon cake, and a lot of talk to catch us both up with the past year's events, I settled into my room. I had a light lunch and then hiked to the Hertz farm to check in. My job still waited for me. I would start the next morning at seven, unloading a freight car of oats from a siding close to the depot. That evening I bought my usual pocket watch at the

drugstore, an Ingersol, guaranteed for ninety days, and guaranteed after that to be thrown away. For one dollar, who could complain?

The next morning, we started shoveling oats into large gunny sacks and loading them into a pickup truck and trailer. We rode sitting on the sacks as the truck took us to the barn. We made numerous trips carrying the hundred-pound sacks of oats on our backs, walking back and forth on two-by-twelve planks, to empty them into the feed bin. At the end of the day, the car was emptied, and we were exhausted. I seldom had trouble sleeping, but that night it seemed I had hardly hit the bed and closed my eyes before it was morning. The alarm said it was time to get up, but where had the night gone? I couldn't jump out of bed, I ached so. Every muscle cried out, "Stop, don't move!"

I made it only by sheer will and because I needed the job to return to school. How much must one give just to paint, to give pleasure to others? After two days had passed, I was close to feeling normal again. It was hard to believe muscles could be so sore.

"I hear you want to be a painter," the foreman greeted me one morning. "Well, I got just the job for you," he added with a smile. I felt uneasy. We rode out to a far corner of the farm, and from the bed of his pickup truck he removed an empty five-gallon bucket and a ten-inch brush attached to the end of a polo mallet handle. A fifty-gallon drum of creosote, its spigot a few inches from the bottom, sat on a low platform near the fence. He pointed at it and said, "Start and go to the end, then come back on the other side and then go this way. Here are a couple of extra brushes. Bring your lunch, and let me know when you run out of paint, painter." He smiled sweetly at me as he drove away.

From where I stood I couldn't see the ends of the fence. The heavy-railed horse fence ran not less than a mile and a quarter each way. I placed the bucket under the spigot and released the dark, smelly substance, shutting off the stream after the bucket was about two-thirds full. I carried it to the fence and started to slop it on the rails and posts. I would show him I was a good painter, even of fences. It was hot, dirty work. I wore gloves and a long-

sleeved shirt, because this stuff burned the skin. Each night when I returned home, I looked like a spotted animal. At last I finished and proudly reported to the foreman, expecting at least a "Good job. Well done, Vogel." But what he said was, "Good. Now there's a mile of chain link fence six feet high to be painted green."

"May I sign it when it's finished?" I asked.

He said, "Get going."

Did you ever paint a chain link fence against the wind?

After that, I painted the trim on a beautiful cottage that sat on the highest point of the estate. They called it the Poet's Cottage. The small road leading to it was flanked by fruit trees, which provided me with plenty of apples, pears, and cherries as I traveled to and from the job. One day, when I was returning to the greenhouse shed where the tools and supplies were kept, two well-dressed men stopped me.

"Who are you? What are you doing here?" the older of the two asked. I recognized him as John D. himself.

"I work for you. I'm painting the trim on the cottage."

He nodded and grunted, "Hummm."

I still recall it as a memorable conversation; truly a word to live by.

Perhaps my best moments on the farm were spent watching the young colts racing about the lush green hills as if playing follow the leader. What a paradise. Sometimes I was sent to the barns to exercise the racehorses if one of the regular boys became ill or had to leave. There I met some of the jockeys and the exercise boys who dreamed of becoming jockeys. We would lead the horses across the country road to the track, mount them, and ride. If the trainer wasn't in sight, we would open them up, having our own race. What a thrill. Sitting so high off the ground, I felt as though I were flying. I wanted to be a jockey. But how could I be a jockey as well as a singer, composer, actor, and painter? Life seems so wonderfully cruel.

The routine continued through the summer, which passed all too soon. I had paid my aunt the usual five dollars a week, banked ten for school, and spent the remaining three for my Sunday trips to Chicago and the museums

of the Institute. It had been a good summer. That fall I arrived a week late for school. At Community House I gave up the basement room and its coal dust for the two rooms on the top floor. These I shared with a fellow student named John Davis, from Pocatello, Idaho. He was studying painting with the noted sculptor, Archipenko.

Malcolm Hackett dropped in at the studio now and then and made suggestions concerning my work. He talked about materials, giving me his formula to size and to prepare the canvas, and his design for an easel, from which I have built many, including one still in use in my present studio. He suggested using a brush wash of turpentine on my palette so that each time I wanted a new color, the brush could be easily cleaned, allowing control of the next color picked up or mixed. He advocated the idea that when a happy accident occurred, I should understand just what had happened. In that way it would no longer be an accident, and I could repeat it when needed. He said one should never rely on the accidental, for a day would come when the "accident" wouldn't be there.

"Know your palette. Its secrets are endless, each discovery a joy. If you like color, and it's obvious you do, your work will bring you much pleasure. Color is very personal, the greatest challenge requiring the most in taste." He told me always to demand the best from the best, and not to settle for second best. "There is much good to be found in the second best, but for you, wait."

When I once complained of my financial problems, he responded, "If you are sincere in what you are doing, circumstance will connive to see that you will be able to continue."

Circumstance has a way of taking its time. Before the semester ended, I had spent most of my money. Carfare was hard to come by, and the school was too far away for me to walk. Eventually, the Dean called me into his office to say, "Vogel, this school is a business and there is no room here for geniuses who do not comply with our rules. I think you had better go elsewhere now."

This rejection did not help my spirits. I worked so hard and asked only for my right to learn. While I was saying my goodbyes, one of my instructors told me not to feel too bad, because the Institute had rejected Walt Disney

and Thomas Hart Benton, among others, along the way. It didn't help, but at least I was in good company.

Well, I thought, so be it. I gave more time than ever to my studio painting, until one day I asked myself, what about the future: do I really want to be a painter? I had to know, and this was the time to find out.

I decided to move to Cary for a year. There would be no one there to talk to about painting and no outside stimulus. I vowed not to visit Chicago or read any books on art, though of course I would take my paints and supplies. I would not stay with my aunt or ask for help; it was important that I rely entirely on myself, just as I had decided to do in the past.

After storing my few belongings in a corner of the basement, with Malcolm Hackett's permission and his approval of my plan, I left the Community House and my many good friends to find the answer to my future.

❋

The train from Chicago was slowing, and the conductor had just called out, "Cary." I looked out the window to see the red brick factory. Well here you are, I thought. Now what are you going to do?

The first thing was to head for Uncle Bud's and Aunt Eleanor's house. As always, my aunt greeted me warmly. Over tea and spice cake I told her of my plans, emphasizing that I did not want to depend on their help or live with them. I had to solve my problem alone, in my own way. I said that I would like to stay with them a few days, however, until I could find a place to rent.

After breakfast the next morning I made the rounds. First I visited Mr. Kern, who owned the grocery store on Main Street. He had no work to offer, but was glad to see me back. Across the street stood Meyer's drugstore. No job was available there, either, though I had a pleasant visit with his daughter, Marjorie, who had sat next to me in school. My visits to the hardware store, barber shop, post office, and bank were equally unproductive; they would keep me in mind. I went to see Mr. Mentch, who had given me my first job in the pickle factory. He suggested that I might talk to the signal man at the rail-

road crossing about a place to live and try a couple of places in Algonquin for possible work.

I visited the gas station and found another friend running it. His father had given it to him after graduation from high school. "Maybe I can help if you're looking for a job outside of Cary," he said. "I have an old Ford coupe out back you can have for ten dollars. It's not bad on gas, and it runs good. It does need a lot of oil, but if you use old drain oil that doesn't cost anything, it'll take you around pretty cheap."

"I'd like to buy it," I replied, "but I won't have any money until I find a job and get settled."

"No problem," he said, "you can have it now and pay me when you can." We went to the back of the station to see my first car. What a delightful vision. Its light tan paint job looked faded here and there, but it didn't have too many dents. One headlight and one windshield were missing, but its Model A tires appeared to be in pretty good condition. How could I resist? I got in and turned the key. The motor turned over and caught immediately.

My friend smiled, "Surprised you! Take it for a spin." He motioned toward the road. I pressed down the clutch, slipped the gear shift into first and released the clutch, and the car moved slowly away. The two of us, my new car and I, drove down the highway about a mile and returned to the station, pulling up to a pump. "Fill 'er up with your cheapest, if my credit can take it," I told my friend. We also filled a five-gallon can with drain oil and put it in the trunk. He warned me again always to check the oil, because the car would use almost as much oil as gas.

Day two of my year of decision proved to be memorable. On my first trip in my first car I headed for Algonquin, a small town about five miles distant, an easy walk, but nicer in my own car. On the way from Cary I had opened the throttle all the way to see what great speed this mechanical wonder offered. Running on the straight and flat, it reached forty-five miles per hour. It could do a bit more downhill, depending on the grade.

Algonquin, a small factory town, made very small toys and very large furniture. I made my first stop the toy factory where small, painted, wooden figures were produced, mostly for use as tree ornaments and stocking gifts at

Christmas. Yes, they needed someone to paint faces on the toys, but no, they couldn't use anyone who studied art. I was unable to change their minds, so I climbed back into my machine and roared down the street to the furniture factory.

Optimistically, I parked in a lot designated for "factory workers only" and entered the building. "Yes, the manager will see you now. Go right in," a secretary said.

As I entered the office, a very pleasant young man came toward me. "What can I do for you?" he asked.

"I'm looking for a job, most anything."

"Any experience?" he asked.

"Yes and no," I replied. I told him what I had done and why I wanted a job. He listened with interest and smiled.

"We make Honor Built furniture here, sofas and armchairs for Sears Roebuck. Come with me, and I'll show you around," he said, and we began to walk through his factory.

"The ground floor is where the cutting and framing is done." The air was filled with a fine dust and the distressing whine of power saws. The sweet odor of fresh-cut lumber filled my nostrils as we climbed to the second floor.

"Here's where the carved legs are attached, and then the carved arm ornaments are put on with a single brad before they're spray-painted. If you want the job doing this, it's yours," he smiled. "You can start now or tomorrow. The pay is forty-eight cents an hour."

"I'm ready now," I replied. He handed me a short blue apron from a nearby hook and watched as I hammered my first carving to what would become the arm of an overstuffed chair that some undiscriminating soul would love evermore.

"Most important, remember, no hammer marks on the carvings; hit only the nail. I'll be back later to see how things are going," he said as he departed.

Eight to five, I thought. Figure a half hour to return home, not bad. That would give me time to paint and clean house. Driving home, I planned and dreamed about how I would fill the year. One thing I knew, somehow I had to get a windshield before it rained. For the present, though, the chilly air felt

good, and it helped calm my excitement at finding a job so soon. I could hardly wait to share the good news.

After dinner, following directions Mr. Mentch had given me, I went down the main highway that led to Crystal Lake and across the tracks to the railroad signal man's house. It was a clean-looking, two-story white house with a large yard, a good-sized garden, and a small barn and chicken coop. A man wearing overalls answered my knock as a bunch of children peered around his legs. I explained what I was looking for and told him that Mr. Mentch had said he might have a place to rent. Indeed he did, he told me, and led me up the outside stairs to the second floor.

Inside I saw two large rooms, plus a bathroom and a good-sized kitchen with a gas stove and a small icebox. It looked freshly painted and very clean. I hardly dared ask the price. "Is ten dollars a month okay?" he asked.

"Can I move in tomorrow?" I answered with relief.

He agreed and said it would be all right for me to pay him on my first payday.

On day three of my return to Cary, my first full day on the job, Aunt Eleanor packed a simple bag lunch to hold me till dinner. The morning went well except that I kept hitting my finger over and over, intent on protecting the carvings I was nailing to the frames.

At lunch I joined a small group of workers. Their conversation focused mostly on the unions and who was trying to organize them. They favored joining. The rest of their talk concerned their softball team. They regarded me as an outsider, so I tried to soften my silence by smiling when it seemed appropriate. I was the youngest, a lightweight, and not worth much attention; this was fine with me, for I had better, more productive things to do.

That evening I moved into my new quarters and did a drawing or two. My hopes soared once again. I arranged to take my meals as usual with Aunt Eleanor and Uncle Bud until my first paycheck and promised that from then on, I would be on my own.

The days passed, but the weekends were quite productive, as I began to paint with a joy I had not often felt before. My work at the factory required little or no thought, and I felt no threat, for my job seemed the least impor-

tant one there. Everything was going along very well until one day someone approached me to join the union. I made the mistake of not just saying, "Yes," or "No," but expressing my full opinion. I declared that unions stifle a man's imagination, incentive, and creativity, all for the security of a wage; that I had ambitions and, if I chose to work there as a career, I would eventually run the place, if not own it. This did not make a favorable impression on the union recruiter. He walked away and left me to my work, but my days were numbered. Someone else told me to go to a union meeting after work, but I refused to give up the time from my painting. The union got voted in; I got voted out. Fortunately, this happened at the beginning of summer.

※

Orson Wells had attended a private school in Woodstock, a charming town about eighteen miles northwest of Cary. On his threat to leave the school otherwise, he had been allowed to produce plays in the town's small but well-equipped theater. It seated about eighty people, and its proscenium spanned about fourteen feet. After Wells graduated and headed for New York to start his career in radio, the theater was given over to a small group from the Art Institute's Goodman Theater. For six weeks each year actors used it for summer stock. When I heard that, I jumped into my car and headed for Woodstock at forty-five miles an hour, arriving at about the same time the troupe did.

When I left there, I had the title of Technical Director and a salary of twenty-five dollars a week. My job was to build and paint the sets and light and work the show. During intermission, I was to sell boxes of taffy (stale) that might contain a prize (unlikely). The job would require about ten to twelve hours of my time each day, plus travel time. I thought it would be fun. The same group of actors put on a new play each week. When the curtain came down on the opening night of one play, the scripts for a new play were handed out, and readings began. The following morning, I was told what they needed, and I started to build and paint new sets. I admired the industry of these young actors. During the day they rehearsed the new play, and in the evening they performed in the current play, always in good humor and without complaint.

One day one of the group became too ill to perform. The director thrust a script at me and said, "You have two hours." The play began, and there I stood on stage once more. I had become an actor. What fun! Not good acting, perhaps, but fun.

The six weeks passed too quickly, and once again I found myself without work. Between doing odd jobs for Cary, such as mowing the village park and sweeping the streets, I caddied at the golf course and did anything else that came along that paid. I managed to work enough to pay the rent and pay off the car. Art supplies took most of whatever money I had left.

Eating became a problem; I didn't miss many meals, just postponed some. Late in the day, just before sunset, I would go to the swimming hole, where I had discovered that if I threw in a line with three or four small hooks, I could catch enough sunfish about the size of my hand to eat for breakfast the next morning. At times I wasn't above taking a potato or two, or some string beans, peas, tomatoes, or whatever I found available from a garden here or there. I knew all the gardens.

I covered every square foot of Cary, crisscrossing, over and over, drawing and painting. Everyone knew about me and paid little attention to my presence, for I seemed harmless. But something had been missing in my work. Figures started to have more appeal for me, not from models, because none were available, but figures I invented. They became a major part of my compositions, and I began to use the landscape less often as my subject. As my year came to a close, all my doubts had been removed. I would become a painter; I was a painter. I felt certain that in just five years more I would be a very good painter.

Before leaving my lovely village, I decided to share my efforts with its citizens as a way of thanking them. With permission from the mayor, I planned an exhibition of my paintings in the village hall. This meant that hanging the paintings would be quite a chore, because they had to be carried up a very long, steep flight of stairs.

To announce this great event, the first art exhibition ever held in Cary, as well as my first one-man show, I made four posters. One I placed in the window of Currin's grocery store, one on the post office wall by the

"Wanted" notices, one in the barber shop, and one in the drugstore. The posters read:

Exhibition of Paintings
and Drawings by
DONALD VOGEL

Sunday August 28th
1938
Cary Village Hall
12 PM

I chose Sunday so that the exhibition wouldn't interfere with any business activities. I chose the time to accommodate the church goers.

When the day arrived, I was almost overcome by doubts about my judgment in doing this. How would the citizens respond? As I stood looking down that steep stairway, my throat went dry. Would anyone come? When twelve o'clock arrived, would anyone at all come?

"God, someone is coming," I mumbled with relief. I smiled, or grimaced, at a lady on her way up. I stepped back and said, "Welcome, I hope you'll enjoy the show." She gave me a quick smile as she passed and started to walk slowly down the long room. Someone else followed her, and then one after another they came. They came and came, but no one said a thing, at least that I could hear.

The population of Cary was posted as seven hundred and fifty, but I know more than that came to my show. I figure that they had all seen me at one time or another with a painting under my arm or a brush and palette in hand, so they just quietly walked around the room and left. I never knew if anyone liked my work. Once again, I had to accept the fact that painting would not be an easy profession. I gave some thought to getting a Bachelor's Degree in Art. It would give me some security, I reasoned. I made the rounds of goodbyes and thanks, kissing my dear aunt and shaking hands with Uncle Bud, and I left my favorite place in all the world.

❋

Back in Chicago at the Artist Community House, I found a few new students, and many of the ones who had been there when I lived there before. They seemed pleased to see me. I know, because they asked if I planned to cook again. At school, a visit to the Dean's office proved fruitful. He would give me another chance. With grateful thanks, I promised to try to behave as an obedient student should. I joined the janitorial force again, to mop, dust, and polish. But it wasn't enough, and money once again became a problem. Then Malcolm Hackett told us that the Community House had to close, because the owner had an offer and wanted to sell it. We would all have to find other lodgings. I looked up to see if the sky was falling. It was, the Dean called me in, and I was out.

Hackett asked, "Something wrong, Vogel? May I help?"

"No, you've already helped me as no one else could, but thanks," I responded, and started to leave.

"Wait!" he said. "I have an idea. You should sign up with the WPA project." He told me where I could inquire about getting assigned to the WPA Easel Project, and he suggested I see Arthur Osver about a room.

❋

In January 1940 the WPA accepted me, but not on the Easel Project. Instead, I was assigned to a museum program where I worked in a large, rather strange building with workshops in the basement. I sat at a table there and die-punched some green material to make leaves for trees in dioramas. The sky had not fallen; it just felt as if it wanted to. After three days of monotony, stamping out leaves, I mentioned my plight to my new friend, Arthur Osver, who said he would try to help me get on the Easel Project.

I had been very fortunate to make contact with Arthur and his lovely wife, Ernestine Betsberg. Both of them were painters, and both had won fellowships a few years earlier at the Institute. They had a room for me and offered to let me take my meals with them. I remember Ernestine as an excep-

tional cook, and every evening we ate only the most delightful meals, always served with a good table wine.

At the time, Arthur worked for Ramon Shiva, managing his paint factory. Through him I spent much time with Shiva at the factory, where I got involved with the chemistry of testing paints, especially oil-base paints. It was a rare opportunity for a young painter to learn about the properties and the tinting strength of the pigments used in the tools he had chosen for his life. Shiva shared his knowledge with me with wonderful generosity. He explained the different pigments as he tested his own paints against all other known brands. He placed samples of paint in an aging-machine that used hours of exposure to a strong light to simulate a number of years of aging. He tested paint by adding a measured quantity of white to equal amounts of color, and then he pulled them together with a spatula to illustrate the power of the color to influence the white. Only one brand held up to his standard colors, the German "Block."

He produced his standard colors in small quantities and sold them only to painters and the Project. He also produced a student color. The standard color had the purest pigment available, ground in walnut oil, while the student color had been ground in linseed oil with one-half zinc white. I used only the standard color as long as I could obtain it. From this association with Shiva, I began to set my palette with a good understanding of its chemistry and the influence each pigment should have on every other through time. I wanted my canvases to ripen and mellow as they aged. I felt this as an obligation.

On February 29, 1940, I got a notice to check in for the Easel Project at 1021 S. State Street in Chicago. Norman MacLeish headed the Project. (His brother, Archibald MacLeish, a noted poet, served as the Librarian of Congress.) Norman welcomed me, set me up as a grade B artist, and told me to get whatever materials I needed. Each month I would have to turn in one oil painting, or two watercolors, or ten prints. I would also have to teach at the Howell Settlement House two days a week.

I picked up a stretched thirty by forty-inch linen canvas, three brushes, and a set of Shiva standard colors. MacLeish said that after I submitted my

paintings, they would be juried and, if the Project accepted me, I could become a grade A painter and get a raise from eighty-six dollars a month to ninety-six. It was a happy moment, for I felt I should be truly free to work exclusively at my craft.

The Howell House nestled in one of the poorer neighborhoods of the city. The Project supported Howell House to supplement the schools. Children could come to play games or to take dance, gym, or art classes. When I arrived at the settlement house, I was assigned a long, narrow room in the basement. A low table, with wooden benches on each side, extended the length of the room. A second table by the door held piles of supplies: paper and boxes of watercolors, pastels, and crayons. The sink had a single faucet. My first class would be made up of children eight to twelve years old, while the second class would be for ages thirteen to eighteen. Someone told me these classes had not been very successful in the past, so they wished me luck. Classes met on Tuesday and Friday afternoons from 3:30 to 5:30 and evenings from 7:00 to 9:00.

At my first class, four children drifted in to look me over. If this is all the interest, I thought, what a waste of time when I could be painting. How could I get out of this? When all four of the children had gathered together, and it looked as if no more would appear, I told them, "Now these are the ground rules. We will paint no Santa Clauses, Easter bunnies, or turkeys. You paint anything you want: what you see on your way to school, what you do at home, what you dream about. If you don't feel like painting, go play a game, visit a friend, do something else. You may come and go as you please. However, when you come into this room, you paint or draw. I will not tell you how to do anything, but I will help you if you ask. Now, pass the word."

By the end of the month I had forty-four students coming and going and enjoying producing pictures. The Project required that I submit ten of the children's pictures each month as a means of checking our progress. The Project awarded a monthly letter of commendation to the settlement house that submitted the best work. My kids received the top honors each time, but I never told them because I wanted them to enjoy what they were doing, not seek a token prize. I learned much from them.

My evening class was a dismal failure. Eight teenage girls attended this class. Is there any more trying group in the whole world? Their maximum interest span amounted to almost ten seconds. Nothing in their lives was more important than boys or fashion drawings of sexy ladies. I could not reach them, try as I might. I couldn't even encourage them to leave. After pleading with MacLeish, I persuaded him to relieve me of this chore and find someone else to take it. I did miss the younger children and still have good memories of that as a rewarding time.

After my first submission, I was notified that I had been placed in the grade A category, and that my check would be increased. What a moment of joy. I had been accepted by my peers as an equal. No award could ever be sweeter.

✻

Soon another move loomed. The Osvers had to move into different quarters, and I had to look for new lodgings. I found a studio at 237 Menomonee Street in a three-story building. Each apartment consisted of eight rooms, and I found a fellow painter, Robert Moyer, to share the expense. He seemed a rather lazy fellow, more interested in social life than in painting. After a month, he moved out. Never mind. That just left me more space to fill with paintings. I acquired a kitten, whom I named Rembrandt, and a small reed pump organ. How could life be more wonderful?

Lincoln Park spread out less than two blocks from my studio. Every day that the weather dawned pleasant, I took my paints to the park. Those subjects still appear in my work today. In the park I found a charming lagoon with boats for hire, a zoo, a red brick pavilion, many paths shaded by large trees, and bridges to walk over or under. The park provided an escape from a city that otherwise gave me little pleasure because of its dirt. Its streets always appeared littered, and the dust and soot darkened a shirt in an hour.

I had taken up painting in casein, a medium developed by Raymond Shiva, and found it very flexible, with soft, brilliant colors that suited me very well. I worked in casein most often in the park, producing some fifty to sixty

pictures. More often than not, some visitor would watch me paint, but this rarely disturbed my progress. One elderly gentleman always said the same thing each day that he appeared: "Young man, I like your work, because I can feel the distance and air in it." Then he would walk on.

I soon learned to take full advantage of the Easel Project. It did not seem to matter how much material I used; the project furnished all tools and supplies without question. I would get twenty to thirty canvases a month with all the brushes, paint, turpentine, and stand oil I needed. I could work in any medium I wanted. I could take a whole ream of watercolor paper and tubes of pigment and brushes. In exchange the Project required that I turn in each month either one oil painting of a specified size, two watercolors, or ten prints from a single edition. They would then frame each work and hang it in a public building. Quarterly, they would send a report informing me where my work hung. For me, it was a dream come true, and I am not ashamed to say I took full advantage. The Project did oblige me to turn in a time sheet every other week, showing that I had painted forty hours each week. Typically I painted from first light to dark, often not even conscious of the passing of the day until I had to turn on the lights.

In addition to supplies, the Project furnished models. I was permitted to sign one up for two weeks at a time, and this I happily did.

The first model I signed up gave me quite a start. When I opened the door in response to her knock, she inquired, "Are you Don Vogel?"

"Yes," I answered, and stepped aside to let her in.

"Where's the studio?" she asked. I pointed, and she strode off, dropping items of her clothing along the way. By the time she stepped on the stand and announced, "I'm ready," she was nude.

I picked up her clothes and placed them on a chair. Throughout the morning, I did several drawings to the accompaniment of her constant chatter. The apartment had become quite warm. I had only one fan, too small to move much air, but I directed it at the model on the stand. Now and then a puff of breeze wandered in through the open studio bay windows and out through the open kitchen door. I gratefully welcomed these brief little respites from the heat as a special gift.

At lunch the model joined me at the kitchen table, nude. I asked her please

to put on her robe. She did so, but left it hanging open, permitting her generous breasts to swing over the table.

A model named Felicia Terry became my favorite. She looked like a walking Matisse drawing. I never tired of drawing her, and I did three or four paintings of her. I drew much more than painted from the model, trying to catch up on the schooling I had lost. I did hundreds of drawings, mostly quick action sketches and five-minute poses.

*

I had made it a habit to keep a large pot of potato soup on the stove, for now and then a hungry artist friend dropped in to eat and visit, but mostly to eat. I always enjoyed sharing my soup, because it gave me a chance to hear the gossip and learn about the artist's work. During one such visit, I became involved in a strange business, a venture into private enterprise. I had bought shares in an etching press and produced a few prints, so this made me eligible to participate in what my friends thought would be a great business venture. We intended for artists to use our press to produce their own etchings. We prepared a small zinc plate that could be slipped neatly into a box. The artist would remove the sized plate from the box, draw on it with a stylus (a stick with a small brad inserted in one end), replace the plate in the grooves of the box, and mail it back to us. We would then etch the plate, ink it, print it at so much per print, and send the prints back. Voila!

My friends promised to do all the work if I would promote it. The idea didn't overwhelm me, but I consented to give it a try. Each day I went to a different high school to lecture to the art classes and demonstrate the techniques of etching. I carried the small press and several boxed plates, as well as the other materials required to give birth to a print. First, I would talk about the history of etching and then demonstrate what I did to produce a print.

One day, as usual, I was explaining that Whistler controlled the biting of his plates by spitting on them, for the saliva kept the acid in a small, controllable pool that he could move about with a feather. With a feather in one hand and the plate in the other, held close to my mouth, I spit. And spit and spit. But apparently I had talked too much that day, for my mouth was com-

pletely dry. Finally, I managed to produce a bit of white spittle that looked like cotton. This delighted my young audience. Our business venture failed.

✵

I decided the time had arrived for me to see what my peers—those other than my friends—thought about my work. The Forty-Fourth Annual Exhibition for the Artists of Chicago and Vicinity was coming up. The jurors included Louis Betts, Alexander Brook, and Morris Kantor, all from New York. That should tell me something, for if they accepted my work, at least I could see how my paintings held up among others. I was twenty-three and still within my self-imposed five-year period to become what I hoped to be, a good painter.

Looking through my racks, I chose the canvas I would submit, *Cary Village*. By mail, I received notice of acceptance. The exhibition would open March 14 and run through April 14, 1940. I confess to a great sense of pride and perhaps spent more time than usual looking at my painting hanging under the same roof as the masters I so admired. No, my ego did not fool me. Would five years be enough? I began to have doubts. I decided not to measure my work by the efforts of the local artists. When I could hang one of my works on the wall with the Impressionist master I admired most and it could hold its own in comfort, then I would consider myself a painter.

The Cincinnati Art Museum held the second juried show to which I submitted my work. Their Forty-Seventh Annual Exhibition of American Art ran from November 2 through December 1, 1940. They accepted my canvas, *Young Girl with Flowers*. This show was followed by a long list of museum exhibitions that accepted my work. Sharing my work inspired me even more, if that was possible.

In the winter of 1940–41, a dealer who owned a small gallery in a charming little house in Chicago asked if I would have a show and share the gallery with a friend of mine, Albert Goodspeed. Albert and I had lived at the Artist Community House at the same time, and he and another friend, Keith Hovis, came by now and again to share my potato soup. Although it was my first

commercial show, I never asked, "Why me?" With all the painters in the city, I was too full of myself to question the reasons. Albert and I had our work in separate rooms in the gallery, and the opening, with mostly friends attending, was great fun. I sold one drawing for five dollars. That was my first sale. I was now a professional.

Two days after the show opened, the weather closed in and closed it down. The coldest day of the year blew in, about ten degrees below zero, and the gallery furnaces overheated, causing a fire. The firemen broke the windows and chopped down the door to get in with their hoses. The gallery was flooded with water, which subsequently turned into ice. The following day, when I went to see for myself what damage had been done, the whole building looked like a cake of ice. The gallery owner told me she had insurance on the paintings, but their condition was more important to me than any monetary matters.

The fire had occurred under the area where Al's work hung. My work suffered mostly smoke damage. I learned from this episode the importance of using good materials. Because Al had painted on cotton canvas, his paintings sagged and hung like limp rags held loosely at two ends. They would never regain their original flat, stretched surface. My works had been painted on linen. When they were returned to my studio, their surfaces looked like the surface of water into which a stone had been dropped, with rings of waves expanding out from the center. After a few hours in a warm, dry atmosphere, however, the surfaces returned to their original flat toughness. There is no substitute for good materials.

My appetite for exhibiting had been whetted, so I sought out additional places to show my work. I found listings of museums in the art magazines and set up what I termed a scorecard. In my first year of exhibiting, I submitted works to eight juried shows and was accepted by five. The next year I submitted to twenty-eight and was accepted by all of them. A juried show for the Butler Art Institute in Youngstown, Ohio, accepted six of my works: three watercolors and three oils.

I submitted a work to the Carnegie International, considered the most sought-after and respected exhibition of all. It was accepted. The Carnegie

sent artists photographs of where their works hung in the show so that they would know the other works with which theirs hung. Carnegie also sent the artists copies of any mentions of their work in the press.

I remember that particular exhibition well. When my forty by thirty-inch canvas of a young girl standing by an open window was returned to me, I found its saccharine sweetness repellent. I felt so embarrassed that I took a knife and slashed the canvas in disgust. It taught me the importance of living with a painting awhile before allowing it to leave my studio. I also learned that acceptance or rejection for an exhibition had little to do with the quality of the work. One painter I had known at the school submitted the same painting three times to the same exhibition. Twice the jurors rejected it; the third time they awarded it the top prize.

When visiting my studio one day, Francis Chapin suggested that I send a painting to the Corcoran Biannual Exhibition. He was going to help juror the show and would make sure my work was accepted. His generous offer pleased me, and I suggested that he pick out the painting I should send. I crated the painting he chose and sent it off, feeling assured of acceptance. The jurors rejected the work. Sometime later I asked him what happened. He said that so many paintings went by so quickly that the jurors looked at each one for no more than five or six seconds on the first and second go-round. He said that, furthermore, if a group of still lifes went by and then a landscape appeared, the landscape was automatically accepted, and so on. Since that time I have enjoyed being accepted in many shows, but I have absolutely no illusions about their importance.

This was a wonderful period for my work, for I had plenty of time to experiment with technique and methods. My palette changed many times until it settled in, almost without my noticing, and has remained relatively constant since. Perhaps the one thing I do unlike any other painter I know is to mix equal parts of whites: zinc, flake (lead), and titanium. The lead flake will give the paintings a mellow tone over time, while the titanium will keep the whites still looking white. I trust that time will prove this practice sound.

✳

In 1941, at Christmas, I was invited to visit my father, stepmother, and brother, all of whom had moved to Dallas. Five years had passed since my last visit with them. I stayed in Dallas for a week, and at that time I met the director of the Dallas Museum of Fine Arts, Richard Foster Howard. We talked about the art scene in Dallas, about my painting, and about the exhibitions where my work had shown. He said, "Why don't you have a show here? Send me some material."

I explored the city and fell in love with it. I found the people kind, warm, and considerate. The climate was mild, the air clean, the skies clear. What a contrast to Chicago. That city could be the hottest or coldest, the meanest, and at times, the ugliest. I remember flying back to Chicago. Looking from the window, I saw a cylinder outlined sharply by blue sky. As we drew closer and closer to the city, the cylinder grew larger and larger. Suddenly we flew into it, a column of dirty air over the city beneath us.

As I left the streetcar to walk back to my studio, the filth on the streets and sidewalks appalled me. I wondered why I lived there. However, after two or three days I found that I didn't see the filth. I just stepped over or around it.

✻

In 1942, when the Easel Project closed down because of our entry into World War II, I was transferred to a division located at Soldier's Field. I had been officially requested as a member of a team that was to camouflage the oil storage area of South Chicago. I had already received my draft number and fully expected to be called up for service, so I thought this project would be a good way to use my time in the meantime.

As it turned out, I took my induction physical and received a 4F classification. The doctors informed me that I had a central nervous disorder that had occurred at birth. They explained that my left side was larger and stronger than my right. This would not influence my longevity or affect the acquisition of insurance, but they thought if they accepted me and I later claimed disability, the government would have to pay me for life. Also, the doctors considered me underweight. If the army would not take me, I deter-

mined to leave Chicago and move to Dallas. I began selling out my studio and packing to go.

A few days before I left Chicago, I took the train to Cary to say goodbye to my Aunt Eleanor and Uncle Bud. I found my uncle sitting on a bench outside Washer's Tavern. I sat beside him and tried to express the gratitude and deep affection I felt for him. He asked what I intended to do with my life.

"Paint," I said. "I am a painter."

After a long silence, he said, "Why don't you get an honest job; work on the railroad or in the gravel pits; be a man and do a man's work?"

The train ride back seemed very long. I felt so depressed, realizing he would never understand. I loved him so. Uncle Bud died about six years later. My aunt sent me a newspaper clipping telling how his friends had taken his ashes and scattered them on the Little Wolf River, where I once had fished with him.

Before departing Chicago, I decided to enter the competition for the American Academy in Rome, so I spent two weeks on a composition dealing with Lincoln Park. It included many figures on a bridge over the lagoon, with several boaters in the water. The day before I was due to leave for Dallas, I looked at my painting and decided it appeared too sweet in color. I felt I hadn't enough time to correct it, so I painted over it. I completed a new composition with two figures in less than two hours.

One of the most difficult partings involved leaving Rembrandt, my loving cat. I traded him to a photographer in exchange for photos of my paintings and a photo portrait of myself with Rembrandt on my lap, sitting in front of the easel with the wet, just-finished composition for the Academy of Rome. This represented a good deal of work for the photographer, and I felt for such an exchange he would take good care of my valued friend.

I gave my reed pump organ to Malcolm Hackett. I considered him my mentor and remembered well his teachings. When I visited Hackett to say goodbye and thank him, I asked him how I could ever repay him for all he meant to me and all he had given me.

"You do owe me a debt," he said, "and you can repay it by giving help

whenever you can to anyone you believe is sincere." I gave him my promise and would like to think I have kept it.

My friend, Keith Hovis, arrived in his car, as promised. We loaded up my bags and the wet painting to be delivered to the shipping room at the Art Institute, where the American Academy of Rome was gathering the paintings for its competition. This done, we set off for the railroad station, and I boarded the train to Dallas and an uncertain future.

My first exhibition suggested by the director of the Dallas Museum proved opportune, for it permitted shipping crates of my paintings from Chicago that would be held in the museum's basement storage until my arrival.

2

Dallas

A home at last

IN 1942 DALLAS'S train station in no way resembled Grand Central or Union Station, where I had done most of my boarding or stepping off trains. Nonetheless, it appeared just the right size to a twenty-five-year-old youth who was allowing himself another five years to reach his goal as a painter. The city held the promise of growth, and I hoped to be a part of it.

At the information booth I received directions to the YMCA, several blocks away. As I walked up Main Street, however, I passed a small hotel, and my body yelled, "Stop!" Turning in, I rented a cheap room on the fourth floor. Thoroughly exhausted, I undressed and flopped on the bed and closed my eyes. As I lay there, just drifting off, I became aware of voices from the next room and the squeaking rhythm of bedsprings. It was not easy to ignore the conversation and sexual athletics, but after what seemed a very long time, all became quiet, and for the next ten hours, finally I slept.

The next morning, after a long, hot, soapy shower, I found a coffee shop to refuel my stomach and my spirits. I then called my father's office, which was located at 2421 Commerce Street, about fifteen blocks from my hotel. His secretary told me that he was out of town for a few days, but that if I would

come by, she might be able to help me find an apartment. It was a long walk, but I welcomed the opportunity to see the city.

My father had known I was coming to town, but hadn't known exactly when. He had written me a most unpleasant letter saying that he didn't want me to move to Dallas because I would disgrace his good name. He was convinced I had avoided the draft somehow and, furthermore, since I was a painter—an *unemployed* painter—I had to be a thoroughly undesirable person. I couldn't argue with him, but I had my own grail. Perhaps it wasn't holy, but it was nonetheless dedicated. His absence pleased me. I had nothing to prove to him, only to myself.

My father's secretary was very kind and helpful. The first thing I needed was a place to live, so she gave me addresses and directions, explaining that a streetcar would take me within a block and a half of one place. I thanked her, boarded a streetcar, and headed for 5705 Reiger Street. There I rented a small apartment in a dreadful firetrap of a three-story frame building that looked like a disaster waiting to happen. The next day I would look for a job. I used the rest of that day to call about the crate I had shipped, send out cards with my new address, find a store and lay in a few supplies, cook a simple dinner, and retire early. I needed more sleep.

Over coffee and toast the next morning, I read the want ads and circled every prospect I could find. Then, well rested, I set off to find a job. Walking down Reiger Street, I heard the streetcar approaching and started to run to reach the corner in time. The conductor saw me and held up his hand to slow me down as he stopped the car and opened the door to wait for me. When I stepped in, he said, "Good morning," and smiled. To my amazement, looking down the car, I saw welcoming nods and smiles from the other passengers.

Tears came to my eyes. I remembered that not long before in Chicago I had stood in a foot of snow in the middle of the tracks, waving my hands above my head and yelling at an approaching streetcar, "Stop, or run over me!" The motorman tried to wave me aside, but when I held my ground, he had to stop. (Another motorman had told me once that most of them felt it wasn't worthwhile stopping for just one passenger, especially in bad weather.) I ran to the back to get on board, but the car started to move even

before I could jump on. The conductor growled, "What the hell's the matter with you, you damned fool?"

My teeth chattering from the bitter cold, I said, "Thank you." After leaving the streetcar on Wabash and giving myself up to the snow again, I had to walk through the canyon, against the icy wind, to Michigan Avenue to transfer to a bus to Soldiers Field, where I worked for the WPA on a war project. On the Michigan Avenue corner I waited for never less than ten minutes. The wind off the lake was so cold the tears froze on my cheeks. I did a painting to express that bleakness, and even now, looking at it makes me feel good just because I'm not there anymore. Oh, Dallas, I thought, I am so happy to be here.

My rent was paid for one month, and I needed to find work soon. Each day I ran down the hill to the streetcar and went from one defense plant to another, applying for jobs. I went to the Arlington aircraft plants and to the Murray Cotton Gin people, who manufactured bombs and such things, but there were no jobs left. It was too late.

In my apartment I sat on the floor, painting. I had no easel, so I turned a chair upside down and leaned my canvas against it. It must have looked odd, and it certainly felt odd to paint a forty by thirty-inch canvas sitting on the floor. My first floor-painting was of a young girl in a large black hat.

I looked in the Yellow Pages under "picture framers" and noted a few names and addresses. The first was John Douglass, who had his frame shop on Brown Street at Fairmount in a large, old house. He used the entire first floor for his shop. The living room in the front of the house served as a gallery, where he hung framed work waiting to be picked up. The dining room held sample moldings. A bedroom served as the storage room, and the kitchen was the workshop.

John Douglass was warm and kind, a true gentleman who created the finest frames in the city. I called on him in the hope of finding a job. He had no job for me, but I found something much more important there, my first friend in Dallas. He welcomed me as an old friend, and I felt like one before I left. He told me about events happening in the arts and about the painters. Their names were all new to me, but I was eager to know them all. John him-

self was a painter, but had been shut out, for some reason, by the local group. They suggested he would do better as a framer, and he had turned to framing to support himself. He became the best framer in the region. He had a man working for him named Bill Casey, who eventually became one of my closest friends.

Bill was a misfit. His many interests and his kindness always got in the way of his financial success. His love for books led to his opening a bookstore, which failed, as did his hardware store, his goldfish business, his worm farm, and many other interesting enterprises. He was a fine craftsman with a knowledge of chemistry that led him to become the first local conservator to restore paintings. Knowing him and being his friend were among the best privileges life in Dallas offered me. He painted only three paintings that I'm aware of, and they were all exceptional.

John suggested that I look for a job in one of the two galleries in the city. He thought Joseph Sartor's gallery might be able to use a framer. I found Mr. Sartor a very unwholesome man, my idea of a typical "social" art dealer. He made me uneasy, and I felt that he could not be trusted. His manner implied an authority he did not possess. He said he would take me on for a week to see if I could do the work, but would pay me only ten dollars a week for what amounted to nine hours of work per day.

When the week ended, Sartor was out of town, so I spent another five days on the job. When I finally had the opportunity to talk with him in his office, he said that I had misunderstood him. He liked what I was doing, but did not have enough work to justify paying me more than ten dollars a week. I was angry, because that was a lie. The gallery's frame shop had so much business that I had to stay hard at it to get the work out. I had been used. I told him what he could do with the job. He seemed totally indifferent, saying only, "O.K."

So there I was. I had to look for work again. My rent was due that day, and I had no job prospects, but I had a can of beans and a can of soup in the larder and sixty-three cents in my pocket. No use to panic, I told myself. I knew a job was waiting for me; all I had to do was find it. As I was about to leave my apartment, I glanced at my mailbox and saw a white envelope. I

would read it on the streetcar, I thought, but then I noticed the return address in the upper left corner said, "American Academy in Rome." I opened it to find a check and a letter stating that I had won a place in their competition.

The once-famous Dallas Little Theatre that became my first home.

The letter went on to say that later I would receive a bronze medal with my name inscribed on the edge. That check provided the breathing room I needed for a while.

John Douglass had talked to me about the Dallas Little Theater, and I went by to see what it was all about. I met the director, Talbot Pearson, and suggested to him that the theater could save money on its insurance if I lived there and worked as the custodian and night watchman. He thought it was a good idea and got approval from the Board of Directors. Within the week I moved into a spacious room backstage in the theater, across from the costume storage. At last I had a studio to work and live in. With dreams of masterworks to come, I immediately set to work to build an easel.

The theater had a great reputation. Prior to my arrival on the scene, it had won the Belasco Cup for three or four years running, but it still had only a fair following. When I arrived, they were about to produce *The Women*, by Clare Boothe Luce, a play requiring several set changes. I made the mistake of offering a few suggestions and soon found myself designing, building, and painting sets, as well as lighting and working the show. For this, Mr. Pearson paid me five dollars a week.

I also served as the theater's delivery service. One day Pearson handed me some photos and typed press releases with instructions to take them to the newspapers. He ordered me to go to *The Dallas Morning News* first and hand them in person to John Rosenfield, and then to go to the *Daily Times Herald*.

John Rosenfield, Amusements Editor for *The Dallas Morning News*, was almost as round as he was tall. When I entered his office, he extended his hand and took the package from me.

"Sit down while I look to see what I want of these photos," he said. "Now let me tell you the rules if you're working at the theater: all press material comes to me first, or we won't use it. Anything I don't want you can take to the other paper. Understand?" Clearly, he was in the habit of calling the shots.

He welcomed me to Dallas and asked about my background. When we had finished talking, he invited me to keep in touch, then called a staff photographer and sent me to the photo studio so they could have a picture of me on file.

At the *Herald* it was quite different. The editor took the package from me, dropped it on his desk, said, "Thanks," and waved me away.

The Little Theater was about a five-minute walk from Douglass' frame shop, so I frequently visited with John. One afternoon the painter Alexandre Hogue came in to see him. It was my first encounter with an active painter in Dallas. John introduced us, saying with some enthusiasm and pleasure, "Alex, you should meet Don Vogel. He's a painter from Chicago and plans to live here."

John Rosenfield, editor of the Arts page in The Dallas Morning News.

I extended my hand, smiled, and was in the midst of saying hello when Hogue broke in with, "Why the hell do you outsiders come here? We don't want you. You come to win some prizes and leave. Go back where you came from."

Poor John turned red and tried to calm Hogue, "Now, now Alex, he's. . ." he said as Hogue turned and left.

"I'm sorry to have upset your friend, but he does seem to have a problem," I said. "I don't think I'm a threat to anyone."

"Oh, he's just that way," John said. "Pay no attention."

What a shock! How could such a thing happen in my chosen city, and from a painter? I had only begun to discover the city's insular nature, the very quality that made it ripe for art fraud years later.

Other signs of a limited view of art appeared in the city's museum administration. The annual Dallas Museum of Fine Arts No Jury Show was

coming, and I thought it might be fun to submit a large painting I had done as a background for the play *The Women*. It was fourteen by eighteen feet. I brought it out and worked some more on it, then delivered it to the museum, to the horror of the museum's acting director, Mrs. Louise McGraw. She had replaced the director, Richard Howard, when he went into the armed services. The lady had little humor or interest in art and was just filling in during the war period.

Mrs. McGraw called me at the theater and asked if I was serious or just pulling her leg. No Dallas painter had ever submitted such a large painting or one done in such a free and splashy style as this before. The more contentious and demanding she became, the more determined I was. I reminded her that no size limits had been stated and that this *was* a no-jury show. My main aim was to show that painting need not be so serious. I was even so bold as to suggest, "Let's enjoy it!"

As she hung up, her parting words were, "I will call some of the board members and get back with you."

The painting stayed. The museum staff had set out a box to collect the public's votes for the favorite painting, with a cash award for the painter receiving the most votes. Afterwards, the museum workman and guard, Jimmy Garrett, told me that I had more votes than all the other painters combined, but McGraw had thrown out my votes. It was good sport.

My first opportunity to create a complete set came when John Anderson's play, *The Eve of St. Mark*, was released simultaneously to little theaters throughout the country. A new play with eight set changes; what a challenge it posed! Pearson gave me a budget of forty dollars to build the sets. "You've got to be kidding," I said, half-laughingly.

"Just do it. That's it," he growled. For a farm kitchen scene I wanted to rent an old lamp to hang over the checkered oil-cloth–covered table. The lamp cost twenty-five dollars. I had no resources other than my budget, so that left me fifteen dollars. I designed the set largely as a light show, using old flats and battens to create silhouettes and moods. It was a success. I've often wondered how sets for that play were designed elsewhere. I feel certain none were done with a budget to equal mine.

I was beginning to dislike Pearson. He treated his actors, who volunteered their time because they loved the theater, as though they were children. He never *asked* them to do anything, but ordered them, like a drill sergeant. Sometime later he wrote a book, *Operating the Little Theater*. It should have had a subtitle, *Or How To Lose Friends and Abuse People*.

We produced a play titled *Three Men on a Horse* and were asked to present it at the army camps. Mr. Pearson was paying me five dollars a week, but offered me an extra five dollars to change the set to make it portable and to work the show at the camps. At the camps I had to set it up, light it, work it, and afterwards break it down and stack it in the truck while the cast and the rest of them enjoyed the hospitality of the Officer's Club. I didn't mind it too much, though, because I met and made friends with several young, interesting, and talented soldiers whose interest brought them to help me.

I discovered the main advantage of being in the theater, whether on the road or in Dallas, was the large number of friendships I gained. Now and then in Dallas, when all was quiet and Pearson wasn't around, I invited all my new friends to bring their dates or friends and join me for a party. They supplied the food and drinks, I supplied the place. And what a place it was for a party! Those parties became quite famous because of the freedom and good fun the stage and costume rooms offered us. They gave us all an opportunity to perform and express ourselves through pantomime and inventive performances. I set different moods by adjusting the lighting, and the costumes helped to release all inhibitions.

The thought of seeing John Douglass in a tutu, tiptoeing onto the stage, still makes me smile. How he ever squeezed that hulk into the tutu remains a mystery. What a spectacular sight it was when he slid down the banister in all that pink net!

We could get the parties together with little advance notice. Two hours and the word spread like wildfire. Pearson never found out; God knows he never would have permitted it.

※

The art scene, aside from the museum (and its activity seemed limited), was all but nonexistent. I decided to send out word that we would have monthly exhibits in the theater lobby with token prize monies given by a few friends of the theater. This is how Will Bryant came into my life. Will, a black man, worked as houseman and chauffeur for some of the most prominent families in Dallas: Karl Hoblitzelle, the Flippens, and the De Golyers. One day he appeared with a small pastel for the show, and as we talked, I learned of his dream to be an artist. I saw to it that he received a prize and invited him to visit me whenever he wanted. Within a short time, Will became a significant part of the arts community.

Despite its limited art scene, Dallas did have the good fortune to be home to an organization called the Civic Federation; it served as the heartbeat of the city. It occupied city-owned buildings at 2419 Maple Avenue, just a few blocks from the theater. An exceptional man, Elmer Scott, headed the organization. The group held town meetings, brought speakers from all over the world, had a chamber music series, maintained a social research library that contained over 7,000 bound volumes and 70,000 pamphlets, and supported several youth programs. It was a wonderful organization. I became friends with Elmer Scott while attending the chamber music and foreign film series, and I suggested the Federation hold a series of art exhibits. He put me in charge and asked me to work with his secretary, Marsha Rudnitzky, who was a delight throughout our association. For ten months, we held a continuing series of small art exhibits by Southwestern artists.

Elmer Scott was a beautiful, elderly man with an immense love for life. He was eager to share his ample supply of good will with all who came within his sight. One of the first things he would ask was your birth date. That might seem odd at the time, but then you would receive a birthday card from him each year on the proper date. Anything of value to enhance one's life he would bring to the Civic Federa-

Elmer Scott, Director, Civic Federation, circa 1942.

tion to share. He was one of the most valuable assets of the city. I always remember him with a smile and pleasant thoughts.

I painted every moment possible and shipped works to juried shows around the country, with continued success. The Witte Memorial Museum in San Antonio requested a one-man show, which I felt honored to accept. I also put up a show of my works at the Little Theater. I tried to do less on the stage and paint more, but Pearson seemed to require more and more. He bestowed the title of Technical Director on me, in the belief that it would make me happy to give him *all* my time. I rebelled. I told him I was a painter first, not a theater person, and that the title was not impressive enough to make up for all the hours I had to put in each day. I told him I wanted a fair wage, or they could get someone else to do the work and I would continue as we had originally agreed.

Some evenings later, the curtain fell on the last performance of a play. The actors took their bows and began leaving the theater. I was striking the set when Pearson came over and said, "Vogel, I want you out of here by tomorrow." I looked up at him and asked what the hell he was talking about. "I have a university graduate to take your place, and he'll be here in the morning," he said.

This came as quite a shock, because I'd had no warning and had no place to go. I told him there was no way I was going to leave by tomorrow. I reminded him that the Board of Directors had put me in, and they would have to get me out. Furthermore, I needed several days' grace. In the meantime, the young man who intended to replace me arrived. He turned out to be a very fine gentleman, and after our discussion of what he had to look forward to, he decided to go elsewhere. The name of my last play had a certain irony for me. It was William Saroyan's *The Time of Your Life*.

The word got around, and four different patrons offered me a place to live, either in their guest rooms or in garage apartments. I chose not to take advantage of their offers, but settled for an army cot in the storeroom of John Douglass' frame shop. I decided that if I could put enough money together, I would go to Mexico and paint there for a year, where it would be less expensive to live.

I went first to the museum to talk to Louise McGraw about having a one-man show with the aim of selling enough work to provide for a year in Mexico. She listened in silence, and when I had finished, she said curtly, "Mr. Vogel, you're crazy if you think that I'd help you sit in the shade under a tree so you could be happy painting pictures." I thanked her for her courtesies and left, closing the door very softly behind me.

When I got back to the frame shop I told John about my reception at the museum.

"Have a show here," John suggested. "You can have the two front rooms."

Nothing happened the first two or three days after I got the show set up, except that a lady complained to me about one of the pictures. It was a painting of a girl in a red coat holding a rather large cat. She thought the figure was a black girl and it angered her that anyone should waste his talent painting "niggers." This attitude came as something new to me. It was a shock that anyone could think in such a way, much less say so. I felt sad for her, especially when she said she was a painter.

One morning John rushed in and woke me, saying excitedly, "Vogel, get up! There's a man in the gallery buying every painting, and he wants to meet you."

Bleary-eyed, I left my comfortable cot, dressed, and staggered out to the gallery to meet Earl Hart Miller, a man I later discovered was considered to be one of the finest interior designers in the country.

Earl actually took two of the paintings for a job he was doing and said he would call me later. Within a week he called and invited me to his home, which he called Louisiana House, to meet the client who had acquired one of the paintings. Entering Earl's home was like walking into a museum. It contained the first total abstract painting I'd seen in any house in Dallas. The painting, by Weeks Hall, a Louisiana painter I did not know, hung in the library above the fireplace over a French Provincial carved mantel. The furniture, the silver, and the paintings were all museum quality or antique. A magnificent Hogarth oil on the second floor landing was the equal of anything in the Dallas Museum. Earl introduced me to his wife, Zan, and the

client. We had a pleasant visit over tea and cakes, and I went away with a check in my pocket.

From December 12, 1943, to January 2, 1944, I had my second one-man exhibition at the Dallas Museum of Fine Arts, scheduled during the period between the departure of Louise McGraw and the arrival of Jerry Bywaters as director. Thirty-one of my works were hung, including four caseins. I titled the exhibit, "An Invitation Through the Frame."

I wrote to my draft board in Chicago about going to Mexico. They notified me that I could not leave the country, because my draft status might be changed. The sale of a few paintings gave me money enough to relieve John of my company as his nonpaying guest. I found a guesthouse on the corner of Gillespie and Turtle Creek, at the rear of a large house owned by Carolyn Burford. The Mansion hotel occupies this property today.

Life in my new home became more an adventure with eccentrics than an opportunity to paint. Les Scott, a radio disk jockey whom I had met at the theater (he had played the part of the drunkard in *The Time of Your Life*), was looking for a place too, so we joined forces and became roommates. On the radio Les was known as "The Great Scott." He had an early morning radio program and apparently an enormous following, especially among women. The telephone rang constantly when he was home, with women trying to date him. We soon had to get an unlisted number.

About a month after we'd settled in, Margo Jones moved into the apartment over the garage. Margo was director of a new theater that introduced the plays of Tennessee Williams to the Dallas area. We became friends, and she asked me to become her technical director. Her offer flattered me, but I had enough to do. I wanted only to paint. We remained friends and, once or twice, went on picnics at White Rock Lake.

Carolyn Burford was a divorcee whose father was a wealthy Tulsa oilman. She had a very beautiful daughter, Ann, whom I painted and of whom I made many drawings. Carolyn was a very strange and difficult person with a fascinating and entertaining background, a true eccentric. Scott and I lived in her guesthouse about six or seven months before he got himself in trouble. He became involved with a married woman named Abby, who got a divorce

thinking she and Scott would marry. Instead, he ran off and married an airline stewardess. I tried to stop the wedding because I knew of his obligation, but he would have none of it. Reluctantly, I agreed to act as his best man and witness.

The morning after the wedding, he returned to the guesthouse and admitted he had made a mistake. His new wife of one night lost her job, and the marriage became a total disaster. This upset Carolyn Burford, and she threw him out, leaving me with more rent than I could pay. Scott and the stewardess somehow had the marriage annulled.

Once again I had to find somewhere to live. A friend gave me the phone number of a place available on Lovers Lane, and I called immediately. The person who answered told me to get there quickly, because the owner, Margaret Calliet, was about to call a taxi to go to the airport. She would not return for a year. If I didn't get there in time, I would miss the chance to rent the small school house.

I took a taxi to 4928 Lovers Lane and found Margaret on the doorstep, waiting for her cab. In five minutes I had arranged to move into the building, which had been a schoolhouse she had built for spastic children. I took it sight unseen. It would cost me twenty-five dollars a month, except during the winter, when the rent would be thirty dollars to cover the higher utilities. She instructed me to give the money to the lady who was staying in her house, and away she went.

I moved then into the most charming and delightful studio I had ever had. It had a large room with a stone fireplace at one end, a tiny kitchen and bath on one side, and a narrow little room with a blackboard on the wall on the other side. A small covered porch overlooked a cornfield. A large iris garden lay between my new studio and the house. The telephone had been included in the rent along with water, gas, and electricity. Dr. Calliet, Margaret Calliet's brother, lived across the driveway in a cottage with his wife and their beagles.

Margaret Calliet handed me a key to my new studio, which I placed on the mantel and never used. The American Academy in Rome had sent the bronze medal they had awarded me for my painting, and I kept this also on the man-

tel. The medal was the only thing ever stolen from that studio. I knew well who took it, but decided it was not worth challenging him. Besides, in some way the medal might give him courage, like the cowardly lion.

Shortly after I settled into my new studio, Earl Hart Miller came by. It soon became his habit, whenever he needed a painting and whether or not I was in, simply to come in and take whatever he chose. He succeeded in selling my paintings now and then to his clients in this way. I was so pleased with his enthusiasm that I asked him to sit for me. After the first day he was very excited and began telling people all over town that I was a genius. By the third or fourth sitting he was rather upset because I had become so intrigued with him that the painting had started to take on a "Dorian Gray" quality. His was the most detailed and revealing portrait I had ever done. I'm sure Earl hated it, but I gave it to him anyway. That portrait was the first of many I painted, though I have never thought of myself as a portrait painter. I did them simply for pleasure and because of my interest in the sitter.

One day Earl invited me to his home for a dinner party so that I could meet the painters of Fort Worth. I will always be grateful to him for that. When I arrived at his house I was overwhelmed by the festivities. A harpist was playing on the stair landing, fragrance from beautiful floral arrangements perfumed the air, and the display of crystal and antique silver on the dining room table absolutely stunned me. All this for a group of simple painters.

Earl introduced me for the first time that night to the painters who would become my close friends. They included Dickson and Flora Reeder, Bror Utter, Veronica Helfensteller, Lia Cuilty, and Bill Bomar. Dinner was delightful; the fine wines and good humor made for an evening I have never forgotten.

I soon made a habit of going to Fort Worth each weekend to be with these painters, or inviting them to visit me. We often went on picnics or had wonderful parties at the Reeders'. I did not have a car, so I took a bus or rode with someone else. I often spent the night at the Reeders', for I felt too exhausted to return to Dallas so late. They had a costume box, and we would dress in the most outlandish ways to act out pantomime and dance. The gatherings

were not unlike those at the Little Theatre but more so, for it was a gathering of talent including poets, painters, and musicians. We took turns acting in groups or as individuals. Some composed music for the flute, piano, or cello, and we did it all for our own amusement. The caring and support of this group, where everyone was ready and willing to help each other, reminded me of the Artist Community House in Chicago that I had so loved. Dallas seemed dull and flat by comparison. I hoped that in some small way I could change it.

Creative friends did emerge in Dallas, though. Bertha Landers and Violet Hayden became frequent visitors to my studio, and we developed a close friendship that still exists. Bertha (Bim) was a printmaker, the finest in Dallas. She created a visual arts department at the Dallas Public Library. Violet was

From left to right:
Bror Utter,
Donald Vogel,
Bill Bomar. 1950.

assistant director of the Library and a collector with an active interest in art. Later, Bim's half brother, Steve Redding, returned from the war and joined in all our festivities. Steve became head of Cokesbury Book Store and gave much support to the artists. Our friendship remains a lasting one.

About this time, the Weyhe Gallery in New York put together an exhibition for the Fort Worth painters, and they asked me to join them. It was called "Six Painters from Texas." It opened in 1944 on September 18 and ran through October 7. Flora Blanc, Bill Bomar, Veronica Helfensteller, Dickson Reeder, Bror Utter, and I sent five paintings each. Sallie Gillespie, director of the Fort Worth Art Association, wrote a few lines about each of us. Of me she said:

Paints for the joy of pushing color to the ultimate point of its expressiveness. He gives to color sensations their fullest power as he builds his designs

in forms which exist through complex gradations of light and dark. There is an oriental voluptuous sense of the decorative in his compositions.

Patricia Peck, art critic of *The Dallas Morning News*, wrote:

Regionalism, when applied to art, is a word which conjures up a vision of the elemental moralities painted in forms of the earth. It may or may not have a message and it has been and is vital and live painting, but if it is said to be regional, it is closer, in many minds at least, with geographical or sociological significance, and it gets to be highly specific.

In two cities of North Texas, a small group of nonspecific regionalists have been busily painting away from the earth. The drama of form in bizarre and fanciful settings, the excitement of texture and the endless elegance of color have been their principal preoccupations. They are closely knit. They have known each other for years, have worked and painted together. They criticize each other without restraint and admire each other freely and deeply. Each has studied and traveled outside of Texas, but each is a Texan, either by birth or adoption.

Will Bryant, the black chauffeur I had met at the Little Theater, began to visit often to talk about painting and to watch me as I worked. In exchange, he insisted on preparing lunch, doing my laundry, and chauffeuring me wherever I needed to go. The Fort Worth artists accepted him immediately, and Will and I drove to Fort Worth often to enjoy various activities. At times on return drives to Dallas we might stop at the home of one of his friends for lunch or dinner. The quality of these people—lawyers, an undertaker, an insurance man, and a school principal—impressed me.

Will and I found Sallie Gillespie a rare individual. She headed the art association which was housed in the Fort Worth Public Library. The Library had only one gallery, but it could hold fifty or more paintings comfortably. During each show, the association held a public forum with a panel to discuss the merits of the works and to defend their views. These were always exciting. It seemed everyone had an opinion and didn't hesitate to express it, at

length. Each year the association honored one of the local artists with a show that received the full support of the city. Each time at least half the works sold, and often it was many more. I felt that the spirit of support I saw in that community was never understood in Dallas.

These activities would decline in the coming years, giving way to the national standard of "leading edge" art. Local art slowly disappeared until it was all but nonexistent as far as the local museums were concerned. It would be up to the galleries to prove it still existed. A new and different awareness was developing instead, one that required more and more words to explain the pictures that were hung. It seemed that the less content a painting had, the more words flowed to explain it. Soon the words held little meaning, but became an art form in themselves. New values for new times. New languages would have to be learned to understand the age.

Regardless of the influences, the Fort Worth artists set the mold that made all that followed possible. Their openness and pervasive good will was contagious. It reached out to the whole community at all levels. They made art exciting and entertaining while holding to a respectable standard. They shunned the elitism that would eventually take hold.

My introduction to the Fort Worth artists led to an association lasting many years that provided me with companionship similar to that I had known in Chicago. The contrast between the Dallas and Fort Worth artists soon became apparent. The Fort Worth artists responded with warmth, open arms, and understanding in accepting me. The exchange of ideas and critiques of each other's work was welcomed and respected. A strong camaraderie grew and became infectious, drawing in many supporters. It seemed that the whole community expressed interest in their efforts. The good will and free expression we enjoyed while engaged in conversation, dance, and song was contagious. How grateful I was to become part of these special, talented artists. Their vision encompassed the world. What a difference thirty miles made.

Much of the activity revolved around Dickson and Flora Reeder. Their home, more often than not, was our gathering place. They both had studied in New York and Paris. Dickson excelled in portraiture and figurative com-

positions. Flora's painting dealt with the subject of fantasies. She played the piano and cello and directed what became the Reeder's Children Theatre, producing a stunning classical play each year. It was a cooperative production for which all the artists and many others volunteered their talents. Even original music was composed and played for each new production. It became one of the major events of the year. Other members included Bror Utter, a painter who was widely collected in the state, and whose paintings were inventive, often decorative, suggestive of stage settings, and touching on the surreal. He enjoyed a large following as a teacher.

Also in the group was Bill Bomar, an exceptional talent who had to overcome the handicap of being spastic. He spent much of his time traveling and studying. His studies took him to the Cranbrook Art Academy in Michigan, and New York, where he spent time with Hans Hoffman, Ozenfant, and Robert Henri who had a studio down the hall in the Chelsea Hotel while in New York. On his frequent visits home he shared time with the group.

Cynthia Brants had also studied in the east, attending Sarah Lawrence College where she had studio time with Kurt Roesch. She returned to Fort Worth and built a beautiful studio of glass and steel on her family's wooded acreage. Her paintings expressed her love of riding and jumping and employed soft bright colors and abstracted subjects that favored horses.

Kelly Fearing graduated from Louisiana Polytechnic Institute and Columbia University and arrived in Fort Worth to teach at Texas Wesleyan College. He melded into the group and quickly involved himself with printing, using the etching press with Blanche McVeigh and pulling several editions of soft ground prints. His early pictures involved landscapes, soon to give way to fish, birds, and animals. His interest in the mystical took over. He left Fort Worth to fill a post in the art department to teach art education at the University of Texas in Austin.

Veronica Helfensteller, painter and printer, shared her home for dinner parties. After marrying, she moved to Sante Fe and opened a candy shop. Her prints and paintings are still available in Texas galleries.

Blanche McVeigh concentrated on producing prints and remains one of the most respected of collectable printmakers in Texas. Some years later she

was kind enough to award my bride Peggy and me a color print as a wedding gift.

As new young painters and sculptors appeared, they were absorbed into the group that continued to change as we slowly went different ways. Marriage, new families, jobs that required moves, and the untimely death of Dickson Reeder all took their toll.

I began to believe Dallas had a department store culture. Neiman Marcus, one of the greatest stores in the country, seemed to be dictating taste. The Neiman's label became a status symbol, and citizens wore it as their badge of success. Too many people came to believe they could buy taste and need not try to develop it. Another difference between the two cities was that many families in Dallas preferred to send their children to Texas schools, such as Southern Methodist University, the University of Texas, or Texas A & M, so they would live near home. The families in Fort Worth seemed to send theirs more often to the East or abroad. I felt that Fort Worth people lived closer to the earth, dealing in cattle, grain, and oil, while Dallas's population grew from banking, insurance, and fashion. All this represents a generalization of the times, but I believe it hits not too far off the mark.

As I met more and more artists in Dallas, I began to understand the problems. Many groups had formed strong cliques that behaved quite dogmatically. They were like religious sects that believed only their members had the ear of God, and to hell with the others who were unenlightened. I suggested that the Dallas Museum of Fine Art bring these people together by inviting them to lecture or have forums. This, like many other ideas, fell on deaf ears, for the museum clique was the strongest of all.

The Dallas Museum remained in flux during those years. Richard Foster Howard had gone into the army, to be replaced by Louise McGraw in the war years. The painter and teacher Jerry Bywaters then took over from McGraw. Bywaters' appointment pleased me, for I felt certain that, as a painter, he would simplify matters and open things up. Bywaters' takeover did none of that, however. It only put him in power. Throughout his tenure, he taught at Southern Methodist University part-time and acted as museum director only part-time. He came to be regarded as a weak director, though he was a nice

fellow from an old Dallas family with enough backing to keep him in office until retirement time. Ed Bearden, a favored student, became his assistant director. The rest of the staff consisted of two guards and a janitor. The Dallas Museum school group was made up of William Lester, Ed Bearden, and a bit later, Otis Dozier. Lester soon left to teach at the University of Texas at Austin.

I became more aware of this closed group when I tried to get a job teaching life drawing at their school. They considered me an outsider, an apparent source of discomfort to them. They didn't trust me. My paintings had nothing to do with the American scene, and I sensed little approval from them, perhaps because of the looseness of my works. But, then I found the rigidness of their works boring; jackrabbits, cactus, and century plants did nothing for me. I didn't question the sincerity of their work, but felt that their pictures would soon be dated and parochial. It was their ball game, and I was coming up to bat. My problem? The umpires were all on their side.

This situation brought about my first political painting. At one of the frequent parties at my studio, I started and completed a forty by thirty-inch panel while my guests danced, ate, drank, and talked all around me and to me. The picture showed two young girls behind a folding screen with a painting on each of its three panels. In front of the panels the girls manipulated three marionettes dressed in harlequin costumes. The three marionettes represented Bywaters, Dozier, and Bearden, each holding a palette or brush or easel and dancing before their own pictures now in their own museum.

The painting delighted me and my fellow revelers. It was a good painting, done in high spirits. However, it fell quite flat with its subjects. Whatever sense of humor they may have had they shared only within their own group. Both newspapers enjoyed my political statement and gave much space to it. It became the star of the show because of the press. The wives of the painted subjects took exception, thinking I was saying that they were controlling their husbands. It was great fun as sides formed. The museum clique had difficulty accepting my exposure of them.

With no support for me from the museum group, I knew that whatever I did I must do at my own risk, on my own terms, in my own way. This, in

time, proved to be a great advantage. Looking back, I can only thank them all very much.

One day while painting at the Lovers Lane studio, I heard a knock on the door and shouted, "Come in." When the knock was repeated, I knew the visitor had to be a stranger, so I set down my brushes and went to the door. When I opened it, there stood one of the most beautiful women I'd ever seen, Betty McLean. She asked if I was Donald Vogel and if I was the most modern painter in Dallas. I was so awed by her beauty that it took me a while to invite her in and correct her misconception. I explained that I was not "the most" anything, but just a painter, nothing special. I showed her a number of pictures I was working on, and she said she wanted me to paint her daughter, Joan.

"I am not a portrait painter," I told her.

"I don't care," she said. "You can paint her any way you want, in cubes or whatever." I fell in love with her immediately. However, when she told me her daughter was four years old, I said there was no way I would paint her. She said, "What about my son Tony? He's seven." I said I would try Tony. If I liked him, I'd paint him. The next morning she brought him in, a handsome, slender young boy, and I told her I would be delighted to paint him. Thus we started.

The following day he arrived with his governess, Miss Slocum, quite an attractive young lady herself. Her presence became most distracting, though, because each time I asked Tony to rest, he would go to her where she lay on my bed, reading *True Romance* magazine, and begin to fondle her. It became so disturbing that I suggested that perhaps I should work with Tony alone.

The next time he arrived I had a horrible problem getting him to cooperate. Once, when I turned my back to answer the telephone, Tony left the stand where he had been posing, picked up a linoleum block ink roller, and proceeded to roll it over my palette, mixing all my paints together. I turned around from the telephone and when I saw what he was doing, I dropped the phone and whacked him a good one under the ear. He fell to the floor quite stunned, then turned around, looked at me, and laughed. This angered me, which rarely happens, so I picked him up and threw him on the bed and sat on

him until his mother arrived. I told her to take the damn brat. It wasn't worth the money.

Betty smiled tolerantly and said, "Oh, we'll just rest for a few days, and I'll call you. If you'll finish it up, I'll stay with him." I finished the painting. It was a fairly pleasant portrait, but I don't think it was anything special.

Thus began a lifelong friendship that opened the doors to the social world in Dallas that is indeed a world in itself. Betty and Jock McLean were the first from this world I met who had a genuine interest in contemporary painting and painters. Betty became an important asset to the community as well as to the nation. This friendship made it possible for the first contemporary gallery of importance to open in Dallas.

Bill Bomar, a most sensitive painter, came over to spend a weekend with me, and I did a portrait of him. We started on a Saturday. I remember it well for two reasons. First, we were listening to the Metropolitan Opera's broadcast of *La Bohème*, which we both admired greatly; and second, Betty McLean came to visit with me. I introduced her to Bill, and we all had a glass of wine. This was the only time I ever knew her to drink. It was an occasion, she said later, worth celebrating. She liked Bill immediately. The portrait of Bill now hangs in the Old Jail Museum in Albany, Texas. I believe it is one of the finest portraits I ever did.

At long last I had gotten back in stride, painting six to eight hours a day and sharing good company on the weekends. Someone introduced me to a young lady, Emily Richardson, who had just arrived from Raleigh, North Carolina, to teach the harp at the Hockaday School for girls. Our friendship ripened rapidly and, before long, I had her sitting for me, playing her harp. I painted her several times.

On a personal level, she added a new dimension to my life. Before her, women had seemed mostly a waste of time, except as models and friends. Emily brought me pleasure and delight in a way I had not felt before, one I wanted to cherish and nurture. I guess I was in love. Our relationship was such that I thought she shared the same feelings. However, when she returned from the Christmas holidays with her parents, she announced her engagement to an old school friend who was about to start his internship at a

hospital in New York. I tried, but could not change her decision. When she left, I felt an emptiness I had not known before. She was my first love, and the pain of our separation caused me to vow I would not let this happen again.

Love had gone, but the arts never failed. The Hockaday School commissioned me to stage a one-act opera to be presented by the graduating class. For this I built a platform stage, the proscenium to support the curtain, and the set, and I installed the lighting outdoors on their beautiful, sweeping terrace of rich, green grass. At the dress rehearsal Miss Ela Hockaday came and sat next to me. I introduced myself to this very proper, haughty, matronly lady, and she said, "Mr. Vogel, I am so very pleased to meet you. Your stage is quite beautiful. I should like to employ you to teach stagecraft and work in our shop." Her tone, which held more of telling than of asking me, put me off. I thanked her, but said that I was a painter and had no interest in teaching at her school. She stood up and, without a word, moved to another seat some distance away. I was no longer of any interest to her.

Later, the flower club of the Dallas Woman's Club commissioned me to build the sets for their annual spring flower arrangement competition. For this I designed and built in their club's auditorium a gallery of walls to accommodate several open, lighted boxes, each to support an arrangement. Each wall represented a different country, such as England, the Netherlands, and France, or a period, such as Early American or contemporary, with appropriate frames.

The ladies moved in to assemble their arrangements, all hoping for blue ribbons, while I put on the finishing touches. Not one or two, but five of them asked me to help or make suggestions, for they wanted to win a ribbon so badly. When I refused, telling them that it was their work, not mine that should be judged, two of them offered me a hundred dollars, and the others, fifty. I refused to be bribed. I never found this fierceness of competition among painters.

I had a number of other requests to design and build sets for benefit shows, but when I asked about the budget, the contacts always responded, "Oh, Mr. Vogel, this is a benefit, and you should volunteer your services." The fact that I frequently was hard-pressed to pay my rent held no interest for them.

In time I found that the time I spent backstage at the Music Hall at Fair Park was for myself, rather than for the theater. I began using the stage as a subject for my drawings and paintings and found this more exciting than working on it. From the wings, the ballet appeared even more beautiful than from the audience. The dancers against the footlights, sweat sparkling like diamonds as it flew from their bodies, the strong backlighting of the large arc lamps and spots across the stage between the wings with the velvety, black background—these things unfortunately never seen by the audience. I failed in my attempts to capture its beauty as felt in paint.

I felt this same sense of excitement with the opera, but less intensely. When Igor Stravinsky came to conduct, I did several drawings of him, one of which *The Dallas Morning News* reproduced. I painted the men setting up the flats and striking the sets, dozens of drawings and studies. Later I had an exhibition of these works in the lobby.

I felt, however, that the most important thing to come from my work at the Music Hall was the number of new friends I made. Many of them came to the studio to visit, and a few sat for me. The director of the Ballet Russe de Monte Carlo came to a party at my studio after a performance, and over drinks I told him of my desire to design a ballet set. He agreed to give me that opportunity, but said that I first must get a release from the stage designers union. The Ballet Russe would pay twelve hundred dollars for a design. I wrote the union for permission to do a one-time design, and they said that I could—for a fee of twelve hundred dollars. I could live well for more than a year on such an amount. This experience did nothing to elevate my opinions of unions.

I continued to exhibit, but closer to home and around the state. Once, when attending the Telenews Theater in downtown Dallas, which showed mainly Pathé news clips of events around the world. I began to think about the wall space on the balcony level. I introduced myself to the manager of the theater, John Altermann, and suggested that the balcony would make a good gallery. He said, "It's yours if you'll take the responsibility for hanging the paintings and whatever else is required." This space proved quite successful, but created many headaches. I spent a lot of my time picking up

works from painters, hanging them, and then returning them. I suppose they thought someone paid me, but in truth, my only reward came from the hope of stimulating more interest in art. But who would believe that?

I also convinced Harry Simmons, who owned Rush Art Supply store, to use a back room in the store as a gallery. The Linz jewelry store people agreed to put paintings in their windows. I was trying to create a consciousness of painting by showing it everywhere possible. The inactivity at the museum spurred on my efforts to take advantage of merchants willing to give me their ear. Unfortunately, I was alone in such efforts and unable to motivate other artists to help.

After hanging a show, I would call the press and hope they would review it. Once, when I called *The Dallas Morning News*, John Rosenfield told me to stay at the Telenews Theater until his critic arrived. I waited two hours, but no one showed up, so I went home. In a few minutes John called, saying, "Why the hell didn't you wait?" I tried to explain that I had indeed waited, but it did no good. The subsequent review of the show was vindictive and totally unjust. The artist, who had just arrived in town and was looking forward to living in Dallas, left with his family within a week.

I went to *The Dallas Morning News* and was giving the writer, Rual Askew, hell for what he had done, when the great John Rosenfield yelled from his office, "Come here Vogel, I've got to set you straight. You damned artists would sell your soul for a line in the paper," and so on and so on.

"John," I said, "you're talking to the wrong fellow. This is a two-way street, and you know it's just as important for you to have something to write about as it is for a painter to be written about. There's no reason for you to be vindictive, you damn prima donna!"

"Okay, Vogel, we'll see," Rosenfield countered. "Your name will not appear in this paper for one year."

"So be it. Enjoy yourself," I said as I left.

He was as good as his word. During the next year, the *News* omitted mention of my name on any number of occasions when there was good reason for it to appear, even when I won a major prize at the museum. Each time I encountered Rosenfield at musicals or other events, we would greet each

other with a smile, and I would say, "Hope you're enjoying yourself." We sat across the table at dinner parties, both of us wearing silly smiles when our eyes met. When the year ended, he removed the order, and everything returned to normal. It proved nothing, except what can happen when two hard heads come together.

Mary Nell Sharp returned home from a year in Mexico City, and for a short period became the art critic for Rosenfield. She found her way to my studio one day, and we became friends immediately. We went to Fort Worth together, and she fell in love with the group as if they were old friends. For two or three months she dropped by almost every other day for a drink and gossip. She kept me abreast of what was happening at the paper and about town. Then one day she arrived in tears. "Rosie" had fired her. He said she was writing too much about the Fort Worth artists when she should be covering Dallas. She stood her ground and said that most of the artists here were dull, except for Vogel, so that was it for her job. I comforted her as best I could, and we had a couple of drinks.

Soon after, she left Dallas for New York and got a job with one of the national art magazines. I followed her writings, of course, and a short time later read her review of a one-man show of prints by a printmaker named Donald Vogel. What a happy review for that artist! At Christmas, when she returned to Dallas to share the holiday with her parents, she came by to tell me what a rotten bastard I was for not writing and thanking her for the review. When I informed her the printmaker was a different Donald Vogel, she said, "Good God! I didn't think it looked like your work, but I never saw any prints you'd done. I really disliked the stuff, but I thought it was yours!"

"Don't feel bad," I said, "just think how happy you made that artist." The moral? Always be a nice guy and a good friend to your local critic.

Not long after that, I went to the Dallas Museum of Art to pick up one of my paintings from the shipping room after a show had ended. While I was signing a release to take the painting, Ed Bearden came in and after a few minutes of gossip said, "Come upstairs. I want you to see two things: a little old lady painting, and our model."

We entered the life class that Ed was teaching at the time, and I glanced at

the model. Wow! I had worked with nudes for years and thought of them only as subject matter, but this creature would have brought out anyone's lustful nature. She looked like centerfold material.

We went on through that room into the paint studio where Otis Dozier's still-life class was meeting, though Otis was not there at the time. At the far end stood a table on which items had been arranged: an Indian blanket, a painted pot, and a shock of colored corn. Around that was a semicircle of easels at which students were painting, and off to one side, all by herself at a small school desk sat a silver-haired lady, named Clara McDonald Williamson. Her thin, bony, transparent-skinned hand held a bristle brush that was adding a small amount of cadmium yellow into a bit of chrome green from a dinner plate that served as a palette. She was so concentrated, she was completely oblivious of her surroundings. Clear blue eyes sparkled from heavy lids that extruded beneath heavy brows that come with age. She was as big as a minute, permitting comfortable sitting at such a desk. I stood quietly behind the lady to watch her paint, and I couldn't believe what I saw. Her canvas lay on the desk at a slight angle. She had penciled in her drawing, and slowly and evenly, like the lowering of a window shade, her picture was emerging as she worked across it from side to side and down.

She soon became aware of my presence and seemed uncomfortable, so I broke the silence and asked her why she painted in that particular manner. She looked up at me and answered, as if it were surely obvious, "So I don't get my hand in the paint."

Before I left there, I made her promise to sell me that painting, or to give me first refusal. She agreed. I had never bought a painting before, only traded to other painters.

As I looked at my own work in relationship to my five-year plan, I concluded that I needed another five years; then I would arrive. After all, schedules were merely arbitrary. The important thing was that the work brought me pure pleasure, and my early life certainly had not been full of pleasure. I had not dreamed I could experience such happiness through my painting.

3

Marriage

The highs, the lows, and the delights between

IN THE YEARS since I'd arrived in 1942, Dallas had been good for me. I had begun to feel a part of the city and had established myself as a painter with a future, even though I had extended my five-year plan. The time had come, in fact, for me to marry. At least I thought so in 1947. Why? I don't know. Something within me said, "Start looking." But how to begin? I thought of myself as quiet by nature, though none of my friends or acquaintances would have agreed. I loved to argue and stir things up for the fun of it.

What qualities did I want in a mate, and what did I have to offer? I pondered the questions. Most important, I wanted someone with the qualities and abilities I lacked. I wanted a good friend and companion, someone who had the patience to tolerate me, someone who was well educated and who possessed an awareness of the practical requirements for enjoying a simple, happy life. I'd learned from my father and mother what not to do. My goals seemed simple, if perhaps impossible. At all costs I would be honest with her. I had no interest in being right, and my need for comforts might not be the same as that of others. I considered myself a doer and a producer, not a user. Money for its own sake was of little interest to me.

After considering all these ideas, I came to the question: Who in her right mind would want me? So I began to get involved with different ladies, six in all, one after another. I liked and enjoyed the company of each of them, and we have all remained friends over the years. At the time, though, my search seemed so prolonged and futile, I thought it might be easier to take a lantern and look for an honest man. I gave up.

One Saturday night Bim Landers, Steve Redding, and I drove over to the Reeders' house in Fort Worth to party. Dickson Reeder had called to be sure I was coming. He had someone he wanted me to meet, a young lady who worked for the Reeders in their children's school theater. The school had been formed and structured after the King Coit Children's Theater in New York, which Flora Reeder had attended. The Reeders' school was the delight of the entire community. All the artists worked on the sets and costumes and contributed in every other way possible.

That evening Dickson introduced me to Margaret Mayer—Peggy. What a courtship followed. The more I learned of her background, the more convinced I became that I wanted this woman for my mate. All that was left was for me to let her know I was a fine fellow.

She soon invited me to dinner to meet her parents. When I arrived, Peggy's lovely mother, Mabel, whom they called Nan, welcomed me. Peggy showed me into the living room where her father was sitting in an armchair, his head hidden behind a newspaper. It was this man, Commander Roland G. Mayer, retired Navy lighter-than-air engineer, who had been floating in those huge airships I had seen in the sky in Jackson Heights when I attended grade school. At the time Peggy and I met, he was general manager of General Dynamics, building the largest plane in the world, the B-36.

"Pops," Peggy said, "I want you to meet Donald Vogel."

He lowered his paper part way, just below nose level, and said, "Humph!" before he returned to the paper again. That brief encounter told me this would not be a comfortable evening. I must have seemed, in his eyes, a poor prospect. At the time, I weighed one hundred twenty-eight pounds dripping wet. The army had rejected me, classifying me 4F, and I had no visible means of support. This Navy hero, whose son had his own destroyer command and

whose daughter had served as a Wave during the war, sat there sizing me up. Perhaps he couldn't see that walking into his house that evening took its own kind of courage.

One of the greatest gifts nature bestows on man is his courting time. The chemistry of both body and mind goes through unique changes during this period. The highs and lows and in-betweens create pure delight. Peggy met all my requirements and more, but how could I ever measure up to her? Somehow, she saw something in me, though I don't know just what it was, and I'm sure the Commander couldn't understand it.

Before we committed to one another, it was important to me to be sure she was aware of whatever prospects the future held. I was totally honest and promised nothing more than what I felt for her. She understood that money never motivated me, and that I had no desire to be rich in money terms. I believe that money can take more away from a person than it gives, and that the values one may lose are more important than the possessions one might gain.

"I will never work for you," she told me, "but always with you." When I heard that, I knew my choice was sound.

Around that time, I received a commission from a man named Danny Fowley to do a double portrait. The Fowleys lived in Grapevine in a beautiful wooded area that covered several acres. I painted Danny lying in a hammock with his wife Ruby leaning against one of the two supporting trees and their Great Dane dog sitting next to Ruby. With the $25,000 I was to receive for this piece, I could pay off all my debts and begin married life with a little comfort for my bride.

When I completed the painting, I took it to the Fowleys' house. No one was home, so I hung it over their mantel and returned to the studio, hoping to hear from them soon. Late the following day, I drove to Grapevine, only to learn that they had rejected the portrait because their houseguest, the widow of Louisiana Governor Huey Long, said, when she first saw the painting, "What a beautiful dog!" Ruby told me that if people thought the dog more important than she, she didn't want it. The Fowleys did, however, buy two of my paintings, and I returned home with the portrait and seven one-hundred dollar bills.

Later that day the phone rang, and Jerry Bywaters at the museum said, "Vogel, I've got the Clara Williamson painting you said you wanted to buy. I guess you want to come by and see it."

I arrived at the museum within the hour. Bywaters was never happy to see me, but this time he was even less so. He wanted the painting for the museum and tried to change my mind. Good to her promise, Williamson had told him I had first refusal, and he felt compelled, on her directions, to call me. He knew of my financial position generally, so he knew he could easily freeze me out.

I hung my head a bit and asked softly, "How much is it?"

His position allowed him to commit to a price. I know he was calculating what amount he could quote to kill my chances and simultaneously give the museum a bargain.

He smiled at me. "One hundred dollars," he said smoothly.

I shall cherish that moment forever. I reached into my pocket and pulled out my gigantic roll of $700, peeled off a hundred-dollar bill, and laid it on his desk. Then I walked out of there with my first acquisition.

The next day I went to visit Mrs. Williamson. She lived on Yale Boulevard, just off the Southern Methodist University campus. Her house was red brick, not very large, but the only two-story house on the block. Bluebonnets covered the ground on either side of the walk leading up to the house, which sat on a knoll about six feet above street level. Mrs. Williamson invited me in for tea and fresh-baked cookies. I wanted to thank her for her wonderful painting and to learn something about its subject, as well as about her. She was sixty-nine years old, and this was the first memory picture she had done.

That was the first of many visits we had together. I cherished them all. Peggy and I later wrote a book, *Aunt Clara*, for the Amon Carter Museum, which gives her complete history.

With my remaining $600, I designed a wedding ring: two nudes with outstretched arms, their hands just touching, their bodies curving down on either side. The engravers were so

Clara McDonald Williamson at 92 years of age on the porch of her home on Yale Boulevard.

carried away with the idea that they got right at it. It was a treat for them to do something different from their usual routine. I was delighted with their work and praised them highly.

I bought a suit and some flowers and paid my rent, and then I was ready for the wedding.

On October 4, 1947, Peggy and I married in the Texas Christian University Christian Church. Afterwards, there was a large reception at a lodge owned by the aircraft plant Peggy's father, the Commander, headed. All the Fort Worth artists joined us for the festivities. Later, with a couple of bottles of champagne under my arm, I returned with my bride to the studio on Lovers Lane. I had very little money in my pocket and no prospects of future income, but that day was the happy beginning of a very happy association.

Walter Hendl playing the piano at Valley House, 1956.

Walter Hendl came into our lives about this time with his wife, Newby, and their charming young daughter, Susie. Walter had come to Dallas as conductor of the Dallas Symphony. I had known many of the orchestra people for some time because they often came to my studio parties. Some of them became close friends of ours, such as Joseph Hawthorne whose father, Charles Hawthorne, was a noted New England painter; Lester Soloman and his wife; Zelman Brounoff, first violinist; Rafael Druian; and Martin Anastasi, among others. The symphony, already part of our lives, grew in importance for us with the Hendls' friendship.

For some time Walter Hendl had made my Lovers Lane studio his second home. His presence provided great fun for Peggy and me because he gave us an inside view of the music world. I called Hendl "the golden boy"; he could get himself into more trouble, yet he always seemed to come out a winner. My favorite story is about something that happened toward the end of his career in Dallas.

Hendl studying the score for a performance of the Dallas Symphony, 1958.

John Rosenfield of *The Dallas Morning News,* had been trying to get Hendl fired for over a year because Hendl refused to let "Rosie" prove his

power by dictating the symphony season's programs. As usual, Hendl had just pulled some stupid blunder or another and then departed to fulfill several guest-conducting dates in South America. On his return, he stopped by my studio, exhausted and pleading for the chance to sleep in our bed for about four hours, until he had to be downtown at a board meeting at the Athletic Club. His future with the symphony was at stake. The symphony board had charged him with being irresponsible, unreliable, and so on and so on. He looked a mess—unshaven, eyes bloodshot, suit wrinkled.

We woke him in time to shave and drink some coffee before he went on his way. He had no car, so we let him use ours. He returned about 7:00 that evening and collapsed into a chair, laughing.

"You'll never believe what happened," he said. "I was late arriving downtown and couldn't take time to park, so when I spotted a young Mexican boy leaning against the wall, I yelled at him to come over. I asked if he could drive, and he said he could, so I told him to drive around the block until I came back. Then I rushed into the club and up the elevator to the meeting room.

"After we had been meeting for about forty minutes, they asked me to step outside so they could talk privately. I was standing in the hall when I suddenly thought, my God, the Vogels' car! I ran down to the street; no car. I waited and waited, and finally, there it came. The boy had picked up a girl-friend, but he had kept circling the block. I threw some money at him and asked him to park the car and leave the keys at the desk. In the meantime, the board decided to forgive me, and I am to continue as before. Now can you imagine how I could ever possibly be called irresponsible?" he laughed.

One time after a symphony concert, George Bolet in a brilliant performance of Rachmaninoff's *Second Piano Concerto*, Peggy and I walked backstage to meet Hendl so we could go to dinner together. As I stood just offstage, looking at the piano, I wondered how it would feel to play such an instrument. To the embarrassment of my dear wife, while the audience was putting on coats and slowly filing out, I sat down at the piano and made very impressive noises.

As the stagehands began removing chairs and music stands, the head stagehand came over to me and said, "You shouldn't be here." I ignored him and continued. When he asked who I was, I responded with authority, "If you

don't know, I won't tell you," and continued playing until Hendl appeared. Peggy was red with embarrassment. Bolet stopped next to her, listened for a moment, and said, "Aha, I have competition." The stagehand, now thoroughly bewildered, hesitated to challenge me further. What a marvelous instrument that Steinway was! One day, I thought, I would have one for my talented friends to play for me, and I would make sound pictures for myself.

※

Dallas continued to change and began to flex its muscles. "More is better, and bigger is better yet," seemed to emerge as the motto. The city fathers felt the pressure to modernize, and General Motors and the rubber companies conned the city into replacing streetcars with motor buses. Streetcars, called old-fashioned, did not seem worthy of a growing metropolis. Our city fathers have made some stupid moves, but this would prove to be one of the worst.

I disapproved of some of the things going on, because I personally aimed to enhance the scene in our city and wished we artists could have worked together to find more exhibition space and seek a larger audience. The three active art clubs in Dallas represented quite different attitudes, all of which might have been reconciled, but the artists couldn't get together for what could have been their mutual benefit. These painting clubs had a leader or teacher and a studio in which to assemble, often to paint a common subject, but mostly to give the members a chance to applaud each other.

The Frank Reaugh Art Club was organized in 1922. Reaugh, who favored working in pastel, was noted primarily for his pictures of cattle on the Texas range. His series known as *Twenty-Four Hours with the Herd* hangs at the University of Texas. Born in 1860, Reaugh was a handsome and remote figure, by far the first painter of note in this area. I never met the gentleman, but I respect his work.

The Vivian L. Aunspaugh Art Club members gathered around a true blue and white Victorian. The Club had selected the rose as their club flower; their motto was "Perseverance." These ladies once asked me to speak to their group. Always ready to talk, I joined them in the living room of one of the club members, talking about abstract painting and challenging them to try it.

Poor ancient Vivian. She sat there with her mouth open, shaking her head back and forth in total disagreement, as if to say "to think of doing such a thing!" In payment for my time I received a case of beer.

Finally, there was the Klepper Art Club, organized in 1930. Frank Klepper lived at 2906 N. Fitzhugh in a delightful small studio house. He invited me there for dinner on three occasions, all most enjoyable, for he provided good company. Klepper was physically not unlike myself except for his leathery skin tanned from hours of painting in the open landscape of West Texas.

Other painters—among them, Edward Eisenlohr, Reveau Basset (head instructor at Dallas Art Institute), Olin Travis and Perry Nichols—had many of their own followers. Like schools of fish, these groups swam in the same water, but not together. Each one was convinced it had the true answer and pitied the others who didn't. I too thought I had "the answer," but at least I sought the answer only for myself, no one else. You must be only yourself to be a painter; no one can respond to the same things in the same way as you, and no one should hold your brush but you. Painting clubs and clubs for painters offer quite a different experience: delightful social engagements and encouragement to produce pretty pictures. Rarely did a painter advance from their midst.

<center>✷</center>

A year and a half had passed since our wedding when Sallie Gillespie offered us her adobe cabin in Taos for a honeymoon. Since we were still short of money, I decided we should accept this generous offer. I carved an invitation in a linoleum block that read, "Going to Taos Sale," and sent a print to fifty friends. The sale proved a success, and I sold drawings, watercolors, and an oil painting.

Peggy and I started out for New Mexico at six o'clock one morning and arrived at six o'clock in the evening. It had been a long hard drive to some of the grandest country in America. In Taos we kept mostly to ourselves, exploring and enjoying the skyscapes and landscape. I painted while Peggy read to me. It was everything we could have asked of a honeymoon, just exactly as it should have been. It seemed much more rewarding and mean-

ingful because we had waited more than a year for the occasion, after we had become more aware of and at ease with each other. We vowed to return to this land of enchantment.

To support us, I did many odd commissions: I painted designs on dining room, bedroom, and bathroom walls; gold-leafed a piano and stair railing; did a gold and silver leaf design on the glass door of a restaurant; and did a series of small, quick portraits of children. Somehow something always came up in time to pay the bills.

I introduced Jock and Betty McLean to Clara McDonald Williamson's work, and they bought two of her paintings. I set the prices for her at $700 for one and $800 for the other. The McLeans were happy to pay it, and it pleased me that Aunt Clara received more for those paintings than I had paid for mine.

Clara continued to produce, and our visits became more frequent. Her pictures were stunning. Her work so impressed me I talked her into letting me borrow two paintings to take to New York to show to Dorothy Miller, curator at the Museum of Modern Art. I hand-carried her two pictures and the one I had acquired and took a plane to the big city, settling myself in the old Chelsea Hotel. Bill Bomar had a studio apartment in the Chelsea down the hall from Robert Henri's studio, where his widow still lived. The hotel gave me a very small room that had one small window looking out on a dark well. When I awoke the next morning (I could tell it was morning only because my watch said so—the well remained dark all day), I saw a strange object hanging from the ceiling that had not been there the night before. It proved, on inspection, to be a brown bat; I had a roommate.

I had breakfast coffee with Bomar and then called Dorothy Miller who agreed to see me at 3:00. When I met Dorothy Miller at the MOMA office, she asked me to state what I had rather quickly, because she was short of time. I began to tell her about the artist as I opened the wrapping that protected the three paintings. She was carried away by them. The MOMA had just closed a naive exhibition the month before, and she deeply regretted that she had not known of Clara's work before.

"These works," she said, "would have been the stars of the show. You must show these to Klaus Perls."

She picked up the phone and talked to Perls, then wrote his address on a card and handed it to me, saying, "Now tell me what the artists are doing in Texas. We've been thinking about them, but our budget won't permit us to send someone down."

I expressed my enthusiasm for their spirit and energies. She thought a moment and then said, "Why don't you put some material together, photos, bios, and such, and we'll see about a Texas show." What an opportunity! This would really set the artists up.

Perls, recognized as a major dealer who specialized in works of the School of Paris and a chosen group of naive painters, at that time had his gallery on the second floor of a corner building on Lexington Avenue. I climbed the steep stairs to meet a very impatient man on his way out. "I can't see you now. Come back Monday morning."

I carried my treasures back to the Chelsea and spent the weekend looking at favorite paintings in the museums. How hungry I was for them. When would I get there with my own efforts, I wondered.

On Monday, when my watch told me it should be morning, I found that my roommate, the brown bat, had deserted me. I hurried uptown to the Perls Gallery and opened the door, but no one seemed to be there. I coughed a few times, and finally a teary-eyed red-haired girl appeared from a back room.

"You'll have to wait," she said softly and disappeared again.

I placed the wrapped paintings against the wall and began looking at the works hanging in the two rooms. Suddenly, Perls entered and yelled the girl's name, whereupon someone broke into sobs in the back room. He stomped off into the back, and I could hear his angry voice mingled with the other crying, pleading whimper in what sounded like bad tragic opera, only without the orchestra. I wanted to disappear. With all this temperament boiling, it was hardly a time to show paintings.

There was a large stack of mail on Perls' desk, and when he reappeared as abruptly as he had first appeared, he went past without even glancing at me, sat down at his desk, picked up a letter opener, and went at the mail as if he might eat it. At that moment he might well have.

I summoned up my courage and coughed again. He looked up. "What do you want?" he barked.

"I? I'm here because of Dorothy Miller," the magic name.

"Oh, yes, the paintings. Let's see them," he said a bit more calmly. As I opened my package, he went on, "I have no room for a show; I am committed for the next year and a half." I placed the first picture against the wall so that he could see it, then turned the second, then the third one around. He said nothing more for several minutes, but left his chair and got on his knees, staring in silence at all three pictures.

"I could throw out my November show," he said finally. "What do you want?"

"I want nothing," I answered, "but to show this work. I think it's important and should be well represented. I have no financial interest in it; it's a matter of friendship."

He relaxed, and our first meeting became a prelude to a long-lasting friendship. He stated the terms he worked on with painters, and I said that I would relay his terms to Clara. Then I left to return to Texas. It was my opportunity to learn for the first time how the New York galleries work with artists. They generally required fifty percent commission. If it is a first show, mailings of the announcement and the printing of a catalogue, plus shipping, are paid for by the artist, who also has to see that the work is well framed. In recent years it has mostly remained the same. It did not seem fair— until I found myself in the business of being a dealer faced with the enormous costs of rents, utilities, insurance, labor, maintenance, and on and on. The dealer is fortunate to earn ten percent after expenses.

The good news I was bearing made me impatient to see Clara and to pass on the news about Dorothy Miller to Jerry Bywaters. At Clara's house, tea and cookies awaited me, along with a warm greeting. I told Clara about Perls' terms and the enthusiastic response her painting received at MOMA. She said, "How very nice of them, but I don't know them and I won't do business with anyone I don't know, especially Yankees."

She was truly unimpressed. I felt so happy for her, for I knew she would have been a winner, but I accepted her decision. After we had chatted awhile, I went off to cut masonite panels, the material on which she painted, and prepare them for her so she would always have a good supply.

When I caught up with Bywaters, he was with Ed Bearden in one of the

galleries at the Dallas Museum, and he was looking very sour. Had I brought on that expression? Surely he must be more relaxed among friends. Yep, it had to be me. I told him about my visit to MOMA and Dorothy Miller's request for information about the Texas painters, with the idea of possibly putting together a show.

"Vogel," he said, looking me in the eye, straight and firm, "I wouldn't trust you to help me across the street."

Ed interrupted, "Hold on, Jerry. Let's hear him out. There may be something to this."

"Hell, no," Bywaters snapped back, "if she wants to do something, she should talk to me, not Vogel." With these words, Jerry left. Well, I sure wasn't equipped to follow through. Bywaters failed to pursue the exhibition and it became a dead issue and Texas artists lost a national, no, international showcase.

Bywaters' arrogance and Rene Mazza's superficiality had much in common. Rene, a portrait painter of indifferent talent, great mediocrity, and much charm, supported himself by an occasional sale and frequent invitations to "make" a dinner party among Dallas' social set. This may have kept him better fed than I, but he was just as poor. The first time he came by my studio, he asked me to teach him technique in using pastel, a medium with which I had little experience.

Another day, in the spring of 1948, Rene brought his very old and dear friend, Baron de Hory, to my studio. His looks were not dissimilar to Rene's, except de Hory was more heavily built and had a ruddy complexion. Baron de Hory extended a limp hand, like a wet fish, and said, "Donald, we shall be good friends, and you need not call me Baron. You may call me Elmyr."

Good God, I thought, I am the last person you should try to impress with a title. This guy is another phony, no doubt about it.

Rene insisted we come to his place to see Elmyr's work and help him get a show. Rene lived in very nice quarters over a garage on an estate next to the Highland Park Town Hall and fire station. Peggy and I went to see his work, and de Hory and Rene received us like used car salesmen welcoming prospective clients. Over coffee we looked at a few of de Hory's paintings. They reminded me of de Segonzac's, fully pigmented, succulent in color, and

bearing strong, direct, fluid brush strokes. The subjects consisted mostly of harlequins and still lifes. He hardly had enough work for a show, but he assured me that within a week he could paint all that might be needed. I had an idea where he could have a show. A young man, Bill Knighton, had opened a frame shop within a block of my studio. It was a generous space, and he used only the far end. I was sure that I could convince him of the merit of using the extra space as a gallery (and I did.)

Before we left, de Hory said he had a couple of paintings to show me. He hated to part with them, he said, but he needed money and would be grateful if I could help. He had a Matisse and a Picasso, which I had barely glanced at before he had a sudden thought and, right in the middle of our conversation, turned to Rene. "Didn't you say that Mrs. Bradison is having a dinner party tonight?" he asked.

"Yes," Rene replied, "but we were not invited."

"Well, call her and ask if it's formal or not and what time we're expected," said de Hory. So that's how he gets to looking so well-fed!

By then I'd had time to look at the paintings. I told him the only one I knew who might be interested in them was Betty McLean, and I would ask her.

After hanging the de Hory show in Bill Knighton's "gallery," I took Betty McLean to see de Hory's Matisse and Picasso. The Picasso was of a broken lamp with its pieces strewn over a table; the Matisse depicted a reclining figure, similar to ones I recalled seeing illustrated in a recent issue of *Life*. Betty expressed an interest in the Picasso and examined it while de Hory told us in great detail that Picasso was a very close friend of his and had given him the painting. He carried on so that I got suspicious. The paintings looked good, but de Hory and the art works themselves left me feeling uneasy.

I suggested that since Betty wrote French as clearly and perfectly as English, she should write to Picasso before she bought the painting. Picasso would respond, no doubt, if Betty mentioned his very good friend, de Hory. Betty said that she'd go with my suggestion, and if everything proved all right, she'd be pleased to buy the painting.

De Hory exploded, "I've never seen such a piece of theater! Well, if you don't trust me, you can't have it."

That signaled the beginning, the first time I exposed de Hory as a fraud. I didn't know that he had painted the Matisse and the Picasso, but I sensed they were false, and he seemed as genuine as a three-dollar bill. Later, I learned that he sold the two phony works to a rancher in San Antonio. Who could know that years later I would be partly responsible for opening a jail cell door for him for his part in the Meadows caper.

My painting continued to go well, particularly with a live-in model whom I painted as she read or mended. More and more, however, I began to invent my figures. Our income remained so sporadic that at times we looked all over the house for lost nickels and dimes.

Sales were few and infrequent, and I welcomed any odd job related to painting. Naturally, when my friend Megan Comini called and asked me to make her a bookbinding press, I was pleased to have the opportunity. Megan had enrolled in a class to learn the art of binding books, which seemed to be the popular thing for ladies to do at the time. I called my friend Bill Sheaffer who had an excellent wood shop where he built furniture and other things. He hesitated to let me use his band saw or any of his tools, but our friendship got in the way of our good judgment.

I set the saw blade and the guide to the required height and width, then switched on the power. The saw's motor hummed authoritatively, its blade ready to bite into the board I was pushing toward its teeth. But I failed to recognize that I had a piece of green wood. When it reached the blade, it bucked, and I pressed down to force it into the saw. My fingers slipped, and my hand flew up and out. The blade bit through the center of my second finger and then into the third finger just behind the nail. My left hand hit the switch to kill the power. I placed my bleeding right hand into my left hand and pressed it into my stomach. "Drive me to the hospital quick," I told Bill.

"I can't drive! I don't even have a car," he gasped.

"Get into my wagon and you can drive it," I urged. "I'll tell you what to do."

He threw the master switch to kill all the power, locked the door, and helped me into the car. He got in on the driver's side and put his hands on the steering wheel, then asked, "Now what do I do?" He really didn't know how

to drive. I gave him instructions, step by step, and somehow we made it to the emergency room at the hospital.

I asked Bill to call Peggy and tell her what had happened while I checked in. The clerk told me to take a chair and wait for the doctor. I mustered up the courage to look at my hand and saw the tips of my two fingers flapping open in a jellied mass of blood. Quickly covering my hand again, I felt the blood rush from my head as I slumped to the floor. A nurse awakened me.

Peggy arrived to give comfort and take charge, and things began to happen. The doctor arrived, took a look and said, "We will have to cut them off."

"No way," I protested, "I'm a concert pianist. You're a clever surgeon; put them together." He ignored me and talked to Peggy, and she persuaded him to meet the challenge.

When I came to, feeling quite drunk, I found my hand wrapped and plastered, looking like a good-sized club. The doctor, while giving us instructions, said that if I had worked in a factory or as a laborer, he would have removed one finger. However, he said, he had enjoyed the challenge of sewing them back in place. They would take longer to heal, but, since time was not a factor, it would prove better in the long run. I thanked him, and Peggy drove us home.

I painted only two pictures during this healing period, both of them with my left hand. Using the untrained muscles in my left hand proved so painful

that I decided the struggle was not worth it. Word of my plight got around, and the Fort Worth artists got together to try and help. Dickson Reeder volunteered to paint a portrait, and they sold chances, with the winner to receive the portrait. In addition, a committee arrived one day to purchase a Vogel painting for the Fort Worth Art Association. I had been unaware of their efforts until after they chose the painting, a forty by thirty-inch canvas of a white floral.

The concern of those people touched me so very deeply I could never fully express my feelings. What true friends they were. I never felt richer, not because of the thousand dollars they left, but for the concern they showed. It all but made the accident worthwhile.

4

Art Dealer

Creating the first art gallery

IN MAY 1950, our first child, Eric Stefan, was born. I stayed with Peggy in her hospital room, holding her hand until she had to go into the delivery room. As soon as Eric emerged, I left. I had to go earn enough money to get them released from the hospital.

A dear friend, Marvin Krieger, told me that the agency where he worked handled the advertising for Pioneer Airlines. General Robert A. Smith, head of the company, wanted a copy of a Peter Hurd mural for their office. To do the copy, I had to fly to Big Spring, Texas, to see the mural, a very dull and badly cracked fresco over the clerks' windows in the post office. Why he sent me there I'll never know. It would have been easier if he'd given me a photo of it.

Leaning against the wall, with my colors on the desk, I started my study. Just as I began to add color, the Postmaster came out and stopped me, saying that I had no right to do a copy. It took a lot of talking to convince him to let me continue. He appeared unimpressed when I told him about my assignment, because apparently he did not care for the General. He relented only after I told him I needed the work to get my wife and newborn child out of the hospital.

"Don't take too long," he admonished me.

When I returned to the studio, I set out to render my copy. I worked all through the night and the next morning without sleep. When I finished it, I called Marvin, and he delivered it to the General for approval. As my friend, Marvin understood my need to have a check immediately. Happily, he returned with the check, and I felt I had conquered the day. I was exhausted. I had a new son, and Eric had an "Uncle Marvin." My first child's birth impacted my life in a way surpassed only by my marriage to Peggy.

The newborn Eric had been home about a week when Betty McLean and her friend, Claire Frost, came to visit and see the baby. The conversation led to their plans to start a small business to keep themselves occupied, perhaps something in the nature of a beauty salon. I responded firmly that they should consider opening a professional gallery dealing with contemporary art because none existed in the Southwest.

"My God, that's it! We're in business," Betty said.

I looked at my easel, then at Peggy and the baby, and responded, "O. K."

Claire did not become involved. Later, I realized that, without meaning to, I had taken her place in Betty's quest to become more meaningfully occupied.

In 1950, at about the same time we started the gallery, Margaret Calliet sold the small studio on Lovers Lane where we lived. The new landlord had some relatives who needed to move in, so he gave us a month to move. This put quite a burden on us, because we had no idea where to go. We learned that a painter friend, Perry Nichols, was selling the place he had acquired as part of his divorce settlement. He had three and one-half acres on Forest Park Road, a rather hilly piece of land with lots of trees. A small stream ran from one end of this long, narrow strip of land to the other.

At one time the place had been a very fine estate, but the main house had been destroyed by fire, and only the foundation remained. The servants' quarters had been taken over for the main house, and a room had been added for the living room/dining room. A large three-

Betty McLean in her gallery, 1952.

car garage had been made into a studio. It was an ideal place and would have been desirable for any painter.

We signed the papers committing us to our first mortgage and became the new owners. However, we had to do some rebuilding right away. On our first visit there Peggy fell through the floor while standing by the sink; the kitchen floor had rotted out. We also repapered the back bedroom, which we planned to use as the nursery for the new baby, because there was dried blood splashed about the walls; Perry's wife had slashed her wrists in a suicide attempt a few months before. There was no problem with the studio. It was quite large, and I soon had it functioning productively.

I intended, eventually, to build a house on the existing foundation, and so I constructed a small model. We never built there, but later we used that design for Valley House.

We set about looking for a location that would make sense for the Betty McLean Gallery, and we tried to be very businesslike about it. Through statistics gathered by the Neiman Marcus people, we learned that the intersection of Northwest Highway and Preston Road had concentrated around it, within a three-mile radius, the second richest potential prospects in the country. Many of the well-to-do in Dallas, in addition to those in Highland Park, had begun to establish very large and beautiful homes in that area.

In 1950 we signed a lease on a small store that had just been completed in a brand new shopping development called Preston Center. We became the third tenants to open for business. A large hardware store had settled there first, but it lasted only a few months before going out of business. Then Contemporary House, the first of its kind that sold furniture, pottery, and accessories, moved across the road from our shop, also the first of its kind. Neiman Marcus moved in soon afterwards.

I made plans to help support the operation with a frame shop in conjunction with the gallery, for I knew framing always produced an income. We set about planning a program and gathering the painters who would become a part of the gallery. In addition to running the gallery, I still found time for my own painting, for painting was always my first interest.

We brought in our first show largely from Knoedler's in New York. This

stunning exhibition included works of Chagall, Winslow Homer, Monet, George Bellows, Mary Cassatt, Picasso, Renoir, Utrillo, Signac, Raoul Dufy, Demuth, Matisse, Vuillard, and Pissarro. All were good examples of their work, and from my current perspective the prices seem incredibly low. Each of the large Monets, twenty-five by thirty-four inches, carried a price of $6000. The Picasso was $7500. The Matisse, a forty-six by thirty-two-inch Fauve landscape, was $6,000. It all seems ridiculous now, but at the time we failed to sell any of them; people complained that the prices were unreasonable.

For a moment during that first show, a ray of hope appeared when a lady decided she would like to try the Picasso, a cubist Harlequin, a stunning picture with a rich golden tone. As agreed, I delivered it to her home the day the show closed. The maid showed me into a large family room to wait, saying that the lady of the house would return any moment. I made the great mistake of leaning the painting against a chintz-covered sofa. Spying a Steinway in the room, I proceeded to amuse myself by making musical noises until a high pitched voice exclaimed, "My God! Take it away, it clashes with my sofa."

Another lady of wealth visited our show and admired the lush Renoir *Odalisque*, saying, "I would buy this charming piece if I hadn't just redecorated my boudoir, but I won't redo it so soon."

Our second exhibition featured work by the gallery artists we planned to represent. Our program called for us to offer works by local or regional talent between each major exhibition of national or international painters. I had a free hand in selecting the artists. At first Betty watched, but she quickly learned the process. Peggy and I wrote all the copy for the descriptions and promotions, and designed the invitations and catalogs as well, all in Betty's name.

We worked closely with a very famous and wonderful art dealer, Curt Valentin, and got several shows from him, which brought to Dallas the work of Marino Marini and Lyonel Feininger. Curt was one of the few avant-garde dealers in New York. He was a true pioneer, bringing works from the Bauhaus and Expressionists while representing advanced American artists. We obtained a Ben Nicholson exhibition from the Durlacher brothers. They represented surrealist and Purist along with a group of Italian painters. Later

we became involved with a French painter, Claude Venard, through Robert de Bolli, a man who later played a very important part in our lives as a friend and a dealer. This association brought us some very important Cezannes, Renoirs, Rouaults, and Bonnards whenever we had a prospective client. Since we exhibited these works almost exclusively, we had our first real opportunity to promote works with New York galleries and to make a place for our gallery among other, larger galleries in the country. This position helped the Betty McLean Gallery secure a national reputation that would continue to serve us.

Between our major shows we had exhibitions of works by Texas artists including Bill Bomar, Dickson Reeder, Clara McDonald Williamson, Kelly Fearing, Seymour Fogel, Michael Frary, and John Guerin. I set forth the working terms for the gallery artists. For the exclusive rights to sell their work, the gallery took one-third commission, framed their paintings if needed, assumed shipping costs, produced a catalog, gave each artist a one-man exhibition, and tried to promote them nationally. Our efforts and connections made it possible to produce a group show of Texas painters at Knoedler Galleries in New York. I set these terms to benefit the painters in every way. Promotion required good catalogs, adding prestige for their future. We seldom broke even, but it was a building time that would prove itself later.

Clara McDonald Williamson was the first painter I asked to join the Betty McLean Gallery. I considered her the best painter of all of us. Being a naive painter, she knew nothing of painting, never went out of her way to look at paintings, and had convinced herself she didn't like painting. She wanted only "to make some beauty." Her work emerged as totally honest. Only once did she ask my advice. She called me on the phone one day and said, "Donald, how do you paint water going down? I have worked so long, over and over to make my river flow down, and it keeps going up. What can I do?"

"That's very simple," I replied, "just turn your painting upside down and paint it."

"Of course! Thank you, thank you!" she said and hung up. She had been working on *Arbor Meeting*, one of her best paintings. You can notice small cracks in the paint where she painted over and over on her river.

I invited all the gallery artists to design the moldings they would like to use for framing their paintings. Bror Utter and Bill Bomar offered designs, and we had the mill run 300 feet of each and finished them to the artists' liking. Both designs proved successful, especially Bomar's, which I still use today and which we always refer to as the "Bomar frame." We aimed to accommodate the painters in every way possible. With my obligation to Malcolm Hackett ever present in my mind, I began, in some small way, to be of help.

After the opening night of our first group exhibition, Jock and Betty McLean invited all of us to dinner at the Cipango Club. Jock sat at one end of our table and Betty at the other. Clara McDonald Williamson sat at Jock's right and Peggy at his left. Clara started addressing him as Mr. McLean, until he gently reached over and took her hand in his and said, "Please call me Jock, and may I call you Aunt Clara?" She fell in love with him at that moment, and forever after she was "Aunt Clara" to all of us.

The gallery bought a Nash Rambler automobile, which made it possible for us to get about with more freedom to travel in search of art and artists. Dickson Reeder, whose opinion we respected, had told us about a painter he knew in Taos whom we should contact. And so, at the first opportunity, Peggy and I headed for Taos, this time to look for artists and to meet Tom Benrimo, Dixon's painter.

Tom and his wife, Dorothy, lived about a quarter of a mile behind the Sagebrush Inn, where we stayed. The flat, sandy sagebrush country was a startling contrast to the canyons, lush with green crops and orchards, which had a richness one might envision in the Garden of Eden. Our meeting with the Benrimos was the beginning of a happy relationship that enriched our lives for many years and left us with pleasant memories ever after.

Dorothy Benrimo, a designer of jewelry and a master of the craft, a rare artist, had qualities that made her truly special. She was statuesque, well proportioned in a classical sense, Olympian of manners, majestic, and imposing with a warm, welcoming smile. Tom had a sensitive nature that radiated warmth and made others feel comfortable immediately, a quality I had known in the Osvers of Chicago. Tom was in fragile health; a collapsed lung

had caused them to move from New York to Taos. Tom and Dorothy's home reflected the quality of their taste. Their simple adobe had an oxblood polished floor shimmering with the color and surface of a rare Chinese porcelain vase with soft corners. Warm Indian rugs, fabrics, and pots, books for winter reading, and records for good listening graced their home. His paintings, which I found stunning, hung on the walls.

After we had exchanged introductions and greetings, we sat down to coffee. A large painting Tom had done, titled *Goat Song*, hung within our view. We talked about painting, and he asked what I was doing and how I felt about my paintings. Then he pointed to *Goat Song*, which had enchanted me and on which I had focused while sipping coffee, and asked how I responded to it. I found myself expounding for several minutes about the qualities of the work and my response to them. I spoke of the subtleties of surface tensions as they moved, tightening and loosening over forms that one line overlaid, then another, through washes of delicate colors, all tightly composed, yet giving a feeling of being free and open, causing one to sense the sound suggested. I was carried away. Tom later said "yes" to my offer of a one-man show for him.

Ours was the only gallery in Texas that offered a commercial outlet for regional artists; consequently, we soon found ourselves invited so often to studios in and about Taos to look at works that we went into hiding. Cocktail and dinner parties in Taos served to strengthen my instinctive feeling that I would never want to live and work in an art colony. It reminded me of living a part in a soap opera. Conversations were filled with details of everyone's personal life and work, and gossip and backstabbing were prevalent. It was so unlike the days of the Chicago Artist Community House, when everybody was a student and always eager to help one another.

The Benrimo show in Dallas opened November 11, 1952, with a twelve-page catalog. Merle Armitage wrote the Foreword. The show included twenty paintings, and the reviews, attendance, and sales were testimony to its success.

During the run of the show, a friend from Fort Worth, Merle Harding, stopped by to see the pictures and visit. She and a companion, Billy Scott, had

been on their way to attend the opera, but he didn't want to come in, saying he preferred to wait in the car. Billy was the kind of character one might see in a stage play or read about in a novel. He had ample money to afford to be bored with the commonplace and to be able to wave a limp hand to poof away people or events that might hinder any move his fancy might take.

When Merle saw the paintings, she became so excited about them that she insisted Billy come inside and look. Reluctantly, he obeyed. She introduced him: "Donald, this stubborn man is Billy Scott." He mumbled something and sat down quietly in a chair. After Merle and I had chatted pleasantly for a while, they left. That evening I received a call at home from Billy Scott.

"Mr. Vogel, I'm at the opera; it's intermission. I saw a painting this afternoon in your gallery that I must see again. I'm spending the night in Dallas and will be by early in the morning. Will you be there?" I said I would.

The next morning I moved the painting in question to the viewing room and left him alone with it. Presently, he came out and said, "I want to buy it. Please have it delivered to me after the show."

He asked nothing about the painter. He had simply fallen in love with a painting. It was his picture, the beginning of a collection. Next, he purchased a sculpture by Charles Umlauf, then a beautiful Lyonel Feininger, *Blue Church on a Hill*. When he died, he left his estate to the Fort Worth Art Association for the theater bearing his name.

The gallery produced many exceptional exhibitions, such as Graves and Tobey, Miro and Calder, Marino Marini, Ben Nicholson, Three Primitive Masters (Camille Bombois, Jean Eve, and Louis Vivin), master drawings from Daumier to Dali, and pre-Columbian sculptures. We held group exhibitions of Sixteen Texas Painters, "Four New Comers," and we included in our gallery artists Cynthia Brants, Janet Turner, and Bror Utter. We set up a series of exchange shows with Frank Perls' Gallery in Beverly Hills, California.

In the summer I held a show for children. We framed their pictures and created a festive setting with balloons and colorful ribbons. I remembered my kids in the WPA easel project in Chicago, and gave all the proceeds to the artist if his or her work sold.

✻

One morning about 11:00 I got a call to pick up a picture to be framed at a house on Overhill Drive. It was a large, impressive frame house that wore its age with a grace that bespoke good care. Stopping under the porte cochere at the side, I rang the bell. A maid answered the door and asked me to step inside.

"Wait here and I'll let her know you've arrived," she said. I watched her disappear into a large room where I could see seven elderly ladies playing poker, some smoking cigars, others cigarettes. The smoke hung like a dark grey cloud over them. The maid bent over and whispered to one of the ladies, who rose and came toward me. Her face, which was almost invisible in the smoky gloom, became visible as she stepped into the hall.

"Aha, Mr. Vogel. So nice of you to come. Let's go upstairs, I have the picture in my sitting room," she said pleasantly. "Your timing is just right. The cards are not going well for me, and being away may help," she continued, as if I were an old friend and aware of what rich Texas ladies did with their mornings. I picked up the painting she wanted reframed and wished her luck with the cards. Before leaving, I stopped at the door to watch her disappear within the smoke as she approached her happy, chattering, gambling companions.

Another group of ladies, known as "The Tuesday Club that Plays on Thursday," played mostly gin rummy. Rumor had it that a million dollars changed hands during a year's play. I knew these ladies well, and I believe it. I liked the spirit of these gals for they added a bit of color to what I had begun to recognize as a highly superficial culture.

The ladies of Texas can sometimes be tough, but none so much as Anne Windfohr of Fort Worth. We had our moments off and on through the years, but finally became friends. Not close, but friends. I first met her when she came to the gallery to see the exhibition of Kelly Fearing's work. Kelly taught art education at Texas Wesleyan College, as it was called then, in Fort Worth and had become a close friend of Anne's. In the development of their friendship, he had influenced her to become interested in collecting art. At

this particular exhibition, she decided she wanted a painting that was marked with a blue dot, which indicated that it had been reserved. That fact meant nothing to her.

"Young man, I want that painting," she barked. "I don't give a damn if it's reserved or not." Her voice could chill a drill sergeant into changing his orders. I would not give in.

"If *you* had it reserved you would expect me to honor it," I responded.

She said, "I get what I want, and don't give me any of your 'honor' bull."

"If the reserve can be removed, I'll let you know," I told her.

She left, mad as a wet hen. About two hours later I received a call from Sam Cantey, a frustrated museum director at heart who worked as the public relations man for the bank controlled by Windfohr.

"What have you done, insulting Anne?" Sam asked. "She's hopping mad and calling you a nasty little bastard for daring to defy her." On and on Sam complained.

"Sam, Sam," I said, "I have no defense; no doubt I am all those things and more, but I am not impressed with her wealth or anyone else's. Courtesy is much more valuable than wealth. Goodbye."

And so began my lifelong friendly relationship with Anne Windfohr. As so often happens, the woman who had placed the reserve on Kelly's painting changed her mind at the end of the show, saying she found it too expensive. Mrs. Windfohr bought the painting, and that was the one and only sale I ever made to her.

Running our gallery required many visits to New York that opened the way to friendships and associations which have lasted a lifetime. In New York, I found a strange contrast in the manner of doing business among the dealers; it seemed to relate to the art they sold. The first New York dealer I met was Curt Valentin. He was considered quite avant-garde and was one of the most highly respected dealers at that time. He had a soft sell approach. For him, art was to be valued for its own intrinsic worth, not bought and sold as a commodity for future earnings.

The atmosphere at Knoedler's radiated quiet authority. It was there I met Coe Kerr and Harry Brooks. What a pair of gentlemen, my kind of men:

good humored, well informed, respectful of one's thoughts and impressions, and never pushing. These men are the kind I would do business with as a collector. They dealt fairly, so a collector could depend on value received. On occasion, Coe Kerr invited me to lunch at the Polo Club to enjoy the good talk of the art world. Coe came to Dallas and developed an interest, which we encouraged, in Southwestern painting. This resulted in a show of Texas artists at Knoedler's. We had missed the opportunity with Dorothy Miller, but this show made up for that a bit.

Soon our gallery's reputation began to reach into Europe. The Marquis Robert de Bolli, a close friend of Betty McLean's, came to Dallas to visit and look over our gallery. In his youth he had been a protégé of Ambrose Vollard, the greatest of French dealers. Now he acted as the sole representative for the Vollard estate. Ambroise Vollard was the dealer who gave Matisse, Cézanne, and Picasso their first one-man shows while dozens of other artists enjoyed commissions and gallery space because of his help. Included among his painters were Renoir, Forain, Degas, Redon, Rodin, Rouault, Bonnard, and Bernard. De Bolli controlled a group of French painters and an Italian sculptor as well. We arranged for the first full exhibition in this country of the painter Claude Venard, de Bolli's favorite. Though the show proved the most successful one we had at the gallery, we considered our lasting association with de Bolli even more important.

After our first year, the books showed that the gallery had lost about $5,000. We knew it would take three or four years before we could expect to see a profit, but the loss concerned me, because it was not mine. Betty did not seem overly disturbed, saying we would soon do better. She always had an upbeat spirit and a positive attitude that surpassed even my own. The same day we had totaled our losses, Jock stopped by to join us for dinner. As we waited for our wives, Jock said, "Donald, you must do better." My heart sank, but he continued, "You must lose at least $40,000 to help me with my taxes."

I rather think that Jock's words were intended more to ease my anxiety than actually to urge me to increase his losses. It was always his nature to be generous. However, with that statement he lifted an enormous burden from me, and I changed my tactics. I soon learned that the only way to make money

is to spend it. No matter how I tried, though, I couldn't spend enough, because the gallery started to gain business. We moved very close to breaking even.

※

Somehow I continued to paint in every spare moment. The studio was comfortable and provided a setting for many late evenings with good company. We found our property very rewarding and, in a small way, our own Lincoln Park, which we thoroughly enjoyed. Our quarters, while small, gave us warmth, comfort, and compatibility with our feelings for one another. The grounds were a wonderful playground for Eric and ourselves. We kept a half dozen bantam hens in a small chicken coop. They produced four or five eggs a day, but more importantly, they gave us visual delight and entertainment. Our days were filled with rewarding work, happy pleasures with many friends, and a boy child to wonder at and love.

Our business had grown to the point that we needed to enlarge the gallery, so we decided to move the frame shop elsewhere. We built a small frame factory on our property on Forest Park Road at the opposite end from the house, and leased it to the gallery. Late one evening, just after the frame factory was completed, we had returned there to find our new framer still cleaning up and stacking molding. I told him to lock up and go home. At about two or three o'clock in the morning a neighbor called to tell us the factory was on fire. I looked out the door, horrified to see the new building going up like a torch. Firemen arrived in good time and managed to save part of the building, so we started over. We had rebuilt the frame factory and were preparing to restart the frame operation when we sold the property under strange circumstances.

It started when a real estate man began hounding us. He first offered us twice what we had paid originally for the property. I told him my plans for the place and said that I had absolutely no interest in selling. He started to threaten us, definitely the wrong approach. I told him to go away and not to bother us any more. He finally reached a friend of ours and had him persuade us to at least listen to the man for ten minutes.

This time he came with a different attitude. He said he wanted an opportunity to find us a place we liked as much as Forest Park Road. If he could find property in a place where we could build whatever we wanted, would we consider selling? This proposal I agreed to, but with the condition that he find such a property within ten days, or he could forget it. I felt that was the most time I could give him.

On the tenth day Peggy and I took a ride north of Dallas and, for some reason, turned off Hillcrest onto a dirt road. Perhaps the farmland and the odor of the trees and barn hay intrigued us. We stopped at a place that had a white picnic table under the trees and walked through the property. We discovered a wonderful creek, clear and clean and very beautiful, at the far end. On our way back toward the car we decided that perhaps we might like to locate our home here.

As we neared the road, a lady approached us, frantically waving her arms and shouting at us, demanding to know what we were doing on her property. When I asked if it was for sale, she calmed down immediately and snapped, "Yes, for a price." I asked how much. Without hesitation she said, "$9500."

Without hesitation I said, "Sold."

The property on Spring Valley Road totaled a little more than six acres at that time. We were paying Perry Nichols $12,000 for his property on Forest Park Road. I asked my friend who had persuaded me to talk to the real estate man how much we should ask for the Forest Park Road property, and he said, "Oh, perhaps $50,000."

I asked him how he came up with $50,000 because, if I could get fifty, why not ask sixty? Oh, hell, I thought, why not ask $70,000 and see what he does.

The real estate agent accepted my $70,000 price without hesitation. We had to pay off the mortgage on the Nichols property we had bought in 1950 and now were selling two years later, and on the new frame building leased to the gallery. Then we could begin our plan for the large project we would call Valley House. We negotiated to stay in the Forest Park house rent-free until we could finish our new house. Happily, the new owners seemed in no hurry to move us out.

We first built a frame shop on the new property to replace the one we had

to leave behind. It gave me the security of knowing I could always make a living to support the family, no matter what else happened. We again leased the frame shop to the gallery and then started construction of the house.

I got the help of an architect friend in Fort Worth, John Wesley Jones, to do the mechanical drawings for my design, and I started to build. At that time we had absolutely no idea of what it would cost; I was acting as my own contractor and had no experience judging the price of materials and labor. Twice a day I went out to supervise, once before the gallery opened, and then later after it closed and, of course, all of every weekend. This period was one of the few that ever slowed my productivity as a painter.

We had the walls about halfway up when we found ourselves without any money. I had to set about then to find a source to secure a loan. Although I had a most generous contract, our income at the gallery, $500 a month for both my wife and me, did not impress the loan companies when I told them that my building project would pay for itself. They also disapproved of my design. It did not meet their specifications of what would sell easily in case of default. We found it fascinating that the young people who came out to sell us mortgage money, without exception, suggested that we exaggerate our income to meet their company's requirements. They eagerly pursued their commissions. Of course, we refused.

We had begun to think we would have to postpone further progress, until Betty McLean sent an elderly gentleman over to see us one Sunday. He was President of the Guardian Savings and Loan Company. We showed him through our building and, as we left, we asked him how he felt about it. "My wife hates contemporary," he commented. "Come down, and I'll fix you up." We pushed ahead, happy and excited, and completed the house without further problems.

We designed Valley House to meet the simple needs of a painter and the comfort of his loving wife, whose needs I always put first. In the studio, windows make up two-thirds of the north wall. The windows, 13½ feet high, have fixed glass at the top and, from the floor, five-foot redwood jalousies that provide air circulation. The living area includes kitchen, dining and sit-

ting as one open space, with windows on the north and south ends and a
metal-hooded fireplace in the southwest corner.

For the floors we used a beautiful split paver brick from Colorado. Our
bedroom and bathroom opened onto a greenhouse, separated by a shoji
screen. The room and bath for the children, on the studio side, enjoyed the
morning sun.

In the construction of Valley House I insisted on using the best materials
that required the least upkeep and that had been made as fireproof as possi-
ble. We used no sheetrock, only plaster, hadite, brick, and redwood and
heavy fir beams, eight by sixteen inches, to support the studio and living area
ceilings.

Building a home represented the third best event in my life, right after
having found the one to love and share my life with, and having a child. In
every way I realized that building a home is ongoing; the house is just a start-
ing place. Soon a change in Betty McLean's life would change Valley House
and my life forever.

5

Valley House Gallery

An ideal gallery/home comes to life

In 1953 Betty and Jock divorced. I found it difficult to understand, for they had seemed to be so close. Betty told me matter-of-factly that Jock's mistress demanded that Jock marry her. When he discussed it with Betty, she said, "Well, fine." It was that simple. They remained very close and dear friends. Peggy went to court with her to stand as witness. The judge said a few words, and the marriage ended. I tagged along.

After the divorce decree, Betty left. Peggy and I went into another courtroom out of curiosity and sat in on another divorce case. In this bitterly contested divorce, the parties used much foul language and mean voices, shouting hideous things at one another. It brought back memories of my home in Queens. Peggy and I looked at each other and promised if our relationship ever disintegrated into such a condition, we would revisit the courts and sit in on another such case. It is a mystery to me how persons who respect each other enough to commit themselves to vows could ever degrade themselves to such a state. Naive I may be; naive I choose to remain.

Betty soon married a man from Houston, Tom Blake. He demanded that she get rid of the gallery because he felt Betty's involvement in a retail busi-

ness was beneath their social position. My feelings about his attitude are better left unexpressed. We set about trying to find someone to buy the gallery. We came quite close, but did not succeed. The interested buyer had cancer, and her family advised against her purchase. She died within two years.

We decided to buy Betty's share and open the gallery at Valley House. As we began to close the gallery, State Fair of Texas officials offered us a display space without cost at the Women's Building during the Fair. It provided our opportunity to announce our name change from the Betty McLean Gallery to Valley House Gallery. For two weeks we had to attend each day, smiling at thousands of people who did not care.

We received our reward when we met and became friends with Julius Cohen, who was exhibiting famous gems from the Harry Winston collection. He came out to Valley House after the Fair and bought four paintings by Aunt Clara. He intended to give three as "thank you" gifts to key people who had helped him with the exhibit and to keep one to hang in Harry Winston's office. He asked me to deliver the paintings to his hotel.

As I got off the elevator, two armed guards met me and directed me to a suite of rooms at the end of the hall. Another guard passed me through an open door. A more vulgar display of wealth I have never witnessed. Tiered shelves loaded with gems on the far wall sparkled with all the colors of the rainbow. Julius came from another room to relieve me of my humble burden. I expressed my feelings about his display and he smiled, "Texans like it this way. Hold out your hand."

From his pocket he removed two stones and dropped them into my hand. "Here are the Hope and Winston diamonds; you are holding two million dollars." A strong heat flooded my hand as I looked at the two stones. The contrast in the two, each carrying the same dollar value, seemed quite remarkable. The Hope diamond, which had been owned by Jock McLean's mother before Winston acquired it, looked dark and almost ugly compared to the clear brilliance of the other stone, named after its owner. Anne Windfohr purchased the Winston diamond some time later.

Our first year at Valley House showed a profit, and each year from then on it seemed to multiply. We started to develop the property into a garden

where we could display sculpture to its best advantage. I determined to have a small lake behind the house for swimming and simple enjoyment, but this plan created many problems. Family and friends soon began to call it "Vogel's Folly" until the idea came to me to sandwich a layer of plastic between layers of sand on the bottom. So the folly became a great success.

During those years I found much more time to paint. My family, my new studio, and the added joy of the property inspired me. The creek that separated us from the Northwood Country Club remained rich in its beauty. Its clear, running water provided pleasurable times fishing, fossil hunting, and wading. A small cove led to a hollow where monarch butterflies covered the trees during migration. When disturbed, their wings would darken the sky; there seemed to be millions of them. We also saw roadrunners, raccoons, armadillos, dozens of squirrels, snakes, ducks, herons, owls, and many other kinds of birds.

Aside from the wildlife that shared the property with us, we had a border collie and three cats. In the greenhouse I built cages for a dozen or so finches and two song canaries. What a perfect environment in which to live and work, and for children to grow up. The contrast to Chicago made my new surroundings even more wonderful. I wondered why anyone would want to live in a city like Chicago.

My lovely Peggy took over the real chores. She ran the business end of the gallery, doing the books and correspondence, writing the catalogs and announcements. In the house, she cooked breakfast and dinner. We always managed to employ a maid to free us during the day so Peggy could turn her attention to our son Eric and to supporting me in the projects I jumped into. She was a rare and wonderful lady in the truest sense of the word, and she made all things possible for me. I found the paintings and did the selling, and we put together some exciting exhibitions for the gallery.

In January 1955, our second son, Kevin Eliot, was born. He added a new but warmly welcomed burden on his mother and a great pleasure to his family. His grandparents, the Commander and Nan, began to mellow a bit, for they truly loved the boys. Upon his retirement, the Commander, whom we called "Pops," bought a farm of about four hundred acres outside of

Burleson. The land made a different person of him, so much so that I believe he almost forgave me for marrying his daughter.

In the heat of the summer we slept in the studio, since it provided a bit cooler air than our bedroom. Now and then, at first light, I would notice a small boy at my easel. I'd quietly awaken Peggy, and we would watch as Kevin, brush in hand, stood before my painting. Cocking his head to one side, he would step back in deep study, then advance, waving the brush as if painting, repeating these movements over and over. What charmed delight there is in watching a child in diapers mimicking his father.

At fourteen months Kevin decided his time had come to paint. As I sat at the easel working on a small picture, he came and insisted on sitting upon my lap. Once there, he wanted my brush. To accommodate him, I put aside my panel and placed a new one before him, filled a brush with cadmium extra light red, and handed it to him. He looked wide-eyed at the brush loaded with paint, and then at the panel. Swish! He made his first stroke. He squealed with joy, drew back his arm, the brush jutting back over his shoulder, and plopped the next daub of cadmium extra light red right into my eye. The young artist's first brush stroke, having left its mark, left me a moment to cherish. After wiping my eye, I cleaned the brush and handed him a full load of thalo green, and we had a happy child. After a few more strokes he turned the panel about, studied it, added another brush full, and finished.

At fourteen months he had painted *Opus #1*. By the time he had finished his third work, or *Opus #3*, he would point to the color he wanted next. When he decided he had finished his picture, he would either ask for another panel or leave the studio in pursuit of other interests.

All the artists who saw his paintings applauded his work. Sy Fogel visited and, upon seeing Kevin's paintings, responded, "Pure Brahms." The director of the Santa Barbara Museum got so carried away that she insisted we have an exhibition of his paintings at her museum. This we did. A great demand arose for sales, but Peggy refused to enter into any commercialization of Kevin; we never made any of his paintings available for sale, though occasionally we would lend one to a painter friend.

On one occasion some of the museum volunteers brought a noted New

York dealer to Valley House for a visit. She was very much involved with the New York scene and was quite vocal in her distaste for everything she saw in the gallery. On the way down the drive to the house for tea, I asked her what she required for a work of art. She waved her hands and proclaimed, "Freedom, only freedom." When I asked what she meant by freedom, she dismissed me.

We entered the studio. On the wall hung one of Kevin's small paintings, limited in palette to brown and black. She hurried over and snatched it from the wall, studying it intently. Then she said, "My God, you have a Kline. What a beautiful Kline this is." She knew Franz Kline and his work quite well. As luck would have it, at that very moment two-year-old Kevin walked through the studio's nine-foot doors.

"I should like you to meet Mr. Kline," I said with a smile. I have never forgotten her expression. I knew I had made an enemy for life.

The story of Kevin hit the local papers, got syndicated nationally, and was picked up on television news with Walter Cronkite. *Life* magazine called and came out to do a story. With cameras set up they started to direct Kevin's actions. I stopped them, telling them that what they were doing had nothing to do with how Kevin did his pictures.

Kevin painting Opus #22 at age two years.

"We know what appeals to our readers and we do it our way or not at all," the man in charge told me.

"Good. Forget it then. We'll not be involved with a false story for *Life* or any other magazine," I responded. They put their things together and left. Never again would I believe stories *Life* published.

In the spring of 1955, shortly after Kevin was born , I visited New York again, alone this time, to keep my contacts open and make new ones, as well as to feed my hunger to see a few great paintings. I went to the Museum of Modern Art to pay my respects to Dorothy Miller and visit the Bonnard and Seurat paintings. In the lobby a group of young people had gathered around John Marin sitting on a bench. I felt tempted to join them because I admired

his work and would have liked to have heard what he had to say, but felt I would be intruding.

Before leaving New York, I treated myself to dessert, that is, a visit to the Frick Museum. I consider it the jewel of jewels that puts things back in focus, challenging one's taste. This visit I especially appreciated because I had just come from the Whitney where the exhibitions included an assemblage piece called *The Abortion*, which consisted of a dirty toilet bowl strewn with bloody rags, toilet paper, and blood-stained sanitary napkins. One work had been composed of three poorly crafted steps pushed against the wall, and a large plywood box with a wedge under one corner so it became a "creative expression."

Visitors had to pay to see such a "brilliant, sensitive collection representing the country's most promising talents." For anyone visiting that museum, I recommend wearing comfortable shoes, for the floors do not give, and each floor you climb makes you feel as though you've hit the basement. I thought, "Oh, Valley House, let me return soon."

On my way home I stopped in Washington, D. C., to visit my favorite painting in all the world, the Renoir *Luncheon of the Boating Party* at the Phillips Gallery. *The Luncheon of the Boating Party*, I am convinced, is the happiest picture ever painted, and I defy anyone to look upon it without feeling better and even smiling. It is pure magic. The brush work, of such ease, flips small jewels of colored light that take form and make the eye dance from object to object in an atmosphere of warm air you can almost breathe. You can taste the wine and hear sounds of happy people. It embraces you, and you become one of the party. As you look closely at the still life on the table then step back slowly, poof! it becomes solid form. Magic? Yes, the painter is the magician. The surface qualities play throughout this composition like a tone poem. If I were a composer, I would set down the notes this painting suggests. I have never counted the hours I've spent with this single masterpiece, for time disappears all too soon when I am in its company.

While at the gallery, I found John Marin and Duncan Phillips sitting in a small bay window of a gallery filled with Marin watercolors. I introduced myself, telling Marin I had seen him first at the Modern the day before and

wanted so much to visit. We talked for almost fifteen minutes before Mr. Phillips asked me who of his painters I admired most.

He rang a bell button at the window, and when a young man appeared, Phillips said to him, "Take Mr. Vogel to the racks and show him our Vuillards and Bonnards." I thanked them for the time they had shared with me and followed the young fellow into the inner sanctum, where the racks supported several works of my other favorite painters.

After visiting the Phillips Gallery and the Frick, I once again consulted my interior time schedule to try to convince myself that in five years *more* I'd surely be the painter I sought to be. I thought to myself, "I know it's in me; it will only take time and work. The challenge becomes greater and more demanding, but I know. . ."

<center>✳</center>

I never showed my work to prospective buyers at Valley House Gallery because my interest dictated that I always support other painters and stimulate interest in collecting. The exception to that rule came when de Bolli invited us to visit Paris and meet Venard, Calmettes, and Baron Renouard and talk about a Rouault exhibition. To put enough money together to make the trip, I held a one-day show of my work in the gallery and sent out invitations as a "going to Paris exhibition." It proved so successful that on September 10, 1958, Peggy and I found ourselves tracing Lindbergh's flight to Orly Airport and the beginning of a wonderful adventure full of wine, women, song, and much art. But the best part of all was that we would establish a link between the French art market and that of Dallas.

We settled in at a nice small hotel that seemed to be favored by professional theater people and diplomats. We called de Bolli, who kept a suite of rooms at the famous Hotel Meurice with his lady, Nel Gini. After a warm greeting, he suggested we rest until time for them to pick us up for dinner. We had a hard time containing our excitement at being there. We wanted to run out and see it all at once, but we obeyed and napped in our French bed.

At 7:45 that evening de Bolli arrived and hurried us along to his Cadillac,

where Madame Gini waited. He introduced us as he drove off, saying he had reservations at Chez Eugène, a noted restaurant. Nel Gini was a handsome lady, lean and trim, simply but beautifully dressed. She had been on the Swiss Olympic Ski Team years earlier and still skied, mostly in Davos. As we passed a large, impressive house overlooking the avenue, de Bolli pointed at it and said, "That's where I was born," as if it were another point of historical interest.

We soon arrived at our destination, a most impressive restaurant. The maitre d' bowed to de Bolli and Madame Gini and showed us to an elegantly set table. We gradually learned that the Marquis Robert de Bolli was a noted gourmet in his country and active in the so-called international set that assembled in the fashionable places the seasons suggested, for grouse hunting in Scotland, and so forth.

After drinks to stimulate our appetite, he suggested that Peggy would enjoy the pheasant, which turned out to be delicious, but left a lead shot attached to a tooth for the rest of the trip. That evening began a life-long friendship and reams of correspondence. The following day we went to the country to visit Venard in Mousseau.

Robert de Bolli and Nel Gini in costume at the Japanese Embassy.

With skies promising a warm, brilliant day, we drove through the suburbs of Paris to open country. Robert would point in a direction and comment, "That's where Renoir painted his such-and-such pictures," or "Pissarro painted his so-and-so." We stopped by Versailles on the way. He described it as a tourist trap, but said that one must see certain parts of it.

We rushed about the palace and gardens, only stopping here and there to listen to the significance of one or another area or object. "All these rooms and no bathrooms. How did they manage?" I asked.

The landscape through which our route took us looked like Venard's country. It fascinates me to observe how the artist makes an area his own by translating it with paint. Cézanne, van Gogh, Monet all did it. As we neared the town of Mousseau, we stopped on the outskirts at a beautiful eighteenth century farmhouse that had been transformed into a comfortable domicile and studio.

Claude Venard met us at the door and, with happy welcoming noises, invited us into his studio. He was stocky and well-built, an athletic man of great energy. In his earlier days he had been a boxer and, as the result of a low blow, he had felt compelled to spend some time in a hospital. To pass the time there, he had started to paint with watercolors and found his new profession.

We looked around with fascination at his many collections. He had collected a number of toy trains that held my interest. We found stuffed squirrels fencing with one another, and frogs mounted in amusing attitudes. After a cup of strong coffee, he pulled painting after painting from the racks. Peggy and I responded with equal excitement and found ourselves saying we must have this one and that and that and on and on, never giving thought to our commitment. With charcoal Venard lettered DALLAS on the back of each canvas we asked for and set them aside.

"Enough," said Robert, "it's time for lunch. Claude, can you recommend a good country restaurant?" Claude made a suggestion, and the four of us set off to wine and dine.

When we arrived at the suggested destination, Robert said, "Stay in the car, I'll check it out." A few moments later he returned and, with a bit of anger, he told Venard he had made a poor choice. He would not consider taking guests to a restaurant that had such a poor kitchen. Robert de Bolli repeated this twice more before he waved us in. It took us most of an hour's driving before he found a kitchen worthy of his palate and good enough for his guests.

Robert would not eat in an unknown restaurant without first looking into the kitchen to see their setup, procedures, and cleanliness. He loved good food, and those who knew about such matters respected his recommendations. The luncheon was superb, marvelous foods and wines, and much talk of painting. We felt privileged to be his guests. Later, as he left us at our hotel, he advised us to rest, for that evening we would join him and Nel as guests of the Japanese ambassador at the embassy. What a day, and with the best yet to come.

We arrived at the embassy at 8:00. Two handsome young Frenchmen in uniform admitted us and showed us into an anteroom where our hosts, the

Ambassador from Japan and his wife, greeted us. They introduced us to their daughter, currently visiting from New York, who studied sculpture at the Art Students League. Because she had come into contact with a jellyfish while swimming at the Riviera, she had a bad skin rash that required her to wear loose clothing. To our delight she appeared in a beautiful Japanese kimono.

Their houseguest, a famous Japanese comedian who was considered the Bob Hope of Japan, joined us. He was on a world tour studying other comedians' acts. De Bolli's brother and a German industrialist made up the rest of that evening's dinner party. After we enjoyed an aperitif and a bit of get-acquainted conversation, dinner was announced. Two young French attendants opened the tall double doors to the dining room, a large room, bare except for the long, colorful, and beautifully set table. More handsome young Frenchmen lined up to serve us, one for each two of the diners. In one corner two Japanese ladies at a table prepared to cook the many dishes we would enjoy. Peggy and I sat side by side in the center opposite the Ambassador and his daughter. They explained what and how we would eat.

The deft service and the light-hearted conversation made us feel at ease, almost as comfortable as eating in our own kitchen. The elegance, tempered by simplicity, made it the most memorable dinner I had ever had. After a dessert of tea ice cream, we returned to a large, square sitting room to be served champagne. The conversation at that point centered on politics and world affairs, and I felt like a fish out of water. Except for me, everyone spoke several languages. They would chat in German or French, then suddenly remember me and speak English for a bit, only to return again to French or German. It didn't matter to me, though, for most of the time I didn't understand their politics.

Peggy and I begged to reserve the next day for ourselves, to explore the Louvre and the Musée du Jeu de Paume and La Tour D'Eiffel. We discovered a masterpiece at the Louvre by a painter whose work is known only as being of the school of Avignon. His *Pieta* we found so moving and demanding we had difficulty leaving it, even after sitting about half an hour absorbing its every detail. As I write I feel its presence. I have looked at hundreds of *Pietas*, but none moved me more than this. It touched my deepest religious

feelings. The Jeu de Paume, the museum of happy paintings, gave us pure delight, the gift of painters who created so much pleasure from bad times and even moments of agony. These are my saints.

We ate very little and in only the simplest restaurants that day in order to rest our stomachs for the next day.

The following day we visited Baron Renouard. We entered a small building sandwiched in between other such dwellings and heard a voice from above in response to the bell. Five floors up-up-up-up we climbed, the steepest, narrowest flight of steps I have ever seen. We arrived exhausted, and were greeted by the artist. Like Venard, he looked well built. He must have been an athlete to run those stairs. His apartment studio appeared as clean as a hospital room, with everything in order, so much so it almost frightened me. We fell in love with both painter and paintings and arranged for an exhibition at Valley House. Some years later he and his lady friend visited us and spent four days in our guesthouse.

After leaving Renouard, we lunched at the famous restaurant in the Bois de Boulogne. We found a table on the terrace and ordered lunch with a magnum of champagne for the three of us. Robert told us of his parents coming in their horse-drawn carriage to dine there when he was a young boy. He entertained us with stories of painters and much history. We spent three hours sipping champagne in the warm, sunny afternoon until we had emptied the magnum and eaten the last wild strawberry.

We left the park to visit the studio of Calmettes, a painter whose work I consider compatible with my temperament. His palette was more limited than mine, but his interest in light breaking into and distorting the figure and objects was related. His pictures contained a charm and pleasantness that I found most agreeable. We parked the car and walked through a narrow street to a strange dwelling that at one time could have been a stable. A handsome man, about my age, with a black mustache, met us at the door and led us into a messy room where his easel stood in the center. At the far end, a screen hid a tiny kitchen under a balcony that was accessible by ladder, and we saw a small bath at the opposite end near the door we had entered. Someone had nailed a flattened, dried out cat that had been run over by a truck, to the wall.

We bought several of his paintings and arranged for a show. Robert invited him to join us for dinner at the Tuni de Juan, a restaurant famous for its duck.

When we arrived there that evening, the maitre d' bowed to the Marquis and escorted us to our reserved table. Calmette appeared at about the same time, and another fine evening began. The duck tasted superb served from the cooking pot, which Robert had requested to be brought to our table. Robert himself stirred the succulent meat in its rich gravy before serving our plates. Calmettes spoke good English, so we enjoyed talking painting, technique, and procedures.

Robert gave us the next day off, but Nel invited us to the Folies Bergères and dinner in the evening. After a night of good sack time in our French bed, and coffee and croissants leisurely enjoyed next morning in our sun-filled room, we became common tourists and enjoyed miles of walking under the chestnut trees by the Seine, to the bird market, through Notre Dame, and to the marvelous Ste. Chappel.

We came upon this awesome structure, Ste. Chappel, quite by accident. The windows there hold the chapel's beautiful magic, a wondrous light created by man. As we headed toward the Orangerie, it started to rain. We had just entered the courts when the sky opened to wash the city. For the next few wonderful hours we sat in the two long oval courtrooms and became lost in the masterwork of Monet's *Nympheas*. One must discover these works for oneself and take time to fully absorb the nuances, the subtleties of light on and below the water, and the reflection of passing clouds and overhanging foliage. The many qualities can be elusive, but they're all there. We remained alone in the galleries, unaware of anyone until a guard appeared and said, "Closing time."

Of all the vaudeville I had ever enjoyed, the Folies Bergères provided the most fun. The dinner became an act in itself, and I could understand why Robert begged off. Nel, Peggy, and I sat at a round table designed more to support a potted plant than to serve three diners. A napkin could have served as a tablecloth. During the performance, so many flaunted breasts bobbed about, I found myself trying to match up the sizes, shapes, and colors of nipples to the build and hair of the girls. Perhaps, I thought, when I draw with-

out a model, I will know; a silly idea, but fun. I tried this with the navel, thinking if only the navel could be seen, its shape would reveal the tensions of the torso.

After the Folies we went to the Lapin Agile to enjoy the music and atmosphere of Montmartre at night. We felt the presence of Modigliani, Utrillo, and Pascin. The sweet, strange odor of long-ago spilled drinks seemed suspended in the clouds of dense smoke, broken by the harsh voice of a worn-out female singer competing with the ancient plucked instruments. After one drink and three songs we escaped into the fresh air.

Before giving up the day, we went to another café, one that had been the favorite of the Impressionist painters. Here I tried to imagine Pissarro, Renoir, and company in good spirited debate. But by now too much time had passed, and their spirits had moved elsewhere.

On our last day in Paris we awoke almost with relief, knowing we would soon be on our own again. The previous days had overflowed with exciting interests, with so many new friends and food only imagined in dreams. We would long remember the care and attention we had received. We met Robert and Nel in their suite at the Meurice, where he showed us about forty of Rouault's paintings of various periods. Their exquisite jewel-like colors appeared so much richer and rewarding than the tiers of gems Harry Winston displayed in Dallas for the Texas rich. The Rouaults would become our major show for the year. We had promises of many others from the Vollard estate.

Why us, I wondered. Robert had expressed his distaste and distrust for most New York dealers. I could not agree with him, because my experience with them had always been marked by their generosity and graciousness.

We wanted to meet one more artist before our last dinner in Paris. We left Nel at the hotel and drove, in about ten minutes, to a series of store fronts. Here we found the sculptor Signori at work on a stone. Beautiful marbles carved into abstract shapes of different sizes and colors filled his studio. We saw white and ochre, black, white and green alpine, as well as different pieces of onyx from Pakistan, Chile, Siena, and Argentina. We saw rare stalactites and lapis lazuli. Signori maintained another studio in Carrara, where he

made searches to select the marble for his work. We committed ourselves to a show of his work when possible and parted with the prospect of having another fine artist to present to Texas.

Our last dinner filled us with delight. I ate my first snails, the first of many more to come over the years, at the famous restaurant in the produce district: Escargot's. We celebrated another great meal. During our dessert and coffee, I said that I had had a dream that I was to show the Rouault paintings of the *Passion*. This astonished Robert.

"How do you know about the *Passion*?" he asked in a surprised voice.

"I don't remember," I replied. "I know that I never saw them, but I have dreamed of them on more than one occasion."

Nel interrupted, "They are too young," she said to Robert.

"We'll see," he said, and changed the subject. We said our goodbyes and spent the last night in our French bed with happy thoughts of Paris. Tomorrow we would leave for Madrid to visit the Prado.

From the moment we arrived in Spain we could sense a difference in mood. The passport inspector looked long and hard before passing us. No one gave us smiles, greetings, or a welcome. The customs inspection gave no promises of good times. What a contrast. Paris, with promises fulfilled, felt light and gay even under gray skies. Madrid hung gloomily with bright, clear skies. Perhaps Spanish pleasures could be found in gloom.

We found our hotel was in a convenient location, about four or five blocks from the Museo Nacional del Prado. What a collection one finds there, so many great paintings and wonderful surprises. To find so many works of Hieronymus Bosch alone would have made our visit a success. His famous triptych, *Garden of Earthly Delights*, was an added highlight. I guess no other museum could surpass the dazzling accumulation of paintings by masters from the fifteenth to eighteenth centuries. To have only a day and a half to become acquainted with the works of Velazquez, Patinir, Murillo, Goya, El Greco, and Zurbaran, plus so many others, seemed unfair. We gave every

minute possible to enjoying these jewels, even though the subject matter spoke mostly of mankind's dark side.

How could one ever forget Goya's fourteen oils of the group known as the "dark paintings," representing a lasting moment of the artist's times; or the magnificence of the portrait of Velazquez's *The Maids of Honor*; the Pieter Bruegel, *The Triumph of Death*; or Joachim Patinir's *Landscape with the Stygian Lake*, and so many other masterworks. The mood of Spain was reflected within the frames on those walls, and even the galleries cried out for more and better light.

We treated ourselves to a wonderful dinner at a restaurant noted to be the oldest in the world. Here we shared half an unweaned lamb so good we returned the following night to enjoy their suckling pig. We found the atmosphere less formal and more to our taste than the elegance of the French restaurants. Our being alone together made it even more special. Peggy made an exceptional companion with whom to travel and to exchange views of the sights and sounds as we responded to them.

On our last day we hired a car and driver and drove to Toledo. The landscape reminded us of driving in West Texas. On the way we passed a Ford tractor plant, and on the opposite side of the road we watched a man plowing a field with a horse-drawn plow. The full view of Toledo suddenly appeared, not unlike El Greco's famous painting, as we descended from the high plain to cross the bridge that would take us into the city. We took in all the sights that good tourists should and returned to Madrid to prepare for an early morning flight to London.

❋

My first impression of London had to do mainly with its scale. Everything seemed twice as large there as it had been in Paris. The hotel bathroom appeared to be about the size of our entire Paris room. My six-foot frame could stretch out in the bathtub without touching either end; my whole body could be wrapped in the bath towel; the bed was king size; and two could sit in any chair. Peggy seemed so small.

We had allowed ourselves just three days. Off we went to the Tate Gallery to indulge in the Turners and Blakes. The Turners were most wonderful, but not to study, for the museum seemed more interested in preserving them than in showing them. The thick plate glass over the paintings acted as a mirror. We found it impossible to see them without seeing ourselves and passing visitors. We finally gave up and headed to the National Gallery.

What marvelous masterpieces we discovered there; what a challenge they offered to any painter at any time. For me, discovering the Uccello battle scenes and Piero Della Francesca's *The Baptism of Christ*, and especially his *The Nativity*, brought tears. Jan Van Eyck's *The Marriage of Giovanni Arrolfini and Giovanna Cenami*, and works by Jan Vermeer and Pieter De Hooch affected us in a similar way. The collection gave out a sense of hope, good will, pleasure, and love, in contrast to the great works of gloom and doom at the Prado.

We managed to see three plays and visit with two dealer friends. Peter Gimpel had invited us to lunch if we ever got to London. Earlier, he had come by Valley House and bought a small Mondrian during the Thanksgiving holidays, so we had invited him to join us for dinner at the Commander's farm. It turned out to be a perfect day, and he seemed to enjoy it thoroughly.

In London, we called him and, as he seemed most pleased to hear from us, we went to his gallery at high noon, but with strange results. He waved greetings from where he sat talking on the telephone, and motioned us to look at his exhibition. Peggy went into the gallery and stood looking about. I glanced in quickly and turned my back to it. She came out, her lovely, warm complexion turned ashen, her hand pressed against her mouth.

"My God, what's wrong?" I asked.

"I think I'm going to throw up," she mumbled, "those paintings were making me sick."

"Forget them and think of the Francesca," I said, taking her hand.

At that moment Peter came and welcomed us most warmly, saying, "We have reservations, so let's talk on the way."

At lunch he asked the dreaded question, "How do you like my show?"

Peggy told him she regretted that it made her ill.

"Wonderful," he said, "that's how we judge our paintings today." He seemed quite serious about it, hard as I found that to believe.

Later that afternoon we found ourselves at a cocktail party given by another dealer at his apartment. Over his sofa hung a large, hideous canvas with an undiscernable subject that we found so repulsive in every way that we turned our backs to it. Our host came to visit with us and, of course, asked our opinion of it. I told him he really didn't want to know, but he insisted. After I told him, his eyes brightened and he grinned with true pleasure.

"It's a great success. You see that's how we judge art now." I looked at Peggy and thought of the National Gallery, the Prado, and the Louvre, and said, "What a price to pay to be different."

The food in London left a lot to be desired. Maybe that's what was responsible for the art.

On our flight home I felt a great hunger to paint and to see the children. The flight permitted me time to reflect on all that had happened and to savor again the many wonderful moments and great paintings. I began to think about Valley House's future, about change and growth, about our promises to the many French painters and sculptors.

6

Spring Sculpture
and the Growing of Collectors

THE VALLEY HOUSE future looked promising. I had employed a framer, John Morrie, who had worked for John Douglass for a few years. He soon seemed part of the family. We, especially the kids, grew to love him, for he never ran out of stories. He had a great feeling for the earth, for planting, and caring for all growing things. Whenever he was needed, John appeared. For twenty-some years, he worked at Valley House and still visits.

At the time he arrived, the grounds needed attention, and we wanted a garden for sculpture. I had always had an interest in sculpting and studied it for a term at the Institute, where I did some clay figures that felt more like painting than sculpture. In this way I learned that good sculpture is even rarer than good painting. I always supported sculptors when possible.

Clarence Roy, a friend of ours and a landscape architect for Lambert Landscape Company, offered to design our garden in exchange for one of my paintings. He selected a very small painting, ten-inches square, in trade for a design that won a national award for the best garden designed for a five-acre property. His design had to be executed, but we had no funds or prospects of receiving any just then. Nevertheless, I told Peggy, "It will be done."

I visited Joe Lambert, owner of Lambert Landscape, and told him about myself and my desire to create a garden. He and Clarence came to Valley House, and we walked about the property. Before leaving, Joe said, "We'll do it. Our crews will be out tomorrow. Don't worry, you can pay us when and as you can." We shook hands on our deal.

During the next month, his crew performed magic. Paths were laid with iron ore gravel, and huge, partially buried millsap boulders arose here and there. The crew installed large ledge stone benches and beautiful grape stake fencing (which appears in many of my paintings) to make a background for flowering bushes and vines. More than sixty flowering fruit trees and a dozen bald cypress trees took root in places that gave them an advantage. Thousands of bulbs would surprise us in the spring, and different ground covers gave varied textures. The grounds of Valley House had taken on a new dimension, which we decided to show in what became the first of our annual spring sculpture shows. We arranged to have a very large exhibition of Charles Umlauf's sculptures and drawings in the spring of 1959. This event led to our creating the first of the many monographs we subsequently published.

In my first attempt at publishing, I went all out. I designed the layouts and controlled the printing done by Brodnax Press, the finest in our area if not all the region. Gibson A. Danes, Dean of the School of Art and Architecture at Yale University, wrote the Foreword. The ninety-eight pages of that first monograph included a fold-out map of the buildings and gardens and listed ninety-eight of the 125 works that made up the show. Even though we sold more than half of the pieces exhibited, we failed to make a profit because of the expenses. However, we felt that the effort proved more than worth the cost, because it established a new appreciation in the community for the quality at Valley House.

The days continued full and happy, as more and more people found their way to the gallery to see the grounds and visit our exhibitions. A good twelve miles separated Valley House from the center of downtown Dallas, and at that time Valley House nestled five miles beyond the city limits. We tried to make the trip worthwhile. I still managed to take time to paint almost every

day. Peggy and I kept the evenings for the children and for reading, drawing, and playing games.

In 1960, while visiting galleries in New York, I had an idea for an exhibition when I saw at Knoedler's Gallery one of the great Monet's *Nympheas*, six and one half by thirteen feet in size. Coe Kerr asked if I wanted it. Of course I wanted it. What could be a more important painting for Dallas? Our museum director, Jerry Bywaters, presented the only hurdle, and getting over him was similar to jumping ten feet straight up, but I decided to give it a try. What could we show around it? Why not a major work from each of various countries, to be called the "Essence of Nations?" Five to seven good pictures would suffice in that case. We made the arrangements, and the wheels began turning. I had what I considered a brilliant idea for television and press coverage. Morgan Knott, a friend who wanted to learn the business, had joined Valley House on a commission basis. He had been the manager of the Dallas Symphony, but he had left it to do something on his own and thought the gallery business worth exploring. I called both papers, *The Dallas Morning News* and the *Dallas Times Herald*, as well as the three television stations, to alert them to the arrival of the famous Monet *Nympheas* at the Railway Express Company dock.

I hired a truck and driver as well as a motorcycle escort to oversee the safe delivery of this rare canvas to Valley House. The French consul would wait for it to arrive and then inspect the opening of the crate and the hanging of the painting as cameras flashed. I sent Morgan to supervise the loading and waited for my ingenious public relations plan to make history, reveling in my brilliance as I waited. The phone rang. It was Morgan. The news people hadn't arrived. The dock loaders insisted on loading the truck and moving it out right away because it was taking up needed space at the dock. What should he do?

"Hold tight as long as you can, then use your own judgment," I advised him. "The French consul has just arrived at Valley House." I asked Peggy to greet the consul while I phoned my dear friend Marvin Krieger to come quickly, bring his camera, and act like a newsman. Who but Marvin would stop what he was doing to help? Once again he came to the rescue. He said he

had run out of film. "Come anyway and go through the motions," I said. The truck pulled in with its escort, and Morgan right behind. Within another minute or two Marvin appeared, God bless him!

"Where is the press?" I asked Morgan.

"They came just as we left the dock and said they would follow us. When we got to Forest Lane, though, they received a radio message that a car had been struck by a train near Inwood Road, and they all left to cover the scene of the accident."

As we unloaded the crate and opened it, I quietly explained to Morgan that Marvin was making like a newsman. We carried the painting into the studio and hung it on the east wall. I thanked the consul for his cooperation, paid off the trucker and escort guards, and laughed at myself as Marvin, Morgan, Peggy, and I collapsed into chairs for a drink to celebrate my ingenious plan, the coup of the century.

The painting looked stunning, and I had it as if it were my own for three weeks. The studio light enhanced every detail of its surface, which revealed its secrets as the light changed throughout the day. Someone, either Harry Brooks or Coe Kerr, had told me that this canvas had escaped injury as the Germans retreated from Paris. It seems that in their frustration they machine-gunned farm buildings, houses, and barns as they sped by in their trucks. Monet's studio and most of the large *Nympheas* suffered bullet holes, but not this one.

What a masterwork! I opened the studio doors first thing each morning before breakfast to see it. I looked in many times during the day, sharing it with friends and visitors, and I went in to view it the last thing at night before going to bed. Since the studio was part of the house, this was most convenient. I tried in every way, directly and through friends and board members, to move Bywaters to buy it for the museum. I never succeeded. Maybe if it had been a painting of a cactus or a jackrabbit he'd have been more inclined.

Three of the museum supporters felt as I did and believed that the painting must stay in Dallas. Mary O'Boyle, Betty Marcus, and one other woman whose name escapes me, brought a certain wealthy woman to Valley House in the hope of stimulating her interest in giving it to the museum. This

woman and her husband owned a great deal of land not far from us, which made it easy to get her here to see the painting.

I well remember greeting them. The woman stood in the doorway of the studio staring at the great painting, but not seeing it, talking instead about her new indoor tennis court, currently under construction.

"How do you like the painting?" Mary O'Boyle finally interrupted her to ask.

"What? What painting?" she asked, staring at it.

"That one," Mary spoke, pointing straight ahead.

"Oh, that. I don't like that," she responded, turning her back to the painting as she continued talking about her tennis court.

It was another sad day when we had to crate the painting. It felt like putting a dear friend in a coffin. Dallas had just lost a masterpiece, as we would lose many more. Within the week the Cleveland Museum purchased the *Nympheas*. They had one of the top directors in the country.

We vowed to continue bringing the finest work to Valley House in hopes that one day Dallas would respond. While we waited for that moment, we took our show on the road as I responded to the requests of various groups to help them start galleries in towns and cities in West Texas. John Morrie and I would load a rented U-Haul truck with paintings and sculpture and head west. We barely made expenses, but we had created interest and planted our seeds.

<p style="text-align:center">✳</p>

As Valley House began to achieve recognition, my own work began to meet with success in Tulsa, Oklahoma City, and closer to home. When in 1960 the Fifth Avenue Gallery in Fort Worth asked me to have a one-man show, it reminded me again that Fort Worth had always been close to my heart. The Fifth Avenue Gallery itself served as the home of the lovely Pauline Evans, just as Valley House now served as our home. Pauline's old and quietly elegant home had high ceilings and soft gray walls that flattered my paintings. Many regarded Pauline as the finest cook in Fort Worth, and when she invited guests to her table they enjoyed a rare pleasure. On the occasion of

the opening she prepared a dinner, mostly for the artist, and the evening was a special one indeed.

I felt grateful to share my work with such wonderful people. It was in Fort Worth that I had first found open-minded and adventurous artists, ones with a worldly spirit and with whom I wished to associate. Even more important, through those friendships I had met my wife. Indeed, I thought many times of moving to Fort Worth, but felt that I could do better in Dallas for the Fort Worth painters as well as for myself. Of course no young group can remain close long. The members marry, have children, or move, but the fond memories always remain. Kelly Fearing went to Austin to teach at the University of Texas; Veronica Helfensteller moved to Santa Fe; Pat and Sara Steel moved to New York; the Reeders spent a year in Paris; and a new, younger group started to emerge. The most promising of them, Charles Williams, a sculptor and a rare talent, had advanced at least ten years ahead of anyone in the whole of the Southwest.

While serving with the Army Corps of Engineers in France between 1945–46, Williams had the opportunity to see the works of such artists as Picasso, Braque, Brancusi, and Miro, all of which had left their influence on him. He lived without egotism, and I found him gentle, kind, and considerate. To an amusing degree, his appearance belied his qualities, because he cared nothing for dress and often looked like a hired hand. It pleased and honored us to represent him and exhibit his work. The garden and sculpture court at Valley House was enhanced with his works. A sculpture of stacked river stones continues to welcome visitors at the entrance of the gallery. His untimely death in 1966 was a deeply felt loss for us.

When a shipment of Venards arrived, I had another flash of genius. We still used the house as a gallery, though we had plans to build another shop and change the current one into a gallery. We knew from the number and sizes of the Venards that the house could not accommodate them, so we pushed the work benches aside in the shop, set up chairs and a bar, and when our invited guests arrived, we had an uncrating party, to the delight of all. One at a time I removed the paintings to expose them to our happy, clapping, and shouting guests.

A voice would shout, "That's mine." Another would say, "No, it's mine." Almost everyone bought at least one picture, but they left them with us to be framed. With this show we added a new dimension to the joy of acquiring art.

We believed it important, too, that we had taken care of our commitment to de Bolli. In addition, it became clear that the time to build had arrived again. The house could no longer function as both gallery and home. We began construction on a new frame shop and a studio guesthouse. We transformed the original frame shop into a gallery. All this necessitated a juggling act, but we felt up to it. The excitement of building always acts as a stimulus, and all went well.

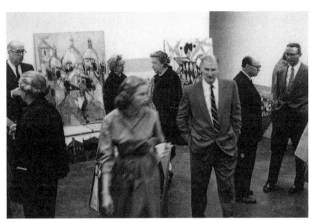

Uncrating party of Venand paintings at Valley House, Peggy and Donald in foreground, 1960.

We began preparing for the Rouault exhibition that we had seen in Paris, and other promised shows. Peggy ended each of her letters to Robert de Bolli with, "Donald still dreams of *The Passion*." I had given up on the prospect, and the building, painting, and selling occupied my thoughts.

Soon the time came again for our annual spring sculpture show. Our garden had settled into a beautiful showcase which attracted hundreds of visitors to view the sculptures as well as the grounds. Our way of doing things had proved successful and gave pleasure to many others beside ourselves. Rual Askew's review in *The Dallas Morning News*, May 19, 1961, was headlined, "Annual Break for Sculpture."

The annual spring sculpture show at Valley House included Charles Williams, Charles Umlauf, Marcel Mayer and David Cargill. In the nine years that they have been evolving, Valley House and the Vogels have skillfully implanted an impressive sphere of influence in the area and done it with far less noise and bombast than some of their competitors. Their uncompromising aesthetic—expressed disarmingly in its physical environment—is compounded of taste, knowledge of what they want to do and the

enviable freedom of being their own bosses. So successful are they at what they are about that they now occupy a position as Dallas' "third museum," a vital force on the battlegrounds of taste.

❋

One day a young friend asked me if I had heard of a Mr. Clark, who had started to collect some Impressionist pictures. She suggested that I invite him to visit the gallery. Generally, I did not seek out clients. When someone expressed interest, I would, when asked, give my time and judgment. I never tried to "sell." With full respect for the viewer, I restrained myself from telling him what he saw. It is the individual's response that's important, not mine. When something very special came in or was made available, I would be eager to share it with those I felt would respond and, respectfully, offer them the opportunity to acquire it.

I considered myself a dealer, not a merchant. My young friend gave me Clark's number written on a small pad tossed on the desk. I thanked her, and we walked through the garden before she left. The mail that day brought me a group of transparencies from Wildenstein that Louis Goldenberg had sent to present to a client. The photographs showed fine examples of works by van Gogh, Sisley, Gauguin, Monet, and Toulouse-Lautrec.

I mused, "Well, if Mr. Clark is ready, I am." I dialed his number and soon found myself talking to a person with a pleasant voice and demeanor.

"Yes, I have heard of you and your gallery. May I come out Saturday morning?" he asked.

He arrived at the appointed time and introduced himself, "I'm Jim Clark, and I'm very pleased to meet you, for I hear many nice things about you."

This tough businessman had a strong face, a firm handshake, and soft clear eyes that sparkled with good humor. This was a man to like and want as a friend. After showing him about and getting acquainted, I introduced him to Valley House's greatest asset, my wife Peggy, who served coffee while we settled down in the studio to view the transparencies. He slowly looked at one, then another, then over again.

"I would like to see this one." He handed me the most significant one of the group, *The Aristide Bruant*, by Henri de Toulouse-Lautrec, his oil on paper from which came the artist's most famous poster. I told him I could have it in Dallas by Tuesday or Wednesday.

"Fine," he said. "Call me at the office when it arrives. If I'm in a meeting, ask my secretary to interrupt to let me know, and I'll come right out." He left me with the warm feeling that at last I had met a real collector in Dallas. On Monday I called Louis and asked to have the work shipped.

"No problem. It will go out this afternoon," he promised.

Tuesday morning the crate arrived, and we opened it to find the stunning oil sketch of Aristide Bruant. We hung it in the viewing room, cleared all other works out, and set the lights to best advantage before I called Mr. Clark's office. His secretary, Virgene, said that he was in a board meeting, but understood that she was to inform him of the arrival. She returned to the phone after a minute or two and said, "Mr. Clark will be out within the hour."

We had set the stage, though this man needed no setting. I am sure I made the gesture more for myself. What a painting! It deserved the best. Within the hour Clark arrived and sank into one of the black kid leather swivel chairs. He said nothing for several minutes. His expression did not change; only his eyes revealed his enjoyment. I knew it had trapped him.

"Put up another picture beside it," he said, breaking the silence. "Anything will do." After more silence, the phone rang.

"Lunch time," Peggy said. "You can invite your guest if you wish."

He declined, and at long last he asked me, "What do you think?"

"I think it's your picture."

"Hmm," he said. "We'll see. Bring it to the house after lunch, and we'll hang it and see."

John Morrie carefully put the painting in the station wagon, and we headed out. Lillian, Jim's wife and a very gracious lady, opened the door and welcomed us.

"In here," Jim said. "We'll hang it in the dining room over the sideboard." I did a bit of measuring and made two small chalk marks for John to hammer the picture hooks in place. We lifted the painting, its wire in place, secured by the hooks.

Jim walked around to the far side of the table, stood in silent thought for a moment, then said, "It's mine. Bill me." We left happy, leaving behind a happy man.

※

In 1961, Peggy and I went to New York to satisfy my appetite, to study again a great masterwork or two, to see a couple of shows, and to make the rounds of galleries. On this trip, as always, the dealers we visited warmly welcomed us. These visits were becoming more and more important to us in our attempts to become known. At times we borrowed works to exhibit or to offer to a particular client; other times we would offer them a picture from an estate in our area. Louis Goldenberg of Wildenstein invited us to dinner with his wife, who came into the city to join us. At dinner I suggested having a major show, perhaps a benefit exhibition to give them an opening in Texas, fertile ground for future collectors. He liked the idea and almost committed himself then, but said he would talk it over and let us know. A few years earlier they had had such a show in Houston that failed, and the experience left them shy about Texas.

Before returning, we spent our last afternoon in New York at the Metropolitan Museum. After lunching there, we spent an hour with the Bruegel *Harvest*. We sat on a bench together and exchanged our responses to the pictures. We enjoyed the Rembrandts alone in the gallery until a young man glanced in, obviously a painter, wearing paint-stained trousers, loose wrinkled shirt, no socks and worn sandals. He returned with three other young, similarly dressed friends. As they walked through the gallery, he closed one hand in a circle, making a horn, and held it to his mouth. With his tongue protruding, he blew a long, ugly, bubbling sound. He waved the other hand up and down with his thumb turned down as he hooted, "Rembrandt, Rembrandt." In disbelief, we stood dumbstruck as we watched them parade through.

I recalled visiting Pat and Sarah Steel's apartment with Bill Bomar earlier for a cocktail party. Several artists of note had attended. Their names elude me, but the conversation still haunts me. As we spoke of painting, and I used such terms as charm, delight, pleasure, atmosphere, and qualities, they

pounced upon me and informed me that painting could no longer be described in such terms.

"Why?" I asked. "Must it be negative?"

"That's right. Bad is good. It's a revolt against all the old standards. Only the new, what we are doing, demonstrates the new values," they proclaimed.

They dismissed me as hopeless. This was the first notice I can recall when image was to become more important than substance. I continued to paint in my own way.

<div align="center">❋</div>

The wheels had been in motion for a Dallas Exhibition, and Wildenstein assigned a gentleman, Vladimire Visson, to come look us over. We met him at his hotel. On the mezzanine some dealer had mounted an exhibition of "old masters" paintings, and as we walked through, I expressed my disgust at the number of fakes represented.

Visson smiled and said, "There are more than you think."

"We must stop this," I said, gesturing.

"No, he leaves tomorrow, and he's done no good here. I inquired at the desk, so let him go, for it would consume too much time," Visson said.

We drove out to Valley House, and he seemed to approve of us and the facilities. We enjoyed a good dinner, and I learned quite a bit about the silent art world behind the selling of legitimate, great masterworks. When we returned him to the hotel, he assured us we would hear from him within the next few days. Good to his promise, he called to say the exhibition was on. We must find a charity for the benefit and let Wildenstein's people know as early as possible in order to simplify the listing and reproductions, because they would print the catalog in New York.

Jim Clark at that time was serving as president of the Dallas Child Guidance Center and said he would be delighted to have the Center named as the beneficiary. We set in motion the local public relations, listing of sponsors, and preparations for the opening festivities. It proved a total success.

The works offered Dallas a range and selection of master artists such as Bonnard, Boudin, Cézanne, Corot, Courbet, Fragonard, Gauguin, van Gogh,

Goya, Hals, Homer, Jongkind, Monet, Pissarro, Redon, Prendergast, Rembrandt, Renoir, Rousseau, Seurat, Sisley, and Toulouse-Lautrec. The Rembrandt, *Esau Seeking Isaac's Blessing*, was the first major work of his ever to be exhibited or offered in Dallas. The same was true of the rare Martinique landscape by Gauguin, and Goya's *The Quarrel at the House of the Cock.*

At that time the Dallas Museum had never offered a show to equal that one. It provided the needed opening for Wildenstein to capture and cultivate the prospects of this area. It served as the beginning for such collections as those of James Clark, Eugene McDermott, Al Meadows, Ed Cox, Pauline Sullivan, and others. Collecting is, of course, a very personal pursuit, and the purchases made from this show separated the discerning from the naive. Valley House had served as an agent through which the direction changed for several collectors, opening a new field of vision. The timing was right. In our own quiet way, we enjoyed the opportunity to participate in the change.

I became fascinated with the painting of Emile Bernard's Pont-Aven period, having sold one given to Theo van Gogh and his wife by the painter. Bernard, a most important man in the French art world, wore many hats: critic, promoter, and innovator. He was born in 1868. His career joined him in friendship with Toulouse-Lautrec, Cézanne, van Gogh, Schuffenecker, Gauguin, and Redon among others. He was the first to write about and support van Gogh with whom he exchanged paintings. He painted with Gauguin in Pont-Aven where they shared leadership of the Symbolist movement.

A beautiful lady, Frances Herd, became the first to see the Bernard painting in Dallas. She had invited me to visit her home and look at some paintings that she had considered purchasing. She had foresight, for the paintings were all bad. They had come from a Russian dealer living in San Antonio at the time. While there, I admired her Steinway, and she offered it to me in exchange for a painting. When she came to Valley House, we made the deal; the piano for a meter-square blue painting by Baron Renouard. Before she left, I showed her the Bernard. She fell in love with it, but did nothing because she planned to move back to San Antonio. That had been the reason she traded the piano.

In the meantime, in the hope of selling the Bernard, I loaned it to a friend whose house was on the annual garden tour. After hanging it there, I felt it

would never leave, it looked so at home. The scale, the color, the light, everything seemed perfect. But after the garden tour she called me to pick it up. I wondered sadly what it would take to sell such a work. Within the week, Frances called me from San Antonio and asked if the picture were still available.

"I must see it again," she said excitedly, "I'll fly right up. I'm building a new house, and the bids are due tomorrow. I want to see it before I read the bids."

We met her at the airport, drove to Valley House, and, over a cup of tea, she bought the painting. She felt that she had to commit herself right then, because after she saw the bids, she would feel she couldn't afford the painting! The very next morning, the lady who had displayed it during the garden tour called and said she missed the painting and had decided to buy it. She took her loss with good grace, however, and said if it ever became available, we should let her know.

Frances did not build her house; instead, she married and moved to Hawaii. More than four years had passed when I received a call from her, saying that her husband hated the picture and requesting I sell it for her. I made one phone call, and within a week the picture was where I thought it belonged. In time, it was to be left to the Dallas Museum of Art where it now hangs. Because of this painting, we wrote de Bolli, knowing Vollard represented Bernard, and secured the first full Pont-Aven exhibition of Emile Bernard work ever held in the United States. We published a simple catalog reproducing all the works included in the show.

We followed this show with an exhibition of thirty-six sculptures of the Italian contemporary sculptor Signori, and with paintings, drawings, and watercolors of Raoul Dufy, born in 1877. Though he worked in oil, textile design, ceramics, tapestries, ballet set design and murals, Dufy's watercolors and drawings are best known. He developed a simple, direct style that was similar to shorthand in writing. This stunning show extracted its own price during the opening when a lady in a large black hat backed into a sculpture stand, a movement that resulted in a smashed marble. The lady disappeared without a word, and so did the two thousand dollars it cost us.

The Pont-Aven, Signori, and Dufy exhibitions laid the foundation for our greatest exhibition yet which would become a saga in its own right.

7

The Passion

The anatomy of an exhibition

OUR MOST memorable adventure as dealers began in 1962. The object of the saga was a work of art, *The Passion*, created by Georges Rouault who we believed was *the* master painter of twentieth century art. We considered it a unique privilege to exhibit an unknown group of fifty-four of his paintings, all based on one great theme. This work is extraordinary because it illuminates not only the Passion of Christ and the Christian religion, but also the deeply moving intensity and passion of the pilgrim, Rouault.

The paintings originated from a poem, "Passion," written by Andre Suares and published in 1939 by Ambroise Vollard, Rouault's dealer. Vollard commissioned Rouault to illustrate the poem. From an oil series, Rouault created eighty-two wood carvings; he then destroyed twenty-eight of the oil paintings because he did not believe them to be as good as the others. The group of paintings that remained is as Rouault himself wished it preserved: a collection that forms a monument to God and man, for man. But I get ahead of myself.

On February 6, 1962, I had stopped off at the frame shop to visit with John Morrie and give him some instructions. As I talked with him, I opened a

letter from Robert de Bolli and glanced at it. Immediately, whatever I had
had to say to John was forgotten as, unconsciously, I sat down to read de
Bolli's words. Tears came to my eyes. I ran down the driveway to the house
to share the news. Then I panicked, thinking, good God, what have I done?
For the first time, the enormity of the commitment I'd made dawned upon
me. Would I be able to do justice to these pictures, dreamt about but never
seen?

Robert's letter began:

February 3, 1962

Please sit down before reading the following words. I am sending 26
Emile Bernards on the 15th of February together by air cargo with 36 Sig-
noris and now be ready for it:

I will send next week the 54 paintings of the *Passion* by Rouault.

They are all the same size (centimeters 44 x 33). The total value is
1,600,000 dollars (one million, six hundred thousand dollars).

They have never been seen except by Betty and Nel, and this collection
leaves far behind all that has been painted by Rouault.

You will certainly understand that the first show has to be a sensation,
and I am glad to offer this opportunity to Valley House.

I must also tell you that I obtained only for one time with the high, high-
est protection one year before returning to France. So choose the best sea-
son and this time ring all the bells of the world.

The paintings are sent by air and insured for 800,000 but please have
them insured for the plain value the very first minute you have them in your
hands.

The marvelous story of all this is that you may find two or three or four
persons who can have this amount deducted from their income tax and give
this treasure to the Museum, which in a few minutes can become a world
attraction and Valley House the first gallery of the states.

Some of the paintings are so beautiful that no words and no price can be
put on them.

A very important thing not to forget from the first minute you have the Rouault is that they are painted on cardboard, so they should be handled with extreme care to avoid breaking the very thick paintings and when you frame them do not try to correct the slight curves. . .that would also break the paintings.

Please treat them with the respect due to the most magnificent collection of the world and do choose carefully the frame worthy of such gorgeous things.

The paintings will be contained in boxes made to the dimensions of the paintings and the customs should be warned and told to unscrew the boxes with great care.

Stay and remain cold-blooded and do not forget that if exceptionally you have one year for the Rouault. . . .

P. S. Needless to say, the *Passion* collection cannot be divided.

Peggy responded to Robert February 6, 1962:

Your letter arrived this morning, and I think that we have read it over five or six times already (and will probably re-read it two dozen more) to make sure that we are really reading that so simple little phrase "I will send next week the 54 paintings of the *Passion* by Rouault"!!! It is a small statement on which all our dreams have been made (to badly paraphrase Shakespeare) ever since a mention was made that such could ever be possible! We are still both shaky and breathless, though we first read this several hours ago—and have happily sent to Davos a cable that can express none of our excitement. We started to telephone you, but Donald said he couldn't talk—and I can't either! So I write while the mind and heart still reel with the fantastic excitement of the gift you so freely give to us. We fully realize the great responsibility and are deeply moved that you offer us this opportunity as you have all the others that have helped us to build a gallery. We do not forget, and are always grateful and humble before this great confidence you show in us.

And in our excitement we float on the clouds in the heavens! We just can't wait to really see these fabulous paintings, and are already in our minds tackling the suggestions you have made which we shall follow to the

letter—and the program that we ourselves must set up to launch the sensa-
tion of the century! Perhaps tomorrow we can try to be "cold blooded"—
but today is all glory, and settling down to talking or thinking of anything
but Rouault is very, very hard.

P. S. Donald asks that you please send us promptly all the background
material and history of the *Passion* that you can permit us to use in the cata-
log and in the publicity that such an event demands.

As promised, within a week of our receiving de
Bolli's letter, three small boxes arrived along with
two men from customs who came to inspect the
contents and make a count. John unscrewed the
lids, which I removed to reveal the Rouault paint-
ings, each separated by heavy cold press water-
color paper, the same paper that each piece had
been painted on. Removing them one by one, so
the count could be made, my heart sank. What
dull, dreadful pieces, I thought as I laid them care-
fully on the table. They looked so bad I wondered
why I had done this. The customs men left shaking
their heads. "Eight hundred thousand bucks for
that stuff," one mumbled as he went.

I had covered a board with dark brown felt and
attached a small shelf to hold one piece at a time.
The display board waited in the gallery viewing
room to support each painting for our private
viewing. I took one of the three boxes across the
driveway after repacking them. Placing the top
painting on the prepared platform and adjusting
the lights, I sat quietly alone for five or ten min-
utes and then replaced it with a second. The

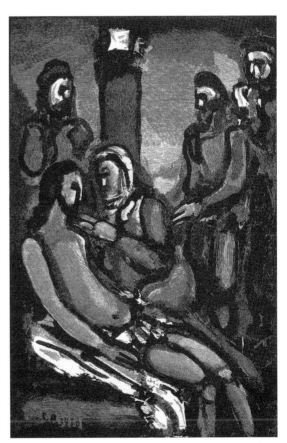

One of the fifty-four wood engravings by Rouault from
The Passion *by André Suarés.*

strange haunting beauty of their jewel-like surfaces slowly came to life. The
heavily lacquered borders surrounding the images became skyscapes, creat-
ing a tonal mood so that a different setting emerged for each subject.

These surfaces were unlike any I had experienced before. They were layer on layer, hammered and rubbed into each other, the pigment washed over as a glaze, then rubbed and hammered again. After looking at the first five, I fell into such an emotional state of exhaustion that I needed a walk in the garden to quell my excitement.

At lunch I told Peggy of my depression when I first counted the paintings. It must have been the light, or the presence of the custom officials. Whatever it was, I had felt a sense of desperation and loss. What a contrast to the excitement and lift I'd felt later, after spending time with just five of the fifty-four. Together, Peggy and I spent the afternoon looking at only those in the first box. The next day would be soon enough to venture into the rest.

We had to get to work. First of all, the paintings had to be photographed by the best photographer, and that would be an old friend, Ulrich Meisel. He brought out his equipment and cameras to make eight by ten-inch color transparencies and black and white photos. The pictures captivated him, too. Would it be possible to keep the news of them quiet before the grand opening? I felt compelled to share such grand news with friends, if not shout it to the world. But with so much to do in preparing this most important catalogue, the publicity and framing, I needed to make a trip to New York.

On February 21 Peggy wrote Robert that

all remains glory! The morning I sent you the cable to let you know of the safe arrival of the most fantastic collection in the world—we had just had the boxes opened here at Valley House by the customs man, and had taken them to the viewing gallery to look at them.

After seeing five—we sent the cable—and we are still on our knees! Actually we spent around 5 hours looking at 18 of the paintings—and were visually and spiritually so moved, so shaken, that we could not look at any more that day. We had to wait for the following morning to look at the rest. After this feast of excitement and beauty, we attempt to collect ourselves, but how hard it is. Donald had dreamed for ten years of what this might be, but in our wildest imaginations we had not conceived of the incredible reality. Rest fully assured that we know what you have done for us, and we do

no longer question why you are so continually wonderful to us. We simply accept with gratitude.

And he responded on March 3, 1962, that "Your enthusiasm about the *Passion* is what I hoped and I expect everybody who understands painting to be moved as you are."

After I arrived in New York, I had so much to do, I wondered where I should start. In hand I had a complete set of eight by ten-inch transparencies and five of the paintings, along with a strong determination. First, I visited with Mr. Heydenryk, the framer I had done business with for several years, and together we designed four different hand-carved frames that would comfortably relate to each other. The frames would be carved in wormy chestnut, stressed, and toned with a gold leaf fleck, creating a rich mellow aged feeling. This master framer's taste and mine agreed.

Of the magazines, I first visited *Life*. I found the Time-Life building very intimidating. My reaction to the scale of the lobby reminded me of my response to Grand Central Station as a boy. When I asked to see the art editor, the woman at the information desk asked if I had an appointment.

"No," I told her, "and I don't have time to wait for one. What I have is too important for me to sit around." She called someone upstairs, then wrote directions, and I headed for the proper elevator to zoom up forty-some floors through the center of this awesome structure. As directed, I walked through a maze of halls, past dozens of small cubicles that looked more like closets than offices.

"Art Editor," the letters read on one door. I knocked and entered. It was little more than a closet. Books, boxes of papers, and stacked magazines on either side made a path just wide enough for me to walk to a chair by a laden desk, behind which sat a heavy-set man whose pale face cried desperately for a little sun. "I'm the art editor. Now what do you have that's so important?" he asked impatiently. He looked at my offering, heard me out, and said, "We'll use this. It's a good story, but we must have it exclusively. No other publications until after we have run it."

I told him I would let him know after I talked to others.

"Okay," he answered, "we'd like to have it, but I understand."

As I left I wondered how people live and work in spaces like cells in a bee-hive. To provide only this space for an educated man, who had to have degrees and many years of experience to attain such a post, seemed to demonstrate a lack of sensitivity in those who ran *Life* magazine.

Next I stopped at the offices of *Look*, which at the time was running a close second to *Life*. They also wanted an exclusive, so I went to *Horizon*, a monthly publication with a hardback cover.

At *Horizon* life existed on another plane. When I showed the secretary the contents of my package, she didn't call, but hurried off to return with the top editor. He showed me into the art department, introduced me to the art edi-tor, and called in a few others. They promised to print no fewer than six full pages of color, to supply me with enough color pages for my catalog without cost, and to coordinate their issue with the opening of our show. Their enthusiasm convinced me that I had arrived at the right place. In addition to everything else, their publication would find its way onto bookshelves, not into the garbage. I also visited the magazines *Art in America* and *Art News* with good results.

I spent most of one day in the library of the Museum of Modern Art, reading all they had on Rouault. Later I went searching for the Vollard publi-cation of *The Passion*. I found one at Weyhe Book Shop. It was incomplete, because the color prints had been sold from it, but it would serve our pur-pose.

As promised, I called Mr. Rousseau, the director of the Met at the time, and told him about my tight time schedule, since I had to catch a plane home.

"Come right over," he said. "If I'm in a meeting, have my aide let me know when you arrive."

When I got there, I waited in his large, beautiful office. A wonderful painting by Degas rested on an easel, placed there for the museum's consid-eration. Mr. Rousseau and I exchanged greetings, and when I removed the first of the Rouaults, he removed the Degas and placed the Rouault on the easel. This gentleman loved paintings; it was easy to see by the response in his eyes.

"These are the finest Rouaults I've ever seen. You should have no problem with them, but I don't think they fit with our program," he said, with the greatest sincerity. I believed him and headed for the airport, impatient to be home and share the events with Peggy and find some studio time.

We had received a negative reply from the man we respected as an authority on Rouault, Jacques Maritain. So on March 26, Peggy wrote to Robert:

Now we come to something of great importance to us. Our little bubble of glee about the possibility of Maritain writing something for our Rouault show has burst—he has again been ill and cannot take on any such task now. And we have found that the time between now and the showing has also made it impossible for other supposed Rouault authorities to take on the task of writing anything, because of article and book commitments already due, and past due.

When Donald was in New York he read over everything that they had in the Museum of Modern Art library on Rouault (all that we haven't already collected here, at any rate) and his end conclusion was that they all more or less repeated themselves, coming up with little new or imaginative about either the man or his work. So—we dare to ask if you would like to, would feel free to, or would have time to write something yourself on Rouault and this series. We had at first felt that it was essential to have for the catalog and/or book, an article by a (you will pardon the use) "recognized authority" on Rouault. But when we found how little interested these supposed authorities were in even bothering to look at something as fabulous and exciting as this unseen group of Rouaults (why, you'd think they'd stand on their heads to catch a glimpse of them and be part of the discovery!), and when we realized also how little each had contributed to the general lore of Rouault—we have changed our minds completely. The most important thing to us now is to have a "fresh" approach, one that has not been gone over already twenty times. And this you could do for us so very beautifully. If you would just write about them and their history as you wrote and have been writing to us—about the man Rouault as you have

known him, telling of some of your meetings with him and what transpired
—well, it would just be really wonderful! We fully realize that you have
always preferred to work quietly with your paintings, but perhaps this
would be the time to cease to be quiet, and write for us something intimate
and beautiful as only you would be qualified to do. Please don't give us a
hasty answer—think a bit before you reply.

Continuing to think in this vein of a "fresh" approach, we have spoken
to the young writer, John Howard Griffin, who had put us in touch with
Maritain, and we have asked him to come over and look at all the paintings,
and then to decide if he would write a bit for us from the religious and philo-
sophical angle on the series. He writes well, and was so profoundly moved
by the few he saw that we feel that he could do something valuable on this
end. Perhaps we shall simply end up creating some true and new authorities!

I regret that my typing is even worse than usual—and just when I do so
want you to follow my meaning completely. Please read between the poorly
conceived lines and know what a great further thing you can do for us and
for the Rouaults.

As always our warmest regards to you and to Nel.

De Bolli responded April 1, 1962:

Now we come to the most important thing that you asked me. You should
remember that more than ten years ago, I stopped writing about art because
I had finally realized that I had no rights to explain what I think were the
meanings of the creator and that, if by chance, I interpret the real sense of a
masterpiece, it does not help the people who are not able to see that by them-
selves.

You were well inspired when you added "Do not give a hasty answer". .
. .When I received your letter, I immediately said...never! and a few days
later, the idea of presenting a new look of ROUAULT as I knew him
germed into my mind and it would perhaps be the best explanation of the
creation of the PASSION.

So as I am going to be at the Nonchaloir from the 17th to the 24th of

April I might try to get over the enormous task, but there is another diffi-
culty; I will write in French and would you find somebody knowing French
well enough to translate into a good and subtle English what I would write
without cheating my meanings?

If yes. . .I accept under the condition that you immediately send me two
parcels as a present, one to the Meurice, the other to the Hotel Cornavin,
Geneva, each parcel should contain 10 dispensers of GILLETTE "super
blue blades."

When you receive this letter, send me a cable telling me if you are sure
to find a translator. . . .

By May 22, 1962, Robert was able to tell us:

I am still working on the introduction to the *Passion*. It will be ready at the
end of the month—I want each word to be the right one so you will have to
find a wonderful translator and I suggest that the French text should be
added in the catalog to avoid any misunderstanding.

By the way, Isabelle Rouault has said to somebody I know: M de Bolli
has wonderful paintings. . .we quarreled long ago over a signature but this is
forgotten. I wish I could see him again. . .the vicious female!. . .

But on June 15, de Bolli wrote:

. . . P S I am rewriting the preface for the *Passion* as I want to show Rouault
as he was really and then enable people to understand the *Passion*—End of
the month you will have it.

❋

With the Vollard book in hand, I laid out the *Passion* pictures as Rouault
intended them to be seen, by spreading them on the gallery floor. Sitting in
the center on a swivel chair, slowly turning clockwise around and around, I
saw the concept come into focus. What a marvelous idea; Rouault had com-

posed them as a symphonic tone poem, opening with a chord that would be echoed throughout, introducing the theme, the Passion. Smaller paintings of figures joined the larger compositions, thus passing through a landscape that functioned as does a bridge in music, introducing the viewer to a new theme. This truly was a masterpiece, unique in concept. The jewel colors glowed like the windows of Ste. Chapelle. There has been no religious work since Rembrandt's that is as moving as the Rouault *Passion*, and to me no painting of the twentieth century as important. But who, in our time of negative creations on the contemporary scene, could afford to agree?

Finally, on July 10, Robert sent his introduction. We called in a French woman, who headed the French language department at Southern Methodist University, and commissioned her to do the translation. She seemed most agreeable. We agreed to her fee, and begged her to complete the translation as soon as possible. Her position and background gave us some comfort, for we felt she must be well qualified.

She returned within two weeks with her translation and said that de Bolli's writing was absolutely impossible and just bad, so bad that he would flunk her class. Moreover, she had done her best to make something out of it that we could use. Poor Peggy, in tears, thanked her and gave her a check. Her words stunned me. After she left, we stared at each other in silence for a few minutes.

"That woman doesn't know French very well," Peggy said, breaking the silence. "In my reading it is most beautiful and sensitive, but what shall we do?"

I suggested we call Howard Griffin and see what he had to say about it. We did trust him. I had first met Howard at one of the usual gatherings at the Reeders' in Fort Worth. He had been blinded in a plane crash a few years before our meeting, and would recover his sight a year or two later. He had an interest in Gregorian chants, and had spent time in manuscript research at the Abbey of Solesmes. His best remembered book, *Black Like Me*, ran in a series in *Life* and *Sepia* magazines.

After we called Howard, we drove to a country house west of Fort Worth to find him in shirt sleeves, sitting on the porch, waiting for us. He read through the first two pages. "This is some of the most beautiful French I've

read in some time," he said. "I'll be happy to translate it and bring it to you next week."

What a relief; once again we had been saved. On the way home we wondered how a French teacher could be so insensitive to the language.

Peggy wrote to de Bolli July 20:

We have several questions regarding the *Passion*, finding that every now and then when we need facts, we don't have them.

1. On the entry papers that accompanied the *Passion*, it was stated that these were all painted between 1927 and 1930. Is this correct? We ask because of a couple of the ones that are dated, carry a date that might be 1936 instead of 1930, notably #122, #125, and #140, which is the Pieta. Since these are new to the whole world and being documented for the first time, we feel we must be accurate in everything that it is possible to be so. Of course, Rouault's numbers are in some cases oddly formed—and these *could* be either 1930 or 1936.

2. Were these paintings actually done to illustrate the Suares poem, and commissioned by Vollard for this publication? Or were they something Rouault simply painted, and then were selected by Vollard for the Suares poem? The former is indicated, as this seems to be a period in which he was primarily concerned with illustrating for Vollard—but we should like to know definitely if you do, and not just make surmises on this end of the line.

3. If these were done specifically to illustrate the Suares work, do you know of any other instance in which Rouault did oil paintings from which the wood engravings or lithos were done? It seems from the various things we have been reading that often he did gouaches for such, but we have found nothing to indicate that he ever did oils in preparation for prints.

Another thing we should like you to discuss with us are the financial arrangements that might be made in the event of sale of the *Passion*. For example, over how long a period could payment be spread that would satisfy you and M. de Galea? One year, two years, three years???? What? We ask because as things progress and we let more and more persons know about the collection, these questions come up. For example, if a foundation is interested in the collection for a public institution, they might very well not be able to

pay the entire sum at a time, as they are dependent upon the interest from invested capital. And we are trying to get Margaret McDermott to form a committee to see if money could be raised to see about this collection for the DMFA. And in this case, wealthy persons might be able to pledge so much per year for a specified time. We bring this up now so that you can think about it if you haven't already, and give us some guidelines to go by. And if, for example, it were to be paid out over two or three years, what would you approve as a down payment? In the event, of course, of an outright cash sale, none of these problems will exist—but with stocks down and money tight, the possibility of term payment may well come up and we wish to be prepared to handle this in a manner that will be agreeable with everyone.

De Bolli responded on August 7:

Regarding the translation, I give you my okay considering that it is almost impossible to translate in keeping the general idea without making the translation a little heavy and clumsy.

Send me too in Nonchaloir as soon as possible the setting in French so that I can send it corrected in time for you.

For the other questions concerning *The Passion*, I can assure you that the dates given on the papers were not correct. Those pictures have been commissioned by Vollard to be reproduced in color for the *Passion*, but Vollard finally gave up his intentions facing the difficulties of the technique at that moment. The paintings were painted between 1930 and 1938.

Christian de Galea being somewhere in the Mediterranean around Spain, I cannot reach him before the 15th of August, so I have to delay my answer concerning the eventual terms of payment. We have to discuss this question together and then I will let you know what we decide.

De Bolli wrote again August 21, 1962:

Christian de Galea having returned from Spain where he was having competition with his sail boat, we had a conference about the non answered questions concerning the *Passion*.

We finally have decided that it is not convenient for us regarding the "controle des changes" to have eventual payment spread over more than one year, on the condition that a down payment of 800.000.$ should be done at the signature of the contract, 400.000 $ six months later and the last 400.000 $ one year after.

We think such terms could be admitted by the controller. I must tell you that the 54 paintings have been sent in time. . .if it were now, they would admit the sending on the condition that we do not sell it, so you see that instead of making things easier, they tightened their position.

Before they decided this new look, I had sent a few paintings to Geneva, so if you need a Cézanne, Bonnard, Renoir, Rouault, Cassatt, Berthe Morisot, let me know, all being exceptional quality.

I am sending the corrected foreword (French version) to you with photos and photo copy of the letter, the part I should like to be reproduced being delimited by red pencil.

We had lately the visit of the Blaffer family from Houston, they knew nothing concerning the *Passion*. I told them that my wish was that this collection should be acquired by the D.M.F.A. she said "why not the Houston museum?". . .A little competition would be a good thing if you could bring Fort Worth to this competition; it would still be better.

Naturally, if Margaret McDermott is making efforts to acquire this treasure for the museum, I will do my best to help her as Nel and I are very fond of her.

Peggy responded to de Bolli August 29, 1962:

Many, many thanks for the corrected introduction, the letter from Rouault and the photograph, which is delightful! We are exceptionally grateful to have all this together, as yesterday morning this enabled us to turn over to the printer all the last remaining things for the catalog—and this is a great load off our minds. Now it will merely be a matter of corrections, small changes, etc, but all the actual material is in their hands, to all intents and purposes complete! All these final catalog decisions, plus the fact that we had a September 1st deadline on material for all the monthly art magazines,

had made August a fantastically hard-pressed, tense, and busy month! These things attended to, we now take a deep breath and turn to the other matters of the *Passion* that must be decided and done before the final presentation. We have also gotten the gallery re-painted, as we felt that the light brilliance of the walls was too sharp to properly complement the Rouaults, so have toned it to a softer, darker value. And half of the paintings are now framed in exquisite, carved, old-wood frames—the remainder of the frames will arrive in the next two weeks—and so we do move along!

Since your last letter has brought much to discuss and many thoughts to explore with you, this promises to be quite a long letter, so please, make yourself comfortable before going on.

We are glad to have something concrete to follow in the way of a financial term payment for the Rouaults with you and Christian de Galea. This may not be necessary, but we felt it wise to be well informed as to your wishes before we settled down to matters of price and payment with a seriously interested possible purchaser. We feel also now, that it is important for you to know that we have quoted no definite price on this collection as yet. We have merely hinted that the cost is in the neighborhood of two million dollars. We have done this because as yet we have not been speaking of money to prospective purchasers, and we feel strongly that we are going to need a very large bargaining margin with such a package. Ordinarily, bargaining is not in our line, but we feel with such a collection, it may become a matter of offer and counter-offer. We also must protect ourselves in the sense that we have already put out around $20,000 in preparation for this exhibition, and know that we shall be spending at least around $10,000 more —plus all our time and energies since we opened the May sculpture show, and this will continue either until the paintings are sold or must be returned. We are dedicated, and rightly must be, but we wish you to understand and know fully how we are proceeding so that if you hear a figure quoted that seems out of line to you that there is purpose behind it, and that purpose is not greed.

Which brings us logically to your visit with the Blaffers of Houston. We are very pleased that you have had the opportunity to talk to them about

this, but at the same time we are hoping that you did not mention to them your price of 1,600,000. If you did mention any price, please let us know, as we shall be in touch with them as we have already had a hopeful eye on the Houston Museum and have been in touch by letter with Sweeney to let him know the great event that was about to occur. He has been abroad for months, however, and we are not sure what his reaction has been. Oh—please let us know also if it was the John Blaffer Seniors to whom you were speaking. This we assume, but there are others, as you well know.

We have already laid plans to excite the museums of Texas, feeling as you do that the competition may help. You see, although Margaret McDermott can listen to all we have to say about this important, incredibly beautiful collection, I doubt that she is ready to accept its contents. In spite of the fact that she is naturally interested in beautiful paintings, she more responsive to Impressionist works. How to explain this?? Rouault just doesn't mean much to her, personally, and her knowledge of, interest in, and excitement about paintings remains completely personal in spite of her two years as president of the board of the Dallas Museum. . . . Anyway, during the past year, an association was formed among the Texas museums to meet together around four times a year and discuss mutual problems and ideas. The group comprises the Museum directors and major personnel plus the executive committees of the various boards of trustees. And they meet here in Dallas in early October. The agenda of the meeting and the entertainment is being planned by Betty Blake (and Douglas MacAgy) and Margaret McD (and Jerry Bywaters). So around a month ago we had a long talk with Margaret (Betty being abroad) and got her to promise to put Valley House and the Rouaults on the list. We plan to give a special showing of a portion of the collection, and see what excitement we can stir up. We hope also to have our catalog published by this time, which we feel will be a great help to us. I think we shall now send a special note to the Blaffers in hopes that they will be participating in this meeting, so they can have a preview (in the true sense of the word) of the paintings.

Now to ask more about this shocking new tightening of the reins of the controle des changes! If this means what we assume it may mean, we are

very upset—naturally! Would you please explain a bit more fully? Does this mean that no paintings by accepted masters will be permitted to be sold until the French government has had the opportunity to purchase such for itself? Does this extend also to living painters, or just to those who have died "with a reputation"? You see that we assume that this is somewhat like the English laws regarding master-paintings, but you have told us just enough to lead us into all sorts of wild thoughts with no basis of real knowledge. So please don't just answer my questions—please give us a rather full explanation of what the laws now are.

We are of course delighted that you had the foresight to send some jewels to Switzerland, and we should like to propose something for your consideration at this time. This is something once more that I hopefully caution you not to answer quickly, but to think about for a time before making up your mind. If we do our job well in letting all know about the coming Rouault exhibition, we shall have gathered here at Valley House during the run of the show, the top collectors and museum personnel of the United States (at least). We do not feel there could be a better time or a better opportunity to sell fine paintings. You have spoken of this exhibition as making Valley House the "first gallery in the world" (that is, anyway, until you open *your* new gallery), and that will be true. But with the Rouault show on the walls, and with also some fantastically exciting paintings in the "cupboard," it would be doubly true. We should not wish to expose bare cupboards to an audience such as we shall have for the *Passion*. You now know what we wish to suggest—that you make a selection of the paintings you have available in Geneva, and let us have them just prior to, and during the Rouault show. Certainly it would be very good to have a Rouault or two on hand, as it will be lovers of this man's work who will come, and when they find they cannot purchase from the exhibition individually, they will want to know if we have any other Rouault?????? We leave this in your hands, and to your wisdom.

Robert was kind enough to send us further Rouaults for interested buyers. As he wrote Peggy the end of October,

Next Saturday the joined pair of Rouaults will leave Paris by air and I hope that you receive them in time. Prices indicated on this list are the prices you have to pay.

We are sorry but the international conjecture added to the tension in France for de Gaulle's referendum did not permit us to leave. Fortunately for you and your exhibition it seems to be much better since Kennedy at last spoke loudly and firmly.

We both admired the catalog, but what a pity that American colour plates are so bad compared to the others. I wish I could have ten of these catalogs, five for Christian and five for me.

Re. the Rouaults that will be sent on Saturday. There is no problem for the three oil paintings, just frame them well.

As to the gouaches which are very good quality, I suggest a green and thick cardboard to cover the white paper around the paintings (the green of the *Passion*).

These gouaches are three of the originals from the (Cirque de l'etoile filante) edited by Vollard.

The large drawing Tartarin a Paris with china ink not signed but bearing a handwriting by Rouault on the top.

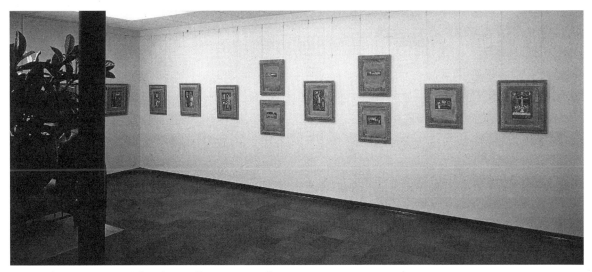

Rouault's Passion *as exhibited at Valley House Gallery, 1962.*

The smaller "Jeune fille" is called "Pucelle" by Rouault himself as you can read it on the bottom.

After much preparation, the opening finally occurred on November 22. Peggy described it, as well as a new twist to the story, in a letter to Robert.

The openings were very exciting and well attended—and the moments of the *Passion* glowed like the jewels they are. We were able to use for them only the two main rooms of the Gallery— so were free to hang the other Rouaults in the viewing room, separated from the *Passion*, but readily to be seen. The framing on the *Passion* worked out marvelously—lovely old (appearing), hand-carved frames, in rough old wood, with some gold flecks from time to time. We used only four styles of frame, just to give a bit of variety, but they are all carefully related to each other, so there is no jarring in the change from one frame to the other. And we have the paintings hung in order from the Suares book, except for one or two that we moved only one hanging space to permit of a more exciting hanging. This all sounds quite cold, but it is anything but, as you can well imagine even through my unimaginative language.

We had the party section of the opening across the driveway, in the frame shop and guest room, both of which were gaily decorated for the occasion. This worked out exceptionally well, as it eliminated all drinking and smoking from the gallery of the *Passion*, and also kept the gallery clear enough so that those who wished to see and study were able to do so—and those who came to drink and eat were happily on the other side, well out of the way. This also permitted a leaving and a returning to the paintings, which is very important with these—one cannot begin to absorb them in one viewing—it is too much—and a recess, so to speak is very necessary. Anyway, we felt it all worked out very well—our only regret being that you and Nel were not here in person to share in all the excitement. And we continue to have good attendance to the exhibition, particularly on the weekends. We are staying open 7 days a week from 10:00 until 5:00, so you know what we have been doing, and what we shall be doing through the end of the year!

We are also making appointments for student groups to come in the evening, when either Donald lectures to them on the *Passion*, or the professor in charge does so according to what he wishes them to receive. It is hectic, but we remain dedicated.

Now, something has come up that is both very disturbing and very important that you should know. Just after one of the art magazines came out with the article on the *Passion*, we received a very nice letter from a collector in Chicago who wrote to inform us that the statement made in the magazine that the missing 28 paintings from this collection had been destroyed by Rouault was false, as she, herself, owned one, and knew of another in a collection now showing at the Brooklyn Museum. This was quite a shock to us, as it undoubtedly will be to you. She was kind enough to send us a photograph of her paintings with the dimensions, etc. and there is no doubt at all that it is from this series. It is Christ with Pilate, and we have checked it in the Suares book, and the wood engravings done from it is on Page 53. She purchased this from Klaus Perls in 1955, and it has remained since in her collection. Since I am sure that you are as eager as we are to learn all that can be learned about these presumably destroyed paintings, we shall appreciate anything you can find out about them. Could you face a visit to Isabelle????

We have turned this over and over in our minds, and many answers occur to us, but we are after the facts, of course. We have thought it possible that Rouault took the group of paintings telling Vollard that he would destroy them, then perhaps laid them aside and forgot to do so, then later, either worked on them more and decided they were good enough to sell, or that his family might have sold some without his knowledge. What we feel that we all must know, is how many of these 28 paintings are still in existence, and if possible, to whom they were originally sold and by whom. We plan to try and find out from Perls where he got them, but we don't wish to pursue this too much further until we hear from you.

This sudden popping up of paintings that are not supposed to be in existence disturbs us in two ways. One that we have made false statements for the magazines (in perfect good faith), and the other that although this fabu-

lous collection of 54 paintings of the *Passion* is still without doubt *the* collection as both Rouault and Vollard wished to preserve it—it still may make it difficult to explain why it must remain as a collection and not be sold as individual paintings when some individual paintings from the original group have already been sold as such. . . .??? We feel, as you do, that this must be preserved as a document for posterity.

I have sent on to you the HORIZON, and shall send you the other magazines as soon as we can get extra copies of them. And I am making a collection of the local press clippings to send on. Some of these are quite good. So—otherwise all goes well, and we have much exciting interest in the collection, many good rumors about the hope to keep it in Texas, but so far nothing concrete enough to report. We hope that you and Nel are well and happy. Betty is just back from New York with reports of Venard and his show there, but she said she would write you about this herself, so I shan't spoil her story. Our warmest good wishes to you both.

※

During the opening, I retreated across the driveway to the studio guesthouse to have a cold drink and visit with friends. Four bankers of the Republic National Bank, I noticed, had settled in a corner at a table to enjoy a drink. As I neared their table I could hear their comments.

"How could you use such a collection?" one of them asked.

"Well, we could put one on each floor in the toilet, but that would leave two over and that would be a problem," the bank president suggested.

For them, the exhibition represented another social event that aided another worthy cause. Names would appear in the paper, the same friends could be seen, and new costumes could be worn. In its way, it was a success.

With the opening behind us, the time had come to place the *Passion* where it could do the most good. It should be well received in the heart of the Bible belt, I thought. With this in mind, I invited our leading clergymen to visit the gallery in the hope of gaining their support and understanding. The local heads of the Methodist, Episcopal, Baptist, Catholic, Presbyterian, and Jew-

ish organizations responded. They seemed pleasant and mostly polite, except the Baptist minister, who found the image of the Christ insulting, ugly, and not his idea of what the Christ image should be. Rabbi Levi Olan proved the exception to the generally superficial response. On his own he returned three times to revisit the *Passion* and talk with me about art in religion. "This is," he said, speaking of the Rouault *Passion*, "the most moving, the greatest visual Christian document of the twentieth century, and a masterpiece of art. It should stay in Dallas and be housed at Southern Methodist University, but I doubt they will recognize its importance."

I considered it a privilege to visit with this Rabbi. In him I had a true supporter, willing to promote a Christian document where too many other leaders seemed blind. Another exception, Roger Ortmeyer, a learned, sensitive gentleman who taught theology at SMU, on occasion brought his classes at night to the gallery to discuss in two-hour sessions the content and qualities of the paintings. Everyone participated in these lively gatherings, and the students came back again and again, often bringing friends. Roger wrote an hour-long talk concerning the *Passion* that he titled "Holiday." I recorded it. This moving talk paid a great tribute to the memory of a great artist. Roger became a champion in promoting the sale with the hope that it would stay at the university. In the end his enthusiasm for it, in part, cost him his job.

Crowds of visitors came by bus and plane from cities around the state and from Oklahoma. More than seven thousand people paid to see the *Passion*. I talked to each group and answered all questions as best I could, trying to stimulate and encourage each individual to see it in his/her own way. It moved me so much that at times I caught myself preaching, and I had to stop short. I had accepted Rouault's teaching through these jeweled colors and the surfaces that locked in so moving an image, and I wanted others to experience and share it as I did. That would not have been possible, though, since I lived with it and had become part of it.

To my way of thinking, not since Rembrandt has a painter created a work so inspired. As art, it is a masterpiece; as a religious document, it is unequaled in modern times. My job challenged me to place the *Passion* where it would contribute the most good. And what better place, I thought, than Southern

Methodist University, to serve the School of Theology and the Arts Department. So I wrote a script to explain the structure and content and made a film that ran a full half-hour.

We set aside plans for a family vacation. Instead, I sent Peggy and the boys to Taos for ten days, because it was most important that Peggy have a change. I began making the film. To fill the void created by my family's absence, I worked day and night to complete my task, in hope of joining them for a day or two. The film-making proved more complicated as the days passed. Finally, on the day they returned, the completed film arrived and we celebrated.

Armed with the names of the two foundations that gave the major support to the University's School of Theology, I drove to Wichita Falls to visit the men who headed the foundations. I hoped to persuade them to give the collection to SMU. I found the first man, a bank president, in his office. He proved to be of the same caliber as the Dallas banker at the opening who would have placed the paintings in the toilets. He typified a friend's description of the motto of a rich Texan: "If you can't wear it, drive it, eat it, or sleep with it, it ain't no damn good." I was as happy to escape this fellow as he was to see me go.

At the second foundation I found a quiet gentleman who responded with interest, and I returned to Dallas with a letter stating that if SMU expressed its desire to own the *Passion*, his group would give it to them. I drove home in the clouds. I had won, we had won, and the city had won!

The next day, by appointment, I walked into a bear cage, the office of SMU President Dr. Willis Tate. He listened impatiently up to a point, then cut me off. "I'm not interested in art," he said, waving a finger at me. "I need money; I have an organ to pay for [and this and that], not art!"

I tried to explain that this would not lessen the annual gift of money from the foundation, because it had already been discussed and agreed upon.

"Get out and don't bother me again. I don't want art," he said. I had no idea how to deal with such a man.

So many events seemed to crowd together during this time. In the midst of it all, Peggy made an announcement: "Donald, I'm pregnant."

"Good God, woman," I said, "that's the most uncivilized thing you could do at this time." As always, she took this with good grace. I tried to hold my focus on the other *Passion*. I had sent catalogs to the major dealers and museums. Two dealers called and made offers that I could not accept. Armand Hammer flew in and viewed the show and offered a million dollars for the collection. I explained my position, and he said, "Thank you," and flew out without further word.

I showed the film to several groups, mostly art- and church-oriented, and made a talk on Rouault and his times. One day a lady visited to view the show and seemed very moved. I told her of my idea for SMU to have the collection. She agreed that it would be ideal and asked me to come to her house, show the film, and talk to a group of ladies who might be willing to buy it and give it to the university.

A new man, Kermit H. Hunter, had been brought in to head SMU's Arts Department. I invited him to see the film and the paintings, and he was excited about the possibilities. He said he would be very pleased to write a letter of grateful acceptance stating the importance of having such a rare work at SMU and confirming the prestige it would bring to the school. With this commitment, the ladies prepared to put the money together, and waited for the forthcoming letter.

During this period, Al Meadows called and asked if I would hang a small group of the Spanish paintings that he had given to the school in the Student Union building. "There is no one but you that I trust to hang my pictures," he said. It gave me the opportunity to see this collection for the first time, and the number of false paintings and their poor condition shocked me.

I hoped Dr. Tate would notice my cooperation. After waiting three days for Dr. Hunter's promised letter, I called the new Dean of Arts. He said he had tried to clear it with Dr. Tate and wondered what I had done to him. Dr. Hunter said, "I've changed my thoughts about the *Passion*. There is no place for it here."

A few days later Dr. Tate had his secretary call to ask me to come and visit. Could he have changed his mind? Perhaps someone had reached him, and he had seen the light. I nurtured only pleasant and positive thoughts as I

entered his office. If his mood had been good, it changed the moment he saw me.

"Vogel, you are becoming a great nuisance," he said. "I want you to stay out of our business. I told you before I don't want art. I need money." He angrily pointed his finger at a spot midway between my eyeballs and said, "Now get out. I don't want to see you again."

No doubt he hoped I would disappear. I didn't. I pointed my finger at him and said, "You have just accepted the Spanish paintings from Al Meadows, and most of them are fake. I advise you to look into them, or you'll be left with pie on your face."

"Al Meadows can do anything he wants," he all but yelled at me. "He represents thirteen million dollars to us. Now get out!" I retreated with nothing more to say to this cultured gentleman.

❋

We kept the exhibit open for more than a year in the hopes of attracting a buyer. In November 1963 the Internal Revenue Service, for reasons only they understood, decided to review our tax returns. As totally naive taxpayers, we welcomed the handsome young man who arrived to examine the books. Peggy took pride in her bookkeeping, and it would never occur to her to be anything but honest. We took an instant liking to this pleasant gentleman and felt pleased when he complimented Peggy on the neatness of her books and the ease with which they could be read. Everything was legal just as it was set up, but he did suggest that we could take an earlier depreciation on the building. "Do it any way that would make you happy," I said.

He then informed us that, because of the way the books had been set up, we should have paid full tax on all paintings at the time of the sale, regardless of whether or not we were paid in full. This cost us $9,000 in back taxes.

"Don't worry," he assured us, "you can arrange to pay it out." Then he left for lunch, expecting to return afterward to finish up.

When he returned, he looked visibly shaken. "Have you heard the news?" he began. "Turn on the radio. Kennedy has been shot!" We listened

silently, filled with horror and disbelief. It seemed as though the world had stopped. Throughout the city people reacted first with disbelief, then sadness, and ultimately with a strange sense of guilt. Why, I could not understand, for the assassin had not come from Dallas, and the number of radical groups in the city could be counted on one hand. Nevertheless, like a dark cloud, sadness and guilt settled over the city, seeming not to dissipate.

In time, the city asked its citizens to submit ideas to a committee for a monument to honor the memory of its dead president. Ah! At last I understood; the *Passion* had remained available for a reason. What a wonderful living memorial it would be to send the paintings around the world in Kennedy's name from the city of Dallas. The sharing of such a rare masterpiece would surely appeal to all people conscious of art and/or religion. Rabbi Olan came by, and I discussed my thoughts with him.

"A brilliant idea and a most perfect monument. I will support it in every way," he said, "but I seriously doubt that the city fathers have the sensitivity to accept it."

I passed the idea around, and hundreds of people wrote to support it. Then one day the newscaster announced that two of the Kennedy clan would arrive to review the results of the city's call for suggestions. Good, I thought, these sensitive cultured people surely will respond; how could they not? They arrived and left and announced nothing. Two or three days passed with no news, so I called to learn that the Kennedys refused to look at anything and said that their only interest lay in the library to be built in Boston. If the people of Dallas wanted to, they could pay for a room. Once again, we were disappointed.

※

I set off on another trip to New York, this time to arrange an exhibition where the Rouault could meet a more sophisticated audience. I intended to try Klaus Perls first, for he had been the first dealer to show Rouault's work in the States. In addition, I liked him and his wife, Dolly. When I arrived, they were out of town, not to return for two days. I visited three other galleries

and, when I described the *Passion*, all offered to show it. One dealer said that he would give me $40,000 to have it. I waited for Perls. As I had anticipated, he was pleased to cooperate, so we set the plans into motion.

On the way home I stopped off in D.C. to visit *The Boating Party* and give my spirits a lift.

The American Federation of Arts planned to have its annual meeting in Dallas, and someone asked us to host a dinner party for them. We accepted the opportunity with pleasure and set forth to entertain our guests in the best way we knew. We decided on a garden party for the more than one hundred guests from around the country. The grounds were, as always, in excellent condition. To decorate, we hung one hundred white paper Japanese lanterns from bamboo poles and from the trees. Lupe (Mrs. John) Murchison, who was in charge of the table decorations, dressed them with watermelon quarters, huge red radishes, and pink velvet ribbons on pale pink linen. It was a beautiful setting.

To add to our guests' pleasure I rehung the *Passion* and opened the house so the bathrooms would be available. Peggy called me to my studio where I found a group of people arguing about some of my paintings that they wished to buy. "I saw that first; it's mine!" said one of them. After a moment of contained pleasure, I told them that I felt flattered that they wanted to acquire my work, but that they were our guests, and to sell them anything had simply not occurred to us.

They looked puzzled, and one said, "We like to buy art wherever we go."

"I'm sorry," I said, "perhaps before you leave, if you still would like a painting, we'll discuss it," because I wanted them to have a happy memory of Valley House. The dinner turned out to be a great success: good food, excellent wine, spectacular dessert, and wonderful company, with weather to match.

To keep the *Passion* at Valley House, we told the "controle des changes," which kept records of all works of art that left France, to make sure that proper tax had been paid, that the paintings had been sold to a Texas foundation, and we paid them the tax of $12,000. We did this to buy more time to await the outcome of the Kennedy memorial project. It also gave us time for the show at Perls'.

Soon after the *Passion* returned from New York, I took the paintings to
Houston for an exhibition in the chapel at Rice University, where they were
well received. A professor lectured to his classes on the Christian symbolism
that existed in each of the paintings. This opened to an even greater depth the
content of this masterwork, these rare and wondrous documents.

Again, time ran out. The Galerie Charpentier planned a major retrospec-
tive show of Rouault and asked to include the *Passion*. It was a sad day when
I closed the lids on the crates and watched the air freight truck pull out of the
driveway. Sometime later someone informed me that the Japanese had
acquired the *Passion* and that the paintings have a room to themselves in a
museum somewhere in Japan.

The loss did not discourage us from producing original exhibitions,
bringing to Dallas and the country internationally acclaimed works of art.
We would soon produce another first.

8

Of Painters, Children, and Henry Moore

IT FELT GOOD to have more time to paint. I continued to show my paintings, and sales increased both for the gallery and for my own work, which I kept separate. Most visitors to the gallery seemed unaware that I painted, a situation I preferred, for it meant fewer interruptions for the studio and the household.

On November 29, 1963, Peggy gave me another wonderful gift, this time a daughter, Katherine Barley, whom we call Barley. Our daughter delighted me so, I told Peggy that we should do this every other year.

"You are uncivilized!" she responded. "This is the last." A new joy and delight brightened the household. Now, more than ever before, even the Commander seemed to have forgiven me for marrying his daughter.

We determined to turn our energies again to our Texas painters, especially Aunt Clara McDonald Williamson. With this in mind, I visited my friend Mitch Wilder, director of the Amon Carter Museum. He responded with enthusiasm and said he would line up other museums for a traveling show, and he commissioned us to write a book about Aunt Clara. We had grown to love her more and more, our business and personal relationship

deepening with each passing year, so the idea of writing a book about her seemed a happy challenge.

During the year, we traveled three times to Aunt Clara's hometown, Iredell, Texas, to visit the sites of each of her memory pictures and talk to people who knew her. These were delightful outings, with romantic picnics by the Bosque River. It is wonderful country, and Iredell a quiet, sleepy town that reminded me of Cary, Illinois.

In Dallas we spent many hours recording Aunt Clara's stories of her life and work. We talked about each painting, finding each story more delightful than the last. Peggy transcribed the tapes and wrote the text, except for a few areas where she rewrote my thoughts, polishing my verbal expression to equal her own. The editor told Peggy she had written the most nearly perfect script the editor had ever handled. They made only one change of punctuation.

Peggy sitting with Barley on the pecan path in the garden that overlooks White Rock Creek.

When we received the galley proof, I felt so proud of it I sent a copy to Aunt Clara's son, Donald. He called one evening in response; unfortunately, Peggy answered the phone and soon broke into tears from his tirade. He threatened to sue and place an injunction to stop the publication of the book, claiming that only he had the right to write about the Williamson family. Peggy tried to explain that we wrote the story from the painter's view, to understand only how Clara responded, and that we had no interest in a biography of his family. He felt insulted by the book and immune to reason. Mitch Wilder told us he talked to Donald Williamson the next day and calmed him down by agreeing to cut two references to the family, and so got permission to publish the book. I had never met a more unpleasant man than Aunt Clara's son.

It is perhaps understandable that his mother's story about how she first started to paint bothered him. On the occasion when Clara told me the story, we were sipping tea, served with her fresh-baked cookies, and sitting in rocking chairs before the fireplace, while a fine crackling arose from the air pockets in the recently placed log. She had been speaking of her husband's illness,

his constant demands, and his not permitting her to paint because he thought it cost too much and wasted too much time. She paused. The rocking chair stopped its motion. She replaced her cup in its saucer. Her eyes closed in remembrance. She finally spoke: "You know, the best thing Mr. Williamson did for me was to die."

After Mr. Williamson had been safely placed in the ground and well covered, Clara's first outing as a widow took her to the art store to buy some paint before she set off to "make some beauty" and a new career.

The disagreeable Donald Williamson reappeared some time later when the Dallas Woman's Club invited me to show a small group of Aunt Clara Williamson's paintings, give a talk, and show the film that Peggy and I had helped produce for the ABC network. The film had come about in an indirect way.

A Methodist group in Fort Worth had approached me about doing a half-hour film about Aunt Clara for national television. The Methodists had seen her exhibition at the Amon Carter Museum and had been delighted with the book. After I assured Aunt Clara that these people were good, God-fearing Christians and Methodists, just like herself, she agreed to the film. She performed like a trouper.

Aunt Clara at her opening at the Amon Carter Museum with Peggy and Donald Vogel, 1966.

Peggy and I had helped in every way with the production and, at one time, took a plane to New York for a conference with the principals in charge at ABC. After all the arrangements had been set, the Methodist Bishop in Fort Worth received a call from Aunt Clara's son. That call so upset him that he called me and asked, "What's with that man? I have never been talked to like that in my whole adult life. Is he sick or what? He swore at me and accused us of using his mother for profit. Never, never has anyone upset me so."

I smiled and could only say, "I can hear his every word as if I were there. Take heart. In the end he'll be happy for it, even if he brings discomfort to everyone in the meantime." ABC showed the film twice on national network television and gave me a copy in appreciation for our help. It pleased us

whenever we could show the film or lend it. The Woman's Club seemed to share my enthusiasm.

※

Shortly after the first of the year, in January of 1964, as I sat in the office of Coe Kerr with Harry Brooks at Knoedler's Gallery in New York City, we began discussing the work of the great English sculptor, Henry Moore. To install a Moore show at the gallery, they had had to add extra "I" beams to support the floor because of the sculptures' vast weight. They planned to tour the sculptures and talked about the schedule.

"Can we have it at Valley House?" I asked. "It would be the perfect place. The gardens were designed for such a show." After much pencil-pushing and indecision, we settled on a show. I could have the month of April 1965. Another blockbuster.

"It will be expensive," Coe said.

"Hell, don't tell me that, let's just do it. We'll manage; we always have," I replied enthusiastically.

Back home, we set the wheels in motion. The grounds needed attention first; we had time to seed with winter rye, move a bush or two, prune the flowering fruit trees. The shop would construct pedestals and order concrete culverts with lids. How about another benefit show? I suggested the prospect to Joe Lambert, and he said he would handle it (my first mistake); but I had a catalog, as well as many other chores to do.

He set up the benefit for the Dallas Symphony Society. His people took over the invitations and the pre-opening party. We would share our commissions on sales equally to help the cause. On occasion, I tried to remind Joe that this was a benefit, not a wedding reception. "Don't worry, I know what I'm doing; this will be a great success," he assured me. I had forgotten that Joe was accustomed to spending other people's money quite freely.

A little more than a year after my conversation with Coe Kerr, the huge van arrived; we were ready. In addition to John and me, I had called in three sculptor friends, plus two muscle men, and we went to work. The grounds

remained wet and soft from rain the night before, which meant we could not use the tractor. We decided to move the pieces by hand and dolly to the point on the drive or path closest to the receiving pedestals. We laid plywood on the grass and pushed the bronzes with loving care, then raised them on platforms, slowly elevating them by adding a two-by-four with each tilt until the sculpture rose to the same level as the pedestal. Then, gently, we nudged the

LEFT *Barley with Henry Moore bronze,* Three Piece Reclining Figure, *1965.* RIGHT *James Clark and Donald Vogel discussing the Henry Moore sculpture in the Valley House garden. Photo by Peter Gimpel.*

sculpture into place. We had placed all the larger pieces by nightfall. There would be time enough the next day to install those going into the gallery.

The day's labor had been exciting and challenging. Touching and feeling the weight and texture of those forms had a strange and wonderful effect on me. I felt part of them. At first light I walked about the garden and looked at each piece. Humph! I felt nothing more than the morning cool; maybe later. I had breakfast and headed for the gallery. On the way up I saw the need for another piece for the island where the driveway splits, so I called Coe and asked about the possibility of bringing in *Knife Edge,* a bronze 112 inches high. It had to be removed at night by a crane, loaded in a special van, and shipped from New York. It traveled day and night, and we set it in place three days later, in time for the show. The effort was justified; it became the prize of the show.

Word of the exhibit spread, and calls came in about possible purchases.

Bobby Stewart, head of the First National Bank, asked me to visit him. He wanted to buy two pieces, one for the bank and one for himself. The exhibit continued to generate much interest, until finally I had twelve pieces committed. Al Meadows planned to come by, so I hung the large *St. Francis* by El Greco in hopes of enticing him.

The opening grew into a spirited affair. Most everyone who was anyone came. Jack Vaughn, in a loud voice, said, "Donald! Come here, I want to buy some of these pieces." He took my arm and pointed as he walked me around the gallery. "I want that one, and that, and that. The little one I'll buy for Cynthia Stewart; she always wanted one."

The room turned still, and all eyes focused on us. I made note and thanked him, then retreated into the viewing room as Algur Meadows entered with his Spanish dealer, Pandorba, who, we would later discover, had sold Meadows his false pictures. He introduced me as we stood before the Greco.

"Well, what have we here?" Pandorba asked as he reached out and touched its surface with extended fingers. "I have better," he said to Al as they moved on.

The catered dinner, while excessive, tasted good; the decorations with thousands of tiny lights blinking in the trees seemed to create a night sky of their own; the dance floor, little used, had a band that at half the size would have been more than enough. It just wasn't Valley House; it was too pretentious, but perhaps it was right for that occasion.

The gardens never looked more beautiful. The rye grass turned the grounds into an English meadow, lush in its fresh green. The bronzes seemed to be part of the earth, and they slowly seduced me into wedlock. Every day, at many different times, I watched the light move on each piece. How could one not fall in love? These abstract forms contained an honest dignity missing so often in contemporary work.

In the days after the opening, I kept trying to reach Bobby Stewart by telephone, but he refused to respond. I couldn't understand, even though I should have, considering my past experiences with Dallas bankers. He never bought the sculptures.

One afternoon a charming elderly lady came who shared my response to

the bronzes. She pointed to a small reclining figure and said, "I'll take this one. How much is it?" She wrote a check and thanked me for bringing such a magnificent show to Dallas and said she would pick up her bronze after the show ended. Her name was Browning. I had never seen her before this occasion, and I never saw her again. Some years later, however, I received a call from a Mrs. Browning to catalogue and assess the value of her paintings for insurance purposes. After I looked over the collection, she invited me for coffee in the sitting room, and I discovered the Moore reclining figure.

"How did you get this?" I asked, picking it up to feel it.

"Oh, that. We inherited it when my husband's mother died. Her heirs took turns choosing things, and this was the last to be picked and we got it. Isn't it awful?"

The last day of the Moore show, Mary Jo Vaughn, Jack's wife, arrived in a station wagon full of kids and headed for the garden. I caught up with her and asked where Jack wanted the sculptures delivered.

"That's why I'm here," she said. "Jack wanted me to tell you to take the reserves off. He says he can get them cheaper in New York." She walked on to catch up with the kids. What had happened? A dozen commitments had been made and not one honored. We loaded the bronzes into the van, and as it pulled away, once again I had tears in my eyes. My efforts to bring great art to Dallas continued to run into a stone wall and, as the van moved, I felt I had collided with that wall again. I never did find out what or who had been responsible for turning off the sales.

For us, the Moore exhibit proved a costly venture, but worth it. We had lived with those works for a month in the spring of the year and felt better for it. Soon we would feel that same sense of reward with a new publishing venture.

9

The Flood

Rains, taxes, and a new book descend on Valley House

IT WAS MONDAY the 21st day of September 1964, when it began to rain, rain, and rain some more. For two days it seemed relentless. We went to bed secure in our belief in what the government engineers had stated: our house and property were out of the flood plain. Then the phone rang and awakened me about 1:30 A.M. Our neighbor, Frank Randt, a heavy-voiced Spaniard, asked, "Has the creek come in your house yet? I am standing in water."

"Thanks," I yelled and jumped from bed to see water rapidly edging up to the terrace "Peggy, get up. I'll get the kids and move the cars. Get everything together, I'll be right back."

I ran about trying to organize everyone at the same time until Peggy took over. I drove one of the cars up to the gallery, and returning to the house, I waded into water about halfway down the drive. It had already surrounded the house and was moving swiftly. We had no time left to do anything but get out.

Closing the door behind us, more as a gesture than because it made any sense, we linked our arms together as we struggled against the now swift, knee-deep current. Peggy carried Barley in her arms; I had my arms piled

high with clothing. The boys, Eric and Kevin, carried some of their dry clothes. We made our way up the driveway to the guesthouse, with no time to think of anything except how high the water might come.

At last the rain stopped. The water did not advance for some time, and finally started to recede. At last safe, I begged for a few moments rest and immediately fell asleep, only to be awakened soon by Peggy, who was shaking me and saying, "The water is coming up again." The heaviest rain yet drummed on the roof. I felt tired and sore, every muscle knotted and aching. Water began coming into the guesthouse and surrounding the gallery.

"THE GALLERY!" I shouted, "I must go to the gallery! Peggy, Kevin, take Barley and sit on the work benches in the shop. Eric, come with me. We have to get into the gallery." But how? Water already stood about a foot deep and ran so swiftly we dared not open a door. Perhaps we could gain entrance through the gallery kitchen window.

We broke the glass to release the latch and climbed through. When we got inside, we saw water seeping through, carrying a fine silt that made walking impossible. To move, we had to slide, without daring to lift a foot off the floor. We moved the bookcase out from the wall and put all the paintings from the lower racks into the bookcase. When we had filled it, we used sculpture stands to hold the remaining paintings. Most important, we had to save the large canvas of *St. Francis* by El Greco. By this time the water stood about eight inches deep in the gallery.

After a time, the rain stopped, and soon Eric reported from the window that the water was beginning to recede. We had won the day. When Eric saw that the water had receded beyond the gallery, we opened the doors to release the water inside, which swirled out to join the rest of the flood as it departed our grounds.

We found Kevin and Peggy, with Barley in her arms, on the road waiting for us. The firemen had rescued them from the shop where they had found them sitting together on a workbench. To Peggy's anger, television cameramen began filming the rescue. She told them not to dare use the film. We wanted no record of any tragic moments at Valley House, and they were tasteless to want to report our reaction at such an unhappy time.

Our dear neighbors and friends, the Cobbs, came by and took the kids home with them. In shock, we walked slowly down the drive. The danger had passed, and now we had to survey the dam-age. It was hard to push open the door; a layer of mud so dense it looked like potter's clay covered the floor. I found a shovel in the carport closet and carved a path into the house. What a mess. The water, which had reached a height of fifty-six inches, had taken its toll. Our beautiful Steinway piano was turned upside down; my collection of art books seemed to have melted; the drawing, print, and photo collection was destroyed. The loss of clothes, furniture, cabinets, and other pos-sessions was difficult, but losing the piano and books hurt most. In some way they had come to symbolize Valley House. More than one hundred fifty of my paintings were lost, but somehow that

FLOOD SALE

Sponsored by
Friends of Valley House
October 25 4 to 8 p.m.

VALLEY HOUSE GALLERY
6616 Spring Valley Road

ticket $5.00

didn't bother me as much, for I knew I had more and better works to paint. We left the house and walked to the road, where we stopped and looked back.

"Should we move on or dig out and rebuild?" I asked Peggy.

"We'll make it better than ever," she said. Our arms around each other, we fell into a long, warm, comforting kiss.

The car that I had moved still operated, so we drove to a nearby motel, where I fell asleep almost before my head hit the pillow. If I ate something, I don't remember. I was totally exhausted.

It took nine dump trucks to clear out the house, and most of the personal possessions we had rescued and set aside were stolen by the men who were cleaning up. Peggy and I cleaned up the guesthouse, and we moved in. It was one of the nice things that happened, for it kept us close, and we enjoyed the imposed warmth as a family. Our mortgage would be paid within a year and, since we had sound credit, the company gave us a new loan.

At first I had tried to get a small business loan from a federal agency set up to take care of such disasters, but that proved fruitless. It turned out that

the man I talked to about the small business loan had been standing by the fire truck when the firemen removed Peggy and the children from the shop by boat. "Yes," he said, "there is no doubt that it was a disaster." He would be pleased to give me a loan if I could get a letter to that effect from the mayor or city manager.

Three people lost their lives in that flood, and the flood left much damage, so it wouldn't have been difficult to recognize the situation as a disaster. Our mayor failed to respond, however, as did the city manager until I reached him by phone. He told me the city would have to declare the county a disaster area and they couldn't do it just to help a few people.

But while city government may fail in times of trouble, friends do not. Each day one or two friends came by with a marvelous lunch in a basket and a nice bottle of wine. They had organized this loving gesture on their own, and it truly gave us a lift and made rebuilding a happier adventure. Betty Blake came by and asked if we would have any objections if a group of friends held a flood sale for us. We were overwhelmed by this interest, and we could only ask her why these people were so kind. We had never asked for help because we found pleasure in giving. Betty answered that Valley House had given them so much pleasure through the years that they wanted to show their appreciation.

Our dear friend, Marvin Krieger, designed and produced, at his expense, an admission ticket to be sold to people who wanted to attend the sale. A bar was set up, with the liquor furnished by friends and sold by the drink. The house had at last dried out, but stood an empty shell at the time of the Flood Sale. The sale was a success, and the volunteers and guests seemed to have enjoyed themselves.

A few days later Betty came out and gave us a check for $10,000 and thanked us. Peggy and I broke into tears. At no time before had we felt so rewarded for our efforts. The people in the city, indeed, made Dallas. It was almost worth a flood to discover the sensitivity of our audience. We pledged to ourselves that our garden would return to an even more beautiful visual delight to share with our friends, and that the gallery would go forward with more fine exhibitions.

At tax time I tried to deduct the loss of my paintings, but no; I could deduct only the cost of the material. My work had no value, they told me. I became convinced that the greatest evil our elected representatives ever created existed in the Internal Revenue Service.

※

The book about Aunt Clara came off the press, and the traveling show began. Clara and the book enjoyed good reviews and a gala opening. We drove Clara to Fort Worth's Amon Carter Museum for the occasion. She wore her prettiest dress, and her shyness, her, "Mercy, mercy, all this fuss just for me?" captivated everyone. As she cut the first slice from a huge white cake, we all applauded her. With her work she had truly "made some beauty." We felt so proud for her, this very good lady who had found her opportunity to make beauty, with much more to come.

Our book that accompanied the show was also well received. Sue Watking Grasty of the *Austin Statesman* described

> Writing as evocative as the paintings; straightforward, unpretentious; it is particularly refreshing to read art criticism not couched in the too usual indefinable yak of art with a broad A.; I like Clara's pictures and would value this book for enjoyment and as a resource; simply delightful; art—yes, but also biography; a critique of Aunt Clara's art; a record of pioneer Texas and a very good exposition of primitive art.

As to my own work, I continued to paint and managed to produce a one-man show in Palm Beach and another in Fort Worth, as well as some group exhibitions. I had not lost sight of my goal; it would just take a *bit* more time. . .

In 1964, around the time I was invited to join the Art Dealers Association of America, I took another trip to New York to reassure the dealers that art was alive and well in the provinces and to attend my first meeting of the Art Dealers Association of America. I felt greatly honored to have been elected

to this group. Valley House Gallery became the first to be chosen in all of the South and Southwest and remained the only such member for many years. This was no self-seeking profit organization, but one I could believe in. They brought back, and to this day retain, an integrity in the profession.

With the paintings of Hugh Breckenridge ever present in my thoughts, I took notice that his contemporaries were beginning to have shows in New York. I checked the prices and spent much time studying these works. Finally, I decided it was time to talk to Dorothy, Breck's widow, about a show at Valley House. I believed him to be the best painter of all those I had seen in New York. Breckenridge was one of the first Americans to realize the significance of French Impressionists' color theories and to carry them to fulfillment in exciting abstract designs. His use of color was unequaled by his contemporaries, and his Impressionist pictures hold up with the best of the French Impressionist masters.

On returning home, I visited with Dorothy and explained why I felt the time had come for a show. She seemed quite pleased and told me to do the show as I felt it should be done. She gave me everything in her possession concerning the artist: his logbooks, a box of medals won in various exhibitions, an unpublished manuscript, photographs, and letters. This material appeared worthy of a major catalog or monograph, another challenge!

Another new client, Vincent Carrozza, came by to visit. He was a gentleman with a healthy enthusiasm who had recently acquired a few paintings. I shared with him my excitement about the Breckenridge paintings and their prospects, and my wish to buy the estate and remove the widow's interest fairly. This would allow us complete freedom to show the work, because it would be costly to catalog, restore, frame, and present it properly.

"Why don't we buy it together on equal terms?" Vince asked.

I had never had a partner before, other than my wife, but knew that to do it my way I could use some support. "Let's explore it," I said. "I'll talk to Dorothy and see what she thinks is fair, and to Peggy, of course, for her labors make all things possible."

I felt a bit awkward, explaining to Dorothy my need to buy her out, but

she said she would be delighted to sell everything and be done with it. I asked what she considered a fair price. She didn't know, of course, and neither did I; so much time and money had to be spent to have a successful show. She named a figure, and I added to it so I would feel more comfortable. I reported the sum to Vincent, who agreed. I had my first partner.

I spread the word that Valley House wanted to buy all paintings by Breckenridge, for Dorothy had given many away or sold them for next to nothing. We acquired about a dozen more pictures in this way.

Peggy wrote the catalog, as usual, and I laid it out. Again, our friend, John Brodnax, printed it. I had such trust in John that I never asked how much a printing would cost. As with most projects, I simply jumped in. John Morrie, our framer, did a superb job. Word got out, and a new excitement began generating about these paintings. Even before the show opened, we sold enough work to pay all the expenses and return our original investment. We produced an exceedingly beautiful exhibit for the superb colorist Breckenridge, who would have been proud of our efforts. With another winner, we had once again found our direction.

A review of the exhibition by John Neville, in the November 17, 1967, *Dallas Morning News*, was titled, "Artists: Valley House 'Finds' Breckenridge."

Valley House Gallery had a comprehensive retrospective exhibition of the works of H. H. Breckenridge, to mark the 30th anniversary of the artist's death. Donald and Margaret prepared a 'handsome' 64-page catalogue. Vogel acquired the estate of Hugh Henry Breckenridge, and by mounting a show of major scope, he hoped to bring the artist back into what he believes to be his proper focus and to renew an interest in HHB, who has been a 'lost' artist. Vogel feels that the reason HHB has been 'lost' is 'that his great success was his failure. He was completely self-sufficient; he found no need for a dealer or agent to promote him or handle his business. When he died, there was no experienced hand to guide the continuing renewal of his reputation and this is something that is necessary even for such a renowned and creative artist.'

Eleanor Freed of the *Houston Post* echoed Neville's interest in her review titled "Art; Dead Artists, Live Wires," that appeared Sunday, December 3, 1967.

> After a quest of almost 20 years, Donald Vogel, long established art dealer, succeeded in acquiring the estate of HH Breckenridge. Artificial respiration is being applied as a result of Vogel's rediscovery of an authentic American talent. . . .Valley House is always a joy, superbly situated in a wooded rural site outside of Dallas. On my last visit there some years ago I saw the memorable 'Passion' of Rouault which Vogel introduced for the first time in this country. The excellence of this catalogue would have brought credit to any museum scholar.

The success of the Breckenridge exhibition and taking on a new partner triggered a chain of adventures in our art gallery that surprised even me.

10

The Meadows Caper
The art fraud that made international news

MUCH HAS BEEN written about the "Meadows Caper" throughout the world. Being the first to break the news to Al and set the events into motion, however, I feel it is time to tell it as it was. Before it ended, it was one of the greatest art scandals of the twentieth century. It triggered news stories that reached every corner of the world and inspired investigations by the FBI and police in Los Angeles, New York City, and Palm Beach, as well as Brazil, France, and Switzerland. For me, the "Meadows Caper" was another chapter in my growing-up years as an artist and art dealer in Dallas, a story that seemed to parallel the city's own growth in art: its painters, its museums, its art galleries, and its collectors.

Had it been possible to yell stop and change the course of events that were about to unfold, I would have done it, for it was my earnest desire to protect Al Meadows and his new interest in the world of art.

It was a dreary December afternoon in 1966. A cold, damp chill was trapped under heavy clouds that held a threat of snow. I was in the studio drawing, in preparation for the start of a new canvas, when the phone rang.

"Hello, Donald, this is Al Meadows. You are the 'Wildenstein of Texas.' I'd like you to sell some pictures for me."

It had been a long time since I had heard from Al, or even thought of him, but my first reaction was a fervent hope that he wasn't talking about his Spanish paintings, many of which had false attributions. "What paintings do you have in mind?" I asked.

"Oh, I have nine I'd like to sell, including a Gauguin, a Degas, a Manet, five by Raoul Dufy, and a Utrillo. Can you come over?"

"On my way in about twenty minutes," I said, hanging up the phone. I could hear the ring of the cash register, if only the paintings were right.

Algur H. Meadows had founded the General American Oil Company of Texas about five years before I had moved to Dallas from Chicago. While I was establishing myself as a reputable art dealer, which allowed me to pursue my work as a painter, Al Meadows was building his oil company worth millions of dollars into one of the largest in the United States.

At the time I had three top-quality Renoirs hanging in the viewing room of my gallery and hoped Al might want one of them. They had just arrived from the Vollard estate in France and had not been on the market before, so perhaps. . . . Pleasant images of things to come passed before my eyes.

Al Meadows, circa 1967.

Memories of Al Meadows' Spanish paintings were all too vivid, though, and not nearly so pleasant. I remembered a meeting with him nearly three years before in a waiting room just off the elevators in his new office building, where I had assembled about sixty paintings for him to approve for the new offices throughout the floor. Joe Lambert, who owned Lambert Landscaping Company and was a highly regarded businessman, had been responsible for my presence.

When Al appeared, Joe introduced us. Al was a friendly gentleman, with a nice smile and a quiet voice. The two of us started to walk, looking at the paintings. He pointed first at a watercolor by Michael Frary, a painter from Austin.

"How much?" he asked.

"One hundred fifty. That one, an oil by Kelly Fearing, also from Austin, is seven hundred dollars, and the next is six hundred. It's by. . ."

He interrupted, and with a wave of his hand, indicating the whole group, said, "I'll give $12,000 for the lot."

"It's a good offer," I countered, "but I want to sell you only what you can use, at my price, with no discount."

"I understand," he said as we walked on. "You know, I do a lot of business in Spain, and I've acquired a large collection of Spanish masters on which I got a very good buy!"

"How's that?" I asked. He explained that he'd had a free afternoon in Madrid one day and had passed a gallery with an old Spanish painting in the window. There was a sign in the window as well, stating that the gallery had examples of all of the important painters of Spain. Al went in and looked at the paintings that were hanging there, and the proprietor told him that if he wanted assurance of their quality, a book was available in the bookstore across the street that showed reproductions of many of the same paintings. When he left the gallery, he walked away for several blocks, then circled around until he came back to the bookstore from a different direction. He bought the book and returned to the hotel to study it, pleased to find that all the paintings he had seen at the gallery were indeed represented in the book. The next day he went back and bought them all "at a bargain price."

Was this fellow for real, I wondered? But at least that story explained why he was trying to buy all the paintings we were looking at as a "job lot."

But time had passed, and hoping his attitudes toward collecting had changed, I accepted his invitation to see the paintings at his house later that day. When I rang the bell, Al opened the door himself. My optimism lasted only as far as the front hall, where I first saw a picture that disturbed me. It didn't feel right. Al saw me stop and said, "That's a Picasso."

"If that's a Picasso, I'll eat it," I answered.

He shrugged and walked on to the next picture. "Utrillo," he said.

"No way," I said.

"Come on, I'd like you to look at all of them and tell me what you think," he said.

We stopped before two large, handsome canvases, unsigned. I said, "These are very fine Valtats."

He said, "They're by Derain. His name is on the stretcher in charcoal."

I responded, "I don't care about the name. They might have belonged to Derain at one time, but they were painted by Valtat."

Looking up at the wall beyond the railing of the second floor, I saw several drawings by one of my favorite artists. "Go on up and look at those Modiglianis," Al invited.

Seeing them brought back memories of the times I had stood alone in the gallery on Michigan Boulevard, a few blocks south of the Art Institute in Chicago, gazing at a large, round table all but covered with drawings by Modigliani. As I handled them and studied every detail, I had felt an almost overwhelming sense of the artist's presence. What a disappointment it was to see that these framed drawings were fakes, and to have to tell Al so. It was so easy to imitate this artist's work, yet impossible to capture its intangible magic. I wondered why anyone would bastardize his own talents for money. An artist should surely respect the talent of a man like Modigliani. But, then, if a person could not honor his own talent, how could he respect another's? To a young idealist like me, hoping one day to give pleasure to the world through my painting, such a betrayal was unimaginable.

In the living room another Modigliani hung over the mantel. "It's bad," I said.

Al challenged me, asking how I knew. I began by saying, "How can I explain it to you? It's wrong; my gut tells me so. It feels like two separate paintings have been put together, and it just doesn't work. I don't expect you to understand, but please take my word. I know and love this artist's work, and there's no way he could have done it."

I glanced into the library and saw a famous Bonnard floral I knew very well. If only this one were good. Oh, let it be good, I thought, as we approached. But it wasn't. This was a disgrace! How could anyone pass this stuff off? It was bad.

Over the fireplace in the library was another Modigliani. "No good," I said.

Al was waiting for me this time. "Ah, I got you! I have a catalog with this on the cover," he beamed. He removed the catalog from a shelf behind a closed door and handed it to me. I agreed it was the painting reproduced on the back cover, but it was still wrong. I wondered if he really had no suspicion that all these pictures were fakes. It was difficult for me to tell. I imagine he was a good poker player. There was no doubt that Meadows was an intelligent man. In business, he was respected, though tough, and he was used to having his own way and being a leader in his field. He employed the advice of experts about exploring for oil from the ground, so why did he fail to do so when it came to oil brushed on canvas? He had overlooked the very basic fact that the exhibition catalog he showed me had pages missing that would have stated the time, location, and sponsor of the exhibit of the Modigliani in question. Why wouldn't he have seen that, I asked myself as we walked on through the house? Why did he fail to check out the men he was dealing with? If nothing else, the fact that a dealer was selling him a picture alleged to be valued at $80,000 for $40,000 made no sense.

Next, he pulled out six more paintings from a hall closet. "I'd like you to sell these for me. Take them with you and let me know what you can get for them."

I glanced at them and felt they were fakes, but agreed to take them. I made it clear, however, that before I offered them for sale, I would check them further. If, as I suspected, they proved bad, there was no way I would sell them because, from then on, as a dealer, I would be responsible. It was agreed. Before I left, he asked that I take with me the appraisals he'd had done and the photos of the paintings with their provenances so that I could check them out for him.

"One more thing I want to talk to you about, Al," I said, "I have three important Renoirs from the Vollard estate you should see. . ."

He held up his hand to stop me and said, "You sell my pictures, and I'll buy one of your Renoirs."

The day didn't improve. More than ever it looked like snow, but the setting was right for the sad drama of the "Meadows Caper."

Back at the gallery I unloaded the six pictures Meadows had given me and examined the backs for the type and age of the canvas, the stretchers, and the tacks, to see what story they could tell. It all added up; everything was wrong. I read over the appraisals and checked the corresponding photos. If the paintings had been authentic, the values established would have been fair market values. "Who wrote this?" I mused. I couldn't believe it when I found the writer was my friend, Carroll Hogan, who worked at the Dallas Museum as a curator and had a degree from the Fogg Museum at Harvard. He would have known these were bad. He must have been involved somehow. (That he was, I learned later from a dealer friend, Leonard Hutton, who entertained our soon-to-be-found-out villains at a party in his apartment.)

After going over the information Al had given me, I called and asked his permission to take the material to New York to confirm my findings. He agreed. I had decided to divide the photos and show them to different dealers, those who had the greatest expertise for each particular artist. My first appointment was with Klaus Perls, then president of the Art Dealers Association of America, with whom I had developed a good rapport in past business. I handed him the packet of photos, and he laid them down one at a time, in two piles, as if they were playing cards.

"Good, bad, bad, bad, good," he murmured, saying nothing else until the last photo was on its stack.

I told him my story and said, "I think we should help Meadows. He's a potential collector, and we shouldn't discourage him." I reminded him of the story of Otto Gerson, a dealer highly respected among dealers. Not too many years before, Otto had planned an exhibition of paintings of Modigliani. Several of his clients advanced him sums of money to acquire paintings for them, and he set off to Europe to buy all he could find. He approached Robert de Bolli, who told him that only two Modiglianis were available and where he could locate them. These he bought, but in Switzerland he found a dealer who had several. He bought them all and returned to hang his show.

When it was up, he invited Klaus, whom he respected as the American expert on Modigliani, to view the show before its opening. Klaus pronounced

Poster for Second Synchromist Exhibit, Paris
1913, 33 ¼ × 20 ½ inches

Landscape, 1908, oil on cardboard, 19 × 22 ¼ inches

Morgan Russell was born in New York city in January of 1886 to Antoinette and Charles Jean Russell. After studying architecture for two years and visiting Paris and Italy, he returned to New York and studied sculpture with James Earl Fraser at Art Students League and painting with Robert Henri. In 1908, Mrs. Harry Payne Getrude Whitney began giving Russell a monthly allowance and that same year he visited Leo Stein and met Henri Matisse, Pablo Picasso and August Rodin. The next year he settled in Paris and worked closely with Matisse and did some Fauvist sculpture, one of two Americans who influenced French art.

His exhibitions include "Synchromie en vert" at the Salon des Independants, the Armory show, and together with Stanton MacDonald-Wright at Der Neue Kunstsalon, Munich, Galerie Bernheim-Jeune, Paris and Carroll Gallery. His next exhibit at the Salon des Independants was called "Synchromy to Form: Orange."

In 1916, he traveled to new York City to organize Forum Exhibition and two years later moved to the Midi. He settled in Aigremont in 1921. He taught at the Chouinard School of Art and the Los Angeles Art Students League after MacDonald-Wright helped him visit California. They exhibited together at the New Stendahl Galleries and the Los Angeles Museum in honor of their reunion. He returned to Paris and spent his winters in Rome until 1935.

Ten years later he moved to the United States where a major retrospective of his work was exhibited at Rose Fried Gallery in New York City. He died in Pennsylvania in 1953. Valley House Gallery represented the Morgan Russell estate and succeeded to sell all his paintings and drawings.

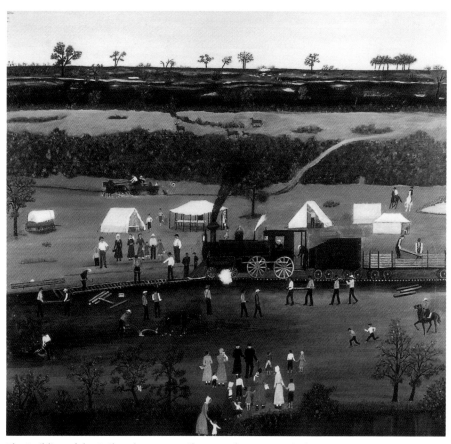

The Building of the Railroad, 1949–50, oil on panel, 27 × 29 ½ inches

Aunt Clara was born **Clara Irene McDonald Williamson** on November 20, 1875, in Iredell, Bosque County, Texas, a stopover on the Old Chisholm Trail. Clara grew up a hard and busy life. She had little or no formal education, and was raised in the tradition of the hard, rough life of the American frontier. In her late 60s she turned to painting and attended some classes at the Dallas Museum of Fine Arts and Southern Methodist University.

Her exhibitions include the Pepsi-Cola "Painting of the Year" Invitational Exhibition, National Academy of Design, New York City; One-Man Show, Betty McLean Gallery, Dallas; American Contemporary Natural Painters Invitational, Traveling Exhibition sponsored by the Smithsonian Institution, Washington, D.C; American Primitive Paintings Assembled by the Smithsonian Institution for travel in Europe and Scandinavia; Executive View, Art in the Office, Assembled by the American Federation of Arts, Exhibited at Time-Life Building, New York City; International Exhibition of Primitive Art, Bratislava, Czechoslovakia, and many other exhibits.

When her husband died at the age of sixty-eight, for the first time she was able to start making sketches of things she saw. She worked in pencil and charcoal, then bought and worked with watercolor, later changing to oils, displaying from the first her very personal style - to "make some beauty."

Margaret and Donald Vogel wrote her biography for the Amon Carter Museum published by the Texas Press titled *Aunt Clara*. Donald Vogel bought her first memory painting, *Chicken for Dinner*, and became her sole dealer and promoter.

Mama Blows the Horn, 1967, oil on panel, 20 × 24 inches

In part, **Velox Ward** wrote of himself for his show at Valley House Gallery, September 27 – October 18, 1970.

"A painting, *One Sunday Afternoon* was accepted in the Dallas Museum Show. About this time Joe Linz put a rope around Don Vogel's neck and held him while I showed him my paintings. He agreed to handle them if we would take the rope off.

Maybe if I took a lesson or two I might improve faster but I don't have time to take lessons and paint, too. So I just keep painting.

In December of 1968 I had only eight paintings left and had to take than off the market until I got enough to display again. It takes me from two weeks to two months to complete a painting. By August 1970, Mr. Vogel thought I had enough for a show.

I get a lot from watching people admire my paintings as they remember the "good ole days". The rural fife of my boyhood has influenced most of my work. Some people see things they've never seen before and might not see

again. . . country churches, the old Cotton gin, sorghum making, scenes around the farmyard and even the outhouse with the Sears and Roebuck catalog inside.

I have been painting for ten years, steadily for the past four. That is the longest time I have ever spent in any vocation. Since I have started painting I have found something I can't seem to master. I won't be satisfied until I can paint a house so real that someone will try to open a door, or paint a mule or horse that anyone might say "getty-up" to. I always try to have some humor and pleasant things in my paintings It is a pleasure to see people smile as they view them.

Vermeer is the artist whose work I respect the most and Andrew Wyeth is next. I will be striving the rest of my days to attain what I want on canvas." Velox Ward, 1970

Valley House produced a monograph catalog with the Amon Carter Museum for a traveling exhibition to seven Texas museums.

Tom Benrimo's career was discontinuous. After an interval of many years, during which he achieved prominence in the fields of commercial design and teaching, he recognized that his compelling interests were again divided. He moved from New York to New Mexico, where he set out to retrieve a place in the interrupted course of his life as a painter.

For him the days of city constriction were over. But their traces were not easily overthrown. For one thing , there were the manual habits of the commercial art trade to overcome. For another, the sudden release drove him at first to adopt a mode of expression that turned out to be a specious medley of romantic feeling and precision. But the expedient shades of Dali in his work soon dimmed and disappeared. More profoundly than in his youthful cubist works, the forces in Benrimo's personality joined again in the serene and luminous canvases of his late period. His own, they are meditative, lyrical and robust. Seven years before his death he offered, as an expression of his philosophy of art, a quotation from Charles Norman. In the present context one sentence stands out. "The work of an artist is his autobiography." Douglas MacAgy

The Betty Mclean Gallery was privileged to give Benrimo his first one-man show. Valley House Gallery continued to represent him until his death and they continue to show his work whenever possible.

Jockeys, 1918, oil on panel, 14 × 15 inches

Moonglow, 1952, oil on masonite, 24 × 30 inches

Ernestine Betsberg was born in Bloomington, Illinois. She spent her formative years in Evanston, studying painting at the Art Institute of Chicago. Early in her career, she won an Anna Louise Raymond Travelling Fellowship which allowed her to spend a year in France. In 1940 she moved to New York with her husband, painter Arthur Osver, and lived there until 1960 with periods of three and one-half years in Rome and one year in Florida. She moved to St. Louis in 1960 and has been a mainstay for other artists in the area since.

The artist's work has been seen in solo shows at Fairweather Hardin Gallery in Chicago, at Syracuse University, the University of Florida, in New York City, and in St. Louis at the Schweig Gallery and the Terry Moore Gallery. Her paintings have also been seen in the prominent national and regional shows including the International Watercolor show at the Art Institute of Chicago. Among the many other museums in which her work has been seen are the Pennsylvania Academy in Philadelphia, the Museum of Modern Art and the Whitney Museum in New York. Her paintings have also been shown internationally in such important centers of art as Nice, Tokyo and Rome.xx

Poulou with Chrysanthemum, 1948, oil on canvas,
27 × 22 ¾ inches

In the Kitchen, 1951, oil on canvas, 40 × 24 inches

Study #1 for Italian Fruit Dish, oil on paper panel, 10 × 10 ¾ inches

Abstraction with bouquet, oil on canvas, 28 × 32 inches

Just fifty-two years ago, the death of **Hugh H. Breckenridge** brought to a close the career of a very significant and successful American painter. As a teacher, Breckenridge inspired his students to seek beyond the accepted; to venture into their own discoveries and inventions. He was sought out by such men as John Marin, Charles Demuth and John Sloan, all of whom attended class under him.

As painter-innovator, Breckenridge also stood with the best. He was among the first American Impressionists; one of Impressionism's most highly regarded exponents in this country. His records list numerous awards: gold, silver bronze medals; citations, certificates, and purchase prizes. Most national exhibitions included his work throughout the span of his lifetime; and he was almost frequently called to serve as juror for major shows, as he was invited to participate as exhibitor. He was so sought after as a portraitist that he refused more commissions than he accepted. He was both honored and beloved as a teacher for over forty years.

With such a background of success, it is difficult to understand why Breckenridge's painting is so little known in the art world of today. Could it be, quite simply, that his great success was his failure? He was completely self-sufficient; he found no need for an agent or dealer to promote his work and handle his business. It was rather his nature to assist others than to seek help for himself. When he died, there was no experienced hand to guide the continuing renewal of his reputation, necessary even for such a renowned and creative artist.

It was in 1945 that I first saw the work of Breckenridge, and it so moved and excited me that through the years I have kept it under surveillance, hoping one day to acquire his estate, and knowing with certainty that the opportunity must finally come to present such an exhibition as I did. It was our hope that in some measure the qualities we have found in Breckenridge, both as creative painter and person, would be felt in our attempt to bring him back into focus. This was accomplished.

Mother and Child, oil on camvas, 46 × 35 inches

Jean-Marie Calmette, born in Wissous on the outskirts of Paris in April of 1918, studied at the Ecole des Arts Decoratifs and the Ecole Des Beaux-Arts. He helped form the group called L'Echelle, with which he exhibited in 1943. His first one-man show was at Garnier's in 1951 and he exhibited in various group shows in Italy, Canada and the United States. He received the second Prix Drouant-David in 1947, the Hallmark prize in 1954 and the Prix du Dome in 1955. Valley House Gallery was pleased to represent him and give him a one-man show in February, 1962. His still lifes, restrained in coloring but violent in expression, have been acquired by the Musee d'Art Moderne in Paris and several museums and private collections abroad.

Les Trios Menestrals, 1964, oil on canvas, 64 × 51 ½ inches

Claude Venard was born in Paris in March, 1913. He attended some evening courses at the Ecole des Arts Appliques, but is mostly self-taught. He has traveled in Belgium, Holland, Germany, and North painting constantly. His numerous group exhibitions include shows of the Forces Nouvelle group as well as shows in the great salons. He has had several one-man shows in Paris and has exhibited in England, Switzerland, Denmark, Sweden, and in the United States at the Betty McLean Gallery in 1951 and was represented in the United States by Valley House Galley from 1953 to 1962. Although he has been exposed to various influences, Venard has retained a personal approach to figurative painting which he practices with great technical skill. He is represented in the Musee d'Art Moderne in Paris and in several foreign museums.

Queens Factory, oil on canvas, 41 ½ × 25 inches

Urban Gemini II, 1990, oil on canvas, 36 ½ × 14 ⅞ inches

Arthur Osver was born in Chicago, Illinois in October, 1912 He was educated at Northwestern University and at the Art Institute of Chicago under Boris -Anisfeld. His teaching experience includes the Brooklyn Museum Art School, Columbia University, the University of Florida, Cooper Union, and Washington University in St. Louis. His list of awards and grants is impressive: the James Nelson Raymond Travelling Fellowship given by the Art Institute of Chicago in 1936, the Guggenheim Fellowship in 1948, and the Prix de Rome in 1952.

In 1956–57 he was the visiting critic at Yale University and was painter-in-residence at the American Academy in Rome from 1957–58. He was on the Guggenheim Advisory Board from 1959–70 and on the American Academy in Rome Advisory Board from 1960–72. In 1967 he went to Europe for a year on a National Endowment for the Arts Sabbatical Leave Grant. In 1975, he was a trustee at the St. Louis Art Museum for three years and was listed in "Who's Who" from 1959 to 1989.

Osver has exhibited his works at major museums in this country and in Rome, Tokyo, and Rio de Janeiro. His paintings are in the permanent collections of forty-one museums, including the St. Louis Art Museum, New York's Metropolitan Museum, Museum of Modern Art, and Whitney Museum, the Chicago Art Institute, the Walker Art Center, Minneapolis, the Philadelphia Museum, and the Pennsylvania Academy of Fine Art, and a long list of forty-seven corporate clients ranging from Abbott Laboratories to IBM to Time Inc.

View of Salamanca, 1965, oil on canvas, 22 × 28 inches

"There were no works of art in my childhood, but I was surrounded by a picturesque reality. My father was a country physician and we lived in New Mexico; in the Sacramentos, at the San Pedro mine, at the lumber camps in the Zunis or in the Jemez mountains, and at the pueblo of Laguna where one of his Navajo patients introduced me to the materials of oil painting. Today, I no longer view the world through the eyes of a child. My v ision has been conditioned by a lifetime of painting, of disciplined observation, but I trust that I still respond as I did then, and I would not suppress or conceal the romantic and representational elements in my art.

Like most men, I have also learned to see through the eyes of others. I left college at about eighteen, and I have elected since to spend my life among painters. I would like always to continue, in the resiny fragrance of the studios, among painters and students. I was not trained in the academies, but I must not claim to be self-taught. I could not name all of the artists living and dead who have been my formation. If you do not discover them in my painting, I will not point them out to you. I believe in tradition; otherwise I would not teach.

The practice of outdoor painting has certainly declined , until nowadays it is even difficult to purchase the standard

continued on facing page

The Artist's Cupboard, 1963–64, oil on canvas, 42 × 32 inches

Loren Mozley (*cont.*)

equipment. But I continue to work directly from the subject , be it the figure, the landscape, or arrangements of objects, using the normal appearance of things, not as a springboard for free self-expression but as a point of return, a reassuring realm of common expression for myself and anyone who sees my pictures. I do not go out of doors for the air. I do not bring home snapshots of picnic spots or trophies to be desiccated and stuffed in the studio. To me the world is confusing, but ordered and alive. I do not distort for fun, nor rearrange, so much as try to seek and sometimes discover, something of an elusive rational order pervading the universe.

With me the image is not spontaneous, but premeditated, and I repeat certain subjects over and over, sometimes for years. The basic structure of each picture is systematic and formal often geometric, since I am a child of the cubist order. The skeleton of a painting in progress is clothed in the flesh, and then the skin of color and brushwork, sometimes intuitional and approaching spontaneous personal gesture. I should like to see the whole finally emerge in a form so simple and convincing that I might withdraw—retire.

Painting often appears to be a manifestation of utter self-indulgence, but surely it must both begin and end as a generous, a social gesture. For without you, you the viewer, a picture is nothing more than a motion in the dark, or a blank canvas.

To me a painting is a profession and a calling which asks a deep respect and an humble attachment. I pray that at some fortunate moment I may be an artist. I try my level best every time I pick up a brush to be a decent and skillful craftsman, a painter."

—**Loren Mozley** (1905–1989)

Fred Nagler was born in 1891 at Springfield, Massachusetts, where he first studied wood carving. From 1914 to 1917, he studied at the Art Students League in New York City, where his professors included Tom Fogarty, Frank Dumond, Frederick Bridgman and Robert Henri. At the Art Student's League he won the Bridgman Scholarship and Annual Portrait Prize, a competition juried by George Bellows and John Sloan. Subsequently, he became a member of the Art Students League Board of Control. In 1940, he was president of the Bronx Art League.

Mr. Nagler has been offered many prestigious positions during his career including: Chairman of the Art Department of the Connecticut College for Women (on the death of Grant Wood), Chairman of the University of Iowa State, and Chairman of the Art Department of the Eastman School of Art.

Fred Nagler has been called a painter's painter which can be substantiated by the fact that he won four of the major awards given by artist juries: the Payne Gold Medal and Purchase Prize at a Virginia Museum Biennial; the Clark Prize and Silver Medal at a Corcoran Biennial, and a Grant from the Academy of Arts and Letters.

Valley House Gallery began representing him with an exhibition of drawings in 1980 and has represented the estate since his death in 1983.

Mother and Child #3 oil on canvas, 36 × 30 inches

Drought of Fishes, oil on canvas, 30 × 40 inches

Requiem, 1957, oil on canvas, 58 × 52 inches, private collection

Red Mirage, 1958, oil on canvas, 39 × 52 inches, Hardwood Foundation Museum

Earl Stroh was born in Buffalo, New York, in 1924. In 1937 he began the serious study of art at the Art Institute of Buffalo. Later, he studied under Edwin Dickinson at the Art Students League in New York City. After attending the University of New Mexico, he moved to Taos in 1947 and studied with Andrew Dashburg and Tom Benrimo. Helene Wurlitzer became his patron in the late 1940's, and he also received grants from the Helene V.B. Wurlitzer Foundation of New Mexico. He was enabled to spend a number of years in Paris where he painted and also studied the techniques of etching at the Atelier Friedlander. During this time he also traveled and studied extensively in South America and in Europe.

He has held one-person exhibits of his work at the University of New Mexico Art Museum, the New Mexico Museum of Fine Arts, the Jonson Gallery, the Roswell Museum and Art Center, the Oklahoma Art Center, Oklahoma City, and the Fort Worth Fine Arts Museum, Fort Worth Texas. He has participated in group shows at the Albright-Knox Gallery, Buffalo, New York, the Pennsylvania Academy of Fine Arts, the Library of Congress, and many others. The artist has also been invited to produce lithographs at the prestigious Tamarind Institute in Albuquerque. In February of 1963, Valley House Gallery presented 31 oils plus several drawings and prints

"The artist has got to have the ability to be both of his time and timeless, to be both personal and universal. Unless he manages to be part of the big chain of creativity that extends from the past into the future he can be no better than a period piece." —Earl Stroh

Fis Leg, oil on canvas, 64 × 74 inches

It is rare that a talent is supported before proof of its maturity, but for **Valton Tyler** the rare is commonplace. In 1970, after briefly introducing himself to us with a few exquisite drawings, arrangements were made for him to use the facilities of the Art Department of Southern Methodist University.

Within two years, Tyler had completed fifty prints. These prints were exhibited nationally, and quickly established, Valton Tyler's mastery of the medium. However, he was no longer pulling prints; he had begun to paint.

Predictably, his first efforts were transcriptions of his engraved images, drawn and colored by brush. But after a dozen or so efforts, it was dear that he had become fluent with oils as quickly as he had mastered the print medium.

continued on facing page

Horse and Rider, oil on canvas, 74 × 84 inches

Valton Tyler (*cont.*)

Since 1973, Tyler has produced close to 200 paintings. His oeuvre demonstrates a progressive yet clearly defined style. The paintings tend to be large, of human scale, and of a consistently high quality. Tyler's subject matter is pure invention, rendered in a realistic manner. Rather than landscapes, his work might best be regarded as mindscapes. Eric Vogel

"The images presented by Valton, never before seen, spring from a purely interior model and present a formal universe of complete invention, a universe inhabited by hybrid figures related through an architectonic materiality, by animal and vegetable creatures and imaginary objects, strangely animated by their tendency to mime organic functions." Jacques Moutoy (translated from the French)

Baron-Renouard was born in Vitre, Brittany, France, in 1918. He studied with Brianchon and Legueult. After building stage settings for several revues, he decided to devote himself entirely to painting. He has participated in the Salon d'Automme, the Salon des Independants, and the Salon de Mai, and received the Prize of the City of Venice in 1948 and won a prize at the Biennale of Menton in 1957. From 1949 to 1953 he held a professorship at the Academie Ranson. He represented in the Musse d' Art Moderne and the Petit-Palais in Paris and has had one man shows in France and abroad. Valley House Gallery has had exclusive representation in the United States beginning in October of 1966.

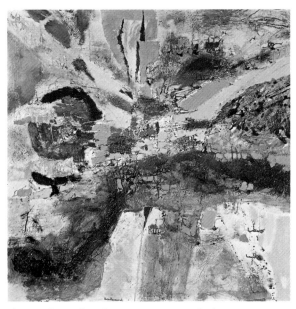

The Dazzling Lake, oil on canvas, 59 × 59 inches

Honegger in his Paris studio

Gottfried Honegger is a creative artist who fits with exactness into our times. As the most exquisitely exact tooling and the purity of precision machines made it possible to land men on the moon, so Honegger's compositions, exquisite, pure and precise, permit no error. From his self-limitations, his exhaustive explorations of circle and square, come a new language of beauty. From a deceptively cool intellectual statement, comes a visual experience which evokes a warmly emotional response. His measured cadences and sculptured forms are ripened by the rich depth of his blues, reds and blacks, and the mind is open to new dimensions.

His sculpture, while maintaining the exquisite precision of his paintings, extends these dimensions to include the total environment. The polished surfaces reflect and become involved with geometric purity in the life of their environment The partial isolation of the paintings is not permitted with the sculpture, for the inner reflected life of the environment is one with the sculpture itself, and the co-existence is unity.

There exists a sincere empathy between Gottfried Honegger and Dallas. His few months as artist in residence at the University of Dallas and as an acutely interested visitor in the Dallas community, have stimulated new directions and vitality in all who have had the good fortune to meet and talk with him and hence to learn from him. The warmth of this rapport that was so established continues to be stimulated by the group of his Biseautages which he created here and left for the area which inspired them.

them all bad except for the two that de Bolli had guided him to. What to do? Otto called his investors and suggested a plan. They all approved. He then returned to Switzerland and acquired several good paintings from the same dealer who had sold him the bad Modiglianis, telling the man he would pay after he received the new pictures in New York. When they arrived, however, he returned the bad Modiglianis to him instead.

Coe Kerr, who was associated with the Knoedler Gallery at the time, told me that Knoedler had participated in acquiring one of these same Modiglianis, had announced that it was bad, and planned to return it. It was placed on the floor, facing the wall, in the main gallery, waiting to be picked up, when one of the gallery's best clients, from South America, discovered it and bought it. She ordered it shipped immediately, leaving a check with the salesman, who was unaware the picture was to be returned to Gerson. Some months later, Coe was visiting the lady in her home and to his surprise, saw her new "prize" proudly displayed. Realizing it was the one he thought he had returned, he asked her where she had bought it. "From you, of course," she replied. He immediately explained what must have happened, and the gallery refunded her money and took the painting back.

I suggested that some plan like this might work for Meadows, though I still did not know the source of his purchases. Klaus said, "Let me call Ralph Colin." Ralph was the founder of the Art Dealers Association, a lawyer, and a first-rate collector. He listened as Klaus related my story, then suggested I call Meadows when I returned and get a letter of permission from him for a panel of experts to review his collection and advise him. There would be no cost to Meadows for this, since the dealers already had planned to visit Dallas for the opening of the Picasso show.

For some, a good stiff drink seems to cure the blues. As for me, my solution was to stop off in Washington, D.C., to visit *The Boating Party* and dream of happily painting happy pictures.

Back in Dallas, I dialed Al's number and learned that he was on the golf course in Palm Beach. He returned my call from the ninth tee and agreed to send me the letter I'd requested. He said that he might not be in town at the time the dealers would visit, but his houseman would admit us, and we

should make ourselves at home. I called New York and sent a copy of the letter to Ralph Colin. It read as follows:

> 261 El Bravo Way
> Palm Beach, Fla.
> January 29, 1967
> Dear Don:
>
> Today on the telephone you advised me there was a meeting of the Art Dealers Ass'n., and it would be possible while meeting in Dallas to have a panel of Experts view my Collection of French paintings and write a report of their Opinion for my information and guidance. This is your authority to have them do this without expense to me, and My Manager, Mr. J.K. Rigsbee, in my office will make arrangements.
>
> Sincerely,
>
> AH Meadows

The plans were set in motion. The panel of experts would consist of Klaus Perls and his wife, Dolly; Klaus's brother, Frank, from Beverly Hills; Stephen Hahn, and Daniel and Eleanor Saidenberg, all from New York; my wife, Peggy, who would take notes; and myself. We would all meet at Valley House and proceed to the Meadows estate. The panel arrived in time to enjoy a cup of coffee and see, for the first time, our home and gallery, which I had often tried to describe to them. I had long held these people in the highest regard for their integrity and their contributions to the world of art. Their presence in my home made me feel still closer to them.

When we arrived at the Meadows home, we were surprised that Al Meadows himself opened the door for us. "Gentlemen and ladies, please come in," he said. "I am pleased with your generous offer to help settle the questions about my paintings." He escorted us inside.

After I made the introductions, Klaus took over. "We might as well start with the Picasso," he said looking at Daniel Saidenberg.

Saidenberg looked it over and responded, "No way." Klaus explained to Al that, in this country, Saidenberg was the undisputed expert on Picasso.

They moved on to the Utrillo. "Utrillo never painted a tree like that," Klaus said. Glancing back at the Picasso and ahead at the paintings to come, he exclaimed, "Elmyr de Hory painted these. Good God! I remember when I helped that. . . This should be the beginning of the end for him." One by one Peggy wrote down the comments. My first judgment was right on everything but some watercolors by Dufy.

All went well until we reached the library. Dolly and I were looking at an Albert Marquet painting of the Seine with a boat on it as Al repeated the story he had told me when I first came to look at the pictures. He added that a man he knew had offered him $45,000 for the painting, and he thought he would sell it to him. I had already told him he should have its authenticity checked first.

Dolly said, "Well, you'd better sell it quick."

Klaus, who was with the others looking at the Modigliani over the fireplace, overheard her and said, "Dolly, keep quiet. Mr. Meadows, you can buy all the fakes you want, but don't dare sell them once you're put on notice that they are bad."

Al became so angry that his face flushed several shades of red. "Nobody tells me what the hell to do," he said. "I do what I want to do in business."

Perls stood his ground, answering, "That's all right; but you're on notice."

At the conclusion of the inspection, Meadows, still flushed, asked the score. Peggy referred to her notes and totaled the count. She handed it to Perls, who then informed Al that of his collection of fifty-eight paintings, forty-four were forgeries. The count proved wrong only for one of the Dufy watercolors, which was later shown to be genuine by the author of the catalogue raisonné, but only when it was opened in Paris to reveal the estate number.

Before we left, Al was informed the panel would furnish him a written report of the findings. He got upset. He wanted nothing in writing. After all, he said, he didn't know if our opinion would prove to be valid anyway. (Later he commented publicly that only a Frenchman can tell whether a French painting is good or not.) Again, we informed him that he would get

the report, but agreed that the dealers would not make their findings public.

Afterwards, we took part of the group to their hotel. The others followed, with everyone planning to get together that evening at the museum opening. Peggy and I had just returned home when Al called, and not too pleasantly asked me to tell the dealers to put nothing in writing, that he wanted the whole affair kept quiet. He spoke as if he thought I had control of those people. I said I'd do what I could, but that since he had invited the Association to his home, it was fairly official. I tried to reassure him that his interest was my interest, and that the dealers wished him no harm. After all, everyone hoped he would continue his interest in art.

That night at the museum opening someone mentioned the events of the day, and it spread like wildfire. It was no longer "quiet" locally. The next day Al, sore as hell, called me and accused me of spreading the story. I told him I wasn't the one and reminded him that I had advised him earlier to buy only from reputable dealers such as Wildenstein or Hahn. On February 8, 1967, I received the following letter on Al's office stationery.

Dear Don:

I was very happy to meet your friends that you brought to my home the other day who are art dealers in New York and California. I listened with complete attention to everything these people had to say, and although I appreciate their comments I am not by a long way being convinced of their conclusions. I will be guided to some extent by what they had to say. I do not want a report written to me of their findings.

Last night, two very important art dealers were at my home. The galleries they represent are tremendous in size. Neither of them belonged to the American Association of Art Dealers. They are too important. Their opinion was quite different in many respects to the opinion of your friends. They do not agree at all that any one can pass upon paintings in an average of one minute each.

On one thing they did agree—that the painting, *In the Flower Garden* was a magnificent painting, but was a wrong attribution. In their opinion this painting should be studied very carefully because the work is so great

and in order to determine for sure and for all time the artist who painted it. They did not believe it was painted by Derain, although in an evening's time they would not make the positive statement that it was not. They believed that it could be by Valtat, but thought perhaps it might have been painted by someone much, much more important than Valtat.

I did not mention to them the names of your friends, nor am I mentioning to you the names of these people. If you will be so kind as to return to me the photographs and the other information I sent to you regarding these paintings I shall be greatly appreciative.

Thanking you for your interest and with kindest personal regards, I am,

Sincerely yours,

Al

One of the two important dealers Al said he would not mention was Frank Lloyd, who controlled the operations of the large and powerful Marlborough Galleries of New York and London. He had been a member of the ADAA until the famous case that involved the estate of the noted painter, Rothko. The ADAA removed Lloyd from its membership when the courts found him and others guilty of manipulating the price of Rothko's paintings. Lloyd subsequently returned to London.

Lloyd oozed authority, money, and social graces. He was tall, his bearing dignified. He clothed himself in expensive, custom-tailored, pin-striped suits, ascots, and highly polished shoes. With a wave of his hand at an *objet d'art* or painting, he could give the impression that his verbiage was completely reliable and should be accepted without question. He typified the type of dealer with whom I avoid doing business. I am equally convinced that he would not have wished to waste his valuable time with me. Men of his type seem to understand the egos of the rich and are always willing to prostrate themselves for a sale. This, of course, is "good business" and is admired by many. Mr. Lloyd obviously planned to sell Mr. Meadows more paintings. Mr. Lloyd must have felt Meadows was a mullet.

On February 15, 1967, Ralph Colin documented the results of the examination by our "panel of experts" in the following letter:

Art Dealers Association of America to Mr. Meadows

Dear Mr. Meadows:

As you know, pursuant to the request and authority in your letter of January 29, 1967, addressed to our Dallas member, Mr. Don Vogel, a group of members of our Association visited your home last week and examined your collection of paintings. Before doing so, they had been supplied by you, through Mr. Vogel, with a copy of an Insurance Appraisal of 59 items in your collection made by Mr. Carroll Edward Hogan of 40 East 89th Street, New York City.

All of the items included in Mr. Hogan's appraisal were available to and were visited by our members with the exception of item 43, the ink drawing on paper by Matisse, which was not available to them.

We regret to inform you that of the 58 items included in the Hogan appraisal which were viewed by our members, it is our members' opinion that 11 of them are or may be by the artists to whom they are attributed, three are probably by established artists but not by the artists to whom they are attributed, and 44 are not by the artists to whom they are attributed.

Since you invited "a panel of experts" consisting of representatives of our membership to view your collection, and write a report of their opinion for your information and guidance, we are reporting to you the opinion which they formed. We deem it of the utmost importance that you have this opinion in mind in the event that you should consider selling, donating or otherwise disposing of any of the items in your collection.

Very truly yours,

Ralph F. Colin, Administrative Vice President

In May, the story broke nationally and internationally. Perls talked to someone with *The New York Times*, and all hell broke loose. The phone rang all day at Valley House as reporters called from around the world—London, Paris, New York; from *Newsweek* and *Time*; from NBC, ABC, and CBS; and so on. Television reporters arrived with cameras, and local newsmen buzzed around. What a carnival! Some press people can be dreadful. It's best to give them nothing, for no matter what is said, they can make it sound negative.

Slowly the story behind the story came to the surface. Fernand Legros, a

naturalized U.S. citizen of French extraction, later identified by Swiss police as "one of the most successful art forgers of the century," and Raoul Lessard, a French-Canadian and "private secretary" to Legros, had learned of Margaret McDermott's connection with the Dallas Museum and had called on her with a car trunk full of paintings. She distrusted their looks and, to get rid of them, suggested that Mr. Meadows might be interested in their pictures. This was just the kind of thing they wanted. They called on Meadows and told him that Mrs. McDermott had said he should look at the rare paintings they had. Her name was the magic key that opened Al Meadows' door.

After the story of the forgeries became known, Louis Goldenberg, president of Wildenstein, told me that he had advised Al what to say to the press and had written a script for him. Al agreed that the paintings should be sent to Paris to be reviewed by a panel of French experts. Al left Louis with three million dollars for the beginning of a new collection and, by admitting his mistakes, became the new hero of the art world. Authorities eventually jailed Legros, Lessard, and Elymr de Hory.

The popular version of de Hory's story was written by the novelist Clifford Irving in his book *Fake*, which I read and found to be full of errors. Soon, I heard that Irving was coming to town to be interviewed by Evelyn Oppenheimer, our local book reviewer. After much hesitation, I called to tell Mrs. Oppenheimer that de Hory was far from a romantic hero, but was instead a sleazy, small-time crook who had left hot checks across the country and habitually used people to his advantage.

I didn't get far, however, for she cut me off, saying, "Mr. Vogel, you are trying to get publicity, and it's not going to work." I was so embarrassed, I could have bitten off my tongue. I was saddened to think that she could believe that was my motive. Not long after, Irving himself was accused of faking material for the biography of industrialist Howard Hughes.

Through the ensuing years we have continued to find fakes by de Hory while doing appraisals, especially in Dallas, San Antonio, and Amarillo. Behind each lies a sordid story and hot checks. Algur Meadows, by purchasing nearly one million dollars in fakes, learned the painful truth that there is no bargain in art if it is not good art. This I have preached and continue to do

so, but few listen. I have resigned myself to believe that people deserve what they get, good, bad, or indifferent.

Five years after closing out the events of the fake paintings I chanced to meet Al at the opening of the James Brooks Exhibition at the Dallas Museum. I told him of some very special and important pictures I had available, especially a painting by Manet, *The Croquet Game*, which certainly was a unique find. The following day I sent him a letter dated August 17, 1972, in which I enclosed photographs and transparencies of twleve paintings. He responded:

> August 22, 1972
>
> Dear Don:
>
> I can see from the photographs you sent me that the collections of paintings you have are really outstanding. For comparison with my own purchases made in the past of paintings by similar artists I would like to have your list show the size of each painting and the offering price.
>
> I am also anxious to see the Manet, *The Croquet Game*, when you receive it. I will try to come by your place when I have a spare moment and view these paintings if you have all of them on hand in your studio at this time.
>
> I am returning the photographs which you sent me.
>
> My best to you,
>
> Al

Al never made another response to my offer. The last note I received from him came on May 2, 1978, in response to my letter suggesting he contact a couple of dealers whom I had visited in New York and who had some extraordinary and exciting paintings. He did not heed my advice, for he had become totally enthralled by Louis Goldenberg at Wildenstein by that time.

Nevertheless, much good came from all this. Al's interest in art grew and matured. He began to give support to the Dallas Museum of Art. He built a museum for Spanish art at Southern Methodist University, with the guidance of Dr. William Jordan, replacing the dubious works with good ones. He planned to leave his collection and support to the city. We all benefitted from this man who started collecting for all the wrong reasons. Good art once again won the day.

The Meadows Caper did have a measurable impact on the art world. Collectors began to look at their pictures in a less casual way. The provenances became more important, and the value of the dealer came to be better recognized. Dallas, like so many cities at that time, was ripe for fraud. Money gushed from the ground. Neiman Marcus sold mink-lined jackets to ranchers and decorated the homes and the clubs of oilmen.

Picture merchants came through the territory and left behind paintings attributed to English and French eighteenth and nineteenth century artists. The unsophisticated bought museum copies of old masters, not stated as such, and fakes. Who was to know? I found such works everywhere I visited: Tulsa, Oklahoma City, San Antonio, Austin, Houston, Fort Worth, and many other communities, but mostly in Dallas.

The local art museums had little real authority and lacked scholarship, taste, and the ability to collect quality art. Verbiage and social connections sold before scholarship and expertise. While visiting my friend Rick Brown, then director of the Kimbell Museum in Fort Worth, I asked what he thought it would take for Dallas to acquire a great work. "Dallas hasn't the balls," he said. "It takes balls to buy a great picture."

The situation was exacerbated by the fact that painting was becoming ever easier to imitate. It relied on controlled accidental results in which a "sense of power" was found, a purposeful lack of composition that had no beginning or end, that could be divided into several parts, each as complete as the whole. There came to be a reliance on the accidental, as in action painting. The preciousness of the nervously scribbled lines and spattered spots were assumed to express some deep, inner meaning. Artists were emoting all over the place. To gain recognition, an artist had to be different, and soon an editor/writer had to be employed to inform the collector what his art was all about.

The hype was on. A market was created, and once the price became large enough, the art was considered legitimate. Bad taste won the day. It was a time of imitators and fakers. A new academy was established. Art became all but pure decoration, a term that was despised by these people. A low sense of thrill was developing in those who marched in step with the ever-lengthening parade.

To the detriment of many regional talents, museums jumped on the bandwagon, buying the works that were being promoted and, in so doing,

proving their own lack of judgment. Everywhere one would encounter the works of the same artist. Other works could be seen only by seeking out galleries. Museum directors gave little time to the talent in their shadow. The prestige of supporting the in-group was too important, and people became captivated with image rather than substance.

In the past, time alone has proved the success of a work. This will continue to be true. It is what makes the pursuit of collecting a challenge. The Meadows affair proved there are many questions to be answered and much to be learned. A major lesson from that whole business is that an ounce of horse sense is worth a pound of misinformation.

Some years later this affair closed on a happier note. A dear friend, Sallie Carter, had invited me to join her and her guests in her box for a Dallas Cowboys game after a fine lunch in the club. At half time I headed to the men's room just as Al was entering. He said, as I tried to pass, "Donald, I'd like to talk to you a minute."

"Not now," I said. "I'm on my way to the men's room. If you're here when I return, we'll talk." I felt indifferent. I had no further interest in talking to him. I had erased him from my thoughts. When I returned, there he stood. This surprised me, and I wondered what he had in mind.

"Donald," he said, "I want very much to thank you. You've done more for me than any other person I can think of. You brought me an interest in art and gave me something I never thought possible."

I was completely taken aback. I couldn't believe it. It delighted me. I said, "Well, I'm glad that something pleasant has come of this, and I'm sorry our relationship had to be strained as it was. The whole problem was the result of a misunderstanding, and I think it was on your part." He agreed. Al had provided a nice ending to the Meadows Caper.

I had reason to be even more grateful our meeting had occurred as it did because, unfortunately, Al died as a result of an automobile accident only a few weeks later.

11

Gallery Follies

Valley House adds a new gallery and new artists

LATE IN 1968, my one and only partner, Vince Carrozza, who had joined me in the acquisition of the Breckenridge estate, suggested a new partnership in which we would open a gallery in the heart of downtown Dallas as part of an ambitious building project called Main Place. When completed, Main Place would consist of four units, including two office buildings, a major department store, a hotel, twelve acres of retail stores, and several well-known restaurants. Vince was vice president in charge of leasing for the complex. He believed the inner city was about ready for a professional gallery with authority, and that Main Place was the ideal place for it.

With the understanding that Valley House would remain my first concern, I agreed to help establish the gallery, control the quality of the art, and find a good direction. We thought it was worth a try.

"Main Place Gallery" opened with a sandpile in the middle of the floor of the print department and unfinished columns. The painters, union men all, left at quitting time. The conditions embarrassed us, but we took it in good humor, humor on which we continued to draw. The gallery, set on the plaza below street level, faced a large fountain with multiple jets that changed

heights on a scheduled time clock. It was a lovely feature, but on windy days we mopped water from the gallery floors. Even those soggy times did not dampen our enthusiasm. We mounted large sculpture about the plaza and

hung tapestries in the halls, and made it a beautiful and large showcase. In fact, we required no fewer than three persons to attend to the gallery at all times because of its size. I blame myself largely for the gallery's failings. I used poor judgment in finding a director and my desire to do things my way, and this situation brought about an understandable conflict with the employees. Events well beyond our control offered no comfort. Not long after the gallery opened, the economy went sour, and the Main Place building project came to a complete stop.

Main Place Gallery, a view at night from the fountain plaza, 1969.

Still, when Peggy would join me for the opening of an artist's exhibition, she'd say, as we approached the gallery, "It looks so beautiful, let's keep it a little longer." But the gallery was robbing me of painting time as well as gallery and home life.

Clients, too, felt something was missing. When I called them to look at a special work of art at Main Place Gallery, they would say, "Take it out to Valley House; I don't want to do that kind of business in town." The time came to throw in the towel and take our losses.

My greatest and perhaps only real disappointment came when I found damaged prints hidden behind paintings in the racks and then heard the artist demand to be paid for prints damaged by customers going through the print drawers, even when only a quarter of an inch of a corner had been bent. We paid the artists in full, and I gave the Dallas Museum its choice of the prints. The remainder went to the Children's Hospital in San Antonio.

It felt good to be home again. Never, never again will I stray from Valley House. I learned from this experience and didn't feel it had been a complete loss.

❋

During 1968 Peggy became ill. The doctors suspected cancer and scheduled an operation to explore a tumor in her breast. The Commander, Nan, and I waited in the family room until the surgeon appeared to ask my approval to remove her breast. For a moment I froze. Must I make such a decision? But, of course, who else? Yes, anything to prolong her life; she was my life too. I loved that woman and wanted everything possible to be done for her. Peggy eventually came home for a recovery period and underwent a series of chemotherapy treatments to arrest the spread of the cells.

A few nice things happened. The Aunt Clara book won the 1967 Southern Books Competition and was listed among the "Top Texas Tomes." The book was really Peggy's creation, and it pleased me that the announcement had come at this time.

I had a one-man show at the Beaumont Art Museum and gave them a canvas sixty by seventy inches, titled *The Wedding Dress*, that I had painted with Peggy in mind. A painting, *The Studio Visitor*, hung at the Hemisfair exposition in San Antonio at the invitation of the event planners. I also had a one-man show at the Shook-Carrington Gallery in San Antonio. From this exhibition, Lady Bird Johnson purchased a painting, *The Yellow Hat*, for use in the White House. I remember receiving a call from Mrs. Shook, full of great excitement.

"Donald," she said, "you'll never guess who just bought one of your paintings!"

"No, I'm sure I won't," I answered.

"Lady Bird! She's taking it to the White House, she's. . ."

"Good God!" I interrupted, "I'm ruined, I'll never live it down, you destroy me!"

"Why, why, what do you mean?" she asked in a puzzled voice.

"I'm a Republican! Now I'll be an outcast," I joked. There was a long pause, then we both laughed at the same time. I assured her that I was grateful for the sale.

Appreciation for Valley House continued to grow. That summer the

North Dallas Chamber of Commerce magazine published an article with photographs, titled, "Valley House Gallery: Oasis of Beauty and Culture." The article told the history of the gallery and mentioned the various exhibitions we had held. The magazine ran photographs of sculptures by David Cargill (*Horse and Rider, Acrobat*), Neujean and Etrog, as well as the entrance to the grounds, the lower fountain pond, the lake sculpture garden, the stream from the lake to the lower pond, the interior of the gallery, me in the studio, and John Morrie in the frame shop. The article concluded,

> Together the Vogels have created, in the galleries and tree shaded gardens of their Valley House Gallery, an atmosphere and a climate of beauty. Their insistence on high standards and sincere cultivation of the best, has formed an oasis at this North Dallas retreat. Their greatest pleasure derives from sharing the excitements and the rewards of participating in fine art with anyone who is curious enough to look, and sensitive enough to see, to enjoy, and to understand.

And of course, along with the community's appreciation, business continued to grow. From my studio and through other galleries, I sold forty to fifty of my own paintings a year. I gave a young Fort Worth watercolorist, Scott Gentling, his first of several shows and produced a handsome catalog to accompany it. That show sold out, as did the artist's second and third shows, at which time I published a second catalog. We considered him a fine painter, but not a very cooperative individual. When one day he had to talk to me about business, I took the opportunity to talk about our differences. He told me that I was making too much money from his work.

"How do you come to that conclusion?" I asked. He said that when I sold a piece for $3,000 I'd take one-third, or $1,000, and which left him only $2,000.

"Look," I tried to explain, "last year I gave you $40,000. I made about $5,000. Now wait," I held up my hand to keep him silent and went on. "I paid for the catalogue, invitations, mailing; I framed your pictures without charge; I maintain the operating cost, the help, utilities, insurance."

He broke in and said, "I don't give a damn about that, your gallery survives on my sales." Again I held up my hand and with a calm more deafening than a roar, I told him, "I was here before you came and I'll be here long after you leave. Goodbye." I thought of Malcolm Hackett saying, "If you find someone who deserves help. . ." Of all the artists I've been privileged to help, this artist became one of the two I dismissed. In both cases the artists were making money for themselves and Valley House, but they failed to understand that we did not pursue our work for money itself. These artists really didn't need us.

In contrast to our difficult artists was the Swiss painter, Gottfried Honegger, whose work we had admired for some time before we met him. Jim Clark, who already had become a major collector of his paintings, introduced us. Honegger enchanted us, and a friendship quickly developed. We commissioned him to do a show, which he produced in his studio in Zurich. It became the first of three such commissions. The second he did in New York, and the third he produced in his Paris studio. All were successful.

When possible, instead of taking our usual commission, we bought Honegger's work for future sales, truly adding further support for the artist. His work, while quite a departure for us, brought us a new understanding. His compositions are exquisite; they are pure, precise, and permit no error. From his self-limitation, his exhaustive exploration of circle and square, comes a new language of beauty that makes a cool, intellectual statement that, I believe, evokes a warm emotional response. His were the first of the Purist school that touched me.

In March 1969 the Mobile Art Center asked me to serve as one of three jurors for the Gulf Coast Art Exhibit at the Center. William Gertz, art historian, and Norman Kent, editor of the *American Artist* magazine, joined me as jurists. Members of the Center wined and dined and received us most graciously. We found it easy to respond to the gentle warmth of our hosts and all those we met. They made this a very special event for the participating artists, giving them much support. It reminded me of the old days in Fort Worth, before they built a new Art Association building that treated art as though it had to begin with a capital "A."

I felt flattered and pleased to accept the Mobile Center invitation to have a one-man show of my own paintings, for this was the kind of audience with whom I like to share my work. They promised a letter to confirm the date of May 11, 1969. I had had it in mind to publish a catalog of my own work, but always hesitated in deference to the artists we represented. But now I could use one. This became my first priority when I returned from Mobile.

With catalogs in hand, the time came to hook a rented trailer behind the station wagon and load it with seventy-two paintings ranging in size from eight by ten inches to seventy by sixty inches. Peggy joined me in driving northeast to Mobile. Mary O'Neill, the Art Center director, welcomed us, as did a woman news reporter who acted as hostess to see to our comforts and to introduce us to the points of interest in and around Mobile. Their hospitality more than lived up to the reputation of the Old South.

The custodian of the center helped me unload and stack the paintings and offered to hang them, as was his custom. I thanked him, but said that I wanted to do it myself. He said that his job involved hanging the shows, and he seemed a bit put out that an outsider should take over. I tried to express as kindly as possible that I must do it my way.

The next morning after breakfast we drove back to the center from our hotel to confront the job of hanging. Several volunteers greeted us and introduced themselves. The custodian stood by waiting for me to ask for his help, for he knew the two large galleries presented a problem to balance. The volunteers also were waiting for my cry.

I walked slowly around the rooms, stopped, looked about, and then studied my audience. I realized that I had stepped onto center stage. Okay, Vogel, let's perform, I thought. I selected the first picture and set it before me on the floor, located the hook and hammered it into the wall, and hung the painting in its place. I chose the second, then the third, and so on, without a scale or level, selecting the next work by size, shape, and color so that the eye would move from warm to cool tones, from an active composition to a simple or quiet one.

My audience began to wonder when I would run out of wall space or have too much. Voilà, the last painting fit as if it had been the last piece of a

jigsaw puzzle. I stood in the center of the gallery to the applause of my audience, all except one: the custodian. No one could have been more surprised than I that the paintings hung so perfectly, but I kept that to myself.

It reminded me of the time I had been standing in the checkout line at a store. The cashier began adding on her register, checking out a woman ahead of me, when I waved my finger over her purchases and announced, "$47.73." The checker pulled the slip and said, "$47.73." They looked at me in awe. I simply smiled.

The opening in Mobile proved rewarding in terms of viewers and sales. Their acquisition committee chose a painting, which I gave them in thanks for all the kindnesses they had bestowed on Peggy and me. Peggy felt in good spirits, but we had an underlying sense of urgency to bring the family together as much as possible. We decided that instead of taking our usual summer trip to the Texas coast, in 1969 we would explore Colorado and revisit New Mexico. Like good tourists, our wagon loaded with all the things needed to make a car trip comfortable, we headed west into the most wonderful vacation ever. Colorado is truly the land of the gods. Thomas Moran and Albert Bierstadt painted no exaggerations. I learned a new respect and awe for their painting.

We took the cogwheel train to the top of Pike's Peak, and nature put on its full show, for on the way up, we saw all the animals one could expect to see. The July heat slowly changed to January chill, and at the top of the peak it began snowing. The skyscape behaved as if it were modeling for Thomas Moran: to the northwest, thunderstorms were clashing; the southwest was brightened by a bright, deep blue sky; to our southeast, sun shafts broke through dense clouds to spotlight Colorado Springs; a gentle snow fell on us from the peak above. Never before had we seen such a show, nature's drama at its best. I could hear Richard Strauss and Wagner.

We kept off the main highways as much as possible to enjoy the wonders of the loggers' and miners' roads. For lunch we stopped near a stream, spread a cloth, and from our basket enjoyed bread and cheese, with wine for us and soft drinks for the children. As a family, in harmony, we drifted for ten days like gypsies, with no set pattern, in perfect weather. The days passed entirely

too soon. 1969 was our last family vacation, and I am ever grateful for my warm memories of that time.

My most popular show at Valley House began to take shape when a local private dealer in Dallas told me about an estate of paintings that included an Inness that looked good and might be of interest to me. I called for an appointment. The house where we met, an old and stately one, had a smell of age and past wealth. In the entrance hall I found the Inness on the floor, leaning against a wall. It was a good size, forty by thirty inches, signed and dated, "G. Inness, 1886," and titled *Harvest Moon*. I asked the price, committed myself to buy, and asked for two days to pay for it. Those conducting the sale agreed. When I returned to the gallery, I called James Graham, a New York dealer friend, and asked if he would like to buy in with me. On my word he sent a check for half the asking price that day.

The estate manager then asked me to appraise the entire art collection and sell it. The collection proved second only to Meadows' for the number of fakes. The "bad" pictures included mostly fake Remingtons and Russells. Several others had false attributions, and a few good ones had been "salted" in. What I learned from the heirs made a fascinating story. Apparently their stepfather, a professor at Southern Methodist University and a much younger man than their mother, had wooed their mother and proceeded to invest her money in "Art." He had worked with a local dealer only too happy to cooperate with the professor's plan to fleece his elderly bride. The husband would buy a picture or two and have his wife pay the dealer, and the dealer in turn would refund most of the gains to the husband. Only one unforeseen event got in his way. He died before she did.

I was pleased to have the chance to represent the heirs, for from that collection, I put together a show, one that gave me the opportunity to illustrate the difference between the real and the fake. It ran from May 10 to June 7, 1970, and we encouraged the viewers to try to determine which paintings were fake.

The results shocked me for, almost without exception, our audience preferred the fakes over the genuine. Mitch Wilder had been kind enough to lend the Remington *The Grass Fire*, one of this artist's greatest works, and beside

it I had hung a bad copy. Because the bad copy had been signed, it joined the rank of fakes. Only when I pointed out what I considered the most obvious flaws did the audience agree. Worst of all, painter friends who taught at the universities couldn't tell the difference.

On one wall I had five pictures signed G. Inness. The largest (forty by sixty inches), titled *Golden Afternoon*, had been painted by his son. Another was badly skinned when cleaned and had much overpaint; still another was

The Grass Fire, *by Remington on loan from the Amon Carter Museum.*

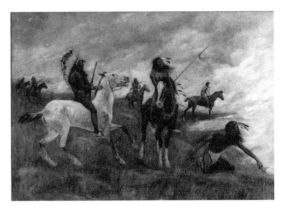

A fake painting signed Frederic Remington, after The Grass Fire.

an outright fake; and finally, I had hung the beautiful *Harvest Moon*. Other paintings included several false attributions to Gainsborough, Lawrence, and Van Dyke. I talked and talked, trying to involve everyone possible.

I made a set of slides so that I could lecture to groups, one of which included the Dallas Woman's Club. At the time I hoped these lectures actually served to bring about a greater awareness, but I often doubt it. The day the show opened, a lawyer representing the Joseph Sartor Gallery, who had sold the paintings, called and threatened to sue me. I invited him to be my guest and by all means, sue; I even challenged him to do so. I never heard from him again.

I did hear about angel wings from the Baptists.

12

Angels and Other Gifts

I HAD BECOME involved with the Joseph Boggs Beale estate and eventually bought it all. Beale, who lived from 1841 to 1926 in Philadelphia, painted illustrations for lantern slides. He was the oldest son of a large, lively, and prominent family, and the great grandnephew of Betsy Ross. Beale's diary vividly chronicled his enjoyment of cultural and art events as well as history as it unfolded before him. I acquired over 1550 of his gouaches in black, white, and beige, which made up the total of his works known to survive. We divided them into three groups: Americana, History and Literature, and Religion. It took a few years, but we sold them all, with a few adventures along the way including one with the Southern Baptists.

I had convinced myself, because of my strong sense of placement, that the Southern Baptist Convention could best use Beale's religious illustrations in their published books for church and Sunday school. I made an appointment to visit with the head of the Baptist Convention art department and book editor, and took a plane to Nashville, Kentucky. From the airport a bus dropped me at the door of a building that seemed second only in size to the Pentagon. Entering, I walked up several marble steps to a large entry hall, received a

badge that authorized me to be there, and got instructions on how to proceed. Maybe the badge acted as security against Methodist spies or some such thing.

I proceeded up more steps and down a long tunnel-like hall with doors on either side lettered with names and positions, dozens of them. A turn to the right at the end brought me to the elevator that carried me down four floors to a storage area with acres of wire cages holding thousands upon thousands of books. After walking between cages and making two turns, I arrived at double doors with lettering announcing they led to the Art Department. The room looked immense.

The receptionist said, "We were expecting you, Mr. Vogel. Your editor is in a special conference and will join you soon."

A young artist came from one of the studios and introduced himself. He became excited when he learned that I had a gallery and wanted to send me some work. He showed me into a conference room, and I opened my box of selected Beales. He called in some of the other artists, and they all expressed great interest and began planning ways of using them. When the head man appeared, they disappeared. As he looked at the pictures, I related the history of the artist and his work. He was well impressed.

"Let me call in our expert. He must okay the details such as costumes and furniture and the architecture, for it must be right for the time and place depicted," he said.

In a few minutes the expert, a solemn-looking man, arrived. We exchanged greetings in a formal manner, and he picked up one of the drawings and studied it a few minutes. We all remained silent.

"This is quite good," he said. He picked up a second, then a third. "Good, very good." Then as he lowered the painting of the good shepherd onto the table, he raised it again and said, "We can't use these."

"Why? What's wrong?" I asked, looking at the good shepherd, the Christ standing in the center of a flock of sheep with a halo of angels around his head and shoulders.

"Baptist angels," he said without humor, "don't have wings."

I lost the game. Without thinking, I challenged his authority, demanding, "How the good hell would you know if angels had wings?"

He looked at me in pity, as if I were a bug to be stepped on. "I will not agree to this work. Goodbye!" He turned and disappeared.

"Did you know that Baptist angels don't have wings?" I said, somewhat in jest, to a lady who came to the gallery to borrow a sculpture for her church.

"That is true; it says so in our Bible," she informed me.

I guess God can't trust Baptist angels too far and refuses to hand out wings to them.

In the first week of June 1973, Peggy and I went to New York to look for paintings for prospective buyers, but mostly to enjoy looking at some favorite masterworks, attend the theatre, and treat ourselves to a few elegant dinners. We kept to ourselves as much as possible. On the way home we stopped in D.C. to revisit *The Boating Party*. On the flight home, we talked of the possibility of another family outing like our last motor trip, this time perhaps to New England or the northwest. We decided to see what the kids would prefer. It was a pleasant dream that was never to be realized.

I took Peggy to see her doctor for a checkup on 4 August, expecting the usual half-hour visit. Instead, the doctor sent me home to get things Peggy would need for a couple of days' stay in the hospital. He wanted her there for tests right away. He dismissed her after two days of testing, and asked us to return on the tenth to discuss her condition.

I waited in a small office while he examined her in an adjoining room. The sounds of their voices penetrated the walls; the doctor's voice was rather loud. He asked her to dress and return to the office. He came in and motioned me to remain seated, and he spoke, as if to the air or the walls, or to himself, "Mr. Vogel, your wife is dying. She has a year or a little more. I tell you this so that you can get yourself and your business affairs in order. This is a 'guesstimate,' of course, because we have no sure way of knowing."

"Does she know? Did you tell her?" I asked.

"No, there is no need to at this time. It may help her fight if she doesn't know," he suggested.

Peggy opened the door. My heart sank deep into my bowels as I smiled and asked, "Are you ready to go?"

The doctor said to Peggy, "I want you to check in at St. Paul's Hospital for further tests tomorrow and start cobalt treatments."

Tests, x-rays, scans, and treatments filled the next eight days. Peggy took this in good spirits and retained her good humor. We were so happy to see her come home afterward. In two months she would have to return for another operation that would hold her condition at bay for another year.

A pleasant event happened at this time when I hired Becky Reynolds, a bright, happy young lady, to help in the gallery as secretary and curator. She had it all together, as they say, with boundless energy and good nature. Given Peggy's illness, we needed just such a spirit at this time.

<center>✳</center>

My affinity for naive works of art brought me into contact with the naive painter, Velox Ward, of East Texas. We had much success in promoting and selling his work. As we had with Aunt Clara, we arranged with Mitch Wilder to have a traveling exhibition at the Amon Carter Museum. Velox behaved like a tough old coot who, I believe, distrusted all living beings. He had convinced himself everyone was waiting to get him ever since, as he told me, he borrowed money from a bank to buy a horse just before he married. A young man needed a horse, not only for transportation, but to work, and he could not support a wife without one. The bank seemed pleased to lend such an enterprising man the money to help him start his new life. When the proper notes were signed, he had his horse, and all went well for him and his new bride for three months. Then the horse fell dead, and he had to pay the bankers for a dead horse.

We produced a good monograph catalog for him, and he demanded that all royalties go to him; we were not to profit from his talent. We received no royalties and had not even any thoughts of such, but I suspect he still did not believe us. Nevertheless, I liked this fellow, for even with all his suspicion he had a good humor.

One day I had a call from an oil company that wanted to commission Velox to do a painting for them for advertising purposes. Without thinking, I told them I was his dealer, but it would be more expedient if they dealt with him directly, and so gave them his telephone number. The oil company commissioned him for $5,000, but the billing never came through the gallery.

Instead, he came and moved out all his work, saying he no longer needed us. We removed our frames and wished him well. I am sure he will never understand what Valley House did for him, but we are grateful for the pleasure his work gave us.

The misunderstanding with Velox reminded me of our relationship with Southern Methodist University, which seemed destined to provide little benefit, except for a few dear friendships. Decherd Turner, a rare, learned man, who was head librarian of the Perkins School of Theology, came by the gallery to introduce me to the mandalas executed by Dr. Joseph D. Quillian, Jr., Dean of the School of Theology. This rare art form has been done since ancient times by a few intellectual men scattered throughout the world. Decherd thought them worthy of a show, and I could only agree. Although I knew the audience would have to be a select one to understand the meaning of this exercise, I felt we could perhaps enlarge the number invited.

Decherd left it to me to tell Quillian that he had approached me about a show. Quillian was quite surprised at the prospect, but agreed with good grace. The exhibit proved more of a success than we had hoped.

My friendships with Dr. Bill Jordan, Director of the Meadows Museum of Spanish Art and acting head of the art school, and Larry Scholder, head of the print department, also permitted me to sponsor a totally unqualified talent to join the print classes at SMU. This curious course of events began with a visit from a man named Robert Tyler, who only wanted some advice about what to do with his brother, who was something of a misfit and whom the family could no longer afford to support. The brother had been in and out of the hospital for disturbed patients in Terrell, Texas. Robert opened a portfolio to show me some of his brother's drawings, and that was enough. I asked Robert to bring his brother in the next day and said that I would be more than pleased to visit with him. The next day they arrived as scheduled.

Robert said, "This is my brother Valton, whose drawings you looked at yesterday."

I offered my hand; Valton hesitated, finally decided I was no threat, and slowly gave me his. "Sit down and tell me about your work," I suggested. "How long have you been at it? What do you wish to do or like to do?"

He slowly began to relax and told a very sad tale. He had been born in Texas City to a father who painted automobiles, a drunkard known to beat Valton at times. Valton's mother was very religious. To escape from them, and from the taunts at school, Valton would retreat into his room and draw things not of this world. The family barely got away with their lives when one day the chemical ships blew up, destroying a good part of Texas City. He recalls the family running beneath a blood red sky of fire as their home was consumed. The experience left its mark.

As we talked, someone came into the viewing room to see me. Valton got up and stood facing the wall in the corner. After the intruder left, Valton returned to his chair.

When Valton came to Dallas, he continued to paint and draw. After he had completed several paintings, he would leave them on the street corners, and the next day when they were gone, he felt rewarded that someone liked them enough to take them. With this validation, he painted more and left them to be taken. Later it was proved to me that this story was true: a stranger offered to sell me a couple of the paintings he had found on the street. Valton was truly a desperate soul trying to express himself, and I knew I had a talent to support.

To what degree, at the time, I didn't know.

"Valton," I asked, "have you ever made a print? No? Would you like to? I think you are a graphic artist and, if you like, I'll try to set you up at Southern Methodist University in the print department. The head of the department is a good friend and a master printer." He nodded his assent.

"If I can pull this off," I continued, "I'll pay your expenses, buy your plates and paper, and buy your production if you do well and stay with it. Agreed?"

"Yes, I will," he eagerly responded. "I'll repay you, I'll. . ." I stopped him, "Don't promise, just produce." I went to the phone and called Bill Jordan and told him what I'd like to do.

"If Larry thinks he's worthy," Bill said, "it's okay with me." I called Larry, and he said to send Valton over. I had taken on a new expense that, at the moment, I could ill afford, but it had to be, and I never doubted that it would work out.

"Keep in touch and let me see your first print," I said in parting. What an experience it turned out to be for all of us. The students in the print class, who were learning technique and were required to pull three prints for a grade, soon stepped aside to watch the performance of an artist who had something to say. Valton worked at his job days and pulled prints throughout the night. At times the students found him asleep on the floor with his works taped to the wall to dry. He was possessed; print after print I applauded as he brought them to me. "When you make fifty different prints," I told him, "I'll publish a book on them."

At the time he already had almost forty, and I had no fear that he could produce ten more. I commissioned Becky Reynolds to interview Valton, to take him to lunch or whatever, and write as much as possible about this fellow, because someday we would need the information. When Valton had a body of work, we would have a show and introduce his work. Southern Methodist University agreed to be the publisher. We would not know until years later what a happy ending the Valton Tyler story would have.

※

About this time, a pleasant and welcome event occurred when the Trammell Crow family acquired one of my larger paintings for their living room. Margaret and a couple of the children visited the studio and chose two canvases to try. We delivered them to their home for the vote of the whole family. The majority voted for one titled *The White Cloth*, a painting fifty-six by sixty inches in size. The painting depicted a figure against a white curtained window in profile, adjusting a white tablecloth. A vase of day lilies and suggested fruits and soft shadows patterned the white areas. It is a quiet picture with a tender, glowing, warm light that pervades the whole surface.

Their purchase genuinely touched me because it seldom happens that a concerned, loving family shares in the choice of something they will live with daily. In addition to the Vogel painting, the room supports a beautiful Gustave Caillebotte landscape, beautifully rich in surface and color, and a very important Renoir that literally shimmers in its brilliant brushwork.

One of Trammell's favorite stories, and mine, is how often his guests admire my painting and at times have favored my painting over the others, until they ask about the painter. When he informs them that it is a local artist their interest disappears. "You see," he will continue, "if you were imported, you'd be great."

The superficial reasons people give to accept or reject art, even the great works of art, never cease to amaze me. By chance, I learned the reason for such a rejection that had puzzled me for years.Some years earlier when Mrs. McDermott stepped down from the presidency of the Dallas Museum Board, she came to me in the hope of finding a painting to give the museum. At the time I had the greatest El Greco, and the only one in the area. It was entirely El Greco; no other hand had touched it.

Mrs. McDermott seemed moved by the painting, and I tried my best to convince her of its importance. "I'll have to let a committee see it." she said. "Bring it over to the house, and I'll let you know tomorrow."

"Can't they come here?" I asked. "The conditions will be better, and I can tell them about it."

"No, I want to show it alone," she insisted. The next morning she called and asked me to pick up the painting. They didn't want it.

"Why?" I asked.

"Never mind, just pick it up."

A major museum in Germany acquired the painting shortly afterwards. For years I wondered what could have motivated them to reject such a rare masterpiece for Dallas.

Then one day in passing I related this incident to Bea Haggerty, the wife of Pat Haggerty, one of the founders of Texas Instruments. She had a fine collection of religious art, and while I was hanging a large work by Igor de Kansky in their family room she solved the mystery

"I'll tell you what happened," Bea said. "I was there. Stanley Marcus told her, 'The museum doesn't need another religious picture, and besides it is too symmetrical.' That's why you didn't sell your picture."

I choked in disbelief.

❋

The garden continued to grow more beautiful, all traces of the flood disappeared, and business improved with each new show. Our annual spring sculpture garden show grew in its popularity. We have always been pleased to share Valley House with groups, students and clubs, for lectures or musicals. We became part of a city tour for convention visitors. To entertain them, we erected a tent I made from a parachute, which we draped around a tree and supported with a ring of one-by-two poles. From there we served our guests lemonade, fresh and sparkling, from a five-gallon glass bowl. We never tried to sell at those times. Our interest was focused on leaving the visitors with nice thoughts of Dallas.

On one occasion, a tour got out of hand. I was due to be in court to stand witness for my brother, who was charged with a D.W.I., when six large buses, two of them double-deckers, came down the drive and took over. They parked off the driveway on the grass between trees, making a hell of a mess. I tried to stop them, but got there too late. Hundreds of conventioneers' wives poured from the buses and swarmed like ants over the property.

I had to get dressed and away to reach the courthouse on time. I put John Morrie in charge and went in to change my clothes. To my horror I met a line of females entering the house. Peggy and the maid were in the garden serving lemonade, so the house stood unprotected. Pushing my way in, I asked them to leave. Again, I had gotten there too late, for they now wandered though every room. I yelled at them to leave. They just looked at me, as if saying, "I paid for this tour so get out of my way." In our bedroom I found them opening drawers and closets, feeling the underwear. I begged them to leave. Finally, I brushed a couple of them aside and gathered the clothes I needed for town. I had to go to the children's bathroom to dress.

I called John to the house, told him to throw the women out, and tried to drive through the congestion. Getting out was not easy, because the buses had begun maneuvering to head out before their passengers returned, and the huge vehicles now blocked the driveway. By driving over the grass, backing, and pulling ahead, I finally got to the street. I hated to leave the property

to such an untethered mass of humanity, but I had a brother in need. From then on when the buses arrived, we locked the door to our home.

Even with such comical disruptions, our days remained pleasantly full, and the compactness of home and gallery, along with good help, made many things possible. We enjoyed the services of a good yardman, Pedro, an elderly Mexican gentleman who kept himself busy at a moderate pace all day keeping the grounds well groomed. John Morrie, framer and handyman, seemed like one of the family, especially to the kids. They all loved him and looked forward to visiting him for his endless stories. A maid, an old-fashioned black lady named Ruthrine Ross, whom we called Ruth, acted as a second mother to all of us. She also served as a second nurse for Peggy and provided loving care, treating Peggy as if she were her own daughter. Becky Reynolds, the brightest of bright young ladies, kept the gallery working, while I painted or took care of my interests in and out of the gallery. Another loyal member kept us honest, our beautiful—in every sense of the word—bookkeeper, Carol Williams.

All these people were indispensable to the operation of a simple business that survived in spite of itself. Looking back, if one ever should, I don't know how we did it. The hard times, though, lay ahead, because our real motivating force, Peggy, continued slowly to fade. Her vital input seemed to ebb away. These were the saddest of times, punctuated by moments of happiness and pride.

In 1973, Southern Methodist University Pollock Galleries opened the first of several Valton Tyler exhibitions, and the University published "First Fifty Prints of Valton Tyler." At Valley House we opened an exhibition of color photography by Ulric and Marie Meisel, which was attended by a huge audience of photographers. All of them wanted to know what film was used, the lens speed, the kind of camera used, and other technical matters; not one had any interest in buying, for they could take their own photos. This was a popular show and easy to enjoy.

Peggy's condition demanded more frequent visits to the doctors, more lab tests, and frequent short stays in the hospital. Eric continued studies in Austin and became involved in producing the first book published on electronic music, *The Technique of Electronic Music*. At the same time, he served as man-

aging editor of the small magazine, *Interstate*. Kevin graduated from high school and spent most of the summer working in the gallery. But on 6 September, Kevin at eighteen years of age left for Europe to explore England and the Continent, with Eurail and hostel passes in hand. The next day Peggy had a minor stroke during breakfast. The day after her stroke, a tremor affected her arm in the morning, and early the next day she fell. Then for three weeks all seemed to go well. Cheerful letters came from Kevin and helped to keep our spirits up. Peggy could no longer write, and typing became painful.

In her last effort, she wrote a note to me on our twenty-fifth wedding anniversary. On a simple folded white paper she typed October 4, 1972, in the upper right corner. Three spaces down and to the left she wrote: "Sharing life with you in such love and happiness and excitement for these wonderful years is the greatest fulfillment I can conceive. You are my whole world and I love you totally." She printed, "Peggy." I hold this note as I copy these words and feel an aching, swelling pain of love and pride to remember what that lady gave and what she left me.

Three days later we returned to St. Paul's Hospital for a brain scan. I took it upon myself to call a friend, Dr. Charles Simpson, considered by his peers to be one of the best neurosurgeons in the city. He said, "Bring Peg in, and we'll discuss the problem." For the first time we listened to a man who spoke in simple terms that we understood as he explained what was happening and what to expect. An anteriogram showed that a second tumor had developed which could and should be removed. The original tumor, inoperable, was slowly closing off her ability to speak and control her limbs. I explained that we no longer had insurance, but I would pay his bill in time.

"No," he said, "there will be no bill, just give me one of your paintings."

"Any one you want is yours," I said in gratitude. On 15 October, the good doctor operated. Marvin Krieger stayed with me through lunch. Soon after, the doctor gave us his report. It was not good. A week later I brought Peggy home.

Wonderful letters kept coming from Kevin, but the most moving of all arrived on a postcard with a reproduction of *David* by Michelangelo. Kevin wrote:

Dear Dad,

I would like to thank you for this trip, but I really don't know how. The experiences I have had so far have really been beautiful, worthwhile, and I feel, invaluable. Today I stood before David. This experience alone is enough to make anyone feel small and reverent. I feel greatly privileged to be able to see these great works at such an early age, or at any age for that matter. It is a shame that everyone can't see these things, because I feel that it would add a greater view to anyone's life.

Please give my love to all, Kevin

Kevin returned home in good time, for we needed his presence in the gallery to free me so I could look in on Peggy. We brought in a nurse to help and a wheelchair so that we could get out to a restaurant or enjoy the garden now and then. Becky left us to marry a young doctor, and in her place we employed a married lady, Ira Jane Hurst, who took hold with authority and held things together. The good Doctor Simpson came to the studio with his charming wife to visit and pick out a painting.

Peggy was confined to bed, never to get out again. Her speech all but ceased, as did the movement of her arms and legs. I rented a hospital bed and had it placed between our bed and the greenhouse so that she could enjoy the changes of the day. I hoped that the warmth of the sun and the fresh blossoms of plants I kept changing would bring her whatever cheer was possible. At night I became the nurse to minister to her needs. I talked to her about the day's events and visitors to the gallery. Her dearest friends visited often during the days, especially Joy Krieger and Billie Anastasi, who spent many hours at her side.

In this time of deep concern, I filled in as both father and mother to Barley, who was barely ten years old and bewildered by the loss of communication with her mother. Barley retreated more and more into her books and began writing little stories and poems that I would read to entertain Peggy.

How I wished that Peggy could have met the beautiful young nude, *Nana,* who would soon become a part of our lives.

13

Nana

A beautiful lady finds a home

I HAD RUN an ad for Valley House Gallery in the *Wall Street Journal* for a year without much result, until one day in late March 1974 I received a call from a Mr. Sutton, who lived in Beaumont, Texas. He said he had seen our ad and had investigated the gallery. He had a painting he wanted to sell. I simply said, "Yes," and he went on.

"It is called *Nana*."

"Good God," I interrupted, "you don't mean *Nana* the nude?" and I described the painting to him.

"Yes, that's it," he said. "How do you know about it?"

I told him I had seen it in San Antonio when I was about seventeen or eighteen. I had paid twenty-five cents to see it and spent two hours or more in awe and disbelief that such a painting was possible.

"Would you like to sell it for me?" he asked.

"Yes! By all means. I'd love to have *Nana*," I replied with excitement. I could not believe *Nana* was coming back into my life. I told him I would immediately send our van for it. And so began another adventure.

Kevin and John left early the next morning for Beaumont to meet with

Mr. Sutton at his car agency. There, with the help of six other men, they loaded a very large and heavy sea trunk into the van. Kevin signed a receipt and received three keys, one each for the locks on the front and both sides of the trunk. The trunk had been painted red, had steel straps, measured seven by ten feet in size, was six inches deep, had been fire-proofed, and was covered with labels from its many journeys.

Unloading the fireproof case containing Nana *at the Kimbell Art Museum, 1974.*

"Close it up," I said when I opened the van and saw what the truck contained. "We'll take it to Perry Huston at the Kimbell. It will need to be checked and a condition report made."

Once the van arrived at the loading dock of the Kimbell Art Museum, a forklift truck unloaded its burden. Workmen laid the trunk flat on the concrete floor, and Perry, one of his assistants, two guards, Kevin, and I watched as each key unlocked the case that had bedded *Nana* for so long. Slowly we raised the heavy lid, fearing that we might awaken this lovely lady too quickly, before she could gently get used to the light. The stretcher had four metal plates that extended over iron strap bars, two on each side, with a bolt that secured the painting firmly to the bottom of the trunk.

My heart sank when I saw the miserable mess inside. What a tragedy. The painting was absolutely filthy! No one had ever cleaned it. They had just kept pouring varnish over it to try to get more color from it. The image was barely visible. We removed the bolts and stood it up, hoping the better light would help, but it only made it worse.

Perry said, "Let's take it into the studio and see."

We put a dolly under it and rolled it through the museum's main hallway, through the office waiting room, into the lab. Perry looked at it through a sniperscope and said, "It's clean under all that stuff and looks real good."

We decided to have it lined, put on a new stretcher, cleaned, and surface-coated.

I called on art historian Becky Reynolds to write an article on the history of *Nana* for possible magazine publication. Our publishing efforts failed, but

the piece was so well done, I want to share parts of it in an Appendix. She described its creation by the mysterious Gospodin Marcel Gavriel Suchorowsky in the late 1870s. *Nana* is the only work of his known, although he exhibited internationally. John Frederick, an American impresario, began displaying *Nana* to huge paying crowds in the mid-1880s. It was inherited and similarly displayed by John's son Harry through the 1930s, when it disappeared from public view. Harry died in 1962 and left the painting to his children.

And that's where I come in. In 1978, one hundred years since Suchorowsky began work on the canvas, Valley House Gallery arranged an exhibition for *Nana* at the Amarillo Art Center in Amarillo, Texas. Every effort was made to recreate the ambiance in which *Nana* had always been displayed. One gallery room was devoted to her alone. The raised platform, the red velvet drape and the theatre lights at the left were all in place once again. At the entrance to the room were reproductions of the posters from the "nineties" bearing *Nana's* name in bold letters and the Imperial Russian insignia. And to complete the event, a barker paced back and forth beckoning the crowd as he cried out: "She all but lives! She all but breathes! Two bits for a ticket to see the Unforgettable, the Wonder of the Art World, NANA."

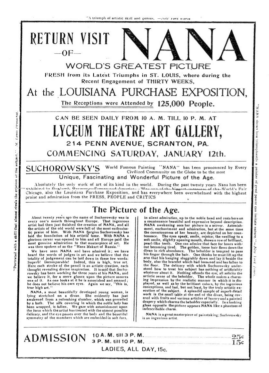

Selling *Nana* became more of a challenge than I had imagined. I knew its size would be a factor and, for most museums in our Bible Belt region, its subject would not help. After many good tries, however, I came up with the most brilliant idea of all: Las Vegas. I could see *Nana* hanging with proper lighting in a plush, opulent room where people could relax with their sorrow in losing a dollar or so and know that *Nana* would give them comfort. What a kind gesture it would be for a club to share such an aesthetic experience.

After many calls, I learned that one man had the power to decide what

happens there in the world of entertainment and anything related to it. He was the one to approach. I called his number, but he was out of town, and someone advised me to send whatever I had and follow up by phone. I sent off my package, writing the whole history of *Nana* with news clippings, photos, and a large color transparency. After a few days and many tries, I got this rough voice on the phone that said, "What the hell are you talking about?"

Nana *by Gospodin Marcel Gavriel Suchorowsky, on view in the Nana Grill, Anatole Hotel, Dallas.*

I explained, or started to, when he said, "That junk? I'm not interested, I threw it in the trash."

He hung up. I should have known better, I deserved it. There are other worlds out there that I know nothing of.

After that experience I occasionally brought *Nana* out to share with friends. I didn't want to exploit her. But one day Margaret Crow was visiting the studio to look at some of my most recent work. We then walked up to the gallery, where by chance I had *Nana* on the wall. Margaret was enchanted and said, "I am going to bring Trammell out Sunday and let him see it. I won't say a word so it'll be a surprise." When we entered the gallery the following Sunday, and Trammell looked at it, he said, "I know exactly what I'm going to do with that. . .I'm building this new addition at the Anatole (hotel) with a bar on the top floor, and we're going to call it the 'Nana Room.'"

Nana stands now as a landmark, the most travelled and gorgeous bar painting in the world.

14

Loss

We bid farewell to Peggy

THE EXCITEMENT of working with *Nana* helped divert my thoughts for an occasional few moments from Peggy's steadily deteriorating condition. I hoped that she could hear me, though I received no response, as I reported events of the day and related whatever pleasant gossip possible. In my restless sleep sometimes I hoped that when I awoke she would already have died. When I did awake, I suffered a dreadful sense of guilt and hastened to check her breathing. Her eyes lost all expression, and it made me feel so totally helpless. Thank goodness I had Barley to get ready for breakfast and school.

On June 7 1974 in the morning, Peggy lapsed into a coma. After lunch Bishop McCray stopped by to visit, and I walked with him to the gallery. We had just begun talking in the gallery viewing room, when Billie Anastasi—who had come to sit with Peggy that day—called me and said to come to the house quickly. There wasn't much time. I excused myself, saying nothing to the good Bishop about my reason for leaving. I arrived to hold Peggy's hand for several minutes before she left us. I asked to be alone for a moment in the hope that my thoughts would be shared with her. By chance, Marvin Krieger came by, and Joy Krieger soon followed. I am ever grateful for the love and comfort these good friends continued to extend.

I had a great distaste for funerals, based particularly on my own experiences of attending my father's funeral in Phoenix, Arizona. The weekend before he died, he and his new wife had stopped by to visit his grandchildren, Eric and Kevin. Barley was not yet on the scene. It was his first visit to Valley House, and he seemed quite impressed. During the afternoon, the two of us walked up the drive to see the gallery and shop. When we returned to the house he asked, "Donald, do you think you could handle a large sum of money?"

"I don't understand what you're referring to," I answered.

"Well," he continued, "I've made another mistake. My marriage is not happy, and I hope to get out of it. Your brother's marriage is a disaster, and you are the only one in the family to succeed in having a happy, good life. I see and feel it all around you. So when I get home, I am changing my will and setting up scholarship funds for your boys, leaving you an important sum."

"Forget it," I told him. "You didn't help me when I truly needed it, and you should know by now I have to do it my way. Big money is a curse as far as I'm concerned. It robs you of the joy of the challenge, and I hope never to make it a goal in itself."

"All right," he said, "I understand, but nevertheless I am going to do it."

He then changed the subject as we entered the house. Three days later in a hotel room in Denver he awoke, left the bed to go to the bathroom, and dropped dead. The undertaker placed the body in his most expensive casket and shipped it to Phoenix, where Dad was to be cremated. There would be no refund on the unasked-for casket, so I insisted the undertaker give it to the next family who could not afford one. A minister, recommended by the funeral parlor, gave a talk selling his own church, exhorting one and all to "save your soul." I found his behavior totally distracting, and it was very poor salesmanship! Then and there I vowed to myself that this would not happen to me or mine. In place of a funeral service for Peggy I wrote the following note to all our friends:

It is with deepest sorrow that I write to acquaint you with our great loss. Peggy died at 2:30 in the afternoon of June 7th. To honor her wish, as decided between us long ago, there will be no services. Her presence will

continue through the gifts she passed on to Eric, Kevin and Barley, her writings, and the love she shared with all she knew. For myself, I have been privileged to have shared love, constant friendship and a full partnership with her for more than twenty-five years. Her spirit gave inspiration; her sensitivity and discerning eye excelled in judgment and taste; her talent produced articles and books of merit. Most of all she created a pleasant, warm atmosphere that made each day more rewarding. She will be missed and remembered.

Before returning to school in Austin, Eric asked to visit with me alone. He had a decision to make involving the family, and Barley's reaction especially concerned him. We were in the gallery when he described his dilemma. He had been thinking of giving up his apartment and moving in with his longtime girlfriend, Elissa, whom he had dated since high school days at St. Mark's School.

"Do you really like and respect Elissa?" I asked. "If so, would you marry her?"

"I never thought about it that way," he said. "When I get back I'll discuss it with her." That was the end of that. . .or so I thought.

Our first garden wedding and reception took place on the 3 August, 1974. Eric and Elissa married as they stood on the island surrounded by the pond in the garden at Valley House. A stone sculpture pedestal served as an altar. Barley, as flower girl, and as happy as any ten-year-old could be, tossed petals on the curved bridge and into the water as the bride and groom approached the altar to take their vows. The many guests lined the opposite shore of the small lake to witness the happy event. After much food, drink, and music, the newlyweds retreated to Austin and subsequently purchased a house in Richardson, about a ten-minute drive from the gallery.

For me, a new challenge arose: what to do with a ten-year-old daughter? I asked myself, what do I know about women other than to love them or paint them? To remedy this, I went to a bookstore and bought a very heavy book, *All About Women*, and I soon became utterly fascinated at just how complicated females are. It's a wonder they can outlive the male of the species. I read every four hundred and some pages of the book, looked in awe at my little girl and wished her luck.

I took her with me to Houston for the opening of Valton Tyler's print show at the University of Houston. We spent the night with my brother and his wife, Tony, and headed for San Antonio the next morning. There, as a tourist, I showed Barley the Alamo and the zoo in Brackenridge Park. We also visited John Leeper, director of the McNay Museum. It was a good trip and gave us a better understanding of our need to help each other. Peggy had done a good job. I had a fine family, one whose members would help each other and me in caring for all of us.

15

Conflicts

The IRS and Other Personal Losses

THE CRUELEST OPPONENT one can have is the Internal Revenue Service. If a person can survive its assault, all other hurdles seem insignificant. When I lost 150 of my paintings in the flood, the IRS ruled the paintings had no value other than the cost of the material. The formula for calculating estate taxes on my work was different. Because Texas is a common property state, one half of my paintings belonged to Peggy's estate. However, this time the IRS valued them at retail cost as if they'd already been sold. The IRS agent explained that when and if I actually sold the paintings no tax would then need to be paid. The IRS required that I pay immediatcly or clsc pay interest and penalty on the tax at whatever future date the paintings might be sold.

This IRS edict had a certain déjà vu. That dark day when the IRS agent had first visited us in 1963 and informed us that we must pay taxes on the total sales in the year of the sales, whether or not we received the income then, had given us a foretaste of the way the IRS worked. The first time, the agent's one kindness of telling us not to worry, that we could pay our taxes out over time, only brought us more trouble. His reassurances caused us to relax and wait for the IRS bill. That was a mistake.

We pushed the IRS bill to the back of our minds, and Peggy and I packed the car and took the family to Port Aransas on the Texas coast for a holiday. How well I remember the day we returned from our vacation.

It was hot, the hottest day of the year in mid-August, and in the cloudless sky the sun beat down relentlessly on our overcrowded station wagon. As we passed by downtown Dallas on the Stemmons Freeway, just fifteen minutes away from the shady protection of Valley House, the left rear tire exploded with a bang-floppy-flop. I pulled off the freeway streaming with traffic. A half hour later, having secured the wagon door and reloaded the suitcases, beach balls, fishing tackle, and boxes containing all the various things needed to make a vacation comfortable, I returned to the driver's seat. There wasn't a dry spot that existed on my body. Even the smudged spots on my face seemed to float on beads of sweat. We moved on, totally exhausted. It was sheer will and the knowledge that home was but a few long minutes away that made it possible to go on. I managed a smile, thinking of a long, cool shower and a soft bed.

At last we arrived at Valley House. I opened the front door, thinking only of cool water washing over me. The family could take care of unpacking. But as fate would have it, when I passed the table that held a foot-high stack of mail, I hesitated, bumping the table, which caused the stack to fall over and reveal a brown envelope. Why I picked it up I don't know, but by then it was too late. It contained a notice from the IRS demanding that the full amount due must be paid within ten days of receipt of the notice. That date was this very day, and their office closed at five o'clock.

I looked at the clock: five minutes before four. I felt more dead than alive. There was no way I could drag myself downtown. Perhaps a telephone call would suffice. They are people, after all, I told myself; they're human, they would understand.

The voice on the telephone revealed no emotion, neither pleasure nor irritation. It sounded dull and matter of fact, as though it was not speaking to another human. The voice said, "Be here before five or you'll pay late charges, no excuses."

After splashing cold water on my face, scrubbing the grime from my

hands, and putting on a dry shirt, I got in the wagon, which felt more like an oven, and headed for town. Arriving at a warehouse building that served as an inquisition and collection depot, I approached a long counter. There a clerk gave me a number and told me to sit on a bench until I was called. Hard wooden benches extended from each side of the door I had just entered to the walls some twenty feet or more in each direction. My companions, already seated, seemed to be mostly men in work clothes. We presented a picture of tired, depressed, beaten souls awaiting judgment from some superior power.

After a long wait, the clerk called my number. A middle-aged woman wearing a stern look simply said, "Vogel, follow me." We passed through a door in the nearly ceiling-high partition just behind the counter, entering a maze of hallways and passing many small cubicles with closed doors, from which mumbled voices could occasionally be heard. After several twists and turns, we arrived at a cell-like room containing a bare desk and two chairs. She gestured toward the one for me and just as my bottom touched the wood, her stern voice impaled me: "You have the money to pay your tax bill in full?"

In vain I tried to explain that the IRS agent had told me that I could pay the taxes out over time, that my present condition made it impossible, and that one could only do one's best. It evoked no warmth from her cold, narrowed eyes. I felt intimidated and helpless. She threatened to take over our bank account, sell the house and business, if I did not produce the money. In my exhausted state I seemed to hear a hollow voice: money, money, we want your money; we have to take care of the poor, the needy; give us your money or we'll make you poor and homeless so we can take care of you, you, you. . . . After performing her assigned job well and truly, as a special favor, she relented and gave me ten days to produce, or else.

The days passed slowly, the August heat continued, business was all but nonexistent, and our bank account stayed under $500. I lost myself in painting. On the ninth day a man came to the gallery and purchased four of my paintings for $10,000 in cash, which he placed in my hand. I thanked him calmly, as if this occurred every day. He had barely cleared the property line when I jumped into the car and headed for the IRS office. What a moment! I handed over the money while muttering behind a smile, "You bastards!"

✻

Thank goodness Valley House continued to attract good business after Peggy's death. Everything that came in, and more besides, went to cover the bills and pay the taxes. I had to borrow from the bank, and felt grateful that I had good credit. I felt as if I had started over, this time from a deep hole. Though I paid a few bills late, I eventually managed to take care of all of them.

We obtained a nice, rather large commission from a bank in Tulsa for a Gottfried Honegger sculpture. On 3 October Honegger and his mistress, Sybil, arrived and took up residence in our guesthouse. Their arrival meant daily trips to Denton, because another sculptor we represented, Mike Cunningham, was fabricating the work for Gottfried. We loaned them a car, which freed me to do business as usual. They made good guests and company for us all. On the 17th they left us, having completed the work. Kevin, John, and Mike hauled the sculpture to Tulsa and helped install it. It was a great success and complimented the building. This was no "turd in the plaza," as Tom Wolfe once described certain contemporary pieces. Honegger is a man of impeccable taste, and his interest lies in the creation of an aesthetic experience rather than in making a cultural statement.

San Antonio had always been supportive of my work, and it pleased me to produce a one-man show there again. This time the mayor and a group who acted as hostesses at the Schoener Gallery had a small, rather special, dinner party for me. The exhibition opened the following afternoon, 2 March 1975. It was such a success that people just removed the paintings from the walls and took them home. As they left, we replaced those paintings with others until we ran out of pictures. The only canvases left were those that were too large for buyers to handle, and we had them delivered after the show.

Later in the month I had a show at the January Gallery in Tulsa that also proved successful. I began to see daylight despite the IRS. A trip to New York seemed in order. Peggy's parents, Pops and Nan, came over to take charge of Barley, as good grandparents always seem happy to do. I wanted to arrange for new exhibitions to stimulate new collectors and directions. The Dallas area had not, to my knowledge, ever had a show of the top surrealist painters,

and I felt perhaps the time might be right. With this in mind I visited a dear friend and a leading dealer of this school, Helen Serger, a remarkable lady, highly respected by all dealers. She welcomed me and graciously offered to help me with whatever work I felt would best suit the occasion. As became my habit, I took her to dinner, for not only did I find her delightful company, but she also generously shared her stories and information. My subsequent visit to Klaus Perls brought an early Dali that would serve as the prize of the show.

At the Coe Kerr Gallery, Fred Woolworth agreed to a possible show of top nineteenth and twentieth century works and to make a visit to Valley House in the middle of the coming month to set things up for a fall exhibit. I left New York after what I called my dessert, a visit to the Frick Museum to pay homage to a few master works. Their Bellini, *St. Francis in Ecstasy*, is, to me, one of the ten greatest paintings of the world. I bypassed Washington, D.C., in order to visit the Monet exhibition at the Chicago Art Institute. I found it disappointing, not because of the paintings, but because of the bad hanging and lighting. The bottoms of all the picture frames were sixty inches from the floor, and the light reflected so badly from the paintings' surfaces that I had to fight to see through a white glare. Whoever installed it should have been put on the janitor's force.

Once back in Dallas, I began to prepare an ambitious catalog for the surrealist exhibition that opened May 7, and Helen Serger delighted me by staying with us as our house guest for four days. I had joined a health club to swim laps each day. The nights I had spent sitting with Peggy had kept me so inactive I had gained twenty pounds, leaving me just two pounds under two hundred. Much to my delight, Ms. Serger joined me to swim, though she complained she found the water too warm at eighty degrees. Barley and Kevin fell in love with her, and they developed a lasting friendship.

While Helen Serger's visit was a great success, the first major surrealist exhibition to come to Dallas was a total failure. Not a piece sold, and the smallest number of people in years attended. Perhaps, as in other firsts, only the history books took note. I considered the show worth a try. A one-man show of my own work at the Rice Gallery in Houston helped me pay for those surrealist masters to be seen.

The American painter's show that came later that year did better. It included fine works by Winslow Homer, John F. Peto, Walt Kuhn, Edward Hopper, Mary Cassatt, Childe Hassam, and many other first-rate painters. For a special opening I had a dinner for Fred Woolworth and his partners, along with thirty or so prospective collectors. We started with cocktails in the gallery as we viewed the show, then we walked to the studio for dinner, coffee, and good conversation. With this happy show, we more than regained our audience.

Sometimes what appears to be good fortune is not. The same might be said of a good friend. I had assumed I was lucky to have been given access to the landscape painting by Paul Cézanne, the last picture he finished before he died. This work, the largest he ever painted, concerned his favorite subject, Mont Sainte-Victoire. He wrote about the painting, saying that at last he had truly expressed what he felt about his mountain. The painting came from the Vollard estate and had never been on the market before. As always, I offered it to Dallas first. The response was so disheartening and the comments so stupid I'll not repeat them.

In Houston I met Mrs. Dominique De Menil, the noted collector, and showed her the Cézanne material. She appeared nonchalant about it and only responded coolly, "Yes, it's truly a great painting; I hope it stays in Houston." Apparently, Texas was not ready for such a masterpiece.

Because I felt that no one here would be able to recognize the Cézanne's importance, I sent the material to Rick Brown, who was in Los Angeles and was acknowledged to be one of the great museum directors in the country. He called me to inquire further about the painting and said he thought it was one of the most important works available on the market. He heartily shared my excitement. Later, he returned the material and expressed his deepest regrets, saying the timing was bad, but he found it a steal at my asking price of $350,000. He wished me luck. While I was in New York, I showed it to Louis Goldenberg at Wildenstein; he asked the source and to my surprise,

rejected the painting as of no importance. When I arrived home I received a wire from Paris, "Cézanne sold, stop any negotiations," signed "de Bolli." And that was that, or so I thought.

Soon after the abrupt sale of the Cézanne, Rick Brown arrived in Fort Worth to assume his duties as director at the new Kimbell Art Museum. He called me and said he was scheduled to give a talk to the Dallas Museum League ladies and would like to come out later to meet me and see the gallery. We sat in the living room and, over coffee, he said that while talking to the museum ladies he had told them the importance of the dealer to the collector, as well as the museum, for it is the dealer who so often finds the important works. He told them about my efforts with the Cézanne, then added the end to the Cézanne story.

He had been trying to get Norton Simon to buy the Cézanne, and all but pleaded with him not to let it go. Norton Simon happened to be at Wildenstein and saw the great picture and asked the price. It was $750,000, more than twice what I had asked. He remembered well my price and, since it was already late in the day, he said he would return. Back at his hotel he called Rick and told him what a fabulous picture it was, "but the price!"

"Go buy it," Rick said, "it's worth much more; don't miss it."

"Why didn't you make me buy it before?" Simon demanded.

"Because you were negotiating the purchase of the Duveen estate and refused to be interrupted." The next morning Simon called Louis at Wildenstein and learned that the Cézanne had sold just five minutes after he left. It seems that Louis called Paris and bought it himself behind my back as I left his office. When I learned of this, I was both hurt and stunned. Never before had I experienced, nor would I have expected, such dishonesty from a dealer in a fine New York gallery, especially one whom I had considered a friend.

Rick and I had a good visit and began a new friendship that lasted through the coming years. I enjoyed many hours in his office, while he considered the purchases of the El Greco, Rembrandt, and other paintings. It was a pleasure to share his enthusiasm and comments.

On 20 November 1975, our dear Aunt Clara celebrated her one hundredth birthday from her bed in a nursing home. This lady, whom I found a

marvel, had painted her last memory picture about two years earlier. It was of her house on Yale Boulevard where I had sat rocking while eating her cookies and drinking her tea. The painting was as good as any she had done twenty years before. Now she wished everyone would go away and let her die, for she felt useless now that she could no longer "make some beauty." In a few months she would fulfill her wish. As I listened to her voice on tapes made years before, her happy laughter brought me smiles and many happy memories. She died 17 February 1976.

Just three days before the passing of Aunt Clara, Southern Methodist University invited me to take part in a symposium on the "Education of the Artist." The panel included Harry Parker, our then-illustrious Dallas Museum director; Dan Wingren, painter; Eleanor Tufts, educator; and Lee Allester and Bill Komodore, painters. I tried to stress that all the degrees offered in universities could not make an artist. That view did not make me very popular. But I had Aunt Clara and Valton Tyler in mind, plus a few others, such as van Gogh. I tried to explain the commercial relationship in the art world that can make an artist self-supporting. I suggested that would-be artists take a business course along the way, because they would be producing a product to sell, and selling meant bookkeeping, taxes, and so on. This kind of knowledge might not be inspiring, I told them, but artists sure as hell had better give it some thought. No, indeed, I was not popular. I wanted to be helpful.

<center>❋</center>

After Valton completed his fifty prints, he told me that he wanted to paint, so I told him to go at it and agreed to help him. I called the art store and told them to let Valton use my account. In a sense I became his WPA Easel Project, but then, turn-about is fair play. It was fair only to a point, though. When the bills started coming in, I found he had been charging $500 to $600 in supplies per month! He was like a kid in a sweet shop. His first paintings appeared very much like his prints. This I thought natural, but I felt confident that time would put him on course. From the beginning, his paintings

were challenging and haunting, with forms entirely his. Nowhere have I seen anything like them, and each new painting excited me more. This talent would require time and much patience but, eventually, I felt he would prove to be a winner. It would not be easy, especially in this part of the world.

When I thought about the patience needed for Valton, I was reminded of Loren Mozley and the course his career took. I had represented Loren Mozley, the finest painter of us all, for most of twenty-five years. We continually showed his work, promoted him and published a catalog. For that effort we received next to no results, other than a sale now and then. I wondered why. Then all of a sudden he was in great demand. We sold just about everything of his. Was it a new consciousness, interest in good painting rather than fashion? I don't understand, except that if you stand still long enough everything comes around.

Loren was one of the first artists to teach and form the art department at the University of Texas in Austin. This quiet man with strong political views felt comfortable enough not to think of selling or promoting his painting and had enough trust in me to leave all such matters in my hands. He worked slowly and without compromise, refusing to be pressed. His influence came mostly from Cézanne. He understood painting and knew what he was doing; he permitted no accidents. He shared his abilities through doing his work, not talking about it. Others could talk about his work if they wished; it didn't concern him, for he knew and I knew. One day, and it may not be in my time, the right person will see, and then the others will follow. All in good time.

But now I began to feel the need for some "good" time.

16
Companionship
New beginnings at Valley House

AS THE DAYS lengthened into months, and the months grew into years, a yearning developed within me for companionship, and I wanted to see where it would lead me. Though I had no sense of desperation or urgency, I started to invite a few lady friends to dinner, opera, and the theater. A dear friend, Sallie Carter, a widow some years older than I, knew Peggy and on a few occasions had invited us to her Dallas Cowboys box to watch the game and to have dinner at her country club. She continued to invite me, and I looked forward to our visits, because it took me from my world into a strange new one that puzzled me. It seemed, without my being aware, that I had become an escort and conversationalist at dinner parties in the homes of the so-called "old" Dallas society.

These good people, kind and genteel, lived with a sort of desperation, waiting for the next party so they could gossip about the last, or so it seemed to me. I became sure of my new, undesired role when, at one dinner party, I encountered Rene Mazza who made a career of performing for these ladies and old men. That evening, as he stood beside me, I overheard him talking to a couple of the ladies about a painter and his work. Then, looking at me for support, he asked, "Isn't that right, Donald?"

"Rene," I said, "where did you hear such rubbish? You don't know what the hell you're talking about."

"Well, it makes a good story, and that's what's important," he replied. With that he turned his back on me and continued to spread garbage.

Later I started to say something to Sallie about him and his relationship to the phony Elmyr de Hory, but she said, "He's such a dear. He is good company, and we are all fond of him."

That did it. I had to escape these dear people if that was how they regarded me too. First, though, I had to pay my debt. I invited the whole group for dinner in my studio. I made a drawing for the invitation and had it printed, decorated the studio, and had dinner catered and served with what I deemed to be simple elegance. In no way would I try to compete, but I would just be honest to the tradition of Valley House. After that, I became more serious in my search for a woman to share my life. I determined one firm prerequisite: I would not marry a woman of wealth. They had different priorities from mine. I shuddered to think what I might lose for what could become false values.

While this nonsense rolled along, my mother died in a nursing home in Houston. We had moved her there to be close to my brother Bob and his wife Tony. Peggy's father suffered a stroke not long after and entered a hospital in Fort Worth, which meant many trips to care for Nan during those stressful times.

During this time, Morgan Russell came into my life. Russell had founded synchronism with McDonald Wright, and the two were the only American painters to have an influence on French painting. Russell entered my life through Madame Russell and her daughter, Simone Joyce. Simone had married Walter Joyce, one of the principals who created Texas Instruments. Madame Russell and her daughter invited me to their house to review Morgan's work and consider handling the painter's estate. I was more than willing, and we started cataloging the next day. I felt pleased to have another challenge resurrecting such an important talent and to learn first-hand, through the work, the transitions and growth of the artist. We set about to restore and frame the works, for they had been neglected for many years.

The show we held was received with indifference. As always, we had given our city the first opportunity. We could do no more. I looked to the West Coast and the east and, in time, sold the entire estate.

*

On November 27, 1976, a nurse from the hospital where the Commander was being cared for called to inform me of his passing and to ask me to come and take charge. He was a good man, a national hero who wished he had been a farmer all his life instead of only in his last years. I think he made his peace with me and found me not too bad a son-in-law. I'll never be sure, but I hope so. We scattered his ashes in the garden to join those of his daughter, as he had requested. The children couldn't have had a better grandfather.

My thoughts of Peggy remained ever present. I made use of the photo albums to keep a visual image alive. One small black and white photo of her sitting at the piano moved me so that I decided to do a portrait for the family as well as myself. At the time the photo was taken, she was pregnant, carrying Barley. I tried, through the painting of her, to express how I felt, and I hoped it would bring me in touch somehow. I started work at first light and, as darkness was falling, I had all but finished the painting. It is a very personal portrait and I painted it with an ease I would not have thought possible. Often, I lose all sense of time and place while painting, but this was somehow different. Barley has only vague memories of her mother, and I hope that, in some small way, this painting will remind her that she had the best.

The years continued sliding by all too fast. Again, I asked myself, have I arrived as a painter, or am I to seek another five years? No, it's not a matter of another few years I told myself; I would be satisfied if I could paint just one good painting before my time was up. A new theme might help, but what?

My son, Kevin, who had begun taking over the management of the gallery, suggested I do more landscapes. More pictures of the gardens had already begun appearing, and at night I produced drawings for ideas to paint. One night I drew the greenhouse off the bedroom. From that beginning came a never-ending stream of greenhouse paintings. Most of them are total

invention and probably could never function as working hothouses, but then why should they? I people them with happy workers and give them nice colored blooms and rich greens. I play with warm and cool lights to create tonal values and air that allows passages to flow through the painting to carry the eye in a subtle way. The greenhouse pictures gained an immediate response, as did the paintings of country dances. Both brought many commissions.

The Dallas Art Museum brought a commission of a different kind. An old friend was placed on the board of acquisitions, which is normal enough for a lady with a lot of money and absolutely no knowledge or background in art but willing to go along with the infallible wisdom of the director. She came to visit me one afternoon after a committee meeting and expressed her horror at the art that had been submitted for approval.

In the garden with
Barley and Kevin.

"Donald," she said, "you know what kind of paintings I like. I want to buy the museum a good painting. Will you find something I can be proud to give?"

"Of course. I would be most pleased. I'll go to New York and see what's available and bring some transparencies back for your approval," I assured her.

The dealers were most cooperative with my effort and showed me the top pictures available at a fair market price. It was a good trip, except that I encountered our museum director in New York City at the same time and, by chance, was seated beside him on the return flight. Because I knew he would have to approve the choice, I told him of my commission and showed him the transparencies. His insistence on knowing the prices put me off. I felt it was none of his business; these were not my pictures or prices, and I had asked for the best possible, without considering my commission. A couple of days after my return our donor friend asked that two of the pictures offered be sent to the gallery for viewing. Two wonderful canvases arrived, worthy of any museum, anywhere: a very large still life by George Braque and the delightful *Boy in Culottes*, by Modigliani. Her choice had been predictable, but either

painting would prove an asset to the museum. She wanted the Modigliani, and I thought that would settle it. Not at all! The director took over and started to tell me what the patron should pay for it, as if it were his money.

Never had I experienced such arrogance. It was unheard of for a museum man to behave in such a manner. After a few calls to New York, we arrived at a bottom figure by eliminating any possible commission. Our director told me that he would see that I received a commission. He did, but the value he placed on my part in bringing this work to his museum insulted me. The painting's owners told me that they left the decision to me; they didn't have to sell the picture to Dallas. Once again, the painting became a gift, in part, from Valley House. Among dealers, the director became a most disliked museum man with whom to do business. In the long run, Dallas lost.

The man did not end his interference. Not long after, he told a client buying a Monet what she should pay us for it. Later he came to Valley House to examine a Sargent portrait to be given to the museum. This time I had him. A second party had committed for the picture if the museum refused it. Sure enough, our man ran true to form and announced the amount the donor would pay, saying, "That's all it's worth."

"Thank you," I said. "Then you don't want it. I have it sold."

"No, no! We want it, I'll okay it." His face held a look of disgust. At last he could feel for me just as I felt for him.

Another spring arrived and stirred renewed interest in putting the garden in shape. After Peggy died, I had escaped the pain of her loss by losing myself in painting more than ever, and by neglecting the garden. A crew of landscapers came in for a week and brought new life to the garden as well as to me.

In the midst of this activity, another adventure awaited in the wings. Mitch Wilder, a true gentleman and director of the Amon Carter Museum, called me to explain a strange call he had received from a George Ablah of Wichita, who wanted to spend a million dollars for an instant collection. Ablah preferred Western subjects and had some idea that the Amon Carter would oblige him and sell some of their paintings. Mitch told him that he needed an honest dealer, and that the only one he would recommend was me. Ablah asked Mitch to have me call if I were interested. This, my calendar

records, happened June 3, 1977. I called, as suggested, to see what motivates a man to forego the pleasures of collecting in favor of having a collection.

George Ablah was, indeed, a man in a hurry with a lot of money. He was most engaging, and our conversation ended with an appointment for me to meet him at the Le Baron Hotel in Dallas on the twenty-third of the month.

The twenty-third turned out to be my day to talk cowboy art. Jim Chambers, President of the *Dallas Times Herald*, invited me to lunch with the board members of the Scottish Rite Hospital for Crippled Children. They wished to find a so-called Western painter and commission him to create a large painting in honor of Senator Blakley. The Senator had left his holdings, including some 400 oil wells and a ranch, to support the hospital. The board members would pay the artist $25,000; my commission would come from the artist. I committed myself to finding the best painter possible; no problem, I thought.

After lunch the time arrived to visit our new friend, George Ablah, so I drove to the Le Baron, a plush, over-decorated hotel that catered to rich people. It reminded me of hotels in Las Vegas. I had gotten there early, so I sat in an overstuffed chair and waited. Soon a tanned, slender man strode into the hotel, followed by three men who were skipping a step to keep up. At the desk he received his key and a welcome from the management. Then he turned and looked at me, following the pointing finger of the desk man. "Vogel? Glad you could come. Follow me; we'll talk in the suite," he said, turning toward the elevators. Thus, I became a part of George's entourage, which consisted of his pilot and co-pilot and a business friend. We followed him into his suite. First things first. One of the pilots phoned for coffee, very hot coffee. A few words passed between us while George swallowed half cups of coffee between pauses on the phone. Call after call. Everyone seemed to understand. We waited until George was ready, and then—go!

I liked this fellow; his performance fascinated me. He scheduled himself so strictly I could sense the wheels turning in his head. I knew such people existed, but this was my first time to see one in action. At last he completed the phoning, and we had a pleasant visit. He would come to Valley House the next day and talk about exactly what he wanted. He said, "I'm going to give one week for art, and I want to do it well."

We walked the gardens and visited the house, my studio, the shop, and settled in the gallery's viewing room to look at an album of photos I had put together for him on available Western art. I wanted to feel out just what he thought he wanted. He asked if I would set up a visit with Mitch Wilder to see the things at the Amon Carter Museum. I stressed the importance of being watchful for fakes, especially in Western bronzes. I called Mitch, and we set a time on the following day.

Ablah arrived with his pilot, and the three of us drove in my car to Fort Worth. During the trip, I answered question after question, giving a short art history course. I thought, this guy is fooling himself if he thinks he's giving only a week to his art venture. He's going to end up with the disease. The Amon Carter Museum was just completing its new addition, and Mitch Wilder, after greeting us, showed us through the new facilities. The bronzes nestled in the basement vault, and Mitch kindly opened the vault so that we could examine them and point out the difference between the good and bad. We spent an hour talking about the qualities of certain paintings of interest to Ablah. Mitch couldn't have been more helpful and generous with his time and advice.

On the way back, Mr. Ablah asked me to fly to New York with him to look at what he might buy, after first going with him to Wichita to see his home. From there we would fly to New York in one of his jets. We set the date for the fifth of July.

Meanwhile, I pursued the Scottish Rite Hospital Commission and secured a list of top Western painters from a dealer friend, Tony Altermann, who specialized in the style. I started calling one Western artist after another, all with the same results. They were too busy and would not be interested unless the hospital board could wait a year and pay $100,000. At that time Western artists were enjoying the top of their market and popularity. Oil and real estate money seemed endless; money likes to show off, and these artists enjoyed the showing. I applauded their success, believing that everyone gets what he deserves.

At long last I managed to find a talent whom I considered the equal of any of the artists I had called, and who was willing to tackle the job. I intro-

duced him to the board, along with examples of his work, and he got the go-
ahead. His work pleased everyone concerned. In 1977 you could still buy a
lot of good art for $25,000 to $50,000, but not Western or cowboy illustration
of years gone by.

On 5 July, I flew to Wichita, Kansas. A young man who worked for Mr.
Ablah met me and drove me to the house, explaining that I should look
through it. Mr. Ablah would meet me at his office, and from there we would
go to the airfield. George had just spent one million dollars decorating. It
looked like the most over-decorated house I had ever seen, and I had seen a
few! The decorator should have been sued for malpractice. Good God! I
thought, the fellow wants to add paintings in these surroundings! The paint-
ings would get lost.

At the office I met George, who introduced me to his beautiful and
charming wife. You could feel the love and warmth between them, so I knew
he had something of value, after all. We went to the airfield and boarded one
of his two Lear jets to head off for the great city.

During the flight, George pressed me for my opinion of his house. I said
that I would rather not comment on it. He insisted, saying he felt something
was not right. I edged my way in by stating that he obviously loved his wife
and that when she was in a room she should not have to compete with all the
patterns and textures that dominated the area. The decor should set her off,
not compete with her. The art he might acquire should accent, by its quality
and its presence, and be felt as something special, not as more ornaments. "If
you're really serious, I'll take you to a few homes in Dallas so that you will
understand the difference," I promised.

He seemed to accept this with a smile. We settled at the Carlisle Hotel for
the night. I had arranged with Fred Woolworth to set up a show for Ablah.
Fred cleared out the second floor gallery and arranged an exhibition of West-
ern paintings and sculpture just for us. In addition, I made plans with Bill
Aquavella for Ablah to see some Impressionist work. After breakfast we
headed for the Coe Kerr Gallery to view the works they had set up for us.
They had done a wonderful job, and I felt proud that they would welcome a
new collector in such a manner. George seemed most captivated by the Rem-

ington sculptures, *Coming through the Rye* and *Mountain Man*, both early casts and top pieces.

After a good visit, we left to see Bill Aquavella. He had a beautiful Monet, a Nymphéas, Pissarro, Gauguin, and other goodies for us to look at. Bill invited us to lunch, which gave us an hour to spare, so I suggested we look at a few American and French pictures at the Met. We all but ran there and raced through the galleries. Later, on the way to the French restaurant, Bill suggested walking down 5th Avenue. As we walked along, George said, "They offered me the Empire State Building for forty million, but I don't think it's a good buy." We arrived at the restaurant early, but a table was waiting. George ordered coffee for himself, only half cups at a time.

"How many cups do you drink a day?" I asked.

"About forty or more, I think," he said.

After George left New York, I stayed another day and arranged for a show at Valley House that included some of the things we had seen at the two galleries. This turned out to be the finest exhibition in Dallas for years. Again, I set up a studio dinner party for the dealers, George, his lovely wife, and the important local collectors, for a pre-opening on 6 September. Late in the evening, when the others had left, Bill, George and his wife and I went to the gallery and visited till after one A.M. The next morning George bought the Monet and two Remington bronzes.

I called the press to share the show with the public, students, and painters, for rarely does one see such a group of pictures together. *The Dallas Morning News* wrote a good review. Bill Marvel, then at the *Dallas Times Herald*, said he had no interest in Impressionist work, that there was nothing new to be said about it.

One visitor to the show was a lady I had first met in 1950 when I had gone to her house to pick up a painting to be framed. My arrival had interrupted her poker game. She came to the Impressionist show with her daughter. By that time she was quite hard of hearing and asked me to walk around with her. We stopped before a large Pissarro landscape and she asked, "How much is that?"

"$600,000," I said softly, so as not to distract the attention of others in the gallery.

"What? Speak up." I repeated the figure a little louder.

"Speak up!" she commanded. I almost shouted the figure, attracting quite a lot of attention and causing others to turn and look at us.

"That's nice, I may want it," she remarked. We walked on to a Monet and repeated the same dialogue.

"Mother, only buy one," her daughter said as she came up to us.

The mother almost committed to buy three before her daughter stopped her. She did purchase a Monet. The daughter eventually inherited it. Stopping her mother from buying the other two paintings cost her about four or five million dollars profit on today's market.

The gallery continued to do well, mostly because of the people who worked with me and tolerated my strange indifference to business. For the most part, the secretaries became involved in all activities and seemed to enjoy the informal manner with which the gallery conducted itself. They usually held degrees in art history and wanted to learn the gallery side. One young lady, Corrine Cain, became a professional fine arts appraiser in Phoenix, Arizona. The graduate student who replaced Corrine became more than an employee. She was one of three delightful and talented sisters, all of whom attended Southern Methodist University at the same time, and who impacted my life from that moment on.

Cheryl, Debbie, and Peggy Westgard had the energy of five packed into three happy pixies. Cheryl entered Valley House by the front door, the others seemed to come in by the windows, the chimney, or any other opening, always with giggles, smiles, and happy spirits. Cheryl started work on 19 May 1978, and settled in with ease. Kevin had begun taking hold, now and then telling me what to do and not to do. It looked as if we had another dealer in the family, possibly two, for Eric asked about a position in the gallery as well.

I had begun appraising art as a courtesy, but it soon was taking up so much time that I began charging a token fee, and it became a part of the business. One day I was asked to catalog and appraise the total content of a small museum in Snyder, Texas, the Diamond M Museum. I took a plane to look

over the collection and made my proposal. It would be a long, tedious job and one I had no temperament for. I felt it important that Kevin and Cheryl handle it, because they could learn much. Each piece had to be photographed and described, sized, dated, reported for condition and history, when and where purchased, for how much, and current value. I told them if they did a good job, I'd send them on a cruise.

In September that year Valley House presented a wonderful exhibit of Impressionist paintings. One of the happier results of that show was that it ignited an interest in collecting for a couple who visited after making inquiries about the gallery and me. They introduced themselves as Elaine and Charles Cole. He said he wanted to invest a sum of money in paintings, purely as an investment. He said he didn't care what painting we selected, but it must be a sound deal. They were a handsome pair and easy to like. I didn't take his words at face value, for I could see them as potential collectors. A good painting can't fail to prove an investment in more ways than they could imagine at the moment.

By chance, I had just received a transparency from Paris of a basket of lilacs by Renoir. It was available from the family who owned it and had not been offered before. It had been reproduced in a couple of books, and much had been written about it. I put the transparencies on the light box and told the Coles that it was the best buy I had at the moment.

"How much?" he asked.

"$225,000," I said.

"Good, I'll take it. Can I give you a check now?"

"No," I replied, "first I'll have the painting sent here and I'll examine it to be sure it's right and in good condition. If you both approve after you see it, then, and only then, do you pay." We talked painting and general chitchat to get a little better acquainted.

Just before they left he said, "Call when it's available. Enjoyed our visit." That became the first of many paintings they purchased. Two more collectors had been born.

True to my promise, I sent Kevin and Cheryl on a cruise. They chose to

take it over the Christmas holidays; on December twenty-first they set sail for ten days in the Caribbean.

I too had set sail on a second voyage, six years after my first one ended. In 1980 I irrevocably ended my membership into the "he is such good company" club with my marriage to Erika Farkac. A landscape designer, Erika and her late husband had been long time acquaintances through Lambert Gardens. What began over popcorn and a Dallas Cowboys game has become the loving marriage that will reach into the twenty-first century.

17

Travels

Discovering the source of great artists

"THERE IS NO WAY I would ever get involved with anyone who works for us!" Kevin announced loudly and firmly. I hadn't anticipated such a strong reaction to my suggestion that he think about finding someone with the qualities of Cheryl Westgard and settling down. The cruise I'd sent them on as a bonus for doing a good job in appraising and cataloging the Diamond M Museum collection had been, in a way, a nudge. But time passed and, sure enough, Erika and I received an invitation to a small church wedding on 21 July 1982, for family only. On that happy occasion Cheryl, who had been the brightest of all our secretaries, became my daughter-in-law.

In late August, after having settled into their newly acquired house about five minutes from the gallery, Kevin and Cheryl put together a gala garden party at Valley House to announce their wedding. In this happy union, with a strong common interest, they would work together as Peggy and I had. May their love grow, as ours did, with true affection and respect.

The adventure of the stolen Jackson Pollock soon followed. It started one day in the second week of September, when I received a phone call from a Jim Sizemore in Muskogee, Oklahoma. He had an oil painting signed "Jack-

son Pollock," and wanted to know if I would be interested in selling it for him. He would be coming to Dallas in the next few days and would bring it with him. I didn't take it very seriously, but agreed to look at it. The next day I saw a man and woman leaving a pickup truck in the driveway. I went out to meet them and was amazed by the beauty of the woman; I had a hard time

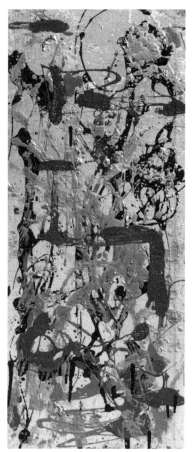

Stolen Jackson Pollock painting, 27 ¾ x 12 inches.

taking my eyes from her. The man looked older and like a laborer. "I'm Jim Sizemore. I called you about the Pollock painting. This is my wife, Carmen," he said.

We went into the gallery and he unwrapped a small picture. It was indeed a Pollock. It had a label showing that it had been exhibited at the Betty Parsons Gallery in New York. Our library produced the catalog of the show and its listing. I asked him where he got the picture, and he told me it had been a graduation present from his high school principal. He said he had been unaware of its value until he read something about the artist and the name sounded familiar. I told him it was worth $100,000. He showed no excitement. I gave them a receipt with a Polaroid photo attached. After they left me with the painting, I made good eight by ten color photos and sent one to Norman Hirschl. He replied that the painting had been stolen, and that a notice of the theft had appeared in the ADAA bulletin. I should have checked for that before they left, but I told myself that Carmen had distracted me.

I tried to phone the real owner, George Helm, three days running and got no answer, and also contacted Sizemore, who gave me another story about how he had acquired the painting: he'd bought it from a street vendor while vacationing in the Virgin Islands. I wrote a letter to Helm and sent it by registered mail. I then called a friend at the FBI, an organization I had come to know and work with from time to time. Helm called me from a hospital bed in Boston where he was being treated for cancer. He sounded very pleased about the news, and his cheerful voice gave no hint he was a sick man.

On 1 October I received a call from Lamar Myer of the FBI. He told me

he was taking charge of the case and would come out to review the painting. He seemed glad to have a case to work on, because D.C. was cutting back on the Dallas office at the moment; things were quiet, and there was simply not enough action to keep all their agents busy. I was glad to turn the painting over to the FBI, since Erika and I planned to leave for a twenty-six-day cruise on 5 October. On our return, we found the following letter from George Helm:

> Your good news about my Jackson Pollock painting has made my day. Thank you for calling back.
>
> I have informed my insurance broker of the great news, and as I told you, I will make restitution to the insurance company.
>
> I am delighted that you are interested in selling the painting for me after all the 'formalities' are over. What do you suppose it may bring? What will your commission be?

I wrote and proposed that Valley House buy the Pollock for $100,000 when the FBI no longer needed it as evidence and he agreed. Our correspondence was friendly, but a letter dated August 9, 1983, left me unhappy. It was from the lawyer in charge of Helm's estate:

> George W. Helm, Jr., died June 19th.
>
> When and if the FBI and/or court releases the Pollock, would you kindly make the final payment to the Estate of George W. Helm, Jr.?
>
> Meanwhile, if I can be of any help please don't hesitate to ask. Should the FBI and/or court wish to have me appear as a witness I would be agreeable to making the trip. I was of course present most of the time Jim Sizemore worked at George Helm's house, and well remember George acquainting Sizemore with the various paintings and bronzes and other fine arts objects, thinking he was 'educating' him. He did his job too well, I'm afraid.

The FBI were unable to close the case, for reasons I do not quite understand. Sizemore apologized for lying to me originally, but never did admit

the theft. The icing to the story is that he in fact requested a portion of any reward money as reimbursement for the "$165 in costs on this painting"!

<center>❋</center>

During the Jackson Pollock caper, Erika and I enjoyed another cruise, this time to the Black Sea. We flew to Venice, where we spent a few days before boarding our ship to embark on further adventures. Venice held the magic I knew from Turner, Homer, and Moran, but for tourists from everywhere it offered its best at sunrise and sunset. Every column and stone, each capital and its carvings, whispered the history of this magical city and brought us memories of stories of Marco Polo, the *Merchant of Venice*, of operas heard and paintings seen, the Guardis and Canalettos.

We sailed out to the Bosporus toward Istanbul as the late sun laid its coat of golden varnish on the floating city. Istanbul suited my palette even better than Venice. I could even forgive the vulgar riches of the Dolmabahce Palace of the last Ottoman sultans. We walked about the city to feel closer to it and its people. The scenes, the faces and figures, all lured me irresistibly to my pen and sketchbook. We walked over the bridge and returned on a small motor ferry with the locals so I could view the mosques as the artist Paul Signac saw them, from the water. A year or two before I'd had a large canvas by Signac, a painted landscape he had done from the Ergene River, looking at the city with its mosques. It was a masterwork. Although another loss for Dallas, Signac's landscape offered me a happy memory come to life.

In the next port of Yalta, Russia, the Purser's office asked me to stay on board until all the other passengers had left the ship. Then two Russian officers began looking me over. One said, "Nyet, nyet," and the other said, "Da, da." Finally, they agreed to let me go ashore. They were having trouble with my passport photo, which showed me clean-shaven. No doubt they thought my full, white beard was the disguise of a spy. I remembered Yalta as the place where Roosevelt gave away the store. We rarely saw people smiling in this city.

The smiles were there, however, when we disembarked at Varna, Bul-

garia. The food also improved, service was given with joy, and the locals invited us to join in the music and dancing. We left feeling better for having been there.

We stayed in Knossos only a day, but it was long enough to gain a general idea of Crete's ancient civilization. In Crete, after viewing the illustration of Theseus fighting the Minotaur on an Attic black-figure vase, I was able to see Picasso more as an innovator than as a creator: he took what had already been created and reconceived it from his own perspective. This way of studying art history offers benefits that cannot be had by sitting in a soft seat under dim lights, lulled by the singsong voice of a well-meaning instructor, and struggling to stay awake.

Three days after we returned home, heavy rains again brought creek waters flooding up, threatening Valley House. It caused us to set in motion plans to protect the house from future floods. Erika took this project in hand, designing the berm and stone wall that would surround the house to keep flood waters at bay. She supervised that work as well as the planting of new ground cover, trees, and bulbs. Within the year it felt as though the berm had always been there, giving evidence of what a caring, professional talent can do. The grounds had never looked so good.

Our trip stimulated me to paint more and more and drew me further away from the gallery and its concerns. Only when someone showed interest in acquiring a major work would my interest return. Many paintings waited to emerge; I felt an urgency, and time became a factor. I had just begun and knew that one lifetime could not possibly be enough. My appetite had been whetted and was growing.

In the spring of 1983, as I looked back and remembered, the idea occurred to me to bring together a group of the artists I had represented or favored over the years. I decided we should have a one-day show and dinner. We mailed invitations and made follow-up phone calls to encourage each artist to ship or bring one of his or her paintings so that we all might admire them and applaud one another over cocktails. All but two, local artists who taught at Southern Methodist University, responded favorably. After we hung the show, the members of this mutual admiration society happily

TOP *(from left to right): Jeanette and Roger Winter, Lyle Novinski, Hub Miller, Barney Delabano, Pauline Muth, Michael Frary, Loren Mozley, Donald Vogel.*
CENTER *Bror Utter, Dorothy Poulos, Fred Nagler, Edith Nagler, Valton Taylor.*
BOTTOM *Mike Cunningham, Deforrest Judd, Kelly Fearing, Stanley Lea, Karl Umlauf.*

sipped their drinks and applauded each other's works, each of us knowing all the while that he (or she) was surely better than the others. It was good to visit and see our contemporaries' production in the spirit of light-hearted competitiveness.

We again served dinner in the studio, and a good one it was: mushroom soup, mandarin oranges and sliced almonds on Bibb lettuce, beef tenderloin, three vegetables, hot breads and rolls, two wines, ice cream with fresh fruit, coffee or tea, and mint-filled chocolates. I had photos made of all of us together and sent one eight by ten to each in thanks for their participation.

My left knee began to give me great pain, which made it difficult to stand at the easel for any length of time. The doctor suggested surgery. By coincidence, I met Joe Namath shortly after that at the health club where I swam laps every day. Joe was in town acting at the local dinner theatre and swam at about the same time I did. In the showers one day I noticed the scars on his

knees and asked him about the arthroscopic operation my doctor had suggested for me.

"Nothing to it. I've had it three times. Do it," he advised. Who should know better than the man who has had it, I thought. With that assurance I consented and found out, after weeks on crutches, that I had only exchanged my ache for pain. It stopped me from doing large works for awhile, but not for long, because I learned to live with the pain. Eventually, the doctor suggested that the knee should be replaced. I said we'd see.

The idea of replacing my knee with a chunk of metal wasn't too appealing to me. It was only after I had spoken with friends at the health club and learned that three of them had had knee replacements (one of them had both knees replaced) that I became convinced that this would be the best course of action. I am pleased to report that the pain went away with what they removed in the way of bone and growth.

The time came to settle my daughter, Barley, in a university that could prepare her to take charge of her future. She had expressed an interest in being part of the gallery and seemed serious enough for me to give her a go at it. She was a bright student and loved to read and write. Her stories and poems showed a fertile imagination, as did her drawings and paintings.

I decided we should take a trip to New York and called a few dealer friends for their advice on the best school for her interest. All agreed that New York University would be the best. I set up an interview for Barley at the university, and Norman Hirschl made hotel reservations for us at the Stanhope on Fifth Avenue, just across from the Metropolitan Museum. This would give me an opportunity to introduce Barley to my world of business and allow her to meet the people with whom I worked. We arrived on 18 May, a lovely time of the year to visit the great city. The interview went well, the school's art department looked most promising, and a few blocks away we found a longtime friend who had once been our neighbor and who had taken in the children after our disastrous flood. "Squeak" Cobb served us a huge breakfast while we caught her up on the gossip about Dallas friends and family.

Norman Hirschl and his charming wife, along with his director of European painting, Martha Parrish, invited us for dinner at the Algonquin Hotel.

Afterwards, they showed Barley around their gallery, and we all went to the theater.

The next day we visited Clyde Newhouse, who became enchanted with Barley and showed her areas of his gallery I hadn't seen before. One room contained reproductions of many of the old master paintings the gallery had sold through the years to major museums around the world. Clyde had much to teach, and he had a wonderful way of talking about painting. Had I not become a painter first, Clyde is the man I would most have wanted to emulate.

We visited many other friends and business associates, and I began to feel a sense of security even with the prospect of having my girl in the wilderness of this city. A gallery offered her a job during the summers. She was on cloud nine. We visited the Met, the Museum of Modern Art, the Whitney, and the Guggenheim. I saved the best for last: the Frick, where I could share the Bellini, the Turners, Goyas, and so many others.

I felt so happy to have shared these pleasures with Barley and to know the best possible outlook awaited her, for her to enjoy and make a part of herself. What could possibly get in the way? Love. She had a boyfriend, and nothing could be more important. She settled on the University of North Texas in Denton. Of course, a father's wisdom is nonexistent at such a time in the life of a young girl. Steering the course for one's children is rarely possible, and I must believe it's for the best. I have been blessed, for they are good, healthy individuals. What more can a father ask?

The summer months proved most productive as paintings flowed one after another with seeming ease, and ideas for new paintings crowded impatiently, one upon another. I have always cherished these periods as happy ones that should be taken full advantage of. Fortunately, the paintings kept coming, because I was called on to supply paintings for three one-man exhibitions, for the many sales from the studio, and for a few commissions. The juices continued to flow until it was time for another cruise. While we were travelling, I filled my sketchbook with ninety ideas for future pictures. It had become my habit to draw in bed, while the television played, to overcome a feeling of guilt for not being productive.

Soon after our return, a young couple who represented a newly published magazine called *The Goodlife* visited me to ask permission to reproduce one of my paintings on the magazine cover. The prospect appealed to me, so I sent them two transparencies and promptly put it out of my mind. A few weeks later I received six issues and found the best reproduction ever done on a painting of mine. That issue became their first to enjoy national distribution.

Phone calls started to come in from people all over the country, wanting to buy the cover picture or to inquire where my work could be found. Nothing in the way of promotion or exhibition that had been done before had ever attracted such attention. In addition, the *Goodlife* people sent me a check for $1000 in payment for having used the painting. The money came as a pleasant surprise, because we had not discussed payment. Later, the cover brought me a show in Washington, D.C.

During the next year, I did little in the gallery other than sell a few important paintings, among them a rare Pissarro still life; a Monet landscape; and a strong, rich Rouault. More important, my brother called to inform me that he had become a grandfather. His son, John Walter, helped produce a delightful girl named Randi Lee, born 15 June 1984, at 10:00 A.M. It was a wonderful gift and brought a new pleasure into his ailing life. The baby proved to be good medicine for his health. I wrote a letter to Randi Lee and sent her a drawing to welcome her to our world, hoping to stimulate her interest in art.

I had completed a couple of large canvases, one seventy-two by eighty-six inches, the other sixty-six by seventy, and thought it time to see a bit more of the world. I knew nothing of Italy and decided to become acquainted. Off we flew to Rome for a bus trip which took us up one side of the country and down the other, a marvelous trip with many adventures, all pleasant and rewarding. I had held the belief that the early Italian landscape paintings were pure invention and that the artists had used a great deal of imagination. But, no. They just painted what they saw. The Italian landscape appeared even more beautiful and surreal than the paintings the early master painters gave us. After the Italian venture, we visited Erika's family near Salzburg and enjoyed three nights of magnificent music. I had always taken pleasure in opera, but never before had I experienced it as I did in Salzburg. In Vienna

we enjoyed the best and most of the Bruegels and other great works I had dreamed of seeing.

Soon after our trip, Teddi Newman and Drew Saunders, with whom we had become acquainted at my show in Washington, D.C., came to visit and select a show for their gallery in Wayne, Pennsylvania, a suburb of Philadelphia. We had immediately developed a warm friendship, and they became new champions for my work. Their show opened on 3 November 1984. The exhibition sold out, and demands for more paintings continued to come. I welcomed this stimulus, which gave me an added push to produce. Another show opened on 30 December at the Hall Gallery in Fort Worth, bringing to a close another good, productive, prosperous, happy year.

Perhaps the virtue of having a gallery, if virtue can be found in the profession, is that the unexpected can happen, and often does. Then, too, a painter's life is seldom dull. I am the first to agree that a painter should never be a dealer. A painter's eye looks at a work in ways that a collector or dealer rarely can, and the painter's attitude gets in the way of what a collector or dealer seeks. It is equally true that a dealer should never paint, for it could humble him. The collector *should* paint, for he can gain respect for what he is buying.

During this period of continued calm, productivity, and pleasure, I produced a successful benefit exhibition for the Ballet Company of Washington, D.C., at the Four Seasons Hotel. Two-thirds of the paintings sold, which made both the recipients and me happy.

✹

In this year of travel, Erika and I motored down to Port Aransas, Texas, so she could fish. She had never caught a fish and had somehow become convinced that she must do so if life was to be worth living. I rented what she needed to accomplish her goal, and we walked out on the pier, where I baited her hook and showed her how to cast. After a dozen or so tries, her casting improved. Two hours passed and nothing bit, so we decided to try the jetty about a mile up the beach. On a nice open space, free of other fishermen or

other people, her first cast snagged and lost the last hook. After turning in the rented equipment, we found a pleasant place to lunch and, as good fishermen do, we told stories.

Undaunted, Erika felt only more challenged to land that first fish. This time I bought her a rod, reel, hooks, sinkers, floats, leaders, and line, along with a box to carry it all in. That should have warned all self-respecting fish that they were dealing with a pro. We found some comfortable rocks and assembled her new equipment, and she was ready to empty the Gulf of fish. With baited hook she hit the water with her line again, again, and again. With bated breath and the patience of a true fisherman, she waited. Time passed. And passed. At last something pulled at her line, and she yelled that she had it!

"Careful," I warned, "don't panic. Reel it in slowly. Steady, now. That's it, now bring it up. You made it!"

It made a barking sound. "Hold it till I take a picture. Steady, got it. Now pass it over to me and I'll take it off the hook."

The fish again barked its protest.

"I'm sorry, little fellow," I said to the four-inches of unhappy croaker as I returned it to the water. But at least we returned home triumphant. The size of the prize is not as important as the winning of it.

Another cruise took us to the Baltic Sea. A visit to Leningrad to see the Hermitage and its great collection, touted as being one of the finest in the world, proved to be a disappointment. The Rembrandts, in desperate need of conservation, seemed a tragedy to us. Only the French works appeared to be in good condition, probably due to their relatively young age. Seeing those paintings did make the trip worthwhile, though, for we viewed some of my favorite Matisse and Gauguin works, among others.

Our ship took us to many ports: Copenhagen, Stockholm, Helsinki, Visby, Amsterdam, and Southampton. We enjoyed the Milles gardens, the Saarinen home, the Aalsmeer auction, Rijksmuseum, and Stonehenge. Between ports of call I filled another sketchbook and worked on my biography for the American Archives, which I had neglected doing for more than a year. At Southampton, Norman Hirschl and his wife boarded the ship for New York, adding to our pleasure.

In New York we visited several dealer friends, among them Clyde New-house. I am especially glad that we saw him, for he died a few months later. I shall always be grateful for his friendship and the generous help he gave me through the years.

On our way back to the hotel from an art store where I had purchased a few large rolls of good linen canvas and stretcher sticks to hold me for the coming year, we stopped for lunch on a street corner and ate hot dogs served from an umbrella-covered pushcart. I had always wanted to do that, but never had, through all the many years and dozens of visits. The temptation had been there, but the spirit had not been willing. The vendor handed us our hot dogs covered with mustard and kraut, and we leaned against a building and lunched on our Coney Island delights while we drank sodas from sculp-tured bottles. The desire for such a picturesque lunch, I discovered, is much more satisfying than the actual event. Something must have become lost in the reality of the experience, for now when I pass such a mobile lunch stand, I no longer feel any interest.

18

A Painter and Art Dealer

Creator and Matchmaker

AFTER our return home from traveling in Europe, I began preparing a new canvas, this one eighty by ninety-six inches. I intended it to be a masterwork. I felt in tune, the juices were flowing, and I had a feeling of confidence that assured me all would go well. I secured the virgin canvas on a special easel I had designed to support my larger works and sanded it lightly with fine sandpaper, then stained it with a light golden raw sienna. I cleaned my palette and squeezed out fresh pigment and then sat back, staring at the inviting surface that was challenging me. It would become a love affair; I would give it my all.

I decided to wait until the next morning, for once started, I did not want the seduction interrupted until my passion with this painting had been well established. I would not allow myself to dream of what was planned. Too often I had painted wonderfully in my dreams; pictures satisfyingly complete, only to find the next day that they were gone. I could remember them, but they could not to be repeated.

What is this process? I asked myself. There is a nagging urge to paint. What should I paint? How should I start? Painting instructors told me that to be a painter, I should have something to say, to express, or to respond to. A

teacher once suggested I paint an apple and, by my painting, express how I felt about it. An apple. What can an apple be but an apple? I asked such questions when I first tried to paint. They are difficult questions for the novice. The inexperienced view can lead a painter to believe that after studying master works, he need only pick up the brush to carry on where the master left off. With a few years of concentrated work, the beginner might be able to reproduce, more or less, the images of the master, but it would not be the beginner's own individual expression.

Once the painter has gained the facility to paint, he must develop his own taste, learn to see, and begin to respond to and trust his own feelings. Only then will he be ready to paint the apple. Then the apple will be his alone. No one else will have painted one like his.

Next comes the big question: Is it good, bad, or mediocre? A painter must be honest. If it's bad, he has a chance. If it's good, he must do better. If it's mediocre, he has problems. At all costs he must avoid mediocrity; it is the plague of mankind. Finally, he will have begun to understand what it is to be a painter. He will understand why a painter is more than willing to spend a lifetime trying to establish his feelings on a piece of canvas or a panel.

When we are young, our energy helps carry us. After a time, our values change, and we seek the nuances and subtleties. The demands I placed on myself, for example, became greater and greater. Soon I could feel a reverence and awe when I stood before a masterpiece. I fervently hoped that one day before I died I would paint such a work, so that someone else would respond to it in like manner. To create such a work, I decided, would make life worthwhile, for I would have left the world a little richer and, now and then, my presence would be remembered.

The next day at first light I left my bed to open the shoji screens to the greenhouse and see what the day promised in the way of light. It was to be my day! I felt like a thoroughbred waiting for the gate to spring open on a fast track. What music should I select? I needed something that did not require that I stop to listen and did not require changes; something tender and supportive, something felt rather than heard. I selected a Rachmaninoff symphony, the Second. That should do it, to start. I had set the stage, and my

excitement grew as I entered the studio, placed the disc on the machine, and approached the virgin canvas with promises that only I could fulfill. I glanced at my sketch, selected a brush, and entered a world known only to painters, a "high" no artificial stimulant could equal. This can be the greatest of all adventures, a true love affair, giving my truest feelings, knowing that if I succeed, others will share a moment or two with me and feel a bit better, perhaps even smile. For a painter, what gift is more rewarding to give? The light seemed to disappear. The day had gone, and for the first time, I felt exhaustion. I sat back on the sofa at the far end of the studio and smiled with satisfaction. It had been a good day. Tomorrow the painting would come together. Perhaps I might even finish it.

In the studio at my easel.

The next day I worked again from first light to just before dusk. I had completed the painting. If I felt the same about it the following day, I would sign it. And I did.

Paintings continued to flow, and my drawings served me well. In the garden and greenhouse themes, I found that employing a still life within a landscape, or including drawings in a still life offered a fascinating challenge. My excitement in painting continued to grow with each passing day. Meanwhile, Kevin and Cheryl were handling more and more things in the gallery. Although I disagreed with some of the works they thought important to show, I understood the necessity for them to learn and make their own decisions, for one day the gallery would be theirs without my help.

The painter-dealer combination is a rare find. Those who seek the profession usually come from the ranks of frustrated artists or art history buffs. Collectors who become dealers arrive with the advantage of understanding the business and coming to the market well financed. The dealer still committed to producing art brings understanding of a different sort. It has served me well as a painter to understand the problems that separate the artist and the dealer.

At the time I entered the profession, little money was required compared to today when it would take no less than a million dollars to become estab-

lished as a dealer with authority. The Betty McLean Gallery and Valley House Gallery received unprecedented press coverage in the early years. Now with more than forty galleries operating in the Dallas/Fort Worth area, Valley House is mentioned only if we send a notice, and the press rarely reports on the importance and quality of exhibits they list. I say this without complaining, understanding the space problems.

Good timing also opened up connections with the major New York dealers who, wanting to get a foothold in Texas, were most cooperative about loaning work on consignment. This arrangement gave us the opportunity to mount several exhibitions that the local art museums could not equal. We distributed the catalogs and monographs we published to museums, dealers, collectors, and the U.S. Department of State, which in turn mailed them to U.S. embassies around the globe. I believe it is fair to say that Valley House played a significant, if not singular, role in bringing Dallas to the attention of the world of art.

Our introduction in 1958 to the private dealer Robert de Boli, who represented the estate of Ambrose Vollard, proved to be our greatest asset. We soon built a reputation solid enough that my voice on the phone could deliver the most prized works in a day or two. We bought estates of artists and represented others, while supporting selected painters by purchasing their output. Working with museum directors, we produced traveling shows at Valley House. We helped in creating galleries sponsored by Junior League groups in Oklahoma and West Texas. Yet in the midst of all this activity, I continued to produce paintings that at one time were sent to seven different galleries representing me. I did not show my work at Valley House because I thought it unfair to do so while promoting other artists. When asked directly about the availability of my work, I would offer an invitation to visit my studio to keep my professions of artist and art dealer separate.

Being accepted to membership in the Art Dealers Association of America in 1964 was for me like being accepted as a top grade painter in the W.P.A. Easel Project. I deemed it an honor to join with the top dealers in the country "to promote the highest standards of connoisseurship, scholarship and ethical practice within the profession and [to increase] public awareness of the

role and responsibilities of reputable dealers." Through the years my respect for the ADAA has grown, for they have removed dealers who have not lived up to their standards.

During the years I spent as an active dealer, I learned just how complicated is the relationship between the creators of art and the galleries that represent them. To the artist, the obligations of the dealer seem less than artistic, but the dealer had better understand business or he will be eaten alive. At Valley House we have always tried to treat artists as I would like to be treated, but even then some remain unclear about our costs of doing business.

These days, maintaining a gallery space in New York City can run up to $100,000 a month for a good location. Then there is the insurance necessary to protect the art and employees, and the fees for bookkeepers, accountants, and lawyers. The dealer must absorb costs for crating and shipping work to prospects; for printing invitations, catalogs, promotional material and advertisements sent to art magazines. There are catering charges for openings and charges for photographing press shots of each work. All these expenses fall to dealers while they try to earn their commissions which are often split with decorators and other dealers, and always split with the IRS.

Dealers invest in artists they believe to be promising and may promote them for years before receiving a profitable return. That commitment is what separates a dealer from a merchant. In truth, in the love affair between the collector and the art, the dealer is a matchmaker. Each collector has his or her own reasons for seeking and buying a certain work of art. I have had clients who wanted an inexpensive print by Picasso or Goya just for the pleasure of claiming to own an original. For the dealer, it does not matter the reason; his goal is to serve the present interests and desires of the customer while hoping to introduce new ones. A good work of art will always have trade-in value, offering the collector an opportunity to change focus or upgrade later on.

As I look back, I take pride in the fact that I helped pioneer the interest and growth of modern art in the region. Becoming a dealer certainly divided my time with painting, but neither was compromised, and I freely acknowledge that it was the total partnership with Peggy that made it possible.

In addition, the lasting friendships I made as a dealer have remained with me as vivid, happy memories. During the summer trip Erika and I took through Spain in 1988, I stood before the ancient Roman bridge that led to the golden walls and towers of Salamanca, and I thought of Loren Mozley. Or rather, the image of his painting appeared in my mind's eye, and I remembered so well the day Loren brought his canvas, *View of Salamanca*, to the gallery with five other works that would be included in his upcoming one-man exhibition. This hauntingly beautiful painting was truly a masterwork. Loren had structured the painting like a fine Cézanne, each brushstroke building it into a unifying whole. Many times through the years, when alone in the viewing gallery, I would bring out this painting from the racks, as was my habit with selected works, to enjoy and study. It made me sad to think that this special friend and favored painter was slowly going blind in a nurs-

Loren Mozley in his studio, Austin, Texas, 1985.

ing home. At the same time, I felt his presence sitting not far from where I viewed the city, painting his canvas that would give pleasure to many others and to me for years to come. The Austin hill country suited his palette, as did Spain, Mexico, and New Mexico. He felt most at home in those places.

Loren was always a man of great patience, understanding, and knowing. He made no demands and was not discouraged by the slow response of buyers to his work. I regarded him as the finest landscape painter in Texas, a genuine painter's painter, and one who gives the most and asks little. For years I offered and showed his work whenever possible, but with little success. I never lost the belief that his day would come.

In 1978, a good three years after Loren retired from teaching at the University of Texas, Donald Goodall, a contemporary of mine at the Art Institute and the Artist Community House in Chicago, decided to give Loren a retrospective exhibition. He asked if Valley House would share it. I quickly agreed and set a catalog in motion. I wrote a small piece for the catalog and shared half the production costs. When the exhibit opened at Valley House,

after a successful run at the university's gallery, people started to buy. Today, few of Loren's paintings are available, for all at once, buyers and collectors had started to respond as if a new talent had emerged on the scene. At last Loren enjoyed the fruits of his labors.

Quite the opposite circumstances occurred with Fred Nagler. I first became acquainted with his work while I was a student at the Art Institute. Several of us seemed to discover his painting at the same time during the Annual American Painting Exhibition. Nagler's painting intrigued us with its color and distortion of the image. We would look for his paintings whenever possible, for we found them exceptional and exciting. We discussed them at times during dinners at the Community House. His subjects, mostly religious, seldom entered into the discussions, for our interests lay in the beautifully controlled, painterly surfaces and nuances of color and line.

Many years later in Dallas, at a cocktail party, I met some relatives of Fred Nagler who asked if I knew of him or his work. I learned that his son Joe lived and worked in Dallas and was a highly respected engineer who headed his own firm. Fred and his wife Edith, also a painter, came to visit Valley House so that I could meet them. It was love at first meeting, and my respect for Fred grew with each meeting through the years until his death in November 1983.

Fred severed connections with his New York gallery soon after he moved to Dallas, and Valley House became his sole dealer. Fred was accorded recognition during most of his professional life. He married well, and both he and Edith enjoyed a life free of financial concerns. He spent his time totally in pursuit of producing fine works of art that should be worthy of surviving throughout time.

One day not long before he died, Fred came by the gallery to visit. He had with him a packet containing close to a hundred drawings, prints, and small watercolors, which he handed to me, saying, "I want you to have these as a gift." I tried to refuse them because of their value and the quantity, but he insisted. With gratitude, I took them and set his splendid gift aside to be cataloged later. In good conscience I could not keep this generous offering, however, so I returned the pictures to his son. Joe and I agreed that the

gallery would represent the estate, and all Fred's works, other than a few selected ones Joe wished to keep in the family, would be turned over to us.

When we had assembled all the works of Fred Nagler, we were delighted to find such a vast number of drawings, watercolors, and prints, including all his etching plates. We were so impressed with both the quality and the quantity of the prints that we decided to publish a complete catalog raisonné. The work should be of great interest to the print collector and the art world. Fred Nagler was very productive and a rare artist. I felt an obligation to leave a record of his gifts to all of us, and privileged to have the task.

Over the years I've learned that all artists, young and old, should keep a photo logbook to record works produced, so that each work's history and whereabouts can be known when needed. This practice helps not only the artists, but also their heirs and historians. The logbook should include, along with a color photo of the work, the title, size, medium, date finished, where shown, when it left the studio, when returned, and, if sold, the name and address of the buyer. I advise artists to make a duplicate copy to be kept in a separate place to avoid loss by fire, flood, or theft, as proof for insurance.

Another happy and eventful year closed with a one-man show in Philadelphia in 1984 and yet another large canvas.

19

The Value of Reputation
New York and Dallas

I SUPPOSE things can go well for just so long before events bring you up short. Nature has her own seasons, which I accept without question. An unkind surprise occurred on February 4, 1986, at eleven o'clock in the morning. As I painted, I had a fainting spell, which all but dropped me. Nothing like that had ever occurred before. When I came around enough, I called Dr. Donald Brown, whose care I had enjoyed for many years. He insisted I come to his office as soon as possible. Kevin drove me, and within the hour, Dr. Brown began examining me. I felt sure he would give me some pills and send me home. Instead, I checked into the Gaston Episcopal Hospital to have a pacemaker implant. It's a remarkable gadget about the size of a thin pocket watch. The day after the implant I sat up in bed, sketching ideas for future paintings; on the third day, I returned to Valley House to resume life as before. My pacemaker is checked with a teletrans machine via the telephone once each third month. What a marvelous age we live in.

I learned long ago that each day brings a new event. My contacts with the police had always been for the purpose of helping them by appraising stolen works of art or exposing con men who were dealing in bad or stolen art. Now

came a slightly different episode. The event began to unfold on Easter morning about 8:30. Erika and I were in the kitchen fixing breakfast and waiting for Barley to arrive to join us. As we looked up toward the road, a black man exploded through the hedge, running through flowerbeds and heading straight for the house.

As the first of two squad cars sped down the drive, the man turned off, heading into the bamboo hedge. The squad car left the drive, plowed onto the grass, and roared up and over the berm, as if to run the man down. A second car stopped just off the drive, and two burly uniformed policemen jumped out and raced after the fleeing man, who was trying to claw and wedge his way into the impenetrable growth. Obviously, he didn't know much about bamboo. The larger of the officers grabbed the fleeing man's feet and pulled him from the hedge, sat on his back, and pushed his face into the dirt. By that time I had bounded out of the house and was approaching the players in this drama.

The prisoner tried to yell, "I have asthma—can't breathe! Let me up!" Then his head would be shoved back into the soft, black gumbo dirt, and again he'd pull up and yell, "God! I can't breathe! I ca—," into the earth.

Barley arrived at this time to join the excitement. Out of the first car came another officer, joined by a fourth one, who had been pursuing on foot. Their prisoner must have been one bad guy for all this attention. The officers handcuffed their man, shoved him into the first squad car, and headed out after thanking us and apologizing for messing up the lawn and disturbing our morning. One policeman, who seemed to have become quite entranced with Barley, then turned all his attention to her. He tried to date her right then and there, and phoned for her a couple of times later, all without success. Easter was off to a rousing start.

Barley had arrived to have breakfast and dye eggs for the afternoon festivities. Through the years it has become a tradition for friends to gather at Valley House to celebrate and join in games and pleasant conversation on Christmas, the Fourth of July, and Easter. In March I have a birthday dinner for many of our dearest friends as well as Erika and son Eric who share the same sign. These events please me, for the garden is never more beautiful

than when it is shared. I try to bring the spirit of these moments into my paintings, especially in the country dance series, which continues to meet with success. They have all sold soon after completion.

In April I had another show in Houston, at the Phillips Cowan Gallery, which met with minor success. Houston has been a tough city in which to gain response to my work, but over the years, I have sold some fifty or sixty paintings from exhibitions and almost that many to the Houstonians who have come to Valley House.

My desire to paint larger canvases continued, so I stretched two, one seventy by eighty inches, and the other sixty by seventy inches. I planned the first to be a group of young musicians, singing and playing; the second was a tennis party. Both went well, and it was a rewarding challenge to do them. A numbered group of still lifes of painters' objects, such as tubes of paint, oil bottles, and brushes, followed the two large paintings. The numbers on the still lifes appear somewhere in the background, one through eight. Boaters were another subject that held my interest.

In 1987, after Erika and I returned from communing with nature in Alaska, events began taking shape that would bring together new adventures to excite my interest. I had renewed our association with Nat Neujean, the noted Belgian sculptor, and bought his *La Belle Toscane*, a most beautiful life-size nude that is a total delight, creating another happy scene in the garden. We set plans for a future one-man show.

Then one day I received a call from a Mrs. Sullivan, with whom I had been working to find a painting for her to give to the museum. Many fine pictures had been shipped in for her approval and the museum's acceptance, but without luck. This call would open a series of events I feel should be shared, for it gives evidence of the integrity of the oft-maligned art dealer. I believe the established dealer has proven more reliable than an ordinary broker or banker, and certainly he gives one more pleasure.

Mrs. Sullivan's call referred to her Monet, the prize in her collection. A chip or two had come off its surface, and all indications were that others were likely to follow. Perry Huston, the conservator who had restored *Nana* and examined the picture of the *Signing of the Declaration of Independence* for

Ross Perot, refused to accept the picture because of insurance problems. The company covering the Monet had told Mrs. Sullivan that she was covered, but if something happened to the painting while it was in Perry Huston's care, they would sue him. This scared the hell out of Perry, and he refused to touch it unless insurance covered the painting while in his care. That would mean double coverage. What could she do? Could I help?

"No problem," I assured her. "Let me call Perry. We're old and trusted friends, and perhaps I can convince him that you won't sue him. After all, he's only to give you a condition report and an estimate of cost before you consider any restoration."

I volunteered to carry the picture to him if she was so concerned, or Perry could pick it up. I called Perry and, after much talking so that he could relax, I assured him that I had known Mrs. Sullivan for some time and that she was indeed understanding and not the kind of collector who is so often impossible. She is truly a lady in every sense. He finally relented, and the next day he examined a very seriously ailing painting.

He called to report his findings and ask advice on how to tell Mrs. Sullivan the bad condition of her prize. Somewhere along the line, the painting had been "transferred," that is, the paint film had been removed from the canvas on which it was painted, and transferred to a new one. In this case it was adhered to a fine white handkerchief linen and it in turn to a similar linen. Then these fabrics were glued with what looked like rice paste to a raw or unsized Belgian linen. It was filled, where losses occurred, with picture putty. Perry estimated that about two-thirds of the surface was over-paint, leaving little that could be called Monet. All of this was coated with a varnish that the strongest solvent he knew could not penetrate.

I reported Perry's findings to Mrs. Sullivan, and she felt truly devastated; her favorite picture was all but lost.

"What can I do about it?" she asked.

I volunteered my help, explaining that I planned to visit Perry and have him show me the problems so that I could fully understand and better relate them for a possible solution. I told her that since the picture had come from a reputable gallery, they should stand behind it and would want to do so.

My visit to Perry's new lab proved most rewarding. I enjoyed seeing an old friend again and his most impressive new facilities for the first time. He removed the Monet from a large fireproof vault and laid it gently on a work table that held a microscope. Step by step he showed its problems, just as he had reported them earlier by phone. It did help to see it through the microscope as he explained what I was looking at. Kevin had come along so that after seeing the Monet, he would be able to recognize such problems should they appear in future paintings the gallery might handle. Perry took us to lunch at a nearby private club to visit and exchange ideas on how best to handle Mrs. Sullivan's problem. The picture obviously had lost its value, so it raised many interesting questions: moral, ethical, and legal. These I would bring up when I reported to Mrs. Sullivan.

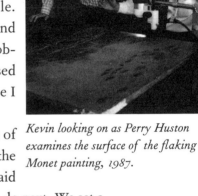

Kevin looking on as Perry Huston examines the surface of the flaking Monet painting, 1987.

My call to explain our findings and to suggest a course of action brought a request from her that I learn the value of the painting if it were to be sold on the current market. She said she would like for her son to join us to help decide what to do next. We set a time for the meeting and, in the meantime, I made three calls to dealers I knew well and told them I had the Monet to sell, giving them the title and number in the catalog raisonné. The figures they quoted ran from three to three-and-one-half million dollars; all the dealers would buy it right now, or sell it and guarantee such a sum.

I reported the results of my inquiries and suggested she and her son visit Perry Huston and ask him to explain the problem personally. I felt it important that they fully understand what was involved before we got together. I tried to assure her that her investment in the painting would not be lost and, if the matter were handled properly, she could profit. I suggested she call Wildenstein Gallery, where she had acquired the Monet, and talk to Harry Brooks, the acting president. I assured her that Mr. Brooks was a gentleman and easy to talk to, and that I had known him since the early fifties. I told her to use my name if she wished.

Would I call, if I didn't mind, she asked, and explain the problem. I said I

would be pleased to do so. I gave Harry the gist of what we had found out and asked that he call Mrs. Sullivan to assure her that they would properly take charge. He said he could do little; the Wildensteins had to be consulted for such decisions.

Our first meeting to discuss strategies and procedures gave me the opportunity to meet Mrs. Sullivan's son, Gill Clements, a well-informed businessman who was not overly informed about the art world, but was quick with facts and figures. This well-built, athletic-looking man had a firm body with no excess fat. He listened quietly and asked probing and meaningful questions. As a good businessman, he had reservations about what might occur and wanted to know all the alternatives. I tried to reassure them and impress upon them that they were dealing with perhaps the finest and richest gallery in the world, and with gentlemen, not merchants. I explained that the Wildensteins dealt in real values, because they stood behind their art.

At the moment, Gill didn't appear ready to accept my evaluation of the Wildensteins, but time would tell. I felt sure we needed to apply no threats or pressures. If we just let it unfold at its own pace, all concerned would be content with the results.

Harry Brooks talked with Mrs. Sullivan and arranged for one of their men to come to Dallas and visit with Perry to examine the picture. The Wildenstein gallery had been unaware the painting had been restored in such a manner and wanted it returned to New York for further study. After much talk among us, we agreed to ship the painting with proper receipt. Alex Wildenstein then offered a three million dollar credit against the acquisition of other paintings and said he would come to Dallas with transparencies of available works.

We arranged a date, and Mrs. Sullivan asked me to help select the pictures to be considered. I suggested that she think in terms of accepting paintings that would grow in value, that could be traded or sold later, when and if she found one she loved as much as the Monet. I could only express my pleasure at the amount of credit extended without our ever having stated a sum.

This event provided my first opportunity to meet Alex Wildenstein, and I looked forward to it. I knew his father, though not well, because most of my

dealings had been with Louis Goldenberg, the past president. I found it easy to like this stocky, well-proportioned man with his easy good nature and friendly smile. Mrs. Sullivan showed him through the house and he accepted a cold drink, we settled down to await his presentation of transparencies.

Alex first showed us two Pissarros. One was a port scene I considered first-rate, but Mrs. Sullivan passed it over. The second was a handsome view of the Tuileries with the Louvre in the background. Both pictures were well-known with good provenance. We moved on to an atypical Sisley, a picture of his two children in a room in the painter's home; it was a most painterly piece, very direct, with an economy of sure, fluid brush strokes. It sparkled and pleased the eye. Next came a Degas pastel of a dancer that had lost something through the years. It felt tired; not the subject, but its surface. Then Alex handed me a Manet, a simple oil with unfinished background. The subject was a bugler, a young soldier with bugle to mouth, blowing.

"I hear you," I jumped. "This is it! My God, what a painting! Forget everything else, this is it!" My enthusiasm startled everyone. Alex smiled, he understood. The painting pleased me highly, for I felt Mrs. Sullivan's son understood and felt the importance of the piece. What a painting to have in Dallas, an opportunity not to be passed up. I intended to give the painting my best so that Dallas might have it. So many good ones had gotten away in the past, but if any influence I could muster would prevail, this one must come and stay.

Next Alex offered another Manet, a still life, another smasher, but not as exciting as *The Bugler*. A Monet followed, but did not tempt us. Then we looked at a couple of Caillebottes and, last, a lush Renoir landscape. I suggested Mrs. Sullivan have the Manet sent down to try, because I felt that once here, it would stay. We agreed, and Alex left to visit a friend. He left the transparencies, giving us an opportunity to review the offerings. My second choice had been a Bonnard landscape, but at the time, it was in Japan. Mrs. Sullivan loved it, and rightly so. It was the best I'd seen in many years. She would consider it. In the meantime, we awaited the arrival of *The Bugler*.

While the Monet resolution progressed, my sister-in-law, Toni, called to inform me that my brother, Bob, was gravely ill and showed little hope of

survival. His physical neglect through the years had taken its toll. I asked her to keep me informed. I would try to get to Houston to spend a day or two with him. Time ran out, however, for her next call informed me of his passing. His body was cremated, and Tony sent the ashes to me to spread in the garden, as he had wished. In part, my family remained with me. I decided to design a simple stone of black granite, eight feet tall, a slender, sculptured form to stand in the garden. It would contain the names of those whose ashes had been scattered there, without dates, leaving space to carve the names of the rest of us in time.

The second day after our visit with Alex Wildenstein, I received a call from Mrs. Sullivan saying the Manet had just arrived and the crate was being opened. The gallery's policy directed that their own men open and hang their paintings whenever the value exceeded a million dollars. It helped keep the insurance company calm.

When I arrived at her house, I found a large truck at the curb. Two men with screwdrivers worked at removing the last of six screws from the inner wooden crate that had been floated inside a larger wooden crate. Finally, when the last remaining screw was removed and the lid set aside, there, resting tenderly on soft plastic blocks, lay our prize, wrapped carefully in waxed paper. Not until the painting was taken into the house would the gallery men unwrap it.

When we finally saw it, it was all I expected, and more. I smiled at its delightful presence and silently applauded its strength. Soon it hung on the wall; the men installed a picture light and departed. We sat and let the painting work its magic on us. Mrs. Sullivan did not yet feel convinced. I didn't want to oversell it or pressure her. I had too much respect for her to do so. Her decision would work itself to the right conclusion. My main fear centered around well-meaning social friends who might not respond to the painting properly, and that could be the end of it. I'd seen it happen before.

A couple of days later Kevin changed its location, hanging it in the living room over the piano. A week later Mrs. Sullivan called and asked me to go to New York with her and her son, Gill Clements. I hated leaving Valley House in the spring, even for a couple of days, to go to that gray, dirty city. How-

ever, if my going would help keep the Manet in Dallas, it would be worth the trip. In a weak moment I agreed.

For days before the trip, I told myself, "I don't want to go. What a waste when there's so much to do and enjoy here." But this trip turned out to be my most interesting one of all, one I would long remember.

For me, waking up in a hotel, no matter how luxurious, is no substitute for looking into the garden at Valley House. However, the Helmsley Palace did offer an improvement over the Old Chelsea Hotel where, long ago, I had shared the room with a brown bat hanging from the ceiling. After a good breakfast, we headed for our 9:30 appointment. Since Alex Wildenstein would be a little late, we were invited to enjoy the pictures, which were hanging in the back gallery. In a few minutes he arrived, saying that he was sorry, but the spider monkeys had gotten out of their cage, and he'd had a bit of difficulty getting them back into it.

He left his story hanging there and showed us into the elevator, and then into the fourth floor room, a red velvet room containing four red velvet-covered chairs and three red velvet chair easels. When we had made ourselves comfortable, he turned toward the door and said, "Bonnard." Two men appeared and placed a beautiful landscape on the nearest easel, the Bonnard that had been in Japan. We all responded favorably to it. Mrs. Sullivan stated her approval and said she would move another picture to accommodate it. Gill favored it, and twice repeated his approval. Their response pleased me. The Bonnard was my kind of painting. By now, they could measure my enthusiasm.

Next, Alex brought in the two Pissarros. They were wonderful pictures, but Mrs. Sullivan had no interest in them. A Degas pastel, a dancer again, came next, followed by the magical Sisley painting of his children. The Sisley proved to be better than the transparency had indicated. A few more pictures came and went, but none stood up to the Bonnard.

Alex left us alone for about twenty minutes to discuss the pictures. Mrs. Sullivan asked me what I would do. "I would keep the Manet above all and then, if possible, I would acquire the Bonnard and the Sisley. I know you favor them. They're both good pictures, and their values should be secure," I advised.

Gill suggested, "Let's have them all sent down and see."

Mrs. Sullivan looked at me, and I simply said, "There's no way to lose."

Alex returned and said, "How about some lunch? I'll show you my house as well." It had been a good morning, and I hoped we had come closer to a decision. The pictures would be sent to Dallas within the next two days, along with a man who would hang them.

Lunch was an affair I will never forget. When Alex invited us to lunch at his house, I assumed we would drive somewhere in the limo, some distance from the gallery. Imagine my surprise when we left the gallery on foot and turned toward Central Park. We walked a few steps and stopped before a large steel door. Alex inserted a key and opened it easily. We ascended about five marble steps to a second door, this one well-designed and welcoming, which led into the foyer. From there Alex showed us into a handsome anteroom for a drink. French period pictures of the eighteenth and nineteenth centuries hung on its walls. His taste was clearly evident throughout the house.

One painting in particular held my attention, a small canvas of tennis players on an indoor court; I could feel a strange density to the light created from the windows and its reflections. It had been painted in warm browns, sepia, and creamy whites with amazing subtleties of half tones. One could feel the silence of a moment frozen in time. A hand-carved frame, unique in design and mellow in tone, seemed married to the canvas. My eyes returned again and again to the scene as we sipped our drinks, until an invitation to adjourn to the dining room interrupted my affair with the small picture. I had not shared my thoughts about it with the others because I felt it best not to disturb their conversation. The picture became mine alone for that little time.

We entered a handsome, airy room. Alex suggested that Mrs. Sullivan and I sit on the side with a view of a large, handsome portrait that depicted a lovely lady with two majestic white dogs, a worthy view indeed. Two servers set warmed plates before us as our host, in easy conversation, told us our lunch would be the best that New York had to offer, lobster and duck.

He began to tell us about the spider monkeys as one of the servants returned with a handsome silver platter heaped with large pieces of lobster, surrounded with the flesh of the claws and covered with a light sauce. The

second attendant followed with a silver server containing more sauce. Of all the lobster I've ever eaten, none could compare with the meal we were served that day.

We helped ourselves as Alex explained his late arrival that morning. The spider monkeys were houseguests for just a few days and would soon be shipped to Alex's game preserve in Africa. The children had failed to secure the door of the cage when they returned the monkeys after their play. It took some time to recapture them, and so he had been late to greet us.

The two servers appeared from the kitchen again, one holding a silver platter larger than the lobster platter and covered in a mound of carved, roasted duck on a bed of wild rice with flat, quarter-sized mushrooms at one end. A brown gravy covered the dish that, again, seemed enough to satisfy a dozen appetites. The second man served the additional gravy. A red wine was then offered. Next came a curved dish containing spiny lettuce with a light dressing. The duck, like the lobster, tasted superb; the best a duck lover ever had.

The conversation turned then to the history of the house and the gallery. A refreshing dessert of fresh pear sherbet served with a bit of pear liqueur poured over it, accompanied by a selection of cookies, interrupted our conversation. The dessert proved both delectable and refreshing. I remembered only one meal that could compare with this, the one Peggy and I had enjoyed at the Japanese Embassy in Paris as guests of the ambassador. The quality, service, taste, and comfort our host offered should have been repaid in kind, but I could not provide such a pleasure. I am ever grateful to him for that memorable experience.

Alex suggested that we take coffee by the pool after we looked around the house. He especially wanted to show us the Bonnard room. We left the table feeling utterly content and relaxed, ready and eager to begin our tour.

The elevator took us first to the third floor, where we passed through the master bedroom into the bathroom to see the spider monkeys. In a large black cage resting in the tub, two young monkeys, a male and a female, huddled in each other's arms as if frightened by us. Before the week ended, they would be enjoying the open spaces of Africa.

Only happy, colorful paintings by Bonnard hung in the living room. What a treat! I found it a much more satisfying place than a museum to enjoy such paintings.

We followed our host to the elevator and descended to the first basement, where we exited into a long hall that led into a beautiful, light room containing a swimming pool filled with crystal clear water. A photo mural of the Serengeti Plains of Africa covered two walls; plate glass mirrors sheathed the other wall, creating a stunning effect. A heavy glass table with six comfortable chairs rested at the other end of the room. The two walls by the table, where coffee would be served, were aquariums that contained a wealth of beautiful fish and plant life. Of all the aquariums I've enjoyed while traveling about the world, in Munich, Amsterdam, Chicago, New York, and elsewhere, none has ever appeared so beautiful.

A servant arrived with small cups of espresso, just the right conclusion to our elegant lunch. Before leaving the house, I made a quick visit to look once again at the tennis court picture in its special frame. I failed to notice the painter's name, for the picture itself captured all my attention. For the painter, it's the work, not the person, that's important to remember. We left with happy memories and headed in the limo to the Hirschl and Adler Gallery to look for a painting Mrs. Sullivan might give to the Dallas museum.

I had called ahead to let my dear friend, Martha Parrish, know we were coming. A very fine exhibition of American paintings greeted us, but its luster seemed tarnished by what we had just left. After a quick visit, hastened because Mrs. Sullivan found no painting she fancied, we had an hour before we had to head for La Guardia, so I suggested a visit to the Frick, just at the corner. Its collection has always served as dessert for me. On this trip I had enjoyed two desserts as I left the city. I thought again about how reluctant I had been to come to New York. Still, Valley House looked better, and I would not trade it for all of New York and its contents. Besides, new adventures awaited me. Mrs. Sullivan had added three new pictures to her collection: Manet's *The Bugler*, a Bonnard landscape, and a small Sisley painting of his son.

❋

A phone call from Mrs. (Ruth) H.L. Hunt set in motion the most challenging commission of my career. Her sweet, kind voice lured me against better judgment to commit to it. I had first met Ruth Hunt twenty-some years before in response to her secretary's call. She requested my services to appraise a painting for Mrs. Hunt at the house. "The house" was one which everyone knew. It was a replica of Mount Vernon that sat on a hill, overlooking White Rock Lake, set off from the road by a vast expanse of lush green grass. I eagerly accepted the opportunity to meet her and see the interior of the famous house. Often when sailing on the lake I enjoyed viewing the house and wondered about the lives of the occupants. On the far side of the lake where I once enjoyed picnics with Margo Jones, Tennessee Williams, painter friends and musicians, the house stood out in its stately whiteness.

The caller met me at the door, thanking me for responding so soon. After introducing herself, she invited me in explaining that Mrs. Hunt would join us in a few minutes. The painting that she was considering was in the living room. My eyes darted about taking in each detail as the lady herself appeared descending the stairs.

"Mr. Vogel, how kind of you to come," she said. She was a handsome woman with graying hair neatly groomed and wearing a simple floral cotton dress. Her smile was warm and sincere, matching her voice.

After exchanging greetings we entered the living room to view a large painting that was dominated by its oversized bright gold leaf rococo frame. Inwardly I shuddered at its subject. Its overall sweetness suggested a saccher- ine valentine. It had been painted by a turn of the century Italian whose name meant nothing to me. Glancing about the room, I saw that it was out of scale to fit with any comfort. Its subject consisted of two lovers standing against the stone balustrade of a castle, costumed á la Romeo and Juliet, star- ing doe-eyed at each other and lit by a full moon framed by tall trees.

"I'm thinking of buying this picture and wanted to know what it's worth," she said.

After taking in a deep breath to hold back a choke with eyes narrowed as if I knew exactly, I said without further hesitation, "3,500."

With eyes wide-open she stared at me and smiled. "That's exactly what they are asking. You must look at my other painting. I'll pay you of course," she said.

I eagerly agreed, for I wanted to see the house where one of the richest men in the country lived. The house lived up to his reputation as a frugal man, and I'll leave it there. Only two other paintings hung in a small library room. Over the mantel hung a Flemish painting, I believe, that was so dirty it was difficult to read. Water stains had long ago run down the wall over the frame leaving whitish streaks on the surface. I suggested she should have it cleaned. On the opposite wall was a painting by Remington that I suggested was a copy or a fake.

"Oh, please don't tell H. L. It's his favorite. Promise?" she asked.

That was our first meeting. Our second meeting at my studio occurred some years later. It was mid-December and I had no notion why this kind lady would visit.

When she arrived, I offered her tea and asked what prompted the visit. "Mr. Vogel, I've decided to give paintings this year to my family, your paintings. May I look at some?" she asked.

When she left, she had chosen eight paintings of various sizes. The largest was a panel of a park scene, which would be wrapped and delivered to Ray Hunt on Christmas Eve. The others were to be wrapped, named, and delivered to Mount Vernon on the 23rd.

The sale certainly gave a boost to our Christmas.

❋

H. L. Hunt had left our world long before my next contact with Mrs. Ruth Hunt in 1988. Mount Vernon was getting a facelift, both interior and exterior. I had planned my visit with the mayor in Cary when Mrs. Hunt called to commission a painting which would include her grandchildren, all fifteen of them, and herself. It should also include some part of the house. After much

stuttering and hesitation I told her that I was not a portrait painter, but that it would be possible to suggest a likeness if that was acceptable. Her response was that she liked my paintings and her family was pleased with their Christmas gifts and understood my concerns. It was agreed that the size would be forty-eight by sixty inches and photos of the children would be sent so that I could acquaint myself with them. Two days later her secretary delivered a large packet of snapshots and stayed long enough to answer my questions as I viewed them. They were set aside and I flew to Cary. During the flight I was trying to imagine how to compose fifteen children ranging in ages from eight months to sixteen years. During my visit to Cary, I made a simple thumbnail sketch of a group of children dancing that would later be the basis of the composition to come.

After returning to Dallas I visited the grounds to photograph different angles of the house and gardens of the Hunt estate. Workmen were busy renovating the interior, bringing a new quality that I had not noticed during my first visit. Mrs. Hunt joined me in the garden so that I could photograph her and set a scale for the placement of the children. It was not possible to meet any of the children, much less gather them together.

Letting several weeks go by without thought of the commission, I placed a panel on the easel, glanced as my small sketch and then set it aside and loosely scrubbed in the picture that in most part would remain. The children were broken into groups, running down the lush lawn chasing a dog that was chasing a cat towards the viewer. In the right foreground one of the girls stood in the shadows of a tree. She controlled the size and the spacing of the other figures. The placement of their grandmother was important to counter the movement of the running children. A stone wall divided an upper terrace and steps offered a view to a portion of the house.

Before completing it, I called Mrs. Hunt so that she could make suggestions if needed. She arrived with one of her granddaughters who happened to be the lead figure in the painting. They both approved with delight after recognizing each child and especially my capturing the spirit and likeness of her.

It was an hour later when Mrs. Hunt called assuring her fondness of the painting and that she loved each of her grandchildren equally. Her only

request was to change the position of two of the children. I assured her it was no problem and that my interest was only to please her and produce a good painting.

"Oh, one other thing. I'll pay for it. I had two darling small poodles that meant so much to me. Would you paint them in by my side?" she asked.

I could only smile and assured her that it would be done and our original agreement was enough.

With changes made and feeling satisfied I sent the painting to her with our shopman, John Morrie, to hang with her instructions and to tell her that it would be varnished after a year.

In 1993, five years after I had completed the portrait, a letter arrived from Swanne Hunt, daughter of Mrs. Hunt, who wrote in a diplomatic tone that her mother was disturbed by one of the girls in the painting and wanted to know if I would correct it. To her it looked as if the girl was about to fall. She asked if I would meet her to discuss the problem. With good humor and interest I met with her the next morning and shared a cup of coffee before looking at the painting. I was taken with her at first sight. She possessed a presence of warmth and authority that made me feel at home. Conversation came easy because of our mutual interests. Her interest in the arts was sincere and active. Her husband Charles Ansbacher, who joined us, was the director of the Denver symphony and reminded me of Walter Hendl. When the conversation turned to the problem in the painting, I assured her that it would be resolved and it would be picked up that afternoon.

Before leaving she told me of her appointment as Ambassador to the Republic of Austria. She asked if she could borrow a couple of my paintings during her three-year service. A time was set for their visit that permitted an hour before she had to leave for the airport for a flight to Washington, D.C.

With the painting back on my easel, and after assuring the running figure would not fall but continue to run, I took advantage of my time to embellish it by adding color and surface texture. I assumed it pleased her, for Swanne wrote me a letter expressing her thanks for my patience and understanding with her mother.

The time had arrived to take advantage of Kevin and Cheryl. They slowly

took over the running of the gallery as I looked on with total approval. More studio and writing time and travel time to see more of the world started. I knew the gallery would continue to prosper and hold the standing it had established.

With the creative juices flowing, I all but became a hermit giving full time to the studio, moving between brushstrokes, written words, and visits to the garden. The garden defined each season with rewarding joy. Art clubs and students from the local universities began to frequent the garden to paint, recording its offerings.

As a way of thanking the past clients and supporting friends of Valley House I wrote and published a small book, *Seeking the Intangible*, as a gift. This led to writing a group of essays and observations: *The Boardinghouse*, published by the University of North Texas Press, related to the Artist Community House, where I lived during my first years in Chicago. Many books and short stories followed as did paintings that continue to be exhibited around the country.

20

I Am a Painter

My gift of thanks

IT HAD BEEN just fifty years since 1938 when I had my first one-man show in the Village Hall in Cary, Illinois. Now I had another idea: what better way to close this period of my life than with another show in Cary, the place that had given me so many happy memories? I phoned the Village Hall and found myself talking to the mayor, the Honorable Kathleen Park. Her warm, friendly voice confirmed her pleasure at my suggestion that we hold an exhibition, and she invited me to come for a visit. Since Erika planned to visit her grandchildren in Oregon at about that time, I decided to make my presence known again in Cary. The mayor and I scheduled a meeting.

I arrived at O'Hare airport and rented a car for the drive to Crystal Lake. There I found lodgings for three nights and settled in to spend the late afternoon drawing, writing, and driving around to reacquaint myself with the area. After a lazy breakfast the next morning, I headed for Cary, five miles away.

Many changes had taken place as I had expected. The old red brick factory with its tall chimney, that favorite landmark which had welcomed me so many times that it symbolized a safe haven to me, no longer existed. But as I entered the village, I saw that much had remained the same. I drove across

the tracks that had carried the old steam-driven trains to and from Chicago and across Main Street. Then I found Meyers' drugstore and Currin's grocery store building still standing. The cone-shaped steeple was missing from Currin's, however. My route took me past what was once Washer's Tavern, where my Uncle Bud had spent many hours, and to the hardware store. The building remained, but it was no longer a hardware store.

A right turn at the corner brought me to the house where I had lived with my aunt and uncle. It had been turned into an office. An asphalt drive led to a parking area in the back where I had played croquet with my uncle and tended the vegetable garden. At the corner, a right and a left turn brought me back onto Main Street. Not far up Main, I came to the old school house, which was now used as a meeting place for senior citizens.

I had the urge to visit my old classroom, so I parked the car and entered the building through the same back door we had once rushed through for recess. I walked down the hall and up the wooden stairs to enter the large, light-filled room. Except for a pool table, a few chairs, and a small wooden table, it stood almost empty. Eight men occupied the end of the room, a couple of them playing pool, the others just watching. Everything stopped when I entered. As I approached the men, I said, "Gentlemen, I'm Donald Vogel. This was my classroom with Mrs. Hubert."

After a pause while the men continued to stare, they finally began to smile, and one of them said, "I think I remember you, yes, indeed." Our conversation took off then, catching up with many "remember so and so," and "he or she died," "they left," and so on. I felt at home again. Only fifty years had passed, after all. Valley House was my first home, but my second home would always be Cary.

After I told the men of my plans to have a show, I went to visit the mayor. The secretary informed me I was expected, and she would call the mayor at her home. After a few minutes, the secretary asked if I would like to wait in the library until the mayor arrived. The library's growth impressed me. The librarians graciously guided me to books dealing with the history of the village, and I caught up with some of the events that had occurred during my fifty-year absence.

Mayor Park soon arrived. Her smile and happy eyes fitted the voice I had heard on the phone. She spent the rest of the day with me. After I was introduced to some of the staff, I showed the mayor drawings of village landmarks I had done in 1938 and an album of photos of some of my paintings, as well as another album of photos of the garden. Her enthusiasm for an exhibition grew even beyond what I had hoped for. We had lunch at the country club and drove around the whole of the area so that I could see its growth and select the most likely place to accommodate my requirements for the exhibition.

To the horror of Mayor Park, I chose to use the spectator balcony gymnasium of the impressive Cary Grove Community High School. It was a narrow room of twenty-four feet that ran the depth of the full gym. It was used for wrestling and rope climbing. Looking from the entrance door the right side wall was hung with floor mats that held stains from sweating bodies retaining a fragrance known to gymnasiums. The opposite wall was composed of folded stadium seats that separated the main gym a floor below. A well-established patina evidenced its use. The lighting served its purpose, which was not viewing paintings.

The look of disbelief from the Mayor was answered by a knowing smile. We agreed that my exhibit would open on Saturday, 3 September 1988, run 1:00 to 5:00 P.M., and continue through 5 September . My camera covered all possible angles and measurements before leaving. I left a puzzled Mayor, who, good as her word, made it possible.

The day evolved into a wonderful experience, because once again the village offered comfort, and I made a few new friends. I knew few had room for works such as mine in their homes, but I felt determined to give them the best show possible. This represented a sentimental journey for me, an opportunity to share the best of my memories with a community that had given me the happiest years of my youth. I had spent less than three years in Cary altogether, but those years were as important to me as any I could remember. Cary had been a safe stopping place for a young boy from a broken family, and I intended to honor the memory of my aunt and uncle, Eleanor and Budlong Talmadge, for the love and care they shared with me.

I returned to Valley House eagerly anticipating transforming a gymnasium into a handsome, functional gallery. With plans completed, I called a theatrical company in Chicago and explained my needs for lighting and a scrim. A call to Cary found a carpenter to build a frame of two-by-fours that would support a heavy seamless paper and the weight of framed pictures from my blueprint. Arrangements were made to rent nine schefflera trees in black containers. The gallery shop would build a divider that would be twelve by eight by four feet, covered with buff colored felt, and assembled in Cary. It would support two large and four small paintings.

I located a string quartet in Crystal Lake and suggested the music, allowing them ample time to practice. I designed a poster that the Cary Art Association could distribute and sell at the exhibit for ten dollars. The proceeds would go to the support of other programs. I printed an invitation and an eight-page catalog as well. There can be no stinting on a labor of love.

Only once did doubt enter my mind about the wisdom of attempting to transport such a project from Dallas, Texas, to Cary, Illinois, 1012 miles away. This small township of about 9500 had been a sleepy quiet village of 750 good, honest friendly people fifty years ago. Why should or would they have interest in some outside painter? Would they see me as just a foolish, sentimental jester with nothing more to offer than homage to an aunt and uncle who few, if anyone, would remember? Was it outrageous self-indulgence to prove to my uncle's town that I was a painter even if it was too late for him to know?

When the time arrived to move the selected works, I called in two men who had worked for the gallery to drive our truck to Cary, help with the installation and then dismantle it and return to Valley House. My older son Eric, Erika, and I would fly to Chicago, rent a car and meet them at the school after settling into a motel in Crystal Lake.

At 9:00 A.M. Thursday, 1 September, we met at the school to find the wall construction in place. The floors were mopped and the soon-to-be gallery awaited our attention. Eric, John Morrie, and Max Lloyd unloaded the truck, and by mid-morning had all but finished hanging the paper when the theatrical company arrived to hang the lights. The flats were assembled and placed

to divide the gallery's excessive length into two areas. The scrim was hung about twelve feet from the far wall permitting room for the quartet, which would be spotlighted to make them visible from the gallery. It also made a background for the largest painting.

By late afternoon the potted schefflera trees had arrived and the lights were being mounted on the support bars. With the walls in place, I arranged the paintings for hanging and determined the direction for the floodlights. All was set and in place until Murphy's Law reared its head. To get power for the lights, a heavy cable had to be run to the lower floor into the room that contained the controlling powerboard for the school. We then found that there was no possible way to tie in. What to do? The light installers suggested finding a portable generator. Where at such an hour in such a small town would we find such an item?

Being forever resourceful, I called the Mayor, who came to the rescue. Luckily, one was available in Fox River Grove and could be delivered within the hour for a rental fee of $400. The owner of the generator had his car packed for the weekend to fish in Wisconsin and had not left yet. The last generator of size to do the job would have been unavailable five minutes later.

Since all construction (except for the generator scare) went better than planned, we scheduled our free day for a visit to the Chicago Art Institute. Before we left Dallas, Rick Brettell had made arrangements for us to view the installation of the Gauguin retrospective that would open the coming week. Eric, Erika, and I boarded the commuter train for the windy city at 9:00 A.M. It had been fifty years since I last rode the cars that were then powered by a steam engine. From Union Station, a taxi delivered us to the shipping dock of the Institute. There I announced our presence and was soon met by a young lady who welcomed us with a warm smile and introduced herself as an assistant curator. She inquired about Rick Brettell saying that they missed him. We followed her through several galleries before reaching closed doors with a sign stating, "Closed for Installation." She opened the door and invited us into a series of galleries of breathtaking paintings. Several persons were at work hanging and moving pictures about. Half of the paintings were leaning against the walls or lying flat.For two hours we enjoyed absorbing each

painting without the interruptions of the milling crowds that would converge once the exhibition opened to the public. When coming upon *The Afternoon of the Gods*, the painting that meant so much to me during my first student year, I told Eric and Erika of its importance to me, how it opened my eyes and mind in viewing paintings. So many memories of the past came to the surface for me to share. And then it was back to Cary.

That evening we left the motel to arrive a half-hour early to see that all was in order at the school, greet the quartet and check the lighting. While driving, my thoughts returned to my waiting fifty years ago at the top of the stairs in the old City Hall for someone to arrive. Was this gesture and expenditure just an ego-trip? Would the audience smile politely and leave? Would the posters and invitation generate enough interest or curiosity?

In the lobby of the school we were greeted by three smiling members of the Art Association who had stationed themselves behind a table supporting

LEFT *Erika viewing my exhibition at Cary Grove High School before guests arrived.*
RIGHT *Greeting early guests at the Cary opening, celebrating the fiftieth anniversary of my first one-man exhibition.*

a pile of posters and catalogues. As we entered the gallery, sounds of music welcomed us as the quartet warmed up. A few chairs, a couple of benches, and a small coffee table holding a fresh bouquet of flowers had been added.

Among the first visitors was the Honorable Mayor Kathleen Park who approached shaking her head. "I could not believe it was possible, but you

did it. It's wonderful and will be remembered for a long time. May I, on behalf of the town, thank you for bringing a moment of beauty to us."

As the visitors started to arrive, each was introduced including three of my boyhood chums with whom I went to school. One brought a few photographs, some taken at the old swimming hole and one of me in a garden carrying a canvas to paint. Best of all, two of my dearest friends, Ernestine and Arthur Osver unexpectedly drove up from St. Louis for the occasion. They alone made the event worthwhile. As we talked, my dealer from Philadelphia, Drew Saunders, and Teddi Newman joined us.

A lady with a poster in hand approached me with her two daughters. "Remember me? I was Majorie Meyer," she said. " And these are my daughters."

I kissed her on the cheek then turned to the girls and told them about the druggist's daughter who was my first girlfriend. We were classmates and at times took walks and went swimming in the Fox River together. I never attempted to kiss her, being too shy to try, but often wanted to. That's why I kissed her now.

It was joyous and the best of openings. That evening added more memories. The dinner was sold out. After dinner Mayor Park introduced me from the podium in embarrassingly glowing terms, then asked me to say a few words. I took advantage of the opportunity to thank them and the memory of my uncle and my loving aunt. I told of what the village meant and gave to me, of working on the Hertz farm, in Mr. Mentch's pickle factory, and as a caddy for its golf course. I also explained that I always considered Cary my second home. Their warm long applause ended the evening.

Memories of my uncle's parting words almost sixty years before echoed once again. He had inquired what I intended to do with my life. When I told him, he said, "Why don't you do an honest day's work, like get a job with the railroad or in the gravel pits?"

"I am a painter," I answered.

Index

A

Aalsmeer auction, 251

Ablah, George, 233–36

The Abortion, 107

Adler Gallery, 272

The Afternoon of the Gods, 283

Albany, Texas, 65

Algonquin, Illinois, 26–27

Algonquin Hotel, 247

All About Women, 218

Allester, Lee, 227

Altermann, John, 67

Amarillo Art Center, 214

America Federation of Arts, 158

American Artist magazine, 195

American Association of Art Dealers, 184

Amon Carter Museum

 additions to, 235

 Aunt Clara's exhibition at, 162, 171

 book written for, 74

 director of, 160, 233

 Wilder exhibition at, 203

"An Invitation Through the Frame" (exhibit), 55

Anastasi, Billie, 211

Anastasi, Martin, 75

Anatole Hotel, 215

Anderson, George, 16

Anderson, John, 50

Annual American Painting Exhibition, 259

"Annual Break for Sculpture" *(Dallas Morning News),* 125–26

Ansbacher, Charles, 276

Aquavella, Bill, 237

Arbor Meeting (Williamson), 91

Arcadia Cafeteria, 17

Archipenko, 24

The Aristide Bruant (Toulouse-Lautrec), 127

Armitage, Merle, 93

"Art; Dead Artists, Live Wires," *(Houston Post),* 174

Art Dealers Association of America, 171, 180–82, 186, 256–57

Art in America magazine, 138

Art Institute of Chicago, 178, 259
Art News magazine, 138
"Artist: Valley House 'Finds' Breckenridge"
 (Dallas Morning News), 173
Artist Community House
 author rooming at, 14–15, 23–24
 closed for summer, 21
 compared to Taos, New Mexico, 93
 essays on life at, 277
 students at, 32
Askew, Rual, 68, 125–26
Aunt Clara. *See* Williamson, Clara McDonald
Aunt Clara (Vogel), 74
Austin, Texas, 258
Austin Statesman, 171

B

Ballet Company of Washington DC, 250
Ballet Russe de Monte Carlo, 67
Baltic Sea, 251
The Baptism of Christ (Piero della Francesca),
 117
Basset, Revo, 78
Beale, Joseph Boggs, 200
Bearden, Ed, 63, 69–70, 81–82
Beaumont Art Museum, 193
Belasco Cup, 48
Bellini, Giovanni, 224
Bellows, George, 90
Benrimo, Dorothy, 92
Benrimo, Tom, 92–93
Benton, Thomas Hart, 24
Bernard, Emile, 97, 130, 131, 133
Betsberg, Ernestine, 32–33
Betts, Louis, 38
Betty McLean Gallery, 89, 91, 256
Betty Parsons Gallery, 242
Bierstadt, Albert, 197
Black Like Me (Griffin), 142
Black Sea, 244
Blackshear, Mrs., 15
Blaffer, John, 147
Blaffer family, 145–47
Blake, Betty, 147, 170

Blake, Tom, 102–3
Blake, William, 117
Blakley (senator), 234
Blanc, Flora, 58
Blue Church on a Hill (Feininger), 94
The Boardinghouse (Vogel), 277
The Boating Party (Cassatt), 158, 181, 202
Bolet, George, 76–77
Bolli, Robert de
 author's visit with, 108–15
 business with, 133, 226
 correspondence, 140–41, 143–52
 directing Gerson to Modigliani works, 180
 meeting, 91, 97
 relationship with, 256
 translation of writing, 142
Bomar, Bill
 author's introduction to, 57–58
 background of, 61
 at Chelsea Hotel, 79
 frame designs of, 92
 visit with Steels, 128
 visiting author, 65
 works at Betty McLean Gallery, 91
Bonnard, Pierre
 forgeries of, 178
 landscape, 267, 269, 272
 paintings of, 271–72
 viewing works of, 145, 269
 works at Betty McLean Gallery, 91
 works at Museum of Modern Art, 106
 works at Phillips Gallery, 108
 works at Vollard estate, 97
Bosch, Hieronymus, 115
Bosque River, 161
Boy in Culottes (Modigliani), 232–33
Brackenridge Park, 219
Brants, Cynthia, 61, 94
Braque, George, 232
Breckenridge, Dorothy, 172–73
Breckenridge, Hugh Henry, 172–74
Breckenridge estate, 191
Brettell, Rick, 282
Brodnax, John, 173
Brodnax Press, 120

Brook, Alexander, 38
Brooklyn Museum, 151
Brooks, Harry, 96–97, 122, 163, 265–66
Brounoff, Zelman, 75
Brown, Donald, 261
Brown, Rick, 189, 225–26
Browning, Mrs., 165–66
Bruegel, Pieter, 116
Bryant, Will, 52, 59
The Bugler (Manet), 267, 272
Burford, Ann, 55
Burford, Carolyn, 55–56
Butler Art Institute, 39
Bywaters, Jerry
 arrogance of, 81–82
 directorship at museum, 55
 leadership of DMA, 62
 meeting of museum directors, 147
 opposition to Monet acquisition, 121
 sale of Williamson painting, 74

C

Caillebot, Gustave, 206, 267
Cain, Corrine, 238
Calliet, Margaret, 56–57, 88
Calmettes, 108, 112–13
Cantey, Sam, 96
Cargill, David, 194
Carlisle Hotel, 236
Carnegie International exhibition, 39–40
Carrozza, Vincent, 172, 191
Carter, Sallie, 190, 229
Cary, Illinois
 author's move to, 6–7
 author's return to, 275
 Cary Village Hall, 30–31, 278
 compared to Iredell, Texas, 161
 employment by, 30
 Vogel exhibition in, 278
Cary Art Association, 281
Cary Village (Vogel), 38
Casey, Bill, 47
Cassatt, Mary, 90, 145, 225
Cézanne, Paul

 relationship with Bernard, 130
 subjects painted, 109
 viewing works of, 145
 works at Betty McLean Gallery, 91
 works at Vollard estate, 97
 works offered by Valley House, 225
Chagall, Marc, 90
Chambers, Jim, 234
Chapin, Francis, 40
Chelsea Hotel, 61
Chez Eugene, 109
Chicago, Illinois, 7
Chicago Art Institute, 5, 13, 24, 224, 282
Chicago Northwestern railroad, 6
Children's Hospital, San Antonio, 192
Cincinnati Art Museum, 38
Cipango Club, 92
Cirque de l'etoile filante (Vollard), 149
Civic Federation, 52
Clark, Jim, 126, 129, 195
Clements, Gill, 266, 268
Cleveland Museum, 123
Cobb, Mr. & Mrs., 169
Cobb, "Squeak," 247
Coe Kerr Gallery, 224, 236
Cohen, Julius, 103
Cokesbury Bookstore, 58
Cole, Charles, 239
Cole, Elaine, 239
Colin, Ralph, 181–82, 185, 186
Colorado, 197
Coming Through the Rye (Remington), 237
Comini, Megan, 84
Coney Island, New York, 252
Contemporary House, 89
Copenhagen, Denmark, 251
Corcoran Art Gallery, 9
Corcoran Biannual Exhibition, 40
Cranbrook Art Academy, 61
Crete, 245
The Croquet Game (Manet), 188
Crow, Margaret, 215
Crow, Trammell, 206, 215
Crystal Lake, Indiana, 278, 281
Cuilty, Lia, 57

Cunningham, Mike, 223
Cutler Hammer Company, 2

D

Daily Times Herald, 48–49
Dali, Salvadore, 224
Dallas, Texas
 art scene in, 52
 compared to Fort Worth, 62
 growth of, 77
Dallas Child Guidance Center, 129
Dallas Cowboys, 229, 240
Dallas Little Theater, 48–49, 52–53
The Dallas Morning News
 article on regionalism, 59
 author's visit to, 48–49, 68
 author's works reproduced in, 67
 feud with Hendl, 75–76
 publicity of Monet works, 121
 review of Breckenridge show, 173
 review of sculpture garden, 125–26
 reviews of Valley House shows, 237
Dallas Museum League, 226
Dallas Museum of Art, 130, 131, 187–88, 192
Dallas Museum of Fine Art, 41, 49–50, 55, 62,
 145
Dallas Museum school, 63
Dallas Public Library, 58
Dallas Symphony, 75
Dallas Symphony Society, 163
Dallas Times Herald, 121, 234, 237
Dallas Woman's Club, 66, 162, 199
Danes, Gibson A., 120
David (Michelangelo), 210
Davis, John, 24
The Day of God (Gauguin), 16
De Menil, Dominique, 225
de Mets restaurant, 17–18
Degas, Edgar, 97, 138, 267, 269
Demuth, Charles, 90
Derain, Andre, 178, 185
Diamond M Museum, 238–39
Disney, Walt, 24

Dolmabahce Palace, 244
Douglass, John, 46–47, 48, 51
Dozier, Otis, 63, 70
Druian, Rafael, 75
Dufy, Raoul, 90, 131, 183
Durlacher brothers, 90–91

E

Easel Project (WPA), 32, 33, 36, 41
"Education of the Artist" (symposium), 227
Eisenlohr, Edward, 78
El Greco, 116, 165, 168, 207
England, author's travels to, 116–18
Escargot's, 115
Essau Seeking Isaac's Blessing (Rembrandt),
 130
Etrog, 194
Evans, Pauline, 123–24
The Eve of St. Mark (Anderson), 50
Eyck, Jan van, 117

F

Fair Park Music Hall, 67
Fake (Irving), 187
Farkac, Erika, 240–41, 244, 250–51, 262
Fearing, Kelly, 61, 91, 95–96, 124, 177
Federal Bureau of Investigation, 242–43
Feininger, Lyonel, 90, 94
Fifth Avenue Gallery, 123
"First Fifty Prints of Valton Tyler," 209
First National Bank, 164–65
Flippen family, 52
Fogel, Seymour, 91, 105
Fogg Museum, 180
Folies Bergères, 113
Forain, 97
Forest Park Road, 98–99
Fort Worth, Texas
 art scene in, 59–60
 compared to Dallas, 62
 exhibitions in, 171
Fort Worth Art Association, 58–59, 86, 94

Fort Worth Public Library, 59
Forty-Fourth Annual Exhibition for the
 Artists of Chicago and Vicinity, 38
Forty-Seventh Annual Exhibition of Ameri-
 can Art, 38
"Four New Comers" (exhibition), 94
Four Seasons Hotel, 250
Fowley, Danny, 73
Fox River Grove, 282
France, author's travels to, 108–15
Frank Perls Gallery, 94
Frank Reaugh Art Club, 77
Frary, Michael, 91, 176
Frederick, John, 214
Freed, Eleanor, 174
Frick Museum, 107–8, 224, 248, 272
Frost, Claire, 88

G

Gainsborough, Thomas, 199
Galea, Christian, 143–45, 146
Galerie Charpentier, 159
Garden of Earthly Delights (Bosch), 115
Gardner, Helen, 15
Garrett, Jimmy, 50
Gaston Episcopal Hospital, 261
Gauguin, Paul, 16, 130, 237, 251, 282
General American Oil Company, 176
General Dynamics, 72
General Motors, 77
Gentling, Scott, 194
Gerson, Otto, 180–81
Gertz, William, 195
Gillespie, Sallie, 58, 59, 78
Gimpel, Peter, 117
Gini, Nell, 108–9, 114
Goat Song (Benrimo), 93
Golden Afternoon (Innes), 199
Goldenberg, Louis
 business with, 126, 128, 225–26, 266–67
 on Meadows forgeries, 187–88
Goodall, Donald, 258
The Goodlife magazine, 248–49

Goodman Theater, 15, 29–30
Goodspeed, Albert, 38–39
Goya, Francisco, 116, 130, 257
Graham, James, 198
The Grass Fire (Remington), 198–99
Grasty, Sue Watking, 171
Griffin, John Howard, 140, 142
Guardian Savings and Loan Company, 100
Guerin, John, 91
Guggenheim Museum, 248
Gulf Coast Art Exhibit, 195

H

Hackett, Malcolm
 at Artist Community House, 14, 32
 assistance of, 19–20, 24–25, 42
 author's promise to, 92, 195
Haggerty, Bea, 207
Haggerty, Pat, 207
Hahn, Stephen, 182, 184
Hall, Weeks, 54
Hall Gallery, 250
Hammer, Armand, 155
Harding, Merle, 93–94
Harrison, Stella and Sam, 5
Harvest (Bruegel), 128
Harvest Moon (Innes), 198, 199
Hassam, Childe, 225
Hawaii, 130
Hawthorne, Charles, 75
Hawthorne, Joseph, 75
Hawthorne Junior High School, 10
Hayden, Violet, 58
Helfensteller, Veronica, 57, 58, 61, 124
Helm, George, 242–43
Helmsley Palace, 269
Helsinki, Finland, 251
Hendl, Newby, 75
Hendl, Walter, 75–76, 276
Henri, Ozenfant, 61
Henri, Robert, 61
Herd, Frances, 130–31
Hermitage (Leningrad), 251

Hertz, John D., 11, 23
Hertz estate, 11–12, 21–24, 284
Hilty Lumber Company, 1
Hirschl, Norman, 242, 247, 251, 272
Hoblitzelle, Karl, 52
Hockaday, Ela, 66
Hockaday School, 65–66
Hoffman, Hans, 61
Hoffman, Joseph, 10
Hogan, Carroll Edward, 180, 186
Hogue, Alexander, 49
Homer, Winslow, 90, 225
Honegger, Gottfried, 195, 223
Honor Built Furniture, 27
Hooch, Pieter de, 117
Hope Diamond, 103
Hopper, Edward, 225
Horizon magazine, 138, 152
Horse and Rider, Acrobat (Cargill), 194
Hory, Elmyr de, 82–84, 183, 187, 230
Hotel Cornavin, 141
Hotel Meurice, 108, 141
Houston Museum, 147
Houston Post, 174
Hovis, Keith, 38, 42–43
Howard, Richard Foster, 41, 50, 62
Howell Settlement House, 33–34
Hughes, Howard, 187
Hunt, H. L., 274
Hunt, Ray, 274
Hunt, Ruth, 273–76
Hunt, Swanne, 276
Hunter, Kermit H., 155
Hurd, Peter, 87
Hurst, Ira Jane, 211
Huston, Perry, 213, 263–64
Hutton, Leonard, 180

I

In the Flower Garden, 184–85
Innes, G., 199
Internal Revenue Service, 171,
 220–22

Iredell, Texas, 161
Irving, Clifford, 187

J

James Brooks Exhibition, 188
January Gallery, 223
Japanese Embassy, Paris, 271
Johnson, Lady Bird, 193
Jones, John Wesley, 100
Jones, Margo, 55, 273
Jordan, William, 188, 204
Joseph Sartor Gallery, 199
Joyce, Simone, 230
Joyce, Walter, 230

K

Kansky, Igor de, 207
Kantor, Morris, 38
Kennedy, John F., 156–57
Kent, Norman, 195
Kern, 25
Kerr, Coe
 business with, 163–64
 meeting, 96–97
 returning fake Modigliani, 181
 role in Monet sale, 121–22
Kimbell Art Museum, 189, 213, 226
King Coit Children's Theater, 72
Klepper, Frank, 78
Klepper Art Club, 78
Kline, Franz, 106
Knife Edge (Moore), 164
Knighton, Bill, 83
Knoedler Galleries, 89–91, 96–97, 121, 163,
 181
Knossos, Crete, 245
Knott, Morgan, 121
Komodore, Bill, 227
Krieger, Joy, 211, 216
Krieger, Marvin, 87–88, 121–22, 170, 210, 216
Kuhn, Walt, 225

L

La Belle Toscane (Neujean), 263
La Bohéme, 65
La Tour D'Eiffel, 111
Lambert, Joe, 120, 163, 176
Lambert Gardens, 240
Lambert Landscape Company, 119, 176
Landers, Bertha (Bim), 58, 72
Landscape with the Stygian Lake (Patinir), 116
Lapin Agile, 114
Lawrence, Jacob Armstead, 199
Le Baron Hotel, 234
Leeper, John, 219
Legros, Fernand, 186–87
Leningrad, 251
Leona Farm, 11–12
Lessard, Raoul, 187
Lester, William, 63
Life magazine, 106, 137–38, 142
Lily (maid), 4
Lincoln Park, 35, 42, 98
Linz Jewelry store, 68
Little Wolf River, 42
Lloyd, Frank, 185
Lloyd, Max, 281
Louisiana House, 54
Louisiana Polytechnic Institute, 61
Louvre, 111
Luce, Clare Boothe, 48
Luncheon of the Boating Party (Renoir), 107

M

MacAgy, Douglas, 147
MacLeish, Archibald, 33
MacLeish, Norman, 33–35
Maids of Honor (Velazquez), 116
Main Place Gallery, 191
Manet, Edouard, 188, 267
Mansion Hotel, 55
Marco Polo, 244
Marcus, Betty, 122
Marcus, Stanley, 207

Marin, John, 106–7, 107–8
Marini, Marino, 90
Maritain, Jacques, 139–40
Marlborough Galleries, 185
Marquet, Albert, 183
The Marriage of Giovanni Arrolfini and Giovanna Cenami (Eyck), 117
Marshall, John E., 9
Marvel, Bill, 237
Matisse, Henri, 90, 186, 251
Mayer, Mabel, 72, 104–5, 223
Mayer, Margaret (Peggy). *See* Vogel, Margaret (Peggy)
Mayer, Roland G., 4, 72, 104–5, 223, 231
Mazza, Rene, 82, 229
McCray, Bishop, 216
McDermott, Margaret, 144, 145, 147, 187, 207
McGraw, Louise, 50, 54, 55, 62
McLean, Betty
 assistance of, 100
 business with, 83
 dinner hosted by, 92
 divorce, 102
 introduction to, 64–65
 meeting Aunt Clara, 79
 visit with author, 88
McLean, Jock, 65, 79, 92, 97, 102
McNay Museum, 219
McVeigh, Blanche, 61–62
Meadows, Al, 155–56, 165
"Meadows Caper," 175–90
Meisel, Marie, 209
Meisel, Ulrich, 136
Mentch, Mr., 25, 28, 284
Merchant of Venice, 244
Metropolitan Museum, 128, 247–48
Metropolitan Opera, 65
Meyer, Marjorie, 25, 284
Miller, Dorothy, 79, 81, 106
Miller, Earl Hart, 54–55, 57
Miller, Zan, 54–55
Milles Gardens, 251
Milwaukee, Wisconsin, 3–4
Milwaukee Pump Company, 2

Mobile Art Center, 195–96
Modigliani, forgeries of, 178–81, 183
Monet, Claude
 at Knoedler's exhibition, 90
 restoring work of, 263–65
 selling work of, 233, 237–38, 249
 subjects painted, 109
Mont Sainte-Victoire, 225
Montmartre, 114
Moore, Henry, 163
Moran, Thomas, 197
Morisot, Berthe, 145
Morrie, John
 business with, 132–33, 173
 employment at Valley House, 119, 208–9,
 212–13
 preparing for exhibition, 281
 road show with author, 123
 transporting paintings, 276
Morrie, Lillian, 127
Mount Vernon, 273–74
Mountain Man (Remington), 237
Moyer, Robert, 35
Mozley, Loren, 228, 258
Murchison, Lupe (Mrs. John), 158
Murray Cotton Gin Company, 46
Musée de Jeu de Paume, 111–12
Museo Nacional del Prado, 115
Museum of Modern Art, 79, 106, 138, 248
Museum of Modern Art Library, 139
Music Hall at Fair Park, 67
Myer, Lamar, 242–43

N

Nagler, Fred, 259–60
Namath, Joe, 246
Nana (Suchorowsky), 211, 212–15, 263–64
Nashville, Kentucky, 200–201
National Gallery (London), 117–18
The Nativity (Piero della Francesca), 117
Neiman Marcus, 62, 89
Nephus, 237
Neujean, Nat, 194, 263
Neville, John, 173

New Mexico, 197
New York City, NY, 162, 171–72, 257
New York University, 247
Newhouse, Clyde, 247–48, 251–52
Newman, Teddi, 249–50, 284
Newmonon magazine, 210
Nichols, Perry, 78, 88, 99
Nicholson, Ben, 90–91
North Dallas Chamber of Commerce, 194
Northwood Country Club, 104
Notre Dame cathedral, 113
Nymphéas (Monet), 113, 121, 123

O

O'Boyle, Mary, 122–23
Odalisque (Renoir), 90
Olan, Levi, 153, 157
Old Chelsea Hotel, 269
Old Jail Museum, 65
Onderdonk, Eleanor, 10
Onderdonk, Julian, 10
O'Neill, Mary, 196
Operating the Little Theater (Pearson), 51
Oppenheimer, Evelyn, 187
Ortmeyer, Roger, 153
Osver, Arthur, 32–33, 284
Osver, Ernestine, 284

P

Palm Beach, 171
Pandorba, 165
Park, Kathleen, 278, 280, 283–84
Parker, Harry, 227
Parrish, Martha, 247, 272
The Passion (Rouault), 115, 132–59
Patinir, Joachim, 116
Pearson, Talbot, 48, 51
Peck, Patricia, 59
Pedro (yardman), 209
Pencil Point, 10
Perkins School of Theology, 204
Perls, Dolly, 15
Perls, Frank, 182

Perls, Klaus
 business with, 157–58
 on Meadows forgeries, 186
 purchase of Dali painting, 224
 reviewing works for authenticity, 180–83
 Rouault work purchased from, 151
 on Williamson paintings, 79–81
Perls Gallery, 80
Perot, Ross, 264
Peto, John F., 225
Philips Cowan Gallery, 107–8, 263
Phillips, Duncan, 107–8
Picasso, Pablo
 forgeries of, 177, 182
 show in Dallas, 181
 Vollard exhibitions of, 97
 work at Knoedler's Gallery, 90
Piero della Francesca, 117
Pieta, 111–12
Pioneer Airlines, 87
Pissarro, Camille, 90, 237, 249, 267, 269
Pittsburgh, Pennsylvania, 4
Poet's Cottage, 23
Pollock, Jackson, 241–42
Pollock Galleries, 209
Polo Club, 97
Port Aransas, Texas, 221, 250–51
Preston Center, 89

Q

The Quarrel at the House of the Cock (Goya),
 130
Quillian, Joseph D., Jr., 204

R

Rachmaninoff, Sergei, 10, 254
Railway Express Company, 121
Randt, Frank, 167
Redding, Steve, 58, 72
Redon, Odilon, 97, 130
Reeder, Dickson, 57–62, 72, 86, 91–92, 142
Reeder, Flora, 57, 60–61, 72, 142
Reeder's Children Theatre, 61

Rembrandt (artist), 130, 251
Rembrandt (cat), 42
Remington, Frederic, 198, 237, 274
Renoir, Pierre Auguste
 forgeries of, 179–80
 Luncheon of the Boating Party, 107
 at Nicholson exhibition, 91
 Odalisque, 90
 viewing works of, 145, 267
 works at Vollard estate, 97
Renouard, Baron, 108, 112, 131
Republic National Bank, 152
Reynolds, Becky, 203, 206, 209–11, 213–14
Rice University, 159, 224
Richardson, Emily, 65–66
Rigsbee, J. K., 182
Rijksmuseum, 251
Rodin, Auguste, 97
Roesch, Kurt, 61
Rosenfield, John, 48–49, 68–69, 75–76
Ross, Betsy, 200
Ross, Ruthrine, 209
Rothko, 185
Rouault, Georges, 132–59
 exhibition of work, 108, 125
 The Passion, 132–59
 research on, 138
 selling work of, 249
 viewing works of, 114
 works at Betty McLean Gallery, 91
 works at Vollard estate, 97
Rouault, Isabelle, 141
Roy, Clarence, 119
Rudnitzky, Marsha, 52
Rush Art Supply, 68
Russell, Charles M., 198
Russell, Madame, 230
Russell, Morgan, 230

S

Saarinen Home, 251
Saidenberg, Daniel and Eleanor, 182
Salzburg, Austria, 249
San Antonio, Texas, 10, 223

Santa Barbara Museum, 105

Sarah Lawrence College, 61

Sargent, John Singer, 233

Saroyan, William, 53

Sartor, Joseph, 47

Saunders, Drew, 249–50, 284

Schoener Gallery, 223

Schuffenecker, 130

Scott, Billy, 93–94

Scott, Elmer, 52

Scott, Les, 55

Scottish Rite Hospital, 234–35

Second Piano Concerto (Rachmaninoff), 76

Seeking the Intangible (Vogel), 277

Seine River, 183

Sepia (magazine), 142

Serger, Helen, 224

Seurat, Georges, 106

Sharp, Mary Nell, 69

Sheaffer, Bill, 84–85

Shiva, Raymond, 33, 35

Shook, Mrs., 193

Shook-Carrington Gallery, 193

Signac, Paul, 90, 244

Signing of the Declaration of Independence,
 263–64

Signori, 114, 131, 133

Simmons, Harry, 68

Simon, Norton, 226

Simpson, Charles, 210–11

Sisley, Alfred, 267, 269, 272

Sizemore, Jim, 241–44

Slocum, Miss, 64

Smith, Robert A., 87–88

Snyder, Texas, 238–39

Soldier's Field, 41, 46

Soloman, Joseph, 75

Southampton, England, 251

Southern Baptist Convention, 200

Southern Methodist University
 author's relationship with, 204
 rejection of *The Passion,* 153
 speaking at, 227
 translator from, 142
 Tyler exhibitions, 209

Spain, 115–16

Spring Valley Road, 99

St. Francis (El Greco), 165, 168

St. Francis in Ecstasy (Bellini), 224

St. Paul's Hospital, 202–3

State Fair of Texas, 103

Ste. Chappel, 113, 142

Steel, Pat and Sara, 124, 128

Stewart, Bob, 164–65, 165

Stewart, Cynthia, 165

Stockholm, Sweden, 251

Stonehenge, 251

Strauss, Richard, 197

Stravinsky, Igor, 67

The Studio Visitor (Vogel), 193

Suares, Andre, 132, 143

Suchorowsky, Gospodin Marcel Gavriel, 214

Sullivan, Mrs., 263–67, 270, 272

Sutton, Mr., 212–13

Sweeney, 147

T

Talmadge, Budlong, 6–7, 25, 42, 279, 280

Talmadge, Eleanor
 author visiting with, 6–8, 11, 25, 28
 author's parting with, 42
 honoring memory of, 280

Talmadge, Francis Osborne, 2–3, 7, 230

Taos, New Mexico, 78, 93

Tate, Willis, 154, 155–56

Tate Gallery, 117

Telenews Theater, 67, 68

Terry, Felicia, 37

Texas Christian University Christian Church,
 75

Texas City, Texas, 205

Texas Instruments, 207, 230

Texas Wesleyan College, 61, 95

Thesus, 245

Thomas Jefferson High School, 10

Three Men on a Horse (play), 51

The Time of Your Life (Saroyan), 53

Toledo, Spain, 116

Toulouse-Lautrec, Henri de, 127, 130

Travis, Olin, 78
The Triumph of Death (Bruegel), 116
"The Tuesday Club That Plays on Thursday," 95
Tufts, Eleanor, 227
Tuni de Juan, 113
Turner, Decherd, 204
Turner, Janet, 94
Turner, Joseph, 117
Twenty-Four Hours with the Herd (Reaugh), 77
Tyler, Robert, 204
Tyler, Valton, 204–6, 209, 219, 227–28

U

Uccello, Paolo, 117
Umlauf, Charles, 94
University of Houston, 219
University of North Texas, 248
University of North Texas Press, 277
University of Texas, Austin, 61, 77, 228
U.S. Department of State, 256
Utrillo, Maurice, 90, 177, 182
Utter, Bror, 57–58, 61, 92, 94

V

Valentin, Curt, 90, 96
Valley House
 chosen as member of dealers association, 171–72
 construction of, 1–2
 design and financing of, 99–101
 floods at, 167–71
 model for, 89
 Moore sculptures at, 163
 opening of, 103
 press coverage of, 256
 sculpture garden, 120
"Valley House Gallery: Oasis of Beauty and Culture," 194
Valtat, 178, 185
Van Dyke, 199
van Gogh, Theo, 130
van Gogh, Vincent, 109, 130, 227

Varna, Bulgaria, 244–45
Vaughn, Jack, 165
Vaughn, Mary Jo, 166
Velazquez, Diego, 116
Venard, Claude
 exhibition of work, 124–25, 152
 first American exhibition, 97
 visit with, 109–10
 works at Betty McLean Gallery, 91
Venice, Italy, 244
Vermeer, Jan, 117
Versailles, 109
Vich Summit Falls, Virginia, 9
View of Salamanca (Mozley), 258
Visby, Amsterdam, 251
Visson, Vladimire, 129
Vivian L. Aunspaugh Art Club, 77–78
Vogel, Barley, 231, 247–48, 262
Vogel, Cheryl, 255, 276–77
Vogel, Donald (not author), 69
Vogel, Elissa, 218
Vogel, Eric Stefan
 birth of, 87
 education of, 209–10
 during flood at Valley House, 168
 preparing for exhibition, 281
 role at Valley House, 238
Vogel, Helen, 8
Vogel, Jake, 1, 5–6
Vogel, John Walter, 249
Vogel, Katherine Barley, 160, 211, 216
Vogel, Kevin Eliot
 advising father, 231
 birth of, 104
 correspondence, 210–13
 during flood at Valley House, 168
 marriage of, 241
 paintings of, 105–6
 trip to Europe, 210
 work at Valley House, 238, 255, 268, 276
Vogel, Margaret (Peggy)
 at Art Dealers Association Meeting, 182–84
 authorship of *Aunt Clara*, 161
 birth of daughter, 160

birth of son, 87
correspondence, 134–35, 136–37
courtship with author, 72–73
death of, 217
at emergency room, 85
floods at Valley House, 167–71
illness, 193, 202–3, 209
McLeans and, 92, 102
pregnancy, 154–55
remembrances of, 231
role at Valley House, 104–5, 257
wedding, 62, 75
Vogel, Randi Lee, 249
Vogel, Robert Fred, 3, 11, 249, 267–68
Vogel, Walter Fred, 1–3, 2–3, 217
Vollard, Ambrose
 business with, 131
 Cirque de l'etoile filante, 149
 meeting, 97
 publication of "Passion" poem, 132, 141, 143
 represented by de Bolli, 256
Vuillard, Edouard, 90, 108

W

Wagner, 197
Ward, Velox, 203–4
Washer's Tavern, 279
Washington, DC, 202
Washington Lee Junior High School, 9
The Wedding Dress (Vogel), 193
Wells, Orson, 29
Westgard, Cheryl, 238, 241. *See also* Vogel, Cheryl
Westgard, Debbie, 238
Westgard, Peggy, 238
Weyhe Gallery and Book Shop, 58, 138
Whistler, James, 37
The White Cloth (Vogel), 206
White Rock Lake, 273
Whitney Museum, 107, 248
Wichita, Kansas, 236
Wichita Falls, Texas, 154
Wildenstein, Alex, 266, 268, 270
Wildenstein Gallery, 126, 129, 184, 225–26, 265
Wilder, Mitch, 160–61, 198, 203, 233, 235
Williams, Carol, 209
Williams, Charles, 124
Williams, Tennessee, 273
Williamson, Clara McDonald
 author's interest in, 160–61
 book about, 193
 death of, 226–27
 exhibition at Amon Carter Museum, 171
 at McLean dinner, 92
 meeting, 70
 sale of paintings, 74, 79
 turning down New York show, 81
 works at Betty McLean Gallery, 91
Williamson, Donald, 161–62
Windfohr, Anne, 95–96, 103–4
Wingren, Dan, 227
Winston, Harry, 103
Witte Memorial Museum, 10, 52–53
Wolfe, Tom, 223
The Women (Luce), 48
Women's Building (State Fair), 103
Woodstock, Illinois, 29
Woolworth, Fred, 224, 225, 236
Works Progress Administration, 32
World War II, 41
Wright, McDonald, 230

Y

The Yellow Hat (Vogel), 193
YMCA, 44
Young girl with Flowers (Vogel), 38